J.M.W. TURNER
'A Wonderful Range of Mind'

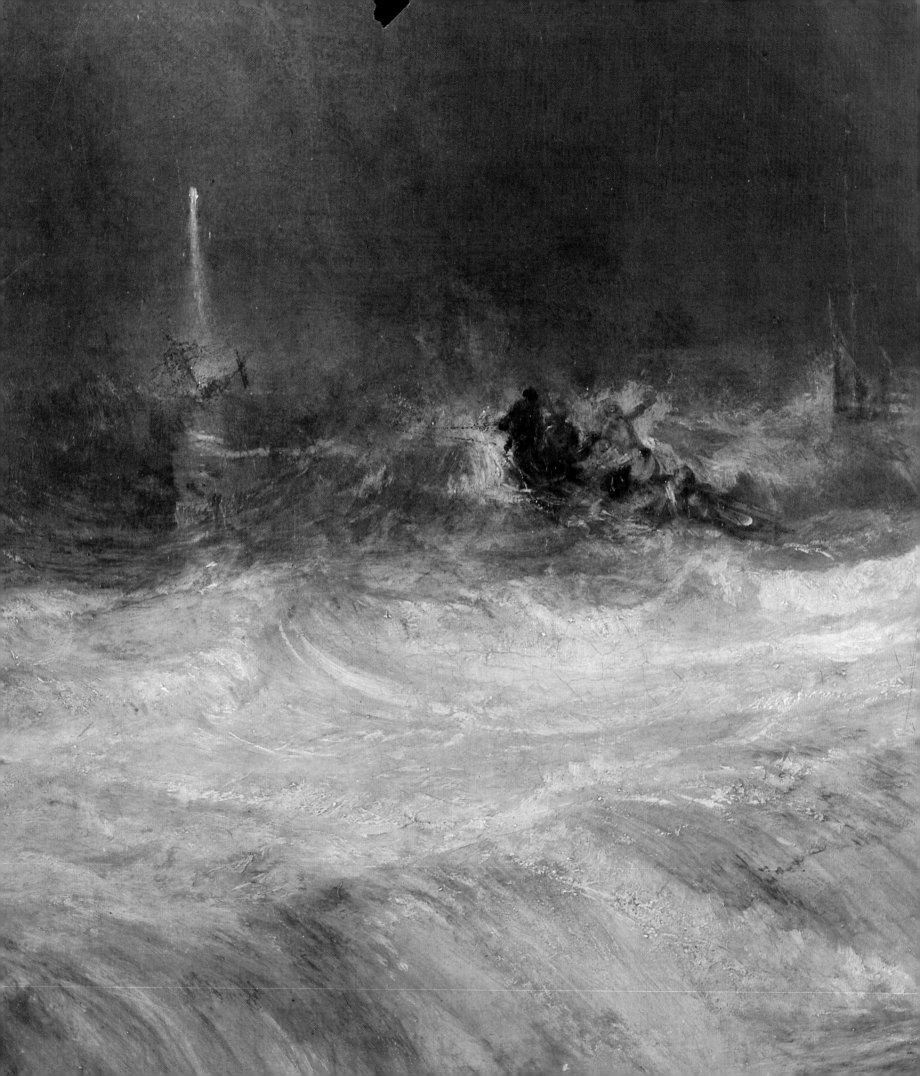

J.M.W. TURNER

'A Wonderful Range of Mind'

JOHN GAGE

YALE UNIVERSITY PRESS

NEW HAVEN AND LONDON 1987

To the memory of Anne Rees-Mogg

Designed by Mary Carruthers
Set in Monophoto Bembo by Tameside Filmsetting Ltd
Ashton-under-Lyne, Lancashire, and
Printed in Italy by
Amilcare Pizzi, s.p.a., Milan

Library of Congress Catalog Card Number 86-51375
ISBN 0-300-037791

(Previous pages) detail of Fig. 312.

CONTENTS

PREFACE

TURNER's genius has never been more fascinating to the wider public than it is today; and there have been many general studies of his work in recent years, as well as a whole new category of specialist treatments of particular parts of it. Do we need another large-scale general book? I believe we do, and chiefly because there is still no introduction to the whole of Turner's professional career, and no biography that has been centrally concerned with the complexities of his art. The main lines of Turner biography and criticism were laid down in mid-Victorian England, and he has suffered from them ever since. His earliest biographer, the journalist Walter Thornbury, gathered a mass of important information from the painter's friends and associates, but he threw it together so carelessly that all subsequent writers on Turner have been prejudiced against his work, to the detriment of theirs. The biographies by Monkhouse (1879), Hamerton (1879), Armstrong (1902) and Falk (1938) all contributed to the extensive documentation of Turner's life, but none of these writers had much familiarity with his working materials, the sketchbooks, several hundred of which are in the Turner Bequest, nor much interest in pursuing that life below the surface. Falk, another journalist, revealed most about Turner's sexual nature; but, unlike his older contemporary, Henry Fuseli, Turner did not parade his powerful sexuality (the evidences of which Ruskin tried so drastically, and so ineffectually to destroy by burning many drawings in 1858), and it bears a very indirect relationship to the character of his art. And although Falk drew up a list of Turner's library, he made no attempt to assess what the painter read.

With few exceptions, modern English critics have preferred to ignore these aspects of Turner's life; but across the Atlantic they have become the focus of a narrowly-based school of psycho-biography which has sought to interpret the subject-matter of some of Turner's late works in the light of his private obsessions. Turner was certainly an obsessive draughtsman, and he has left us some twenty thousand sheets as evidence of this compulsion; yet he was never in any special sense a 'private' artist, and this flourishing new school of interpretation has depended for the most part on the lack of a thorough professional biography which would follow the everyday circumstances of his working life. This lack is the more acute because, as this book will show, Turner's life was unusually full of 'events'.

The most important biography to date, by the poet Jack Lindsay, was first published in 1966, and has recently been re-issued in a shortened and revised version. Lindsay made the first extensive use of Turner's writings (he has also been the editor of his poems); but a tendency to interpret the art chiefly in terms of the domestic life

prevented him from writing the truly 'critical' biography announced in his original title. Our fundamental biographical source remains the *Life* published by A. J. Finberg in 1939 (revised edition 1961), many years after he had compiled the first inventory of the watercolours and drawings in the Turner Bequest. This monumental work had put Finberg in the best position to know the temper of Turner's mind, and in an earlier book, *Turner's Sketches and Drawings* (1910) he had shown himself to be a sensitive and imaginative commentator; but, surprisingly, he introduced very little of this knowledge and sensitivity into the *Life*, which he determined should be simply a 'chronicle-biography'. Finberg's acute distaste for Thornbury led him to jettison most of that biographer's original material so that, while he enriched immeasureably the documentation of Turner's personal circumstances, he produced a remarkably arid and superficial study of the artist.

It is into this biographical vacuum that I am introducing this book, which is an attempt to present some of the many facets of Turner's life as they shaped and directed his art. I shall look at where he went, what he read, the company he kept and the institutions he supported; but all of these will be related to the art which was the overriding concern of his life, and the only reason that we have to engage with it. Turner's variousness was not the curiosity of a dilettante, but the ceaseless endeavour of a professional artist dedicated to nourishing and cultivating his central pre-occupation, namely his painting.

The problems in establishing the professional context of Turner's career have not been helped by the almost complete lack of studies of the major art institutions of his day. The only extensive history of the Royal Academy was published as long ago as 1862 and there has been no full study of its rival the British Institution, an exhibiting society founded in 1805, for which the unpublished documentation is abundant. Knowledge of Turner's works has increased enormously in recent years, notably through the publication of Martin Butlin and Evelyn Joll's great catalogue of his oil paintings (1977, revised edition 1984), and the more summary catalogue of most of the finished watercolours published by Andrew Wilton in *The Life and Work of J. M. W. Turner* (1979). I have myself collected most of the surviving correspondence in *Collected Correspondence of J. M. W. Turner* (1980) and a supplement in *Turner Studies*, VI, i 1986. But the present book is essentially an introduction and an interim study, for a full-scale professional biography of Turner will have to wait for the completion of Andrew Wilton's new inventory of the drawings and watercolours in the Turner Bequest, the first volumes of which are beginning to appear, and for the edition of Turner's notes and lectures which is being prepared by Maurice Davies and Barry Venning.

Among the many people who have helped to make this book I should like especially to thank Ian Bain, David Blayney Brown, Ian Fleming-Williams, Francis Haskell, John House, Joan Kerr, Andrew W. Moore, John Munday, Constance – Ann Parker, Leslie Parris, Michael Pidgeley, who provided Fig. 7, Eric Shanes, Sam Smiles and Raymond V. Turley, who provided the photograph of Fig. 234. The Master and Fellows of Trinity College, Cambridge kindly allowed me to quote from the Dawson Turner correspondence and the Trustess of Dr Williams' Library from the diary of Henry Crabb Robinson. Alex Potts read the manuscript and made many helpful comments. My family encouraged and forbore.

I dined with the Royal Academy last Monday in the Council Room – it was entirely a meeting of artists (none but the members and exhibitors could be admitted) and the day passed off very well. I sat next to Turner, and opposite Mr West and Lawrence – I was a good deal entertained with Turner. I always expected to find him what I did – he is uncouth but has a wonderful range of mind.

John Constable to Maria Bicknell, 30 June 1813

ABBREVIATIONS USED IN THE TEXT

BJ Refers to the numbering in M. Butlin & E. Joll, *The Paintings of J. M. W. Turner*, revised ed. 1984

R Refers to the numbering in W. G. Rawlinson, *The Engraved Work of J. M. W. Turner, R.A.*, 1908–13

RLS Refers to the numbering in W. G. Rawlinson, *Turner's Liber Studiorum*, 2nd. ed. 1906

TB Refers to the numbering in A. J. Finberg, *A Complete Inventory of the Drawings of the Turner Bequest*, 1909. The revised Inventory by A. Wilton (1987–) will include a concordance with Finberg's numbers

W Refers to the numbering of the catalogue of Watercolours in A. Wilton, *The Life and Work of J. M. W. Turner*, 1979

INTRODUCTION
Modernism and Romanticism

WITH the opening of the Clore Turner Gallery on Millbank in 1987, the terms of Turner's will, which bequeathed the contents of his gallery and studio to the nation, have come close to being fulfilled. The Turner Gallery is thoroughly characteristic of the efforts of many artists of the Romantic period to erect monuments to themselves, and that this has taken so long in the case of Turner is due to a number of not very significant accidents, beginning with his faulty drafting of the will itself. But the wonderful opportunity of seeing the whole range of Turner's output, in oil painting, in watercolour, and in the graphic media, gathered together in one place, presents its own problems, for Turner was enormously productive, and this, the largest single collection of his work, is not only vast in extent, but also very varied in character, so that it is more difficult than ever to see its direction on a first encounter.

The earliest critic to write comprehensively about Turner's production, John Ruskin, the painter's friend and patron who is still his greatest interpreter, attempted to solve this problem by dividing the work into distinct periods, of studentship, of mastery, and of decline. Among the paintings characteristic of the first period he chose *The Decline of Carthage* (Fig. 290), painted in 1817, when Turner was forty-two, of the second, he chose *Ulysses Deriding Polyphemus* (Fig. 4), and of the third, one of the painter's most popular late paintings, *Peace, Burial at Sea* (Fig. 226).[1] Despite the eccentric chronology, this is a plausible division, for, faced with a roomful of Turners we are first of all struck by the change from the more sombre and gandiose canvasses of the earliest phase to the smaller and often dazzlingly luminous paintings of the last years, where the precise nature of the subject cannot readily be seen. But to parcel out Turner in this way is in the strictest sense superficial, for it must soon be clear to us, as it was to the painter's contemporaries, that the raising of key and colour about 1820 was only one development in his essentially painterly sensibility, which had been striving for the expression of atmosphere and light since the first decade of his career – a decade which, incidentally, Ruskin chose to ignore. It will be equally apparent that Turner's devotion to the art of the past, and especially to the seventeenth-century Franco-Roman master Claude Lorrain, remained with him until the final oils of 1850 (Fig. 283), which are modelled on Claude's many *Seaports* (Fig. 155), although the terms of that devotion evolved continuously. Finally, it will be only too clear to the visitor that Turner's subjects were unusual and that when, as we must, we approach to read the labels to discover what they are, we shall also approach the surface of the pictures, which is precisely what Turner intended we should do.

Ruskin's wish to expound Turner's work simply in terms of a developing style was

in tune with the general inclination of nineteenth-century writers to see painting as a series of visual discoveries, and this is an approach which has dominated criticism until our own times. Twenty years ago, the Museum of Modern Art in New York, not usually given to celebrating the masters of the early nineteenth century, mounted an exhibition of Turner paintings and drawings and in his catalogue, Lawrence Gowing wrote,

> Turner isolated the pictorial effect, as one skims the cream off milk. He proceeded to synthesize it afresh with an almost excessive richness. To complete the product he was apt to add synthetic details; we do not always find them convincing. His essential creation did not require them, and eventually he realized it. He had isolated an intrinsic quality of painting and revealed that it could be self-sufficient, an independent imaginative function.

And in a commentary on Turner's idiosyncratic characterisation of Rembrandt (see below), Gowing added that Turner 'imagined colour as a separate fabric, fragile and vulnerable, yet sacred and sufficient in itself to supply all the reality that is required from a picture'.[2]

This is not the Turner who is the subject of my book, which proposes first of all to identify him as a Romantic artist, as Gowing's exhibition was concerned above all to show that he was a painter who transcended Romanticism, and could speak directly to the American abstract painters of the 1960s. Gowing's appreciation represents the strongest strand of twentieth-century criticism, and it has a pedigree which goes back almost to the beginning of Turner's career. The admirers of Turner who are seeking to re-instate the role of subject in his work are obliged to admit that even in Turner's lifetime there were very few among his public who paid much attention to his subjects, and fewer who understood them. Even Ruskin, who came to have a greater understanding of the temper of Turner's mind than any other critic, was rarely concerned to unravel them in detail, and many he dismissed as conventional nonsense.

Two factors chiefly contributed to the tendency of Turner's contemporaries to ignore his subjects. One was the aesthetic of the Picturesque movement, which dominated the appreciation of landscape in nature as well as in art in the early part of the nineteenth century; and the other was the unconventional quality of Turner's style and handling, which occupied most critics' attention throughout Turner's lifetime, and for long after it. The Picturesque aesthetic, with which Turner himself became involved in the 1790s,[3] sought to apply to the perception of real landscape formal values derived from the study of art, and, as Turner was to do in his account of Rembrandt, to excuse even the most ignoble forms and subject-matter – such as pigs, boors and dunghills – if they were skilfully treated with the artifices of light and shade (see p. 103). It was an emphasis which made subject-matter more or less

1. Edward Goodall after J. M. W. Turner, *Tantallon Castle*, 1822. Line-engraving, 17 × 25 cm. Yale Centre for British Art (R 198).

irrelevant, and hence, as we shall see, Turner's efforts to raise the status of his own speciality, landscape, had to draw on the theory and practice of history-painting and of poetry. The public for landscape art did not expect to find it a repository of thought, and even when critics used the term 'poetic', as they frequently did in the case of Turner, they used it in a very general sense to excuse what a more literal eye might (and often did) censure as unnatural.

The balance of imagination and reality in Turner was always a precarious one. When he emerged onto the international stage, as early as 1808, in a German history of British painting, a warm and detailed appreciation of the truth of early sea-pieces like *Fisherman Upon a Lee-Shore in Squally Weather* (BJ 16) and *Ships Bearing up for Anchorage* (BJ 18) was tempered by what was to become a constantly re-iterated complaint that the 'latest' works were too hastily painted. In connection with the latter picture, the critic coined a fruitful phrase when he wrote of the 'studied neglect' (*studienartig Sorglosigkeit*) of the handling.[4] In this same year the engraver John Landseer, in the

2. Eugène Isabey, *Côte de Douvres*, 1832. Lithograph. Paris, Bibliothèque Nationale.

longest and most important early assessment of Turner, spoke of the way in which he had raised the key of his pictures without using the usual techniques of tonal contrast: 'he has been particularly successful in seeming to mingle light itself with his colours'.[5] Thus, in the first decade of the nineteenth century and only the second of Turner's working life, most of the parameters of Turner criticism had already been established, and they did not include detailed attention to subject.

Where subject did come to play a role was in the context of the engravings, which gave, in any case, very little sense of the painter's personal touch. A rare understanding of the role of the figurative element in the engraved image was shown by the French critic Amadée Pichot, who visited England in the mid-1820s, and sent back prints from *The Provincial Antiquities of Scotland* to Baron Taylor, an influential patron of French landscapists, who was at that time in the process of making a great picturesque survey of France. Of *Tantallon Castle* (Fig. 1) Pichot wrote,

> It is not only the foliage of the trees that is tossed by the wind; what a wonderful use [Turner] has been able to make of the dog buffetted by the blast, and of the poor woman who can hardly wrap her plaid around her, while her little boy goes to look for water to revive his fish! You can't stop admiring the truth, the power and the brilliance of these contrasts . . .[6]

It was in fact on French print-making that Turner had perhaps his greatest impact at this time, for it was exclusively in the form of prints that his work was available abroad, although some artists, like Eugène Isabey (Fig. 2) and Théodore Gudin (Fig. 112) did make the journey to London, and may well have seen Turner's Gallery as well as finished watercolours in the exhibitions of his engraver W. B. Cooke (Figs. 3, 111).[7]

But in England it was Turner's annual offerings to the public exhibitions which almost exclusively occupied the critics, and here it was his increasingly personal handling of colour and paint which gave the focus of attention. In the 1820s they cast about for ever more extravagant analogies for the painter's substances and textures, and, as gourmandism was already a way of life among the art-loving classes, they hit upon the analogy of food. Probably the earliest *exposé* of Turner in the kitchen was *John Bull*'s attack on *Mortlake Terrace* (Fig. 12), the culmination of a long critical campaign against the painter's love of yellow in that decade:

> he is in painting, what a cook would be in gastronomy, who, fancying he could make a good curry, curried everything he could get hold of, fish, meat, fowl, and vegetables: MR TURNER, indeed, goes further, for he curries the rivers, and the bridges, and the boats upon the rivers, and the ladies and gentlemen in the boats . . .[8]

Even painters, who were sometimes credited with being the only admirers of Turner's late work, could find the new style perplexing. The American landscapist Thomas Cole, who took some of Turner's stylistic as well as his thematic concerns across the Atlantic in the 1830s, remained chiefly impressed by the early works, and found the colour of, for example, *Ulysses Deriding Polyphemus* (Fig. 4) far too extreme. The works which he saw at the Academy and in Turner's gallery in 1829

> are splendid combinations of colour when it is considered separately from the subject, but they are destitute of all appearance of solidity. Every object appears transparent or soft. They look as though they were made of confectionary's Sugar Candy Jellies. This appearance is produced by an undue dislike to dullness or black. The pictures are made up of the richest, brightest colours in every part, both in light and shade . . .[9]

As late as the turn of the century, Renoir, who came closer than most Impressionists to Turner's techniques, could dismiss his work as little more than *patisserie*.[10]

3

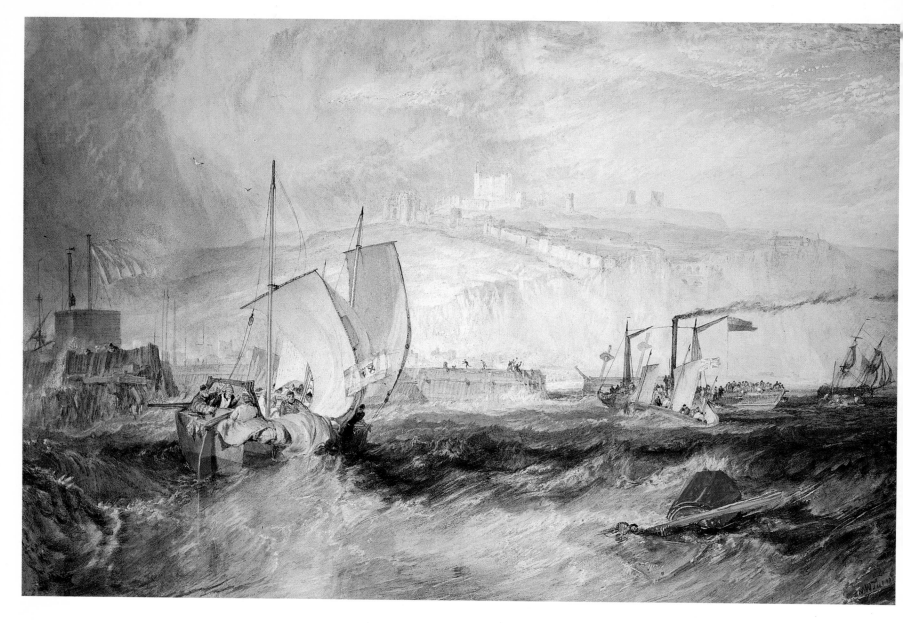

3. J. M. W. Turner, *Dover from the Sea*, 1822. Watercolour and bodycolour, 43.2 × 62.9 cm. Boston, Museum of Fine Arts (W 505).

This was an approach to Turner which captured the public imagination, and a later President of the Royal Academy, Sir Wyke Bayliss, recalled a scene in a Christmas pantomime, probably in the early 1840s, which showed a picture-dealer's shop on a street:

In the window is a painting by J. M. W. Turner, crimson and gold and white, at which a crowd are gazing with blind eyes and open mouths. Amongst the crowd is a baker's lad with a square tray of confectionary on his head. Elbowed by the crowd, he loses his balance, and the tray falls, smashing the window and plunging through the wonderful canvas. The picture-dealer rushes madly out of the shop with his arms uplifted in horror at the catastrophe. But a happy thought seizes him. Disentangling the baker's tray from the debris of the picture and window-glass, he perceives that it is precisely the size of the painting. Moreover, it is dashed all over with the crimson and gold of the jam tarts it carried. Happily it carried also a bag of flour. The baker runs away, but the picture-dealer takes possession of the tray. He scatters a little of the flour over the jam tarts and the harmony is complete – crimson and gold and white. The tray is fixed into the picture-frame, and ten minutes later an old

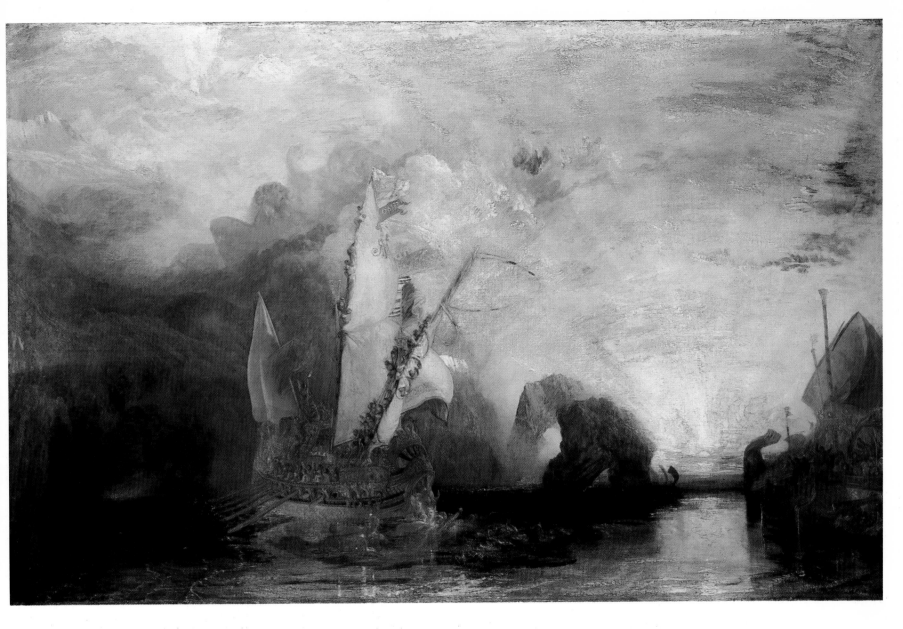

4. J. M. W. Turner, *Ulysses deriding Polyphemus – Homer's Odyssey*. Oil on canvas, 132.5 × 203 cm. R.A. 1829. London, National Gallery (BJ 330).

gentlemen, a well-known connoisseur, walks leisurely down the street. He sees the new Turner, buys it at once for a thousand pounds, and – all's well that ends well.[11]

Turner was sometimes hurt by this nonsense,[12] yet he was also ready to join in the fun, and on one occasion at a dinner he condescended to analyse the salad in terms of his own painting for the benefit of his neighbour.[13] But it was also this tradition of critical bluster, in the form of the Rev. John Eagles' attack on *Juliet and her Nurse* (1836; BJ 365), in *Blackwoods' Edinburgh Magazine*, which first moved the seventeen-year-old John Ruskin to defend Turner, and in so doing, raised the standard of art-criticism in England to an entirely new level.[14]

Ruskin's *Modern Painters* (1843–60) began as an attempt to show that Turner's late style was truer to nature than any other landscape art had ever been, and to achieve this Ruskin was led into a sustained and exhilarating examination of the nature of perception and representation. But by the time he came to write the last volumes of the book in the 1850s, Pre-Raphaelitism, for which Ruskin was also the leading spokesman, had given a wholly new meaning to visual 'truth', and he now laid much greater emphasis on the imaginative and symbolic elements in Turner's work, even

though he was never inclined to look at the more elaborate subject-pictures in any detail. Something of the quality of Ruskin's vision and of his writing can be seen in his account of a late watercolour, *Dawn After the Wreck* (Fig. 5):

> It is a small space of level sea-shore; beyond it a fair, soft light in the east; the last storm-clouds melting away, oblique into the morning air; some little vessel – a collier probably – has gone down in the night, all hands lost; a single dog has come ashore. Utterly exhausted, its limbs failing under it, and sinking into the sand, it stands howling and shivering. The dawn clouds have the first scarlet upon them, a feeble tinge only, reflected with the same feeble blood-stain on the sand.[15]

The range of interpretation which Ruskin introduced into his great work was not entirely unprecedented. A remarkable anonymous discussion of the whole of the painter's production appeared in 1833, three years before Ruskin's first Turnerian essay, the *Reply to Blackwoods*, in *Arnold's Magazine of the Fine Arts*, and it deserves to be rescued from oblivion.[16] The dozen pages of this review were by far the longest treatment of Turner's work before the appearance of *Modern Painters* itself, and within the framework of what is essentially a eulogy, it introduced a number of sharp evocations of particular works:

> When the miscellaneous crowd, composing the visitors to the Royal Academy exhibition, first beheld Turner's painting of 'Pilate washing his Hands' [Fig. 6] all experienced the influence of its blaze of light, its gorgeous colouring and magical chiaroscuro. But its grandeur of conception, its passion, expression and pathos, few understood and less appreciated; and the many condemned what they could not understand, and looked on the noble effort of genius only as a mere mass of unmeaning colour. In our opinion the grandeur of idea, the power of invention, and the awfully sublime effect on the mind, cannot receive too much praise. The more than chaotic mass, the infuriated multitude, that shouted 'Let him be crucified!' like an agitated sea undulate before us; we all but hear the Babel-like din of many voices; and by the distance at which is seen the figure of Pilate, with expanded arms, how admirably is given the idea of space? Like Rembrandt, by the mere power of light and shade and harmonious colouring, Turner can rouse the sublimest feelings of our mind . . .[17]

In this technical analyses too, the author of this essay introduced a topic which was to become one of the most influential aspects of Ruskin's treatment. Speaking of the broken colour which Turner introduced into every part of his pictures in the 1820s and 1830s, the reviewer observed:

> There is not one quality for which Turner is more pre-eminently distinguished from among his numerous beauties than his knowledge of breadth. Not only does it signify a clear and gradual union of shadows and half-tints, but that every part of a picture should present a mass of broken colouring. This last expression may appear somewhat vague. We will enlarge upon it. If an artist will attentively look at any object in nature, for instance, a lawn, he will not find it a mere mass of green; but discover it agreably broken and diversified by a variety of tints and tones of colour. The principle of it lies in this. In less than a square inch in every spot of nature, no two tints are of a similar strength and colour. It is then by the subtle union of such a mass and variety of tints that true breadth only can be given; and in doing so, no artist has carried this principle so approaching to perfection further in his works than Turner.[18]

It was the doctrine of the natural truth of gradation and stippling, transmitted through Ruskin's subtler and more comprehensive treatment of it in *The Elements of Drawing*

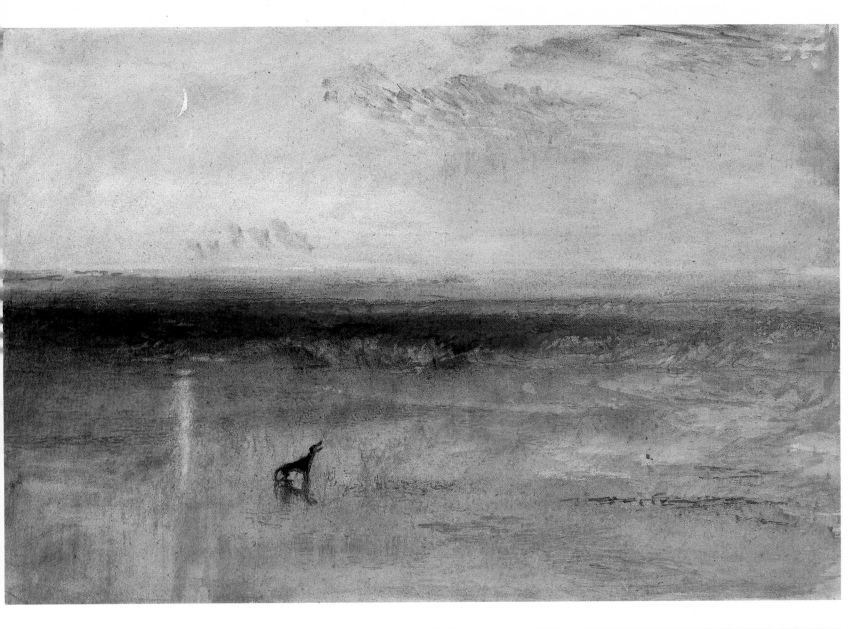

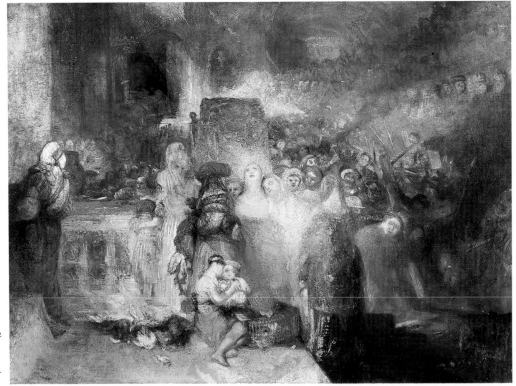

5. J. M. W. Turner, *Dawn after the Wreck*, c.1841. Watercolour, 24.5 × 36.2 cm. University of London, Courtauld Institute of Art (W 1398).

6. J. M. W. Turner, *Pilate washing his Hands*, Oil on canvas, 91.5 × 122 cm. R.A. 1830. London, Clore Gallery for the Turner Collection (BJ 332).

(1857), which so impressed a group of French post-Impressionist painters at the end of the century.

Turner's attitude towards Ruskin was ambivalent. He had a great affection for his young patron and disciple, yet he was cleary embarassed by the length and the highly-wrought rhetoric of his writing: 'He sees *more* in my pictures than I ever painted'.[19] Both these qualities still make Ruskin hard to approach as a critic, and it is perhaps understandable that the only modern anthology of Ruskin's writing on Turner has been in French.[20]

The *cliché* that Turner's art bore a closer relationship to the buffet-table or the confectioner's than to nature was only one of several attitudes towards it which recurred throughout the nineteenth century. Another, and clearly related, story, was the impossibility of telling which way up his pictures should hang. This idea first appeared in an especially vituperative review of Turner's small Roman exhibition of 1828, which included the *Medea* (Fig. 122) and the earlier state of *Regulus* (Fig. 309), by the elderly Austrian landscape painter Josef Anton Koch:

> This show was much visited, ridiculed and hooted, which is not the case with mediocre and unexceptional things. The old *Caccatum non est pictum* [see Fig. 7] was still a refrain to make you laugh, for you know how little it takes to keep people happy. The pictures were surrounded with ship's cable instead of gilt frames. It is not easy to describe them . . . although the composition purporting to show the *Vision of Medea* [Fig. 122] was remarkable enough. Suffice it to say that whether you turned the picture on its side, or upside down, you could still recognize as much in it . . .[21]

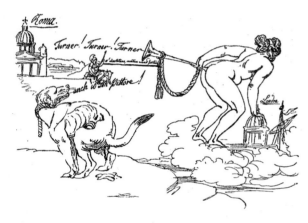

7. Circle of Josef Anton Koch, *Satire on Turner*, c.1828. Medium and present whereabouts unknown. The inscription below the trumpet reads, in translation, 'Oh, charlatan, crapped is not painted'; and the dog utters words traditionally attributed to Correggio, when he saw Michelangelo's Sistine ceiling: 'I, too, am a painter'.

Turner was particularly the butt of this German circle in Rome, who produced a scurrilous satire on his reputation (Fig. 7); but at the same time he did speak to the more painterly among them, and notably to Carl Blechen, some of whose Italian studies seem to have been executed very much in his spirit (Fig. 20).[22] The squib that Turner's paintings could be understood as well any way up became something of a tradition in England and France as well: Haydon spoke of it in the 1840s and Prosper Merimée reported a decade later that Turner's framers had to consult him on which way up to put the hanging-rings, a story which had been given currency by the earliest biographer, Peter Cunningham.[23]

All these criticisms, of course, tended towards the notion of Turner as an abstract artist, whose works were simply an agglomeration of colours more or less harmoniously arranged; and this view was given a good deal of impetus by the public display of a group of unfinished paintings and watercolours at the new Turner Gallery in Marlborough House in the late 1850s. Turner's own attitude towards the unfinished works which form such a large proportion of his Bequest is not at all clear. In some notes, which are now, regrettably, lost, he had proposed that a group of unfinished canvasses should be shown in his Gallery every five years, and a selection of 'unfinished drawings and sketches' every six.[24] But the will, with its several codicils up to 1849, specified that only 'finished pictures' should be kept. Given the nature of the late style, this was a very difficult distinction for the executors (even those who were professional artists) to observe, and a Chancery Decree of 1856 eliminated it, treating all his works on exactly the same level.[25] A small number of unfinished canvasses were included in the first Marlborough House exhibition the following year, clearly labelled as such, and a French critic made a surprising observation of the reception of these works by the public:

> For a moment, seeing the word *unfinished*, in front of the most eccentric of these canvasses, I thought that these unruly paintings were no more than bizarre lay-ins [*ébauches*], which the painter had used as experiments or as guides; but the Englishmen I was with assured me that most of these pictures were in fact finished

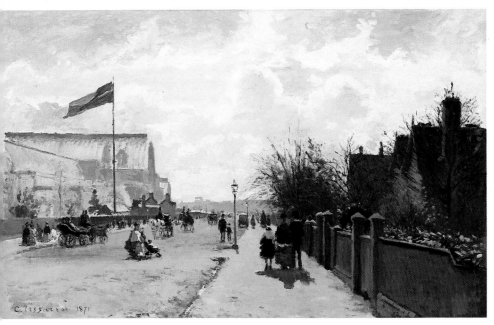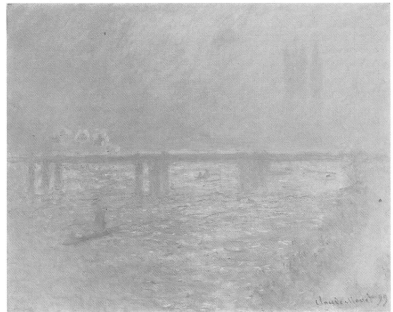

8. Camille Pissarro, *Crystal Palace, London*, 1871. Oil on canvas, 48 × 73 cm. Art Institute of Chicago.

9. Claude Monet, *Charing Cross Bridge*, 1899. Oil on canvas, 65 × 81 cm. Santa Barbara Museum of Art.

[*achevés*], and were complete expressions of the master's ideas. And they told me that these were the works which they and the London public preferred . . .[26]

When, in the 1860s, the Turner Gallery was transferred to the new South Kensington Museum (now the Victoria and Albert Museum), among more than a hundred oils were only five unfinished works, again clearly labelled as such; but there were many more sketches and watercolour beginnings, and the impact they must have made on the young Impressionists Monet and Pissarro, when they visited London in 1870/1, is suggested by the account of another French critic about the same time:

> The rooms devoted to the landscape-painter Turner include an enormous number of lay-ins and sketches [*un nombre immense d'ébauches et de croquis*] of all sorts, the former relating to well-known pictures and the latter simply experiments or impressions captured on the wing in front of nature, but all showing the genius of the artist at his most secret and profound.[27]

Camille Pissarro, who perhaps derived most from Turner on this trip, and who represented the Crystal Palace in a very Turnerian light (Fig. 8), recalled most vividly not the *ébauches*, but subject pictures like *Rain, Steam and Speed* (Fig. 10) and *Peace, Burial at Sea* (Fig. 226) and an unspecified *Seascape*, as well as watercolours 'of fish and fishing tackle', which may well have been Fig. 317, when he recommended his son to visit the collection a decade later.[28] *Rain, Steam and Speed* became, indeed, a sort of talisman to the Impressionist group, and Félix Bracquemond's etching after it (which, although unfinished, shows all the figurative details) (Fig. 11) was included in their first exhibition in 1874.[29] As late as the turn of the century Claude Monet seemed to look at London very much with this painting in mind (Fig. 9).[30] One emphasis in Turner's work which clearly attracted the Impressionists was his handling of light.

The characterisation of Turner as essentially a painter of light already had a long history in French criticism, as it did in English; and it had been given its classic formulation in the late 1850s and 1860s by a distinguished advocate of Realism in art, Théophile Thoré, who wrote under the name of W. Bürger. At the Manchester Art Treasures Exhibition of 1857, which included a large body of Turner's work from private collections, Thoré was greatly impressed by the *Mortlake Terrace* (Fig. 12), which had so incensed the English critic of 1827: It was, he said,

> the work which represents for me the genius of Turner in all its extraordinary

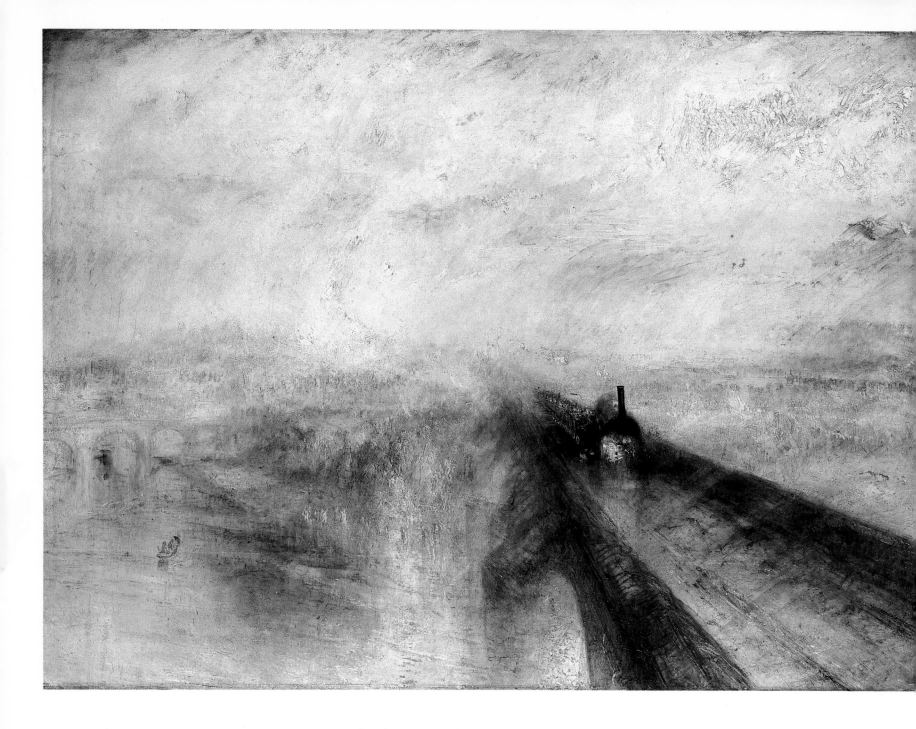

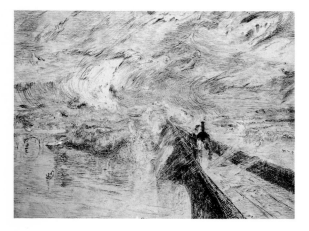

freedom, completely independent of any influence from the Old Masters . . . This terrace . . . is seen in sharp perspective, like some of Canaletto's views of the canals of Venice: the balustrade running diagonally across the canvas with a row of very delicate trees. That is all that you see. To the right, below the parapet, must be the Thames, and along the path to the left you may imagine terraces of houses. But there is too much sunlight, dispersed through the misty and dusty atmosphere, for us to be able to see clearly what is round about. All that we can see of trees and stonework is enveloped in, and devoured by the light; everything seems to be made of light itself, and even to emit rays and flashes of light. Claude, the great master of light, never did anything so prodigious . . . I too have seen beside the Thames these remarkable effects of the conflict of sun and fog and dust, and I reckon that this landscape of Turner's is a masterpiece.[31]

Mortlake Terrace is one of several works into which Turner introduced the optical effect

12. J. M. W. Turner, *Mortlake Terrace, the Seat of William Moffatt, Esq. Summer's Evening.* Oil on canvas, 92 × 122 cm. R.A. 1827. Washington D.C., National Gallery of Art (BJ 239).

10. *(facing page, above)* J. M. W. Turner, *Rain, Steam, and Speed – the Great Western Railway,* Oil on canvas, 91 × 122 cm. R.A. 1844. London, National Gallery (BJ 409).

11. *(facing page below)* Felix Bracquemond, *La Locomotive. D'Après Turner,* 1874. Etching. Paris, Bibliothèque Nationale.

13. *(following pages)* Detail of Fig. 10.

of halation, where light is so dazzling that it seems, as Thoré said, to erode the contours of the forms themselves. Turner used it on the balustrade, and he heightened the effect by pasting a black dog, later painted over, just beside it.

In a later history of English painting Thoré summed up his view of Turner in more general terms:

> No painter perhaps of any school has painted the subtle and impalpable effects of light so marvellously. His craving for light made him conceive of colour combinations which the great colourists before him had never forseen. His feeling for the infinity of nature made him reveal in his works the infinity of art, and thus demonstrate that there is still, and always will be, a new art after the masters of the past.[32]

This was a heady challenge as well as a comfort to the generation of the Impressionists, and when a group of them, including Monet, Pissarro and Renoir, wrote to the

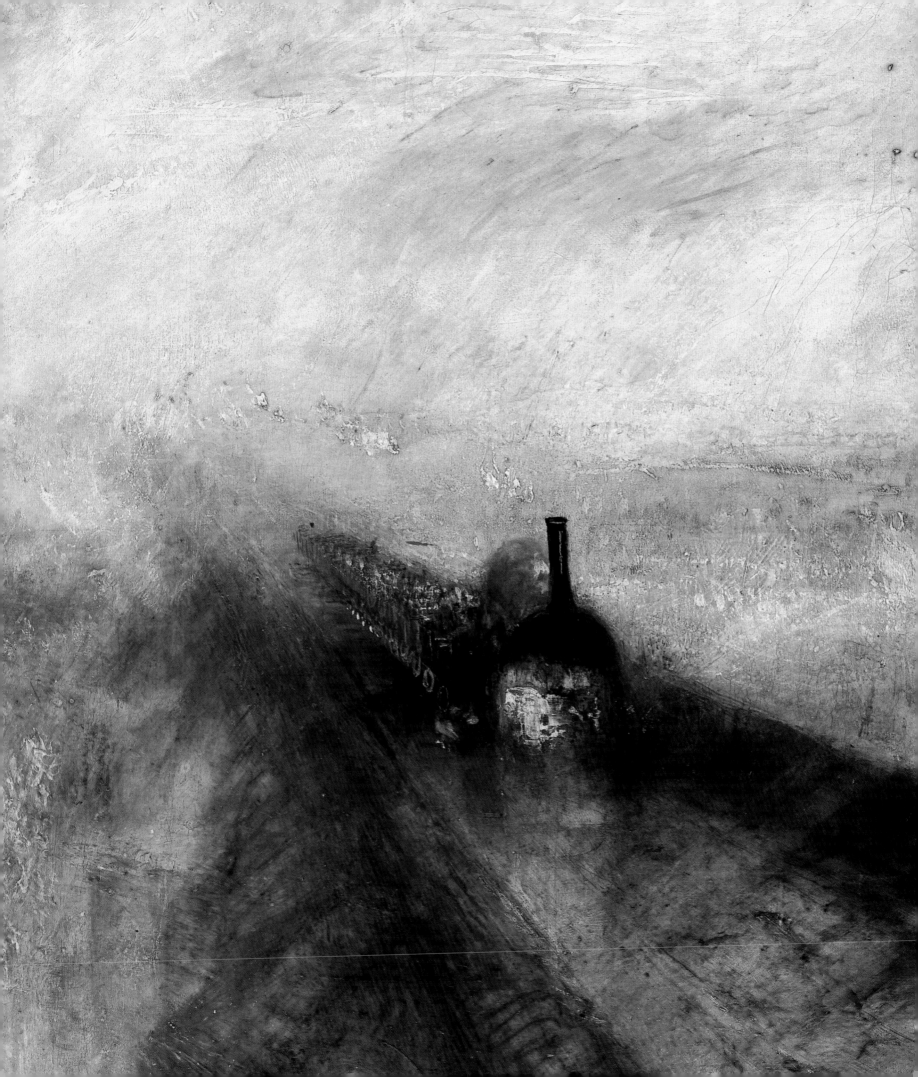

14. J. M. W. Turner, *Lanscape with a River and a Bay in the Distance*, c.1845. Oil on canvas, 94 × 123 cm. Paris, Musée du Louvre (BJ 509).

Director of the Grosvenor Gallery in London in 1885, no doubt in the hope that he would also notice and promote their own work, it was the struggle that they shared with Turner 'against conventions and routines', and in favour of 'the scrupulously exact observation of nature' and the expression of 'forms in movement' and the 'most fleeting phenomena of light' which they drew to his attention.[33]

Nature was still, in 1885, a central pre-occupation of the Impressionists and Post-Impressionists; but towards the end of the decade Turner began to be approached in very different terms by a group of Symbolists, who took up the contemptuous dismissal of Turner's colouristic excesses by literal-minded critics in the earlier part of the century, and turned it into a positive evaluation. The most important stimulus to this triumphant recognition of Turner's *matière* was one of the late unfinished *Liber Studiorum* subjects, now in the Louvre, which was exhibited in 1887 simply under the title of *Paysage* (Fig. 14). Thoré-Bürger and the Impressionists had claimed that Turner

15. Felix Ziem, *Venice with the Doge's Palace at Sunset*, Oil on canvas. Paris, Petit Palais.

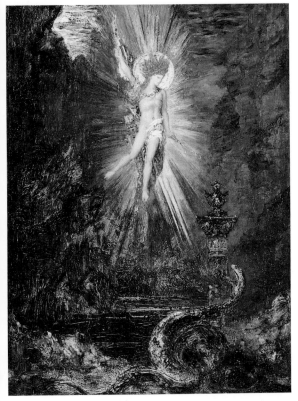

16. Gustave Moreau, *Apollo victorious over Python*, c.1885. Oil on canvas, 23.1 × 16.5 cm. Ottowa, National Gallery of Canada.

17. J. M. W. Turner, *Apollo and Python*. Oil on canvas, 145.5 × 237.5 cm. R.A. 1811. London, Clore Gallery for the Turner Collection (BJ 115).

painted essentially what he (and they) could see; the Symbolists, and especially the novelists J. K. Huysmans and Edmond de Goncourt, now established that he painted rather what he dreamed. 'As for Turner', wrote Huysmans of the 1887 exhibition

at first he stuns you. You find yourself facing a confusion of pink and burnt sienna, of blue and white, rubbed on with a rag, sometimes round and round, sometimes in lines, or in zig-zags in several directions. You might say that it was done with a rubber-stamp brushed over with breadcrumbs, or with a pile of soft paints diluted with water and spread onto a sheet of paper, folded, and then scraped violently with a stiff brush. This gives rise to an astonishing play of mixtures, especially if you scatter a few flecks of white gouache on it before folding the paper.

That is what you see from close to, and from a distance . . . everything balances itself out. Before your incredulous eyes a marvellous landscape rises, a fairy place, a radiant river flowing beneath a sun's prismatic rays. A pale sky vanishes into the distance, engulfed in a horizon of mother-of-pearl, reflecting and moving in water that is irridescent like a film of soap, and the spectrum of soap-bubbles. What land, what Eldorado, what Eden flames with this wild brilliance, these floods of light refracted by milky clouds, flecked with fiery red and slashed with violet, like the precious depths of opal? And yet these are real places; they are autumn landscapes with russet trees, running water, forests shedding their foliage; but they are also landscapes that have been vapourised, where dawn fills the whole sky; they are jubilant skies and rivers of a nature sublimated, husked and rendered completely fluid by a great poet.[34]

The landscape was from the collection of Camille Groult, who was responsible, with the dealer Charles Sedelmayer, for introducing most Turners to the Parisian public in the 1890s. In 1891 Edmond de Goncourt was pursuaded by Groult to go and see one of his newly-acquired Turner scenes of Venice. 'This picture', wrote the novelist

is one of the ten that have delighted my eyes the most. For this Turner is liquid gold, and within it an infusion of purple. This is the goldsmith's work which bowled over Moreau, *stunned* in front of this picture by a painter whose name he had never heard before. Ah! this Salute, this Doge's Palace, this sea, this sky with the rosy translucency of Pagodite, all as if seen in an apotheosis the colour of precious stones! And of colour in droplets, in tears, in congelations of the sort you see on vases from the Orient. For me it has the air of a painting done by a Rembrandt born in India.[35]

With such enthusiasm, it is of little consequence that Groult's 'Turner' was probably one of the forgeries he kept to tease the experts;[36] perhaps even one of the many pastiches made by Félix Ziem in these years (Fig. 15). Ziem's interpretations of Turner, like Edmond de Goncourt's, were entirely decorative, but the symbolist figure-painter Gustave Moreau, who was so astonished at what he saw, is likely to have been affected by the subject-matter as well as the style. Turner had in fact been compared with Moreau in the 1880s by the French critic Ernest Chesneau, for his handling of mythological subjects like *Apollo and Python* (Figs. 16, 17).[37] *Apollo* is a drama of light and darkness, based as much as anything on Rembrandt, who was also very much a master of Moreau's; and it was Rembrandt who probably attracted another Symbolist, the Belgian painter James Ensor to Turner in the 1880s, for Ensor, too, was concerned to interpret Rembrandt with the most brilliant of palettes. He copied Turner's work, probably in London, and was especially stimulated by the religious subject-pictures, which he made the starting-point for some of his own (Fig. 18).[38]

It was at the suggestion of Pissarro, and possibly of this master Moreau too, that the young Henri Matisse made a pilgrimage to London early in 1898 to see the Turners.[39] Shortly afterwards he painted a thoroughly Turnerian sunset in Corsica (Fig. 21), but

18. James Ensor, *Adam and Eve driven from Paradise*, 1887. Oil on canvas, 205 × 245 cm. Antwerp, Royal Museum of Fine Arts.

19. J. M. W. Turner, *Sunset on the River*, c.1807. Oil on panel, 15.5 × 18.5 cm. London, Clore Gallery for the Turner Collection (BJ 194).

20. Carl Blechen, *Sunset in Italy*. Oil on panel. Berlin (East), Nationalgalerie.

21. Henri Matisse, *Sunset in Corsica*, 1898. Oil on canvas, 32 × 42 cm. New York, Private Collection.

what remained with him most of all perhaps was not the motifs, but the freedom of Turner's manipulation of colour and light. As Matisse wrote many years later 'Turner lived in a cellar. Once a week he threw open the shutters, and then, what incandescences! what dazzle! what jewellery!'[40] This was also very much the impression left with Matisse's friend the neo-Impressionist Paul Signac, who made his own pilgrimage to Turner in London in 1898. Although in his manifesto of the movement, *From Delacroix to Neo-Impressionism*, written at exactly the same time, he drew on Ruskin in his argument that Turner had helped to introduce a more 'objective' technique of painting from nature by using broken colour, in his private notes he came to a rather different assessment of the meaning of the London trip:

> The works of Turner prove to me that we must be free of all ideas of imitation and copying, and that hues must be created. The strongest colourist will be he who creates the most . . . Make compositions more extensive, more varied in hue, more replete with *objects* (for the justification of hues: Turner's draperies) . . .

And in a letter to a friend about *Rain, Steam and Speed*, the *Deluge* paintings (Figs. 302, 305) and *War* (Fig. 228). 'These are no longer *pictures*, but aggregations of colours, quarries of precious stone, *painting* in the most beautiful sense of the word.'[41]

It was Turner to whom Signac particularly appealed when, in the 1930s, he wrote a section 'on the discredit of subject' for an encyclopaedia article, citing especially *Norham Castle, Sunrise* (Fig. 22)

> In this picture, simplified and stripped of all that is useless, the castle, the river banks, the herd of cattle, all that the painter wanted to exalt reveal themselves much more clearly than in the composition [probably Fig. 120] where all the elements contradict each other, injure each other, kill each other. The red spot suggests the herd better than the eight separate units of the first picture, where the artist, too much the dealer in gems, has accumulated too much beauty. In the second [Fig. 22], the painter alone appears, the old painter who has seen his way to sacrificing all the picturesque to the pictorial.[42]

It was, of course, French painting between 1860 and the First World War which shaped more than anything the modernist conception of pure pictorial values, independent of subject, and Turner lent himself especially vividly to such a conception. The French critic Marcel Brion, in his monograph on the painter of 1929, reproduced for the first time a substantial number of unfinished works.[43] And in the large showing of British painting at Louvre in 1938, the majority of the Turners, both in watercolour and in oil, were unfinished, and included the *Norham Castle* (Fig. 22), which, like most of the other oils, had first been exhumed at the Tate Gallery in 1905, and had never before been seen abroad.[44]

II

This modernist approach to Turner has become a well-established, and even a distinguished tradition, but it is nonetheless peculiarly unsuited to grasping the range and originality of Turner's art. That a late unfinished sea-piece from the collection of Lord Clark (BJ 472) should, in 1984, have become, at £6½ million, the most expensive painting in the world, and that a sheet used by Turner only to test his brush should recently have been exhibited by the British Museum in a survey of British landscape watercolours, and illustrated in colour in the catalogue,[45] suggests that there is something very amiss about the evaluation of his work on these, by now, traditional

22. J. M. W. Turner, *Norham Castle, Sunrise*, c.1845. Oil on canvas, 91 × 122 cm. London, Clore Gallery for the Turner Collection (BJ 512).

lines. Turner's subject-matter has come to be scrutinised only in very recent years, but it is already clear that he put a great deal of energy and imagination into devising it, and that it was a major pre-occupation with him. One of the reasons why it has taken us so long to realise this is that Turner, self-taught as he was, suffered from difficulties with language amounting to something like dyslexia. He wrote a great deal, he lectured, and he published some of his writings, but much of this was barely intelligible to contemporaries and has remained so to us. In the context of the essentially verbal culture of nineteenth-century England, this disabled poet who insisted on publishing some of his poetry, and who lacked social address, became a figure of fun. He also became immensely wealthy, and yet he was loth to spend money on himself or his surroundings, so that he ended his life in loneliness and squalor, condemned to drink his solitary bottle in the darkened Coffee-Room at the Athenaeum.[46] Turner was the most famous and successful English artist of his day, and he did not, as has often been supposed, shun the society of his friends; yet he disdained to cultivate the social graces

18

which, in Regency and Victorian England, were expected of the successful in all branches of life. In this, as in so much else, Turner belonged to the ethos of the eighteenth century, when the miserliness and eccentric life-style of artists like the sculptor Joseph Nollekens, or the painters Richard Wilson, James Barry and John Opie, hardly attracted comment among the lovers of art.

In an earlier study, *Colour in Turner*, written almost twenty years ago, I felt able to describe Turner only as an 'intellectual *manqué*', but all the considerable work which has been devoted to his art in the intervening years has tended to reinforce the notion of his intellectuality in the fullest sense of that word. Certainly his contemporaries saw him as a man of sense as well as sensibility. He was an artist whose every activity was purposeful, and his intellectual interests were not simply confined to questions of theme and subject, that is, to reading, but were also directed towards matters of style and technique, which have usually been associated merely with the hand and with the painterly eye.

What I have tried to do in this new book is to sketch in an outline of the career and interests which lie behind the work, in all its richness and complexity. I have done this not on chronological but on thematic lines, but a detailed chronology of Turner's life may be found on pp. 235–43. The themes of academic training and activity, of travel, of painting for publication, of the study and emulation of the ancient and modern masters, of patronage, and of poetry and ideas are introduced each on the basis of a few cases which relate them directly to Turner's work, for it is, after all, for this work alone that he has earned his high place in our national heritage. In all of these themes the emphasis must be on the painter's endless curiosity about everything with which he came into contact, and his total lack of prejudice about what might be serviceable to art. The credo which he outlined in the context of nature, about 1809, in his notes to Opie's *Lectures*, can be extended to his encounters with architecture and history, with poetry and technology, with several branches of the natural sciences, and not least with the mythology surrounding the act of painting itself:

> He that has that ruling enthusiasm which accompanies abilities cannot look superficially. Every glance is a glance for study: contemplating and defining qualities and causes, effects and incidents, and develops by practice the possibility of attaining what appears mysterious upon principle. Every look at nature is a refinement upon art; each tree and blade of grass or flower is not to [the artist] the individual tree grass or flower, but what is in relation to the whole, its tone, its contrast and its use and how far practicable: admiring nature by the power and practicability of his Art, and judging of his Art by the perceptions drawn from Nature[47]

It was this restless, incessant searching that impressed many who met Turner, like the architect C. R. Cockerell, who was briefly his collaborator, and who noted after an encounter in 1821: 'In [Turner's] conversation [I] could perceive he had *lectured* – gazing at everything and in truth always studying'.[48] We need to recapture the artist these contemporaries knew; but we must also attempt to understand why they were often so much at a loss to perceive in the art what they nonetheless recognised in the man. Sir Lawrence Gowing wrote of Turner twenty years ago that 'it is not certain that we are yet prepared to see him whole'.[49] This is perhaps the best time to renew the attempt.

CHAPTER ONE
The Making of a Landscape Painter

WHAT, we may wonder, did Turner discuss with Constable on that evening at the Royal Academy banquet in 1813 when he revealed his 'wonderful range of mind'? We might expect it to have had something to do with landscape-painting, and its neglect in England; for here were two of the most ambitious English landscape artists, and destined to become the most famous, who made their way within an institution which had very little time for landscape as such. Following the priorities of the Italian Renaissance and the French Academy of the seventeenth century, art at the Royal Academy was focussed on the human figure as the repository of action and moral expression, to which landscape could, at best, serve as a humble background or support. The art-gossips of the day assured the aspiring landscapist that even great men like Gainsborough and Richard Wilson, who had been founder-members of the Academy, had barely been able to survive in this branch of painting. The whole of Turner's career and Constable's, too, may be seen as a campaign to remove this stigma from their chosen speciality; but as a boy, Turner was obliged to find his training and his living outside the institution to which he looked for guidance at such an early age. Teaching at the Royal Academy was confined to the figure; and the chief outlets for landscape were in the making of presentation drawings for architects and in topography, neither of them very prestigious or very lucrative occupations. And yet the young Turner threw himself into both of them with characteristic energy and flair. The earliest biographers agree that the young artist first attended lessons in perspective given by Thomas Malton Junior, an architectural designer and draughtsman[1], and then went into the office of the architect Thomas Hardwick, who suggested that the boy should enter the Royal Academy Schools. Thus by the age of eleven or twelve Turner seems to have been destined for an architectural career.

Some accomplishment in perspective drawing was, of course, a pre-requisite for an architectural draughtsman; the Professorship of Perspective at the Royal Academy had been established chiefly with the architectural students in mind, and when Turner came to compete for the post in 1807, his only possible rival was the architect and designer, J. M. Gandy.[2] But his early training left Turner not only with a remarkably subtle command of pictorial space, and the capacity to make outstandingly beautiful lecture diagrams (Figs. 31, 210, 211), but also, and more importantly, it introduced him to a range of seminal ideas which we might hardly expect to find in such a technical subject. Some of them, because of the colouristic basis of aerial perspective, were to be concerned with notions of colour, a topic which was to occupy Turner again about the middle of his career. Joshua Kirby's handbook, *Dr Brook Taylor's Method of Perspective Made Easy* (1754), of which he later owned the third edition of 1765, will have

23. *(facing page)* Detail of Fig. 36.

24. J. M. W. Turner, *Copy after Gainsborough*. Watercolour, 15.5 × 20.5 cm. Princeton University Art Museum. Copied from a plate in Kirby's *Perspective* (see Fig. 25) into a sketchbook 'left at – Mr. Nureaways – Bristol about 1790 or 1791'.

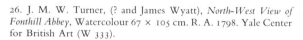

26. J. M. W. Turner, (? and James Wyatt), *North-West View of Fonthill Abbey*, Watercolour 67 × 105 cm. R. A. 1798. Yale Center for British Art (W 333).

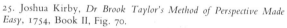

25. Joshua Kirby, *Dr Brook Taylor's Method of Perspective Made Easy*, 1754, Book II, Fig. 70.

introduced him, for example, to an orthodox Newtonian account of the formation of colours by the variable refraction of a beam of light, as in the rainbow, but Malton's father's *Compleat Treatise on Perspective* (1775) included a more traditional and anti-Newtonian doctrine of colours, which held that they were a function of the interaction of light and darkness,[3] and this was an idea which was to remain with Turner throughout his life.

It was this notion which perhaps suggested to Turner in later life that the eye was itself a prism, and perceived coloured fringes around all tonally distinguished objects in nature: to a lady who questioned his use of touches of primary colour throughout his pictures he retorted, 'Well, don't you see that yourself in Nature? Because, if you don't, Heaven help you!'[4] Kirby's book, on the other hand, gave Turner not only his first and influential experience of Gainsborough's pastoral style (Fig. 24), which, as we shall see in a later chapter was to occupy him much around 1800; but also the contrasting image of a world organised according to a few simple geometrical principles (Fig. 25), an image which impressed Turner so much that he recalled it many years later in his lectures as it had been formulated in a passage from Mark Akenside's *The Pleasures of Imagination*:

> Such is the throne which man for truth amid
> The paths of mutability hath built
> Secure, unshaken, still, and whence he views
> In matter's mouldering structures, the pure forms
> Of Triangle or Circle, Cube or Cone.[5]

In Turner's fertile mind, even technical details could take on the resonance of a universal idea.

That Turner should have been introduced so early to achitecture was to be of great significance for his intellectual development, for it was in architecture, and particularly in the rather austere Neo-Classicism exemplified by Thomas Hardwick, that a taste for radical simplicity was introduced into late eighteenth-century English art. As Turner put it in a lecture of 1818:

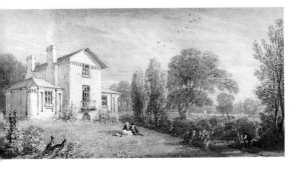

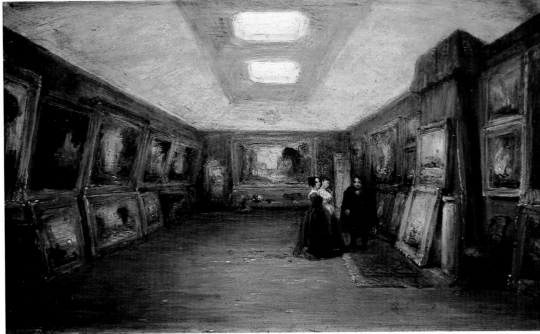

27. George Jones, *Turner's Gallery with Visitors*, c.1852. Oil on millboard, 14 × 23 cm. Oxford, Ashmolean Museum.

29. J. M. W. Turner, *Sketch for Frontispiece to Liber Studiorum*, c.1812. Graphite, pen and ink on paper, 18 × 20.5 cm. Boston Museum of Fine Arts.

30. J. M. W. Turner, *Refectory of Kirkstall Abbey, Yorkshire*. Watercolour, 44.8 × 65.1 cm. R.A. 1798. London, Sir John Soane's Museum (W 234).

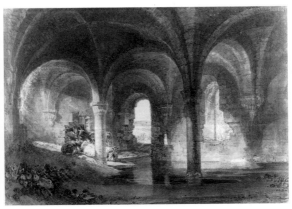

Architecture moves steadily and uniformly towards geometric form by principle, towards geometric form by judgement, towards geometric form by propriety, towards geometric forms to render them practical; for every design partakes of geometry, and evinces the more power by the arrangement of fewer forms than in the other departments of the arts.[6]

Hardwick's Church of St Mary The Virgin at Wanstead, N.E. of London, (1787–90) was a monumental Tuscan and Ionic design, of which Turner prepared an elaborate watercolour view, now lost, although the sketch for it survives in the Turner Bequest. His association with the architect was a short one for he must have found the routine less than stimulating, and Hardwick is said to have ended it by suggesting that the boy should abandon architectural drawing and study painting at the Academy, whose Schools Turner entered in the autumn of 1789.[7] Yet Turner was working for other architects in a similar capacity about this time, and he continued to do so throughout the 1790s[8]; as late as 1798 James Wyatt showed a view of his newly-built Fonthill Abbey at the Royal Academy Exhibition, without mentioning in the catalogue that it was executed by Turner (Fig. 26).

Turner's early experience of architecture was decisive for the direction of his career. In due course he practiced in a minor way as an amateur architect himself, designing some Neo-classical lodge-gates for his friend, Walter Fawkes, at Farnley Hall, and for himself a small villa at Twickenham (Fig. 28) and a picture-gallery in London (Fig. 27).[9] He collaborated with several architects on archaeological publications[10]; and, most important of all, he included architecture as a separate category in his manifesto of the range of landscape-painting, the collection of engravings entitled *Liber Studiorum* where the frontispiece (Fig. 29) itself incorporated important classical and mediaeval architectural fragments. Turner's categories in this publication are not, as we shall see, entirely self-evident but one of the more clearly architectural of the plates, the dramatic Piranesi-like *Refectory of Kirkstall Abbey*, was based on a large watercolour of 1798 belonging to the architect John Soane (Fig. 30), who was Turner's closest friend in this profession. A note 'to define the profession and qualifications of an architect', with a reference to 'Turner' in Soane's diary for 1792,[11] probably refers to his friend, for the

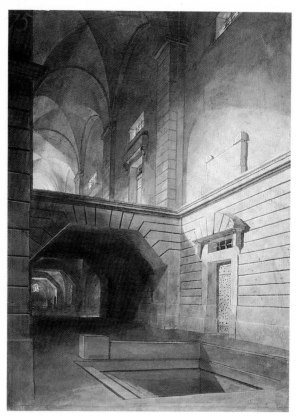

31. J. M. W. Turner, *Interior of a Prison*, c.1811. Watercolour, 72 × 51.7 cm. London, Clore Gallery for the Turner Collection (TB CXCV–128). See Fig. 129.

32. After James Stuart, *Reconstruction of the West Front of the Parthenon*, 1787. From J. Stuart and N. Revett, *Antiquities of Athens*, II, 1787, chapter I, Plate III.

debate about the functions of the architect which was alive in the Academy at this time, focussed on whether a gift for architectural drawing, of the sort which Turner had been practising for the previous three or four years, could alone qualify for the title. The Academy thought not; and when Turner's teacher Thomas Malton Junior applied for associate membership as an architect, in competition with Soane a few years later, he was rejected precisely because he was '*only a draughtsman of buildings*, but no Architect', upon which Malton changed his tack and set about qualifying for admission as a painter.[12] Turner took a similarly exclusive view in the case of Soane's pupil, Gandy, whose sublime conceptions and style of drawing are so often close to Turner's own. When, in 1803, Gandy was applying for Associate membership of the Academy as an architect, Turner objected that he had not yet produced any buildings.[13] Soane himself, in a lecture given at the Academy in 1812, summed up the debate in reference to a drawing of the Trevi Fountain in Rome by Sir William Chambers, the most prominent establishment architect of the later eighteenth century:

> There is a chasteness in the manner, with an effect produced without much labour which makes this drawing preferable to the present more elaborate mode of treating Architectural Designs. A superior manner of Drawing is absolutely necessary; indeed it is impossible not to admire the beauties and almost magical effects, in the architectural drawings of a Clérisseau, a Gandy or a Turner. Few Architects, however, can hope to reach the excellency of those Artists, without devoting too much of that time, which they ought to employ in the attainment of the higher and more essential qualifications of an Architect.[14]

Before the funding of the Institute of British Architects (now the R.I.B.A.) in the second quarter of the nineteenth century, the architectural profession was indeed a very miscellaneous one, and Turner touched many sides of it.

Both his own Neo-Classical designs for buidings (Fig. 28), which are very much in tune with contemporary architectural thinking, and his renderings of earlier architecture in many of the superb perspective diagrams (Fig. 31), show that he was well able to meet professional architects on their own ground. And although his architectural tastes were essentially Neo-Classical, he was, it seems, as able as his younger contemporaries to see architecture in freely expressive terms, and was, as I suggest in a later chapter, planning to build his refuge for indigent English landscape artists in English Tudor (cf. Fig. 189).

C. R. Cockerell, one of Turner's architectural collaborators, recalled a conversation with the painter in 1825, when he 'stood more than two hours with him talking of Vanbrugh, Hawksmoor & others he as usual standing with his hat on'.[15] Cockerell was also an archaeologist, and perhaps the most abidingly important aspect of architecture for Turner was archaeological excavation and reconstruction, which was becoming highly developed in this period, for it amounted to the visual reconstruction of the Classical past. Several of his most ambitious paintings depend upon the practice of reconstruction, and use it to make contrasts with the decay of the modern world. The first of these, *The Temple of Jupiter Panellenius Restored* (Fig. 287) owes its theme, together with its companion (Fig. 289) to the *Essay on Certain Points of Resemblance between the Ancient and Modern Greeks*, published in 1813 by F. S. N. Douglas; but its realisation could only have been achieved with the help of recent publications by archaeologist-architects like James 'Athenian' Stuart and Nicholas Revett (Figs. 32–3).[16] Towards the end of his life, Turner showed a renewed interest in this type of architectural reconstruction, for example in a pair of paintings shown at the Academy in 1839, *Ancient Rome. Agrippina Landing with the Ashes of Germanicus, The Triumphal Bridge and Palace of the Caesars Restored* (Fig. 35) and *Modern Rome – Campo Vaccino* (Fig. 36). The theoretical reconstruction of the Palace of the Caesars on the Palatine Hill, of

33. James Newton after Nicholas Revett, *Restoration of the West Front of the Temple of Jupiter Panellenius on Aegina*. From Revett's *Antiquities of Ionia*, II, 1797, Plate II.

34. James Newton after William Pars, *Temple of Jupiter Panellenius Aegina*. From Revett's *Antiquities of Ionia*, II, 1797, Pl.IV. Typical of the picturesque views of Greek ruins, showing local costumes and customs, which served Turner for Fig. 289.

which only the scantiest remains survived, was an exercise which had taxed the ingenuity of several eighteenth and early ninteenth-century architects; and Turner's solution can be related to some of their efforts.[17] The companion picture is inscribed PONT[IFEX] MAX[IMUS], probably in allusion to the role of Pope Pius VII in the excavation of the Roman Forum (the Campo Vaccino); and Turner appropriately shows an architect or archaeologist at work on a column of one of the temple ruins (see p. 58).

<div align="center">

II·

</div>

Thus by the age of twelve Turner seemed to be launched on a lucrative career as an architect; but within a few years he had settled for the far more humdrum trade of a topographer, which, like architecture, left its abiding mark, in Turner's intense response to particular places, but which seems equally indirectly related to the sort of artist he became. Is this a paradox, or was there indeed something in the nature of topography, as it was practised in the late eighteenth century, which could appeal to a young painter of imagination?

Surveying the exhibition at the British Institution in 1821, Thomas Griffiths Wainewright, the artist, forger and poisoner who was also one of the more perceptive critics of his day, observed:

> Landscape predominates; not . . . the landscape of Tiziano, of Mola, Salvator or the Poussins, Claude, Rubens, Elsheimer, Rembrandt, Wilson and Turner, but that kind of landscape which is entirely occupied by the tame delineation of a given spot; an enumeration of hill and dale; clumps of trees, shrubs, water, meadows, cottages and houses; in which rainbows, showers, mists, haloes, large beams shooting through rifted clouds, storms, starlight, all the most valued materials of the real painter, are not.[18]

Wainewright's attitude, and a good many of his fine phrases were borrowed from a lecture by Henry Fuseli, Professor of Painting at the Royal Academy, published the previous year, in which these 'tame delineations' or 'views' were characterised as 'map-work'.[19] Turner, in a letter of 1811 apparently took exception to these aspersions of Fuseli's,[20] and with good reason, for topography had been the staple of his art since its beginnings; and it continued to be so until the end of his life. As the next chapter will show, he never lost his attachment to the direct experience of particular places like Scotland, or Switzerland or Venice, even though he may have visited them many times. In a sense, however, Fuseli's words were exact: the origins of water-colour landscape in England were closely related to surveying and map-making[21] and an important source of patronage for landscape draughtsmen was still the armed services, who especially needed these skills. Three of Turner's early friends, William Alexander, William Delamotte and W. F. Wells were teachers of landscape to army cadets; and Turner's own brief teaching career began, it seems, about 1794, with lessons for a certain 'Major Fraser' (TB XX, p. 17). More important, the phase in his drawing-style which succeeded the 'architectural' drawings of *c*.1787–91, and can loosely be termed 'Picturesque', was indeed rooted in late eighteenth-century conventions of topographical art.

Topography was essentially a collective enterprise, devoted to publishing visual records of important sites or buildings for a growing public of travellers and antiquarians, whose needs were also catered to by the vastly increased number of British and foreign guidebooks which appeared at the end of the eighteenth century. The Romantic period witnessed an enthusiasm for touring and sight-seeing among the

35. J. M. W. Turner, *Ancient Rome; Agrippina landing with the Ashes of Germanicus. The Triumphal Bridge and Palace of the Caesars Restored.* Oil on canvas, 91.5 × 122 cm. R.A. 1839. London, Clore Gallery for the Turner Collection (BJ 378).

36. J. M. W. Turner, *Modern Rome – Campo Vaccino.* Oil on canvas, 90.2 × 122 cm. R.A. 1839. The Earl of Rosebery (on loan to the National Gallery of Scotland) (BJ 379).

37. (*facing page*) Detail of Fig. 35.

38. John Robert Cozens, *Between Lauterbrunnen and Grindelwald*, c.1776 Watercolour, 24.8 × 36.7 cm. Oxford, Ashmolean Museum.

middle-classes as well as the aristocracy, which led not only to the permanent revaluation of Gothic architecture and the establishment of particular 'beauty-spots' in the Swiss Alps or the English Lakes, but also to a vogue for sketching which was to give employment to a whole new generation of drawing masters – many of them watercolourists of great distinction – and support to a greatly expanding manufacture of artists' materials. The practice of topography was based on on-the-spot sketches which might be made by an ungifted amateur, or even with a mechanical aid like the *camera obscura*. These sketches or outlines were then passed to a professional artist or artists, one perhaps a landscape specialist and another an expert in the figure, who might not know the subject at first hand, but who could develop the slight beginnings into finished 'picturesque' watercolours, adding effects of lighting and weather. The same division of labour might be repeated when the view came to be engraved. An engraver's workshop would include a specialist etcher, who would provide the outline, rather on the same basis as the preliminary on-the-spot drawing, and the work would be completed by a landscape engraver, and perhaps a figure-engraver as well. All of these stages can be seen in some plates of the most important topographical enterprise of the late eighteenth century, Thomas Hearne's magnificent *Antiquities of Great Britain*, which began to be published in the 1770s and was not completed until 1807 (Fig. 39). Hearne was both an engraver and a water-colourist, but for some plates of his publication he used outline-sketches provided by professionals like Joseph Farington, or amateurs like Sir George Beaumont; he used Bartolozzi as a figure-artist; and for the engraving he used a number of specialists in the workshop of William Byrne. Hearne's methods were of great importance for Turner because the topographer was a close friend of Dr Thomas Monro and John Henderson, Turner's most significant patrons in the mid-1790s. It was probably Hearne who shaped the practice of Monro's famous 'Academy', which played a central role in training a whole series of young landscape artists from 1794 until well after 1800.

The first account of this evening 'Academy' is quite explicit about its procedures. Monro, at his house in Adelphi Terrace had 'young men employed in tracing outlines made by his friends – Henderson, Hearne &c. lend him their outlines for this purpose', wrote the landscape painter and diarist Farington in December 1794; and four years later he recorded:

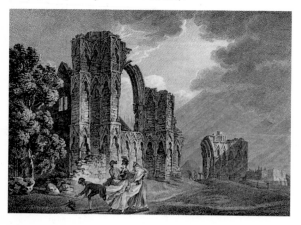

39. W. Byrne and S. Middiman after Thomas Hearne and Francesco Bartolozzi, *St Mary's Abbey*, York, 1778. From Thomas Hearne, *Antiquities of Great Britain*, 1807.

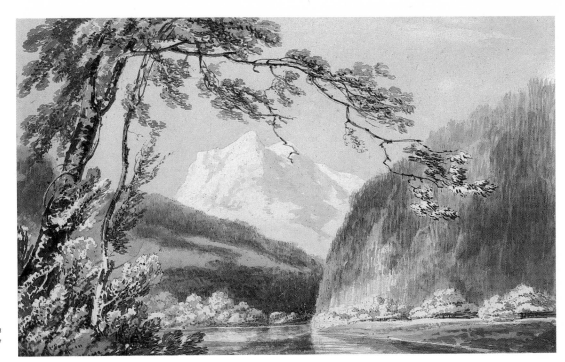

40. Monro School (?Thomas Girtin and J. M. W. Turner) *Between Lauterbrunnen and Grindelwald, c.*1794/7. Watercolour, 24.3 × 37.7 cm Yale Center for British Art.

41. J. M. W. Turner after Thomas Hearne, *The Ruined Abbey at Haddington, c.*1794. Watercolour, 17.5 × 20.3 cm. Oxford, Ashmolean Museum (Herrmann 60).

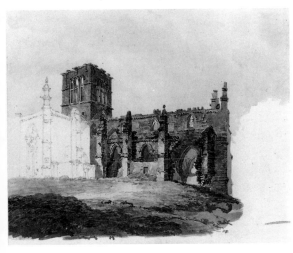

Turner & Girtin told us they had been employed by Dr. Monro 3 years to draw at his house in the evenings. They went at 6 and staid till Ten. Girtin drew in outlines and Turner washed in the effects. They were chiefly employed in copying the outlines or unfinished drawings of Cozens &c &c of which copies they made finished drawings. Dr. Monro allowed Turner 3s. 6d. each night – Girtin did not say what he had.[22]

Thomas Girtin, Turner's companion and also his chief rival in these years, had already been schooled in this tradition of topographical art before he entered the Monro circle, through his association with the amateur antiquarian James Moore[23], and he must have been particularly piqued at being confined to the outlines, which were, indeed, little more than tracings. But this division of labour into the supply of topographical data and the provision of picturesque 'effects' helps to explain some of the manifest anomalies in the 'Monro School Copies', which are not 'copies' in the usual sense of the word (Fig. 40). Admirers of the greatest late eighteenth century watercolourist John Robert Cozens, whose drawings provided most of the prototypes for Monro School work, have been surprised at the failure of the copyists to feel the essentially refined and lyrical mood of Cozens's art, even where, as has been discovered in a number of cases, it was not only outline sketches but the painter's watercolours themselves which were made available to the young students.[24] If the capacity to endow a given outline with imaginative 'effects' was an essential component of the topographer's art, the best effects might well differ from those of the model; and this is certainly what Turner's robust and painterly variations on Cozens achieved. It may well be that Girtin's enforced distance from this rather cavalier treatment of a great master (since he was chiefly responsible for the outlines only) allowed him to remain in his own work the most sensitive follower of Cozens in his generation. The functions of outline and 'effects' can be observed in the unfinished view of the ruined Abbey at Haddington (Fig. 41) copied by Turner from a design by Hearne in Volume I of *The Antiquites of Great Britain* (1786). Turner probably copied the engraving, but his drawing also shows clearly how a simple outline might be clothed in busy brushwork and rich, shaggy textures.

Not that Turner was only an 'effects' man; we also know of outlines by him which were finished for Dr Monro by the far older and more famous watercolour painter

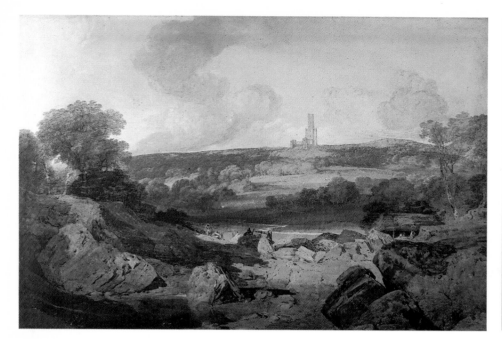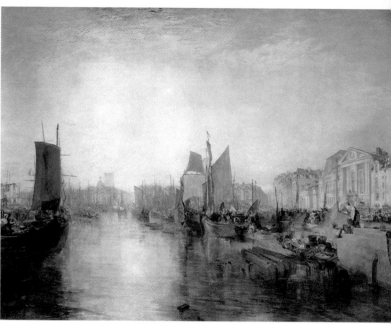

42. J. M. W. Turner, *East View of the Gothic Abbey (Noon) now building at Fonthill, the seat of W. Beckford Esq.* Watercolour, 68.5 × 103.5 cm. R.A. 1800. National Trust for Scotland (Broderick Castle, Isle of Arran; W 338).

43. J. M. W. Turner, *Harbour of Dieppe (Changement de Domicile).* Oil on canvas, 173.7 × 225.4 cm. R.A. 1825. New York, The Frick Collection (BJ 231).

John 'Warwick' Smith[25], but the emphasis on this intermediate and more imaginative stage of the topographic process nonetheless remained central to Turner's practice. If his extensive touring was designed to furnish him with 'outlines', he was, where such fieldwork was impossible, quite prepared to use models by others, for example in the *Views in India* of the mid-1830s (w 1291–7). Even in the case of a very familiar terrain like Switzerland, as late as the 1840s he did not hesitate to use map-like panoramic prints;[26] and an exhibited oil of the 1820s could quite openly be based on sketches by an amateur (Fig. 235).

Thus topography for Turner had a particular emphasis, which was not always satisfactory to his patrons or his public. His wealthiest patron, William Beckford, who commissioned some of his largest and most impressive views in the late 1790s, the Fonthill series (Fig. 42), later complained that one of them was 'a very fine drawing, but rather too poetical, too ideal, even for Fonthill. The scenery there is certainly beautiful, but Turner took such liberties with it that he entirely destroyed the portraiture, the locality of the spot.'[27] And in the 1820s another perceptive critic, Henry Crabb Robinson, was puzzled by the title of Turner's *Dieppe* (Fig. 43) at the Royal Academy Exhibition:

> If he will invent an atmosphere and a play of colours all his own, why will he not assume a romantic *name*. No one could find fault with a Garden of Amida, or even of Eden *so* painted, but we know Dieppe, in the North of France, and cannot easily clothe it in such fairy hues – Men like realities and to be reminded of them and I can understand why such artists as Constable and Collins are preferred to him.[28]

Dieppe is a large oil, an unusual scale and medium for topography, which was traditionally based on water-colour and usually destined for engraving. Perhaps the most far-reaching effect of Turner's early training as an architectural draughtsman and a topographer was indeed his thorough grounding in that medium of watercolour, which he at length released from these traditional and limited functions, and turned into a major means of expression. It was the application of the methods as well as the subject-repertory of water-colour to oil-painting which led, as we shall see in a later chapter, to some of the most original elements in Turner's style.

Turner's training as a landscapist and as a painter took place outside the Royal Academy because there was no opportunity for it within that institution. There were, of course some watercolour specialists, like Paul Sandby, among the Academicians and many landscape artists, of whom Joseph Farington and P. J. de Loutherbourg were to become of especial importance to Turner, but they played no significant role in teaching. But by a happy accident, the Professor of Painting during Turner's years as a student, the ill-fated Irish history-painter James Barry, had retained his early sensitivity to landscape, and in a lecture on chiaroscuro, which Turner will almost certainly have attended, he discussed the way 'effects' could enliven tedious subjects, in terms which must have struck a sympathetic chord in the young painter:

> There are times when the scenes about Hyde Park, Richmond, Windsor and Blackheath appear very little interesting. The difference between a meridian and an evening light, the reposes of extensive shadow, the half-lights and catching splendours that those scenes sometimes exhibit, compared with their ordinary appearance, do abundantly show how much is gained by seizing upon those transitory moments of fascination, when nature appears with such accumulated advantage, If this selection be so necessary respecting objects intrinsically beautiful, how much more studiously ought it to be endeavoured at, when we are obliged to take up with matters of less consequence. How many of the deservedly esteemed productions of the Flemish and Dutch Schools would be thrown aside as intolerable and disgusting, were it not for the beautiful effects of their judicious distribution of the lights and darks . . .[29]

44. George Green after Mauritius Lowe, *Royal Power assisted by Virtue and Wisdom*, 1793. Mezzotint, British Museum. Lowe, the ill-fated history painter who was reputed to have been Turner's first supporter as a painter, practised a monumental allegorical art which may well have stimulated his lifelong interest in figurative symbolism.

Although he showed only landscapes at the Academy Exhibitions throughout the 1790s, Turner's training in the Schools was not, of course, in this department, and it is clear from the first that he proposed to give a good deal of attention to the human figure. Perhaps his earliest supporter as an Academy student had been Mauritius Lowe, a shadowy figure in the history-painting of the late eighteenth-century, whose destitute daughters later claimed that he had first recognised Turner's genius, and had helped him to become an artist.[30] Lowe had begun his career as a miniature painter, but had subsequently prospered in the Academy Schools, winning the first Gold Medal for History Painting in 1769, and a three-year scholarship to Rome. There, however, he frittered away his time and forfeited his grant. In spite of the protection of Dr Johnson, Lowe enjoyed little success on his return to England, and at present we know of little from his hand but some grandiose drawings and prints in the sublimest style of English Neo-Classicism.[31] His importance to Turner lies chiefly in his uncompromising espousal of history, and in the fact that among his several contributions to the Academy exhibitions was a vast *Deluge*, which, after the solicitations of Johnson, was eventually hung in the Antique Academy in 1783. Lowe's interpretation of the subject was unconventional: drawing attention in his title to Genesis VI, 4: 'There were giants on the earth in those days . . .', he showed 'one of the gigantic antediluvian princes [who] gains his last refuge with his little daughter', defending her against a lion.[32] The episodes of an infant borne aloft, and a giant supporting 'a beautiful little female' were separated in Turner's outstandingly figurative treatment of the same subject (Fig. 163), where he peopled the foreground both with a mother attempting to sustain her baby, and a gigantic negro supporting a young white girl.

Lowe was also important to Turner because his notion of history-painting was closer to the Baroque emblematic and allegorical than to the Neo-Classical narrative tradition (Fig. 44). Turner remained attatched to emblematic devices throughout his

45. J. M. W. Turner, *Venus de' Medici*, c.1789/92. Black and White chalk on brown paper, 40.7 × 27.7 cm. London, Clore Gallery for the Turner Collection (TB V-G).

46. J. M. W. Turner, *Seated Academy Figure*, c.1793/9. Black, white and red chalk on brown paper, 47.7 × 31 cm. London, Clore Gallery for the Turner Collection (TB XVIII-C).

47. (*above*) J. M. W. Turner, *Holy Family*. Oil on canvas, 102 × 141.5 cm. R.A. 1803. London, Clore Gallery for the Turner collection (BJ 49).

48. John Raphael Smith after Sir Joshua Reynolds, *Madonna col Bambino* 1791. Mezzotint, 51.7 × 36.4 cm. Cambridge, Fitzwilliam Museum.

life (Figs. 10, 280),[33] and it has been argued by Eric Shanes that his whole approach to the visualisation of thought was in terms of figurative allegory.[34]

He had been sponsored as a probationer at the Academy by the Piedmontese history and decorative painter J. F. Rigaud, and in the 1830s he was still sufficiently mindful of that association to present the Academy with a triple portrait by Rigaud, which included the Keeper of the Schools at the time he was admitted as a student, Agostino Carlini.[35] Only a handful of Turner's studies in the Antique Academy (Fig. 45) and the Life Academy (Fig. 46) have survived, but he showed himself to be an unusually dedicated student, if not a particularly gifted one. The statutory term of study in the Schools was six years when Turner joined them, and was increased to seven in 1792[36]; yet Turner worked from casts of antique statuary in the 'Plaister' Academy until the end of 1793 (four years) and in the Life Academy from June 1792 until two weeks before he was elected an Associate Academician at the end of 1799 (seven years).[37] Turner's attendances were intermittant, but they were supplemented by private study, and as he came more and more in the late nineties to aspire to being a history-painter, he made what was perhaps his first art-purchase, a large group of figure studies and sketches from the Antique by the history-painter Charles Reuben Ryley, which proved, as Turner wrote later, 'how far common interlects [*sic*] can be cultivated by sheer industry and intense application'.[38] When Turner visited the Louvre in 1802, by far the majority of his many studies were from history-paintings (Fig. 127) with a dominantly figurative content; and later the same year, as soon as he was made a full Academician, and was able to apply for the post of 'Visitor' (i.e. instructor) in the Life-Academy he was, as Farington put it, 'very urgent' to do so.[39] This was a somewhat surprising request, for the office of Visitor had traditionally gone to 'Painters of History, able Sculptors, or other persons properly qualified'[40], and Turner had not distinguished himself especially in the Schools he had so recently left. The only precedent for an application from a landscape-artist seems to have been that of Sir Francis Bourgeois in 1795, and he had been rebuffed by Farington with the slighting remark that 'it had always been usual to select such members for that purpose as were known to be particularly intelligent in Academical studies.'[41] The urgency of Turner's application must have been affected by his experience of the crisis in teaching which developed towards the end of his period there. Under the Keepership of the sculptor Joseph Wilton (1790–1803), this was a low period for the Schools, for Wilton was old and lax, and the students typically lazy. In 1792 and 1797 no medals had been awarded for life-drawing because the standard of entries was so low[42], and a watershed was

49. Thomas Pingo, *Royal Academy Silver Medal (reverse): The Torso Belvedere*. London, Royal Academy of Arts.

50. William Mulready, *Design for the Turner Medal*, 1858. Pen and ink, 8.5 × 8.3 cm. London, Royal Academy of Arts.

reached in 1799, when an Academy Committee investigated the running of the Schools, expelled some students and relegated others from the life class to the Plaister Academy.[43]

It was thus probably with reforms in mind that Turner applied to be Visitor in 1802, but he was told that his appointment would amount to an undesirable pluralism, since he was also to serve on the Academy Council the following year.[44] As if in defiance of what he seems to have regarded as a law against landscape painters as Visitors[45], in 1803 he exhibited his most figurative composition to date, *The Holy Family* (Fig. 47), painted in a style which has something of Titian, but more of the manner of the founding President of the Academy, Sir Joshua Reynolds (Fig. 48). But that this did not in the event become the starting point for a career based on the Grand Manner, was probably due to the universal hostility of the critics, inside and outside the Academy towards this picture, one of whom advised Turner 'to take an eternal farewell of History'.[46] In spite of this rebuff, Turner did nevertheless return from time to time, and especially around 1830 (Figs. 122, 136), to subject pictures in which several figures were deployed on a large scale.

By the end of 1811 however, when Turner was already lecturing as Professor of Perspective, the case was altered, and his renewed application to be Visitor was granted. He served in the Life Academy for eight years between 1812 and 1838, and in the latter period of his Visitorship he became famous for his innovations in posing the model. Even in his own day as a student, the life-model seems to have been set in postures recalling classical sculpture: the muscular model shown in the study reproduced here (Fig. 46) is posed rather similarly to the *Torso Belvedere* (cf. Fig. 49), a cast of which Turner presented to the Academy in 1842. Turner's gift has now disappeared, and it is curious that he felt the need for it, for in 1816 the Prince of Wales had already given the Academy a cast from the Vatican itself, where the original was preserved.[47] But it is likely that the *Torso* had an especial resonance for Turner as, indeed, it did for the Academy at large, for it was depicted on the obverse of their silver medal (Fig. 49); in his tenth Discourse Reynolds had asked 'what artist ever looked at [it] without feeling a warmth of enthusiasm, as from the highest efforts of poetry?', and Hogarth in the *Analysis of Beauty*, another text very familiar to Turner, had claimed that Michelangelo had discovered in the fragment a principle 'which gave his work a grandeur of gusto equal to the best antiques'.[48] True to his Reynoldsian upbringing, Turner held Michelangelo in particular veneration, and it was perhaps to commemmorate his own brief service as Deputy President that he presented the Academy with a copy of the artist's poems in 1846.[49] It is thoroughly appropriate that the only significant follower of Turner's late style in Britain should have been, not a landscape painter, but 'England's Michelangelo', G. F. Watts.

Turner's primary interest as Visitor was to demonstrate how nature might be reconciled with art, and in this case with the canons of the Antique. In the 1830s he became celebrated for setting the model not simply as, but also beside, a classical work (Fig. 51). A student later recalled:

When a visitor in the life school he introduced a capital practice, which it is to be regretted has not been continued: he chose for study a model as nearly as possible corresponding in form and character with some fine antique figure, which he placed by the side of the model posed in the same action; thus, the 'Discobulus of Myron' contrasted with one of the best of our trained soldiers; the 'Lizard Killer' with a youth in the roundest beauty of adolescence: the 'Venus de 'Medici' beside a female in the first period of youthful womanhood. The idea was original and very instructive: it showed at once how much the antique sculptors had refined nature; which, if in parts more beautiful than the *selected* form which is called *ideal*, as a whole looked common and vulgar by its side.

51. William Etty, *Female Nude standing beside a statue of the Venus Pudica*. Black, red and white chalk on brown paper, 56.3 × 38.8 cm. University of London, Courtauld Institute. Etty shows a subject set by Turner in the Life Academy.

52. William Hogarth, *The Analysis of Beauty*, 1753, Plate 1 see pp. 33, 117–8.

Turner's conversation, his lectures, and his advice were at all times enigmatical, not from want of knowledge, but from want of verbal power. Rare advice it was, if you could unriddle it, but so mysteriously given or expressed that it was hard to comprehend – conveyed sometimes in a few indistinct words, in a wave of the hand, a poke in the side, pointing at the same time to some part of a student's drawing, but saying nothing more than a 'Humph!' or 'What's that for?' Yet the fault hinted at, the thing to be altered, was there, if you could but find it out; and if, after a deep puzzle, you did succeed in comprehending his meaning, he would congratulate you when he came round again, and would give you some further hint; if not, he would leave you with another disdainful growl, or perhaps seizing your porte-crayon, or with his broad thumb, make you at once sensible of your fault. To a student who was intent on refining the forms before he had got the action of his figure, he would thrust with the point of his thumb at the place of the two nipples and the navel, and – very likely with the nail – draw down the curve of the depression of the sternum and linea alba, to show that pose, action, and proportion were to be the first consideration. To another who, painting from the life, was insipidly finishing up a part without proper relation to the whole, he would – taking the brush from his hand, and without a word – vigorously mark in the form of the shadow and the position of the highlights, to indicate that the relations of the whole should be the student's first consideration. The schools were usually better attended during his visitorships than during those of most other members, from which it may be inferred that the students appreciated his teaching.[50]

It is not at all surprising that Turner's friend, William Mulready, who was himself particularly attached to the Life Academy, should have thought it appropriate that the Turner Medal for landscape, for which he submitted a design (Fig. 46), should demonstrate the study of the living nude figure.[50]

By this practice Turner brought into the Academy Schools a characteristically Neo-Classical aesthetic which had long been appreciated outside them, and was particularly associated with the Elgin Marbles. The sculptures of the Parthenon had, as the History-

painter B. R. Haydon put it, 'that combination of nature and idea which I had felt so much wanting in high art . . . I saw, in fact, the most heroic style of art – combined with all the essential detail of actual life.'[52] Stimulated by his view that the greatness of Greek sculpture had been achieved not by a close study of anatomy, but by a knowledge of geometry and of the naked figure in motion, Turner's friend Sir Anthony Carlisle, Professor of Anatomy at the Royal Academy, sponsored a series of displays by boxers at Lord Elgin's gallery, shortly after the arrival of the Marbles in England.[53] Turner does not seem to have been present at these displays, but by the 1820s, when Carlisle was regularly using athletic demonstrations as part of his Academy lectures[54], he must have been thoroughly familiar with the notion of the realism of the greatest Greek sculpture; and in 1819 he certainly witnessed a similar living display of classical 'attitudes' arranged by the sculptor Canova at the Venetian Academy in Rome.[55] As we saw in the introduction, the idea of a reciprocal interrelation of art and nature was particularly congenial to Turner as a landscape-painter too. Moreover his method in the Life-Class had the added advantage of establishing a theme of study without recourse to formal instruction, which he disliked. Turner preferred example to precept: 'suppose you *look*', was his characteristic answer to the question 'how?'.[56]

Nor did he use the Life Academy simply as a means for teaching his students. His own notebooks are full of swift and brilliant notations from the living model, and it

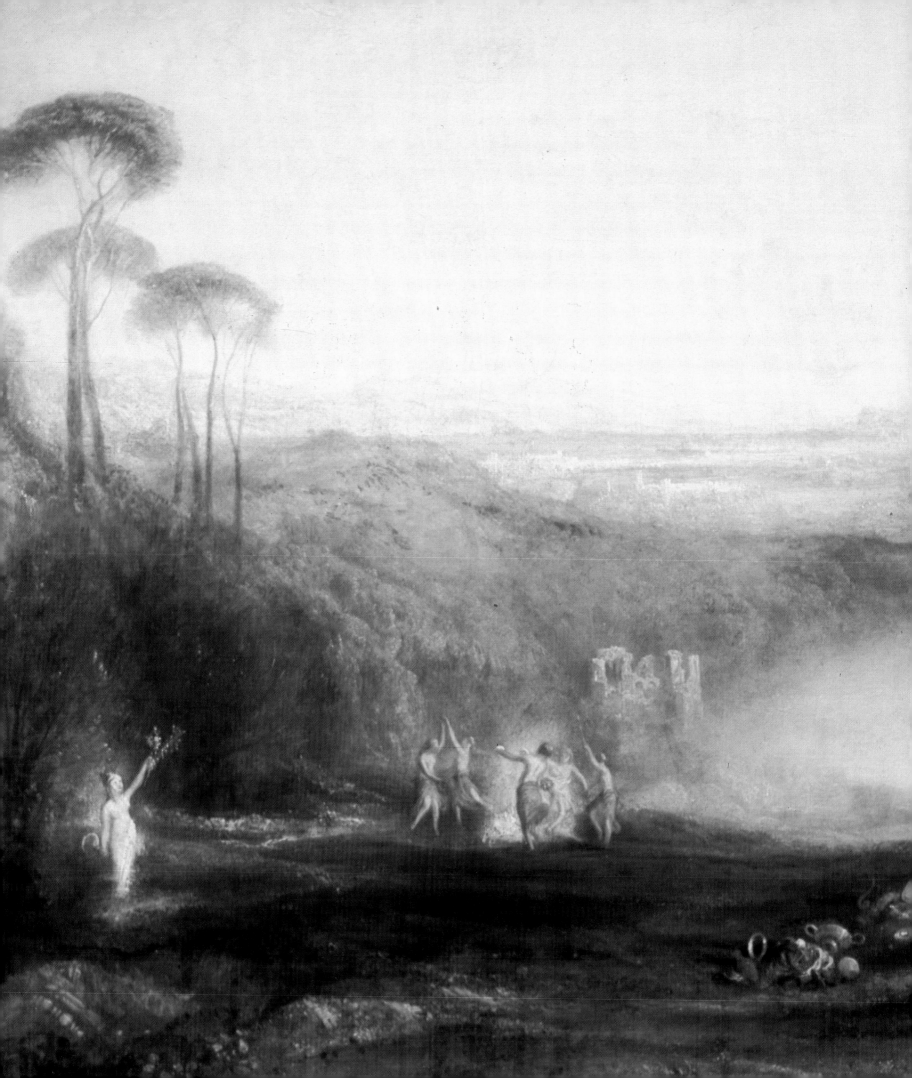

54. J. M. W. Turner, *Life Study*, c.1832. Red chalk, 19.4 × 8.3 cm. London, Clore Gallery for the Turner Collection (TB CCLXXIX (b)p. 6).

55. (*facing page*) Detail of Fig. 53.

seems that he was prepared to set quick poses with the needs of his own paintings in mind. A red chalk study in a sketchbook of 1834 (Fig. 54), for example, is related to one of the dancing figures in *The Golden Bough* (Fig. 53) exhibited that year; and we know of this picture that the original foreground group of the Fates had been studied in his class, painted in a sketchbook, cut out and stuck to the canvas, with the unfortunate result that it soon peeled off.[57]

I have dwelt on Turner's interest in the Life Academy in a discussion his emergence as a landscape painter because, as I shall show in later chapters, the significant deployment of the figure was one of the many ways in which he brought the resonances of history to topographical views. After his shaky start in 1803, Turner did not so much aspire to the condition of the history-painter, as infuse topography with a narrative expressiveness in which the figure played a central role. This involved first of all a study of the physiognomy of landscape; and in pursuit of that physiognomy Turner became one of the most travelled artists of the Romantic period.

CHAPTER TWO
The Professional Tourist

In person Turner had little of the outward appearance that we love to attribute to the possessors of genius. In the last twenty years of his life, during which we knew him well, his short figure had become corpulent – his face, perhaps from continual exposure to the air, was unusually red, and a little inclined to blotches. His dark eye was bright and restless – his nose aquiline. He generally wore what is called a black dress-coat, which would have been the better for brushing – the sleeves were mostly too long, coming down over his fat and not over-clean hands. He wore his hat while painting on the varnishing days – or otherwise a large wrapper over his head, while on the warmest days he generally had another wrapper or comforter round his throat – though occasionally he would unloose it and allow the two ends to dangle down in front and pick up a little of the colour from his ample palette. This, together with his ruddy face, his rollicking eye, and his continuous, although, except to himself, unintelligible jokes, gave him the appearance of one of that now wholly extinct race – a long-stage coachman.[1]

It is no surprise that Turner acquired some of the characteristics of the weather-beaten traveller, for a habit of constant locomotion shaped his style of life for more than sixty years. It is the aspect of his life with which we are most familiar today, for we have books on Turner in the North of England, on the Thames, in Holland, on the Rhine, in Switzerland and in Venice, as well as at large on the Continent of Europe; we have articles on many aspects of the English and European tours; and in the last decade alone there have been large exhibitions of his activities in Yorkshire, in Wales and in Scotland, as well as on the Rhineland and in France. Turner was, as we have seen, deeply interested in the methods of topography and, unlike so many of his professional contemporaries, he was not content that sketches made on a single visit should serve him for the rest of his life. His tour-sketchbooks survive in hundreds, and it is clear from some of their labels that he regarded them as a sort of reference library to which he frequently referred, and, which he continually brought up to date. How did he come to set off, year after year with renewed relish, on those arduous journeys which, from the point of view of his career as a painter of scenery, were increasingly unnecessary?

Although his background was humble, Turner's family circumstances were very favourable to the development of a picturesque tourist. The crucial role of his parents in this development has never been fully appreciated. Ruskin, in a poetic evocation of the painter's boyhood, stressed the impressions he must have derived from the bustle of his native Covent Garden market and the quays along the Thames; yet the earliest

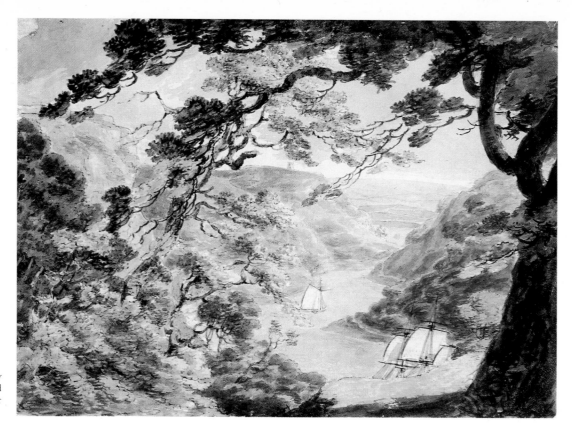

58. J. M. W. Turner, *View from Cook's Folley, looking up the river Avon with Wallis Wall and the Hot Wells*, 1791, Pen and watercolour, 19.7 × 27.3 cm. London, Clore Gallery for the Turner Collection (TB VI, p. 24).

57. J. M. W. Turner, *View of Minster, Isle of Thanet, c.*1784. Pen and watercolour, 27.6 × 37.8 cm. Private Collection (W 4).

works we know were not of London subjects. They are views in and around Margate, on the north coast of Kent (Fig. 57), and in and around Oxford, and they began an attachment to these areas of southern England which lasted Turner for the rest of his life. In both places he must have stayed with relatives of his mother's.[2] One of those relatives, Joseph Mallord William Marshall, was also active as a butcher at Brentford, on the Thames west of London, and Turner seems to have stayed with him regularly there, as well as at his later home at Sunningwell, near Oxford, from about 1785.[3] Although we know next to nothing of the boy's activities at Brentford, except for the colouring of a book of topographical engravings, Brentford was the area in which Turner chose to settle soon after he became independent, and it is likely that the scenery had already made a considerable impression on him as a child.

In 1791 he ventured further afield, to stay with a friend of his father's, the Bristol fell-monger (leather merchant) John Narraway, from whose house he made his first extensive tour, around the city and to Bath and Malmsbury. It was in the Avon Gorge near Bristol that he had his first, profound, experience of the sublime scenery which was to occupy him for a lifetime (Fig. 58), and watercolours based on sketches made during these visits formed the staple of Turner's exhibits at the Royal Academy in 1792 and 1793. Narraway may be regarded as Turner's first substantial sponsor, for not only did he acquire a sketchbook and several of the drawings made from these sketches (probably by gift), but also the young painter's first Academy exhibit, *The Archbishop's Palace, Lambeth* (w.10) of 1790; and he is likely to have introduced Turner to wealthy connexions like Captain Fowler of Cote House (w.21) and Lady Lippincote of Stoke House, into a view of whose splendid Jacobean mansion (Fig. 59), the artist introduced himself sketching with Narraway's son, as well as the young Sir Henry Lippincote and a friend.[4]

According to Narraway's niece, writing after Turner's death, the boy painter would sketch what her uncle and cousins asked him to do[5]; and as soon as he began to make independent tours in the year following the first Bristol visit, we find Turner noting the names of purchasers on the backs of his sketches, which might suggest that these

59. J. M. W. Turner, *Stoke House, Bristol, the Seat of Lady Lippincote*, 1791, Watercolour, 29.9 × 41.2 cm. Private Collection (W 20) This drawing, which first belonged to the Narraway family, includes Turner himself, sketching in the foreground.

60. J. M. W. Turner, *High Tor Mine, Matlock*, 1794. Pencil, 11.7 × 19.3 cm. London, Clore Gallery for the Turner Collection (TB XIX, p. 25).

were also made under instruction. Yet it is likely that they represent commissions given on the basis of the sketches themselves, and that the painter's choice of subjects was his own. The surviving sketches and finished watercolours from this first visit to south Wales in the summer of 1792 show a combination of architectural or antiquarian interests with more purely landscape motifs – a combination which was to characterise Turner's touring habits for the rest of his life.[6] He made, for example, detailed drawings of Tintern Abbey on the Wye and a stormy distant view of Llanthony Abbey in the Black Mountains, but also a number of views of waterfalls on the river Mynach and some very ordinary cottages and farm-yards in their hilly setting. All these categories of drawing have notes of purchasers on the back, and it is probable that Turner was already aware that each type of subject had its market: he had probably already seen examples in the work of the French-born landscapist P. J. de Loutherbourg and of Thomas Hearne.

By the time of his first extensive tour, in 1794, a new factor had emerged in Turner's career, the production of work for engraving, a factor which was to supply the pretext for most of his watercolours until well into the 1830s. His first engraved view was of Rochester in Kent, on the route to Margate, published early in 1794 and probably based on material gathered the previous year (w.87); his second was *Chepstow Castle* (w.88), which may well have been sketched on the Welsh tour two years earlier. But now in 1794 a major journey to the Midlands, East Anglia and north Wales was evidently planned with the print-market in mind, for a dozen views of towns and architectural antiquities, based on the sketches of this tour, were published in several illustrated magazines over the next three years.[7] The book which Turner compiled from his sketches on this occasion he characterised as his 'First Tour', and to prepare himself for this undertaking he made notes on an itinerary taken perhaps from an unidentified guidebook which not only gave him practical information like distances, but also evaluations of some of the sites as 'fine' or 'romantic', as well as, for example, more detailed instructions for crossing Matlock Dale in Derbyshire (Fig. 60), which seem to have been given by word of mouth.

61. John Robert Cozens, *Third View on the Reichenbach, near Meiringen in the Valley of Ober-Hasli, c.*1776. Pen and watercolour, 24 × 36.4 cm. London, British Museum.

The best tour of this Dale to cross the R[iver] at the turnpike, up the winding rock to Hag rock, advance to an larg Elm, then to severall Ash Trees, above th.to the right a rock 150 F.High. Still further till a Adams bench, from which a Walk leads to the Bottom, where is another which leads, by the river Bank, by a Thick Wood [which] leads to a Cascade. A small distance a Rock, 450 F.perpendicular . . . (TB XIX p. 4)

The Derbyshire Peaks had long been a favourite resort of picturesque tourists; they had provided the material for many of Joseph Wright of Derby's best-known and most dramatic canvasses of the 1770s and 1780s; and one of Turner's earliest surviving drawings (TB I,H) had, indeed, been a view in Dove Dale adapted from an engraving in a tour-book by the high priest of the Picturesque movement, the Rev. William Gilpin. One of Turner's closest friends, the watercolourist James Holworthy, settled in the Peaks in the 1820s, and Turner renewed his acquaintance with the area on an extensive tour about 1828.[8] The approach to touring which Turner adopted in the early 'Matlock Sketchbook' was one which he followed for many years, long before he began to collect guidebooks for himself in the 1810s; and we know that he also consulted friends, like the still unidentified transmitter of information about South Wales in TB XXVI (1795), or Joseph Farington, the Royal Academician, who pointed out 'particular picturesque places' in preparation for Turner's tour of Scotland in 1801.[9] For Turner was never very adventurous in his choice of topographical subjects; he found his market chiefly among a public already familiar with the sites he represented, and what mattered more to them was the thoroughly individual way in which he saw them. It is notable that for the long list of architectural subjects in the Midlands, the West Country and Wales which he borrowed about 1799 from the antiquarian James Moore, he selected, for the most part, only those items which Moore himself had starred.[10]

When he made his first excursion across the Channel in 1802, Turner passed quickly through France to the Alps, whose scenery he had long known in the work of John Robert Cozens (Figs. 38, 61) and, probably, John 'Warwick' Smith, many of whose Swiss watercolours were owned by Turner's new patron, Walter Fawkes, of Farnley Hall, near Leeds. So many of the sketches which Turner made on this trip were elaborated into watercolours for Fawkes (Figs. 63–4) that it seems possible that he was one of the three 'noblemen' who are said to have financed the trip, the three months of which cost some forty-five guineas, exclusive of travelling. Another patron was certainly Lord Yarborough, who acquired the most important product of this first continental tour, *The Festival of the Opening of the Vintage at Macon* (Fig. 62).[11] It is even possible that Fawkes was Turner's travelling-companion, with whom, in Paris, the painter bought a cabriolet for thirty-two guineas, and hired a Swiss servant at five *livres* a day.[12] Certainly Fawkes already knew parts of Switzerland very well, and, according to an earlier companion, had himself 'sketched with magic skill' the Lake of Geneva and its surroundings, paintings of which he later acquired from Turner – both a large watercolour of about 1805 (W.382) and a large oil of five years later (BJ 103).[13]

Turner's progress to ever more distant places continued to be eased both by the advice of friends and by the availability of an increasing number of published guides. In the summer of 1811 his two-month excursion to the western coastline of England was even more purposeful than usual; for although his commission was simply to gather material for W. B. Cooke's publication, *Picturesque Views on the Southern Coast of England* (Figs. 109, 271, 272), Turner himself conceived of the enterprise on an altogether higher plane: no less than a commentary on the political and moral state of this bulwark of the nation at the height of the struggle against Napoleon. He consulted a detailed gazetteer, and made notes from it on history and antiquities, modern engineering, geology and manufactures.[14] These were some of the topics he included in

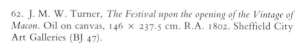

62. J. M. W. Turner, *The Festival upon the opening of the Vintage of Macon.* Oil on canvas, 146 × 237.5 cm. R.A. 1802. Sheffield City Art Galleries (BJ 47).

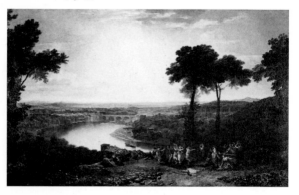

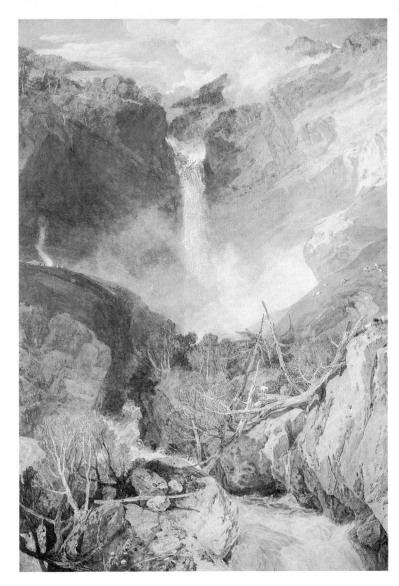

63. J. M. W. Turner, *The Great Fall of the Reichenbach, in the Valley of Hasle, Switzerland*, 1804. Watercolour, 102.2 × 68.9 cm. Bedford, Cecil Higgins Art Gallery (W 367). This drawing, based on an 1802 sketch, was shown at Turner's own gallery in 1804, at the R.A. in 1815, and at Fawkes' London house in 1819.

64. J. M. W. Turner, *Lake of Geneva, with Mont Blanc from the Lake*, c.1805. Watercolour, 71.5 × 113 cm. Yale Center for British Art (W 370).

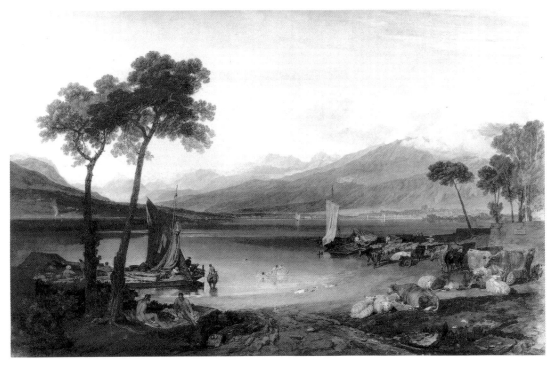

65. J. M. W. Turner, *Mer de Glace, with Blair's Hut*, 1806. Watercolour and bodycolour, 27.4 × 38.9 cm. University of London, Courtauld Institute of Art (W 371). Based on a sketch made in 1802, this drawing, which first belonged to Walter Fawkes, shows the great glacier of Chamonix-Mont Blanc, with the refuge built by the English Alpinist Charles Blair in 1779.

the long poem which he intended should serve as a basis for the letterpress to accompany the engravings, but was never allowed to use.[15]

Turner set off westwards along the Thames, through Chelsea and Twickenham, pausing at Runnymede to meditate on the origins of English liberty[16], and at Old Sarum in Wiltshire to admire the human skill and perseverance which had constructed the Roman road and ancient British earthworks there. Here he turned south, and struck the Hampshire coast at Christchurch, proceeding westwards along it through Dorset, Devonshire and Cornwall, to Land's End. Then he followed the north coast of Cornwall and Devon to Watchet in Somerset, turned inland to Bridgewater, and continued back to London via Salisbury again. Throughout this journey Turner was concerned to observe the characteristic activities of the local people; and, although he no longer kept separate sketchbooks for figures, as he had done in Scotland in 1801 (TB LIX) and in Switzerland the following year (TB LXXVIII), he gave more specific attention to them in this series than he had ever done before, except in his oils.

The *Southern Coast* began to be issued only in January 1814, and it lingered on well into the 1820s; it was perhaps as well that the publishers rejected Turner's patriotic commentary, for by the middle of the next year the French wars were finally brought to a close with the Allied victory at Waterloo. The Continent was now open again, and Turner could seriously direct his thoughts towards Rome.[17] But, as it turned out, his second European journey was not to Italy, but to Belgium, Holland and the Rhine, and the pretext was almost certainly Turner's wish to contribute to the great wave of paintings commemorating the recent victory, which had been stimulated by a competition sponsored by the British Institution in 1816. (see BJ 138) Before he left for this second continental trip, Turner drew up a short guide in a sketchbook (TB CLIX) which, in view of its rather random sequence, the interpolation of useful phrases in French, Dutch and German (the '*Fourberies*-Cheats' of Brussels, the '*Abtritt*: Privy' at Basel), and the bizarre phonetic spelling of many names, may well have been based on a conversation, perhaps with the 'Miller', who is credited with advice on a watering-place near Bonn.[18] This itinerary mentions sights and inns all the way up the Rhine to

66. J. M. W. Turner, *Neuweid and Weissenthurm*, 1817. Bodycolour on toned paper, 19.7 × 31.1 cm. Winchester College (W 661).

Basel, and along the Main to Frankfurt, but in the event, Turner followed the suggestions not of his own notes, but of his chief published guidebook, Charles Campbell's *Traveller's Complete Guide through Belgium and Holland, with a Tour in Germany*, which described the particular stretch of the river between Mainz and Cologne as 'the truly *fine part* . . . than which nothing can be more magnificent: it is truly *une paysage unique* . . .'[19] Campbell recommended six to eight days for seeing the scenery between Mainz and Bonn, but Turner was more hard-pressed (he listed '*Geschwind* quick' among his German words), and took only ten days for the return journey by river and road, in which time he made all the pencil studies and perhaps even most of the painted beginnings for the fifty-one watercolours he finished for Fawkes as soon as he got back to England. This magnificent series (Fig. 66) presents again and again the broad expanse of the river as a light-filled foreground, and in its brilliant economy of design and its several techniques, sometimes painted directly on white paper, but usually over a grey wash, it is a prelude to the incomparably various sketching methods which Turner brought to his experience of Italy two years later.[20] Certainly that most luminous of all his oil paintings the *Cologne* (Fig. 67), shown at the R.A. in 1826 and now in the Frick Collection, goes back in spirit to his experiences on the Rhine in 1817 and, like another great product of that journey, *The Dort* (Fig. 160), it is as much as anything a celebration of modern tourist traffic.

67. J. M. W. Turner, *Cologne, the Arrival of a Packet Boat. Evening*, Oil (?and watercolour) on canvas, 168.6 × 224.1 cm. R.A. 1826. New York, The Frick Collection (BJ 232).

68. (*facing page*) Detail of Fig. 67.

But it was Italy that Turner yearned most of all to visit after the peace of 1815, and when he finally achieved his objective in 1819, he had already been preparing his journey for some years. He had originally proposed to go in 1816 and to cross the Alps by the Simplon; it is very likely that his first thoughts were of an essentially classical tour, under the guidance of his former patron, Sir Richard Colt Hoare, whose *Hints to Travellers in Italy* of 1815 was probably the first Italian guidebook to come into his hands. It was Colt Hoare, who had been an important sponsor of Turner's classical subjects as recently as 1814[21], who probably directed his attention to two large-scale guides, one textual and the other visual, from which Turner made extensive notes in a sketchbook he labelled 'Forign Hint' (TB CLXXII). The textual guide, J. C. Eustace's two-volume *Tour through Italy* (1813) was to remain the chief source for Turner's understanding of that country as an essentially didactic experience, a repository of moral *exempla*; the other guide, John 'Warwick' Smith's *Select Views in Italy* (1792–9),

69. J. M. W. Turner, *Passage of Mt Cenis Jan. 15 1820*, 1820. Watercolour 29.2 × 40 cm. Birmingham City Museums and Art Gallery (W 402).

70. J. M. W. Turner, *Copies of Plates from Smith, Byrne and Emes, "Select Views in Italy" (1792–9)*, 1819. Pen and ink, 16.4 × 11 cm. London, Clore Gallery for the Turner Collection (TB CLXXII, p. 20a).

from which Turner made thumb-nail copies of all eighty-four plates (Fig. 70) gave him a visual introduction to many sites he subsequently visited himself.[22] The little Roman temple of Clitumnus for example, between Foligno and Spoleto, which Smith had elaborated for the engraver from a sketch by Colt Hoare, was the subject of a substantial note taken from Eustace in Turner's 'Hint' sketchbook (TB CLXXII, p. 4a) and was also sketched by him from the life during his own visit (TB CLXXVII, pp. 36a–37a). Colt Hoare may also have been behind one of the first 'topographical' Italian subjects which Turner painted, the large watercolour *capriccio* exhibited in 1818 as *Landscape-Composition of Tivoli* (W 495), for this was clearly the pendant to another watercolour, *Rise of the River Stour at Stourhead*, Colt's great landscape garden in Wiltshire, although that drawing (W 496) was not exhibited until 1825.[23]

In 1817 Turner began to make more practical preparations for his Italian journey. A

notebook (TB CLXIII, p. 1) gives details of an Italian grammar and methods of purifying water and driving away bugs and fleas, as well as addresses for securing passports and purchasing carriages in London. But he was prevented from venturing so far abroad that year, and towards the end of it was contracted by the architect James Hakewill to make a series of watercolours to be engraved in a *Picturesque Tour of Italy*, based on Hakewill's own sketches, made with the help of a mechanical device, the *camera lucida*.[24] The association with Hakewill was of particular importance to Turner; although only a few subjects were to be published, it is likely that he looked over the whole series of some three hundred drawings prepared by the architect in 1816 and 1817, and it is remarkable how often he chose to draw exactly the same places.[25] It may well have been the range and quality of Hakewill's pencil drawings that induced Turner to ask the architect to sketch out an Italian itinerary for him in the 'Route to Rome Sketchbook' (TB CLXXI) and on another loose sheet (TB CCCLXVIII B). Hakewill naturally recommended his own route, over the Simplon and down the west coast as far as Rome and Naples, then back to Florence and over the Appenines to Bologna, Verona, Padua and Venice, returning via the Tyrol. But in this same sketchbook Turner played with a number of alternatives, using his most practical published guidebook, Reichard's *Itinerary of Italy*, of 1818[26]; and in the end, although he visited essentially the same places as Hakewill, he did not do so in the same order. In 1819 Turner entered and left Italy via Paris and Lyon, over the Mont Cenis pass (Fig. 69), and this was almost certainly because of his interest in the Carthaginian general Hannibal, the subject of one of his greatest paintings (Fig. 270). In the caption to that picture, Turner had referred to Salassian tribesman (see below p. 192) and this shows that he accepted the view that Hannibal had crossed the Alps in 218 B.C. by the pass later known as the Little St Bernard, into the Val d'Aosta.[27] But another Italian guidebook, by Henry Sass, which Turner probably acquired and read in 1818, opted for the Mont Cenis pass as Hannibal's route, and Turner naturally wanted to test that suggestion for himself.[28] That the association with Hannibal came instinctively to him in this area of the Alps is shown by his (faulty) recollection of the caption of the 1812 painting on his visit to the Val d'Aosta with his friend and patron H. A. J. Munro of Novar in 1836[29]; and as late as one of the last visits to Switzerland, in 1844, Turner was apparently still discussing the question with his travelling-companion, the greatest English expert on Hannibal's campaigns, and the chief proponent of the Little St Bernard theory, William Brockedon.[30]

Sass's book may also have been behind another very significant feature of Turner's Italian itinerary in 1819: his early detour to Venice; for Sass himself had seen Rome before Venice and regretted it: 'after what I had seen [of Ancient Rome], these [Venetian] buildings seemed trifling and insignificant'.[31] Turner's route to Rome thus took in Venice on the way, and he painted there some of his most brilliant watercolour sketches (Fig. 71). The extraordinarily limpid quality of these sheets might suggest that he had at last found his ideal *motif*; but in fact his attitude to Venice in the 1820s is perplexing. He regarded the city as the home of the Venetian painting which, as we shall see in a later chapter, had attracted him so much in the Louvre in 1802, and he spent a good deal of time studying it afresh (TB CLXXI, CLXXV). He also made a large number of topographical sketches in pencil, mainly of the chief sights around the Bacino di San Marco, the Arsenal and on the Grand Canal as far as the Rialto. This was the area that had recieved most attention from Hakewill, and, indeed, Turner continued to have Hakewill specifically in mind (Figs. 73–5). But, surprisingly, compared with Rome he made very few colour studies indeed. When he returned to England, apart from two or three watercolours for Fawkes, Venice formed no part of his new Italian repertory, until, for quite contingent reasons which we shall explore in a later chapter, he came to paint his first Venetian subject fourteen years after his visit

(Fig. 196), and so initiated that infatuation with Venice which lasted until the 1840s.

There has however recently come to light a very large unfinished canvas of *The Rialto* (BJ 245), which is closely related to a watercolour in Dublin (Fig. 72) and probably dates from about 1820. It suggests that Turner envisaged an exhibition picture on a par with *Rome from the Vatican* (Fig. 81) which he did in fact exhibit at the Academy in the year of his return. The prominence given to the arch through which the Rialto is seen suggests that the painter was thinking of the passage in Canto IV of Byron's *Childe Harold's Pilgrimage*, in which the poet had contrasted the fate of the commercial centre of Venice with that of the characters created by Shakespeare in *Othello* and *The Merchant of Venice*, and in the then very popular drama of Thomas Otway, *Venice preserved* (1682):

71. *(facing page top)* J. M. W. Turner, *Venice: the Fondamenta Nuova from near the Arsenal*(?) 1819. Watercolour, 23.4 × 29.7 cm. London, Clore Gallery for the Turner Collection (TB CLXXXI, p. 5).

73. J. M. W. Turner, *The Rialto ?c.*1840. Watercolour, over pencil, 19 × 27.3 cm. London, Clore Gallery for the Turner Collection (TB CCCXVI-7).

Ours is a trophy which will not decay
With the Rialto; Shylock and the Moor
And Pierre, cannot be swept or worn away –
The keystones of the arch . . .

For Byron's vision of an Italy reduced from its earlier power and esteem by internal decay and foreign invasion became Turner's vision; and just as the poet's celebrations of Waterloo and the Rhine had been presented to the painter in Campbell's *Guide*, so his tragic view of modern Italy was constantly offered to Turner in his guidebooks, from Henry Coxe's *Picture of Italy*, which he probably used in 1819,[32] to the letterpress of Hakewill's *Tour* itself. Hakewill's text (probably by J. T. James) to Turner's plate of

74. John Pye after J. M. W. Turner, *The Rialto*, 1820. Line engraving, 15.2 × 22.7 cm. Yale Center for British Art. (R.144).

72. *(facing page, bottom)* J. M. W. Turner, *Venice: the Rialto, c.*1820. Watercolour, 28.7 × 40.7 cm. Dublin, National Gallery of Ireland (W 725).

75. J. M. W. Turner, *Venice: the Arsenal*, c.1840. Watercolour, 25.3 × 31.7 cm. London, Clore Gallery for the Turner Collection (TB CCCXVI-27).

76. *(facing page)* Detail of Fig. 75.

The Rialto (Fig. 74) for example stressed that this area of Venice embraced both its political beginning and its end, for it had been the original settlement of the Heneti in the fifth century A.D. and had witnessed the last stand of the Venetian people against Napoleon in May 1797. Turner may have indeed been thinking of Byron's *Childe Harold* in this instance too, for he gave his view a Shakespearean twist by including a number of oriental figures, and a woman looking from a window to the right who is strongly reminiscent of Shylock's daughter Jessica in his painting of 1830 (Fig. 140). A very similar view was used in 1837 for the scene from Shakespeare's *Merchant of Venice*, known as *The Grand Canal, Venice* (BJ 368).

When Turner came to paint Venetian subjects regularly in the 1830s and 1840s, it was again the tragedy of Venetian history which served to focus his attention. In some works he alluded to the fate of what Byron had called 'the dogeless city'[33], and in many others he portrayed the hollow gaiety of Byron's

> pleasant place of all festivity,
> The revel of the earth, the masque of Italy.

The seriousness of his aspirations is reflected in the choice of oil rather than watercolour for the finished works; but there are also many watercolour sketches, including a superb series of rather developed views of the city battered by storms (Fig. 95), and an incandescent one of the Arsenal, which has a degree of finish more usual in drawings intended for reproduction (Fig. 75). The Arsenal was another symbol of the failure of Venetian military prowess: as Thomas Roscoe put it in one of Turner's later tour-books, 'While Venice had an existance as a free state, upwards of a thousand artisans were constantly employed there, and double that number in time of war. At present,

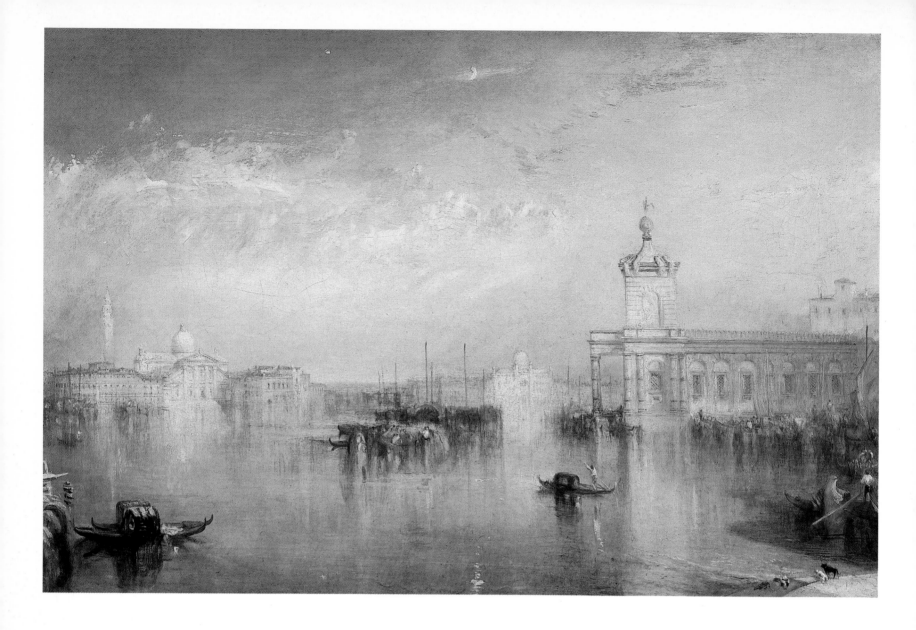

77. J. M. W. Turner, *The Dogano, San Giorgio, Citella, from the Steps of the Europa*, Oil on canvas, 62 × 92.5 cm. R.A. 1842. London, Tate Gallery (BJ 396).

78. *(facing page)* Detail of Fig. 77.

the Arsenal serves only as a spectacle to strangers, and a monument to the fallen glory of Venice.'[34]

In 1842 Turner showed at the Academy a pair of Venetian subjects whose contrasted themes articulated his view of the decline of Venice in the clearest terms (Figs. 77, 79). In the one, *The Dogano, San Giorgio, Citella* [i.e. *Le Zitelle*], *from the Steps of the Europa*, the view from the former Palazzo Giustiniani (which in Turner's day had become the Hotel Europa, where he often stayed) is dominated by Benoni's seventeenth-century Dogana da Mar (Customs House), the symbol of Venetian mercantile enterprise, some of whose luxury products are displayed on the hotel steps immediately below it. But on the little turret stands the figure of Fortune, prey to every wind; and in the companion picture, *Campo Santo, Venice*, this fortune has brought misfortune on the city, which now looks across the lagoon to its own cemetery, and whose waters now bear only humble fishing-vessels and floating garbage. If Turner's view of Italy, and especially of Venice, had been shaped by writers like Byron and Eustace, they too will have reminded him that such a fate might well be in store for England herself, hence the urgency of his message. As Byron had written of the city in *Childe Harold's Pilgrimage*

. . . thy lot
Is shameful to the nations, – most of all,

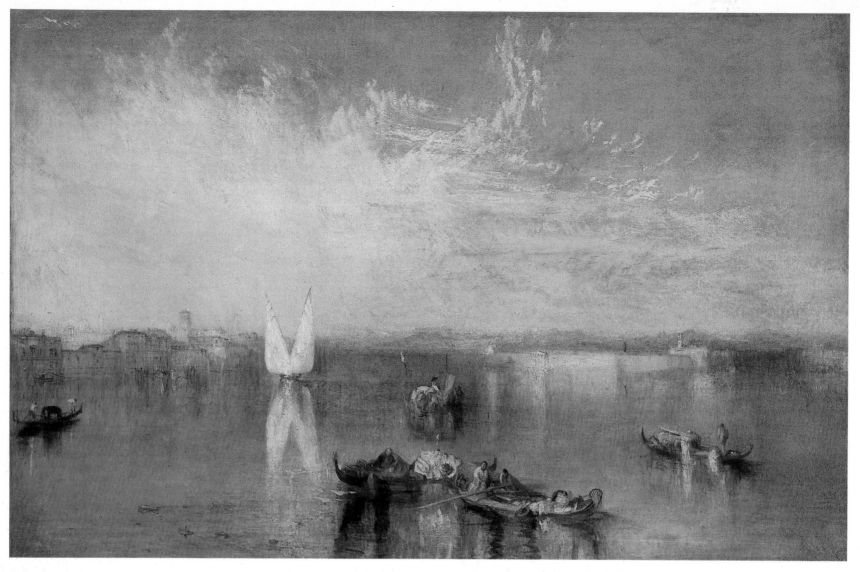

79. J. M. W. Turner, *Campo Santo, Venice*. Oil on canvas, 62.2 × 92.7 cm R.A. 1842. Toledo, Ohio, Museum of Art (BJ 397).

Albion! to thee: the Ocean queen should not
Abandon Ocean's children; in the fall
Of Venice think of thine, despite thy watery wall.
(Canto IV, xvii)

Hakewill's collaboration with Turner not only affected the painter's immediate response to Italy, but continued to be felt in his treatment of Italian subjects for many years to come. Turner's last two Roman subjects, for example, the *Ancient Rome. Agrippina Landing with the Ashes of Germanicus* (Fig. 35) and the *Modern Rome – Campo Vaccino* (Fig. 36), both of 1839, reflect Turner's reading of the text to Hakewill's *Picturesque Tour*. We have already seen how *Ancient Rome* represented Turner's bid to enter the archaeological debate on the most appropriate reconstruction of the Palace of the Caesars. His cue for the vast and dazzling restoration he proposed was provided by the caption to Hakewill's view of the inscrutable remains of this edifice, which stated that Nero's rebuilding of the Palace after the Fire of Rome had been

on a plan so gaudy and sumptuous, as to have occasioned it to be called (not undeservedly) by the name of the *domus aurea* [golden house]. The scale of the proportions of the edifice were no less imposing than the richness of its ornaments, and may be imagined from the fact that it contained three several porticoes, each upwards of a mile in length, and that the vestibule was of a dimension large enough to contain a statue of the Emperor, being a hundred and twenty feet in height . . .

80. *(facing page)* Detail of Fig. 79.

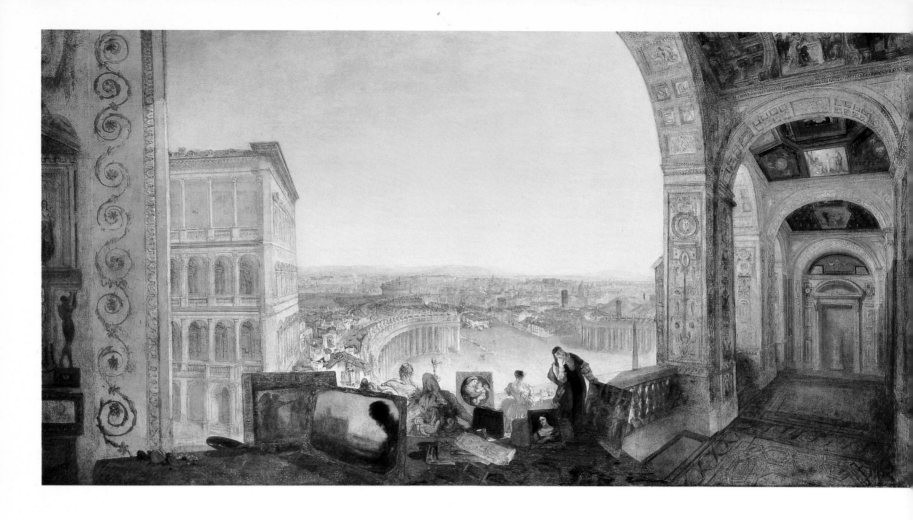

81. J. M. W. Turner, *Rome, from the Vatican, Raffaelle, accompanied by La Fornarina, preparing his Pictures for the Decoration of the Loggia.* Oil on canvas, 177 × 335.5 cm. R.A. 1820. London, Clore Gallery for the Turner Collection (BJ 228).

83. *(facing page)* Detail of Fig. 81.

82. J. M. W. Turner, *Forum Romanum*, 1818, Watercolour, 14 × 21.6 cm. Ottawa, National Gallery of Canada (W 705).

The pathetically contrasting *Modern Rome* similarly presented the recent archaeological excavations of the ancient city, which Turner had already made the figurative subject of his plate of the Roman Forum for Hakewill (Fig. 82). Here the text informed him that 'the excavations near the three columns in the foreground were undertaken at the expense of the Papal government', and so the painter felt it appropriate to note the Papal presence by an inscription, PONT[IFEX] MAX[IMUS], on an architectural fragment in the foreground of his picture.[35]

As had happened with the earlier tours, Turner's first Italian visit was influenced not simply by his reading and his patronage, but also by the advice of friends. In the course of his several visits to Scotland Turner had become intimate with a group of Edinburgh artists, including the landscape painters John Thomson of Duddingston and Hugh 'Grecian' Williams, both of whom he met in 1818 in connection with their collaboration on Sir Walter Scott's publication, *Provincial Antiquities of Scotland*. Their topics of conversation included questions of technique and colour;[36] and at a dinner at Thomson's in 1831, Turner even made a very rare pronouncement on his attitude towards landscape symbolism.[37] Thomson and Williams are usually, and rightly, held to have learned a good deal from Turner's style,[38] but the traffic in ideas was certainly not entirely one-way. When Turner went sketching with them in 1818, Williams had just returned from an extensive journey in Italy and Greece, and many of the attitudes which Turner brought to Italian art, and, indeed, his attention to particular examples of it, suggest that he had discussed it with the Scottish painter, whose views, as expressed in his letters to Thomson, were subsequently published as *Travels in Italy, Greece and the Ionian Islands*. Williams, for example, had been especially enthusiastic about Claude's *Sea-Port with the Villa Medici* in the Uffizi in Florence, as 'equal to any of the finest of Claude's paintings to be seen in England', and Turner gave it more than

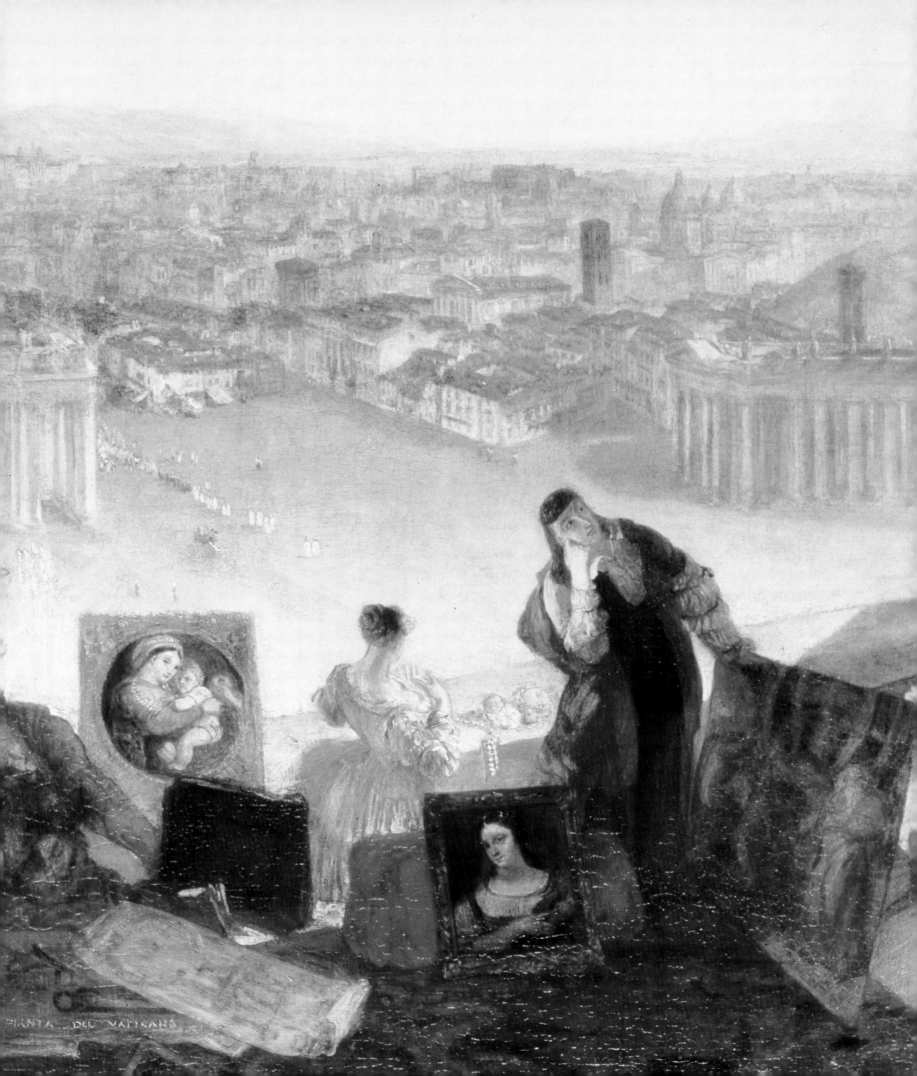

usual attention on his visit in 1819.[39] At the Villa Borghese in Rome, Williams had remarked of Titian's *Sacred and Profane Love*, 'as a piece of colouring the picture is faultless', and Turner made it the subject of a sketch and some notes on this colour.[40] Williams felt that the frescoes of Raphael's *Loggie* in the Vatican 'have not that laboured appearance which is perceptible in his oil paintings; there is a freshness of colouring, too, and grandeur . . . which his easel works never exhibit'[41]; and Turner duly converted the vault-decorations into easel pictures in his vast tribute to Raphael, *Rome from the Vatican* (Fig. 81), shown at the Academy on the anniversary of Raphael's death, in 1820. When Turner chose a moonlit night to make a remarkable study of the Colosseum (TB CLXXXIX–13), Williams, as well as Byron, had been rhapsodising there before him.[42]

These interests reflect no more than the conventional tastes of the tourist, but other hints by Williams which were taken up by Turner were more unusual and more up to the minute. In the Palazzo Mozzi in Florence Williams had seen *The Saxons Swearing Fidelity to Napoleon by the Light of the Moon* (1812) by a pupil of Jacques-Louis David, Pietro Benvenuti, the Director of the Florentine Academy. Williams though it one of his best paintings, and Turner must have thought so too, for he made an elaborate notation of its colour in one of his 1819 sketchbooks.[43] But, although Turner headed a list of landscape artists working in Rome with the French painter whom Williams also thought the best, Didier Boguet,[44] and although he owned a picture by the Franco-Italian painter Giacomo Berger, Turner felt that the art at Rome was 'at the lowest ebb'.[45] So did Williams: 'In landscape composition', he had written in 1816,

> we look in vain among the Romans for any one to rival a Turner, a Callcott, or a Thomson [of Duddingston]. The representation of familiar and rustic life, in which Wilkie rises so far above all comparison or competition, is to the Roman painters absolutely unknown. In portrait painting, which of them can compare with a Lawrence, a Raeburn or a Geddes . . . ? In the beautiful art of painting in water colours, Britain stands supreme, or rather, she may be said to have appropriated it exclusively . . . From the state of the art of painting in Italy, and, indeed, I may say on the continent in general, it has little chance of being revived, except by the example of the modern British painters. Were the Italians so fortunate as to have such eminent men residing among them, as Sir Thomas Lawrence, Mr Turner, or Mr Wilkie, it cannot be doubted, that the effects of their example would powerfully tend to ressuscitate that divine art, to which Italy . . . still owes the main part of its interest and importance . . .'[46]

Thus, in preparing his first Italian journey, it seems that Turner took advice wherever he could find it. This was even more essential in the case of Greece, which he never visited, although he made many paintings and watercolours of Greek subjects, relying for topography and local colour on the sketches of others. One of these was the architect C. R. Cockerell, who also supplied Williams with much material for his second book, *Select Views in Greece* (1829), a copy of which Turner acquired for his library. Turner also consulted other travellers for his figures, and here Williams was especially important. The curious Greek soldier who wandered into Turner's *Fishmarket* drawing of 1824 (Fig. 296) seems to have been based on the 'Janizary' published among a set of Greek costumes in Williams' 1820 *Travels* (Fig. 297); and the foreground of the view of *The Acropolis of Athens*, whose architecture was based on a sketch by another architect, Thomas Allason, appears to represent a *djerid*, a form of joust particularly favoured by the Waiwode, the Turkish governor of Athens, as described by Williams in his book (Fig. 274).[47]

Italy in general, and Rome and Venice in particular, remained the focus of Turner's foreign excursions until the end of his life; he was at Rome again in the winter of

84. *Carte Itineraire de la Bretagne*, 1800. 516 × 693 mm. London, Clore Gallery for the Turner Collection (TB CCCXLIV-426). Turner used this map for pencil sketches of Dinan and St Malo.

1828–9, and in Venice at least twice in the 1830s and 1840s. But soon after the first Italian visit he also began to explore France more thoroughly, and now he untypically extended his interests to a virtually unknown area, Brittany, for which he was obliged to use a map published a quarter of a century earlier (Fig. 84).[48] No Breton subjects, are known to have been elaborated into pictures or finished watercolours, and it is possible that here, for once, Turner was following an entirely personal whim. The thirst for fresh experiences reached its height in 1833, when Turner made what was probably his most extensive tour, to central Europe, including Berlin, Dresden, Prague, Vienna and Venice, where, probably stimulated by his recent appointment to a committee in charge of settling the Royal Academy in the new National Gallery building in Trafalgar Square, he made a particular study of public picture galleries.[49] This tour, however, also produced little new work outside the sketchbooks, and it was not until

85. J. M. W. Turner, *The Red Righi*, 1842. Watercolour, 305 × 458 cm. Melbourne, National Gallery of Victoria (W 1525).

the 1840s that a new concentration on Switzerland bore fruit in the most important series of painting in Turner's later career.

Already in 1802 Turner had covered a good deal of ground in south-western, central and northern Switzerland, but on that occasion the emphasis had been, on the one hand, on the area around Mont Blanc, which had been the most popular resort of English tourists since the mid-eighteenth century, and, on the other, the Via Mala and the Pass of the St Gotthard to the east. Now, in a regular series of summer campaigns between 1840 and 1844, he deepened and extended his acquaintance with the north shore of lake Geneva, and, in particular with the whole range of the central Alps from Constance and Zürich in the north to Bellinzona and Lake Como in the south. Turner's attention was now concentrated on the lakes of Zug and Lucerne and their mountains: in the two series, of altogether fifteen watercolours, which he prepared for a select group of collectors in 1842 and 1843, nine were of subjects in this area (Figs. 85–6, 251). He now came to this part of the country fully conscious of its role in the history of European liberty, a role which had been recently celebrated by Byron and by Samuel Rogers, in their poems, illustrated by Turner in the 1820s and 1830s; and it is no surprise that he should have settled particularly on this region, which united extraordinary

natural beauty with the associations of a glorious past. For the first edition of Murray's *Handbook for Travellers in Switzerland* (1838), Lake Lucerne was

> distinguished above every lake in Switzerland, and perhaps in Europe, by the beauty and sublime grandeur of its scenery. It is hardly less interesting from the historical recollections connected with it. Its shores are a classic region – the reputed sanctuary of liberty; on them took place those remarkable events which gave freedom to Switzerland – here the first Confederacy was formed; and, above all, its borders were the scene of the heroic deeds and signal vengeance of WILLIAM TELL, on which account they are sometimes called Tell's Country.[50]

Turner had already drawn Tell's Chapel near Brunnen on his 1802 visit (TB LXXVI, pp. 41, 70; cf. w.378), and about the same time he had even considered painting the historical subject of the hero's escape from his persecutor Gesler's boat, (TB LXXXI, pp.

86. J. M. W. Turner, *Lake Lucerne – Moonlight, the Righi in the distance, c.*1841. Watercolour, 23 × 30.7 cm. University of Manchester, Whitworth Art Gallery (W 1478).

36–7). He continued to look for Tell's relics on these last visits of the 1840s; and he also showed a particular liking for the area near Brunnen from which could be seen both Tell's Chapel and the site of the three springs which miraculously appeared after the swearing of the oath of the Rütli (or Grütli) in 1307, which brought the three Cantons of Uri, Schwyz and Unterwalden into the first Swiss Confederation against Austria.[51] This branch of the lake, known as the Bay of Uri, was particularly praised for its beauty and its associations by Sir James Mackintosh, who had visited it in 1814 in the company of Samuel Rogers and his sister, both of whom were close to Turner in the last decade of his career. 'It is upon this', wrote Mackintosh,

> that [Lucerne's] superiority to all other lakes, or, as far as I know, scenes upon earth, depends. The vast mountains rising on every side and closing at the end, with their rich clothing of wood, the sweet soft spots of verdant pasture scattered at their feet and sometimes on their breast, and the expanse of water unbroken by islands, and almost undisturbed by any signs of living men, make an impression which it would be foolish to attempt to convey by words . . . The only memorials which would not disgrace such a scene are those of past ages renowned for heroism and virtue; and no part of the world is more full of such venerable ones . . . The combination of what is grandest in nature with whatever is pure and sublime in human conduct, affected me in this passage more powerfully than any scene which I had ever seen. Perhaps neither Greece nor Rome would have had such power over me. They are dead. The present inhabitants are a new race, who regard with little or no feeling the memorials of former ages. This is perhaps the only place in our globe where deeds of pure virtue, ancient enough to be venerable, are consecrated by the religion of the people, and continue to command interest and reverence . . . The solitude of the Alps is a sanctuary destined for the monuments of ancient virtue . . .[52]

The contrast here between Switzerland and modern Greece and Rome was likely to strike a special chord in Turner, but even Switzerland in the 1840s was beginning to show signs of moral and political decay. In Lucerne itself the disturbances which were in 1845 to break out as the civil war of the Sonderbund, between the Catholic and the Protestant Cantons, were already brewing, and Turner was taken by surprise. As he wrote of his visit in 1844: 'I went to Lucerne and Switzerland, little thinking or supposing such a cauldron of squabbling, political or religious, I was walking over'.[53] It was only after Turner's last visit, at the end of the decade, that the Cantons finally came together again to form the modern Swiss Federation.

Another chapel, built near the spot at Küssnacht where Tell shot Gesler, was the starting point for one route up the Righi, the mountain which particularly engaged Turner on these tours (Figs. 85–6).[54] The Righi was one of the easiest, and hence one of the most popular climbs in Switzerland, and the rewards at the summit were considerable: 'a panorama' as Murray's *Handbook* put it, hardly to be equalled in extent and grandeur among the Alps.' The sunrise seen from this peak, wrote an earlier traveller, 'forms an epoch in one's life, which can never be forgotten'.[55] Yet Turner never drew it from the summit; he kept his distance, working in all times and weathers from his hotel, across the lake at Lucerne. It may be that he felt the Righi was already too popular a vantage point, and he did not want to share his experiences with the two or three hundred other tourists who were said to congregate daily on the summit to catch the dawn.[56]

The Swiss and north-Italian journeys of the early 1840s were Turner's last major excursions; in 1845 he made brief visits to northern France, and he even appears to have planned a last visit to Venice that year, although nothing, apparently, came of it.[57] There were a number of short tours in Kent even after that, when his health was rapidly failing. As an old man he had considered visits to Ireland and the Holy Land, and on his

deathbed itself he was planning to take his doctor on a guided tour round the whole of Europe and show him all the places he had visited.[58] No artist can ever have travelled so much, but, neither had any artist ever travelled with such an intelligent sympathy both to for people and for places. It was a sympathy that was extraordinarily well-informed.

II

It has often been suggested that Turner was essentially a solitary; yet it seems clear that for most of his major tours he had companions for all or part of the journey.[59] The recollections of these companions have usually been used by biographers for the light they throw on the painter's parsimony, or his secretiveness, but they also bear witness to a degree of sociability and even of social presentability which may come as a surprise.

As a young man Turner had, indeed, been something of a dandy (Fig. 293) and a list of clothes which were presumably for touring, in a sketchbook of 1799, includes three coats, five coloured, four white and one black waistcoats, four underwaistcoats, six shirts, eight cravats, six cotton stockings, and two pairs of black and one of white silk stockings (TB XLVI, p. 120). Even as late as 1817 he travelled to the Rhine with at least seven cravats and three shirts – for he noted them as lost with one of his bags (TB CLIX, p. 101). But a growing negligence made itself felt from the time of the first Italian journey, when the architect T. L. Donaldson recalled an occasion at Naples, after having climbed Vesuvius with Turner and an unnamed friend.

> They were all invited to dine with the British Ambassador . . . White waistcoats were the fashion at that time; but Turner, not being provided with one, rambled about & found one at a second hand clothe dealer's shop. The price asked was 5 shillings. Turner thought it too much : not being able to converse in Italian, he asked Donaldson to accompany him to the shop & try to obtain the waistcoat for a less sum. Donaldson & Turner went to the dealer's & succeeded in buying the article for 3s/6d.'[60]

A similar story was told of Turner's last Contental excursion, to the Normandy Coast in 1845, when 'he carried nothing with him but a change of linen and his sketch-book'. Arrived at Eu, near one of King Louis-Philippe's chateaux, he was staying frugally at the house of a fisherman, when he was unexpectedly invited to dine with the king, who had known him at Twickenham at the close of the Napoleonic wars.

> Turner strove to apologise – pleaded his want of dress – but this was overruled; his usual costume was the dress-coat of the period, and he was assured that he only required a white neckcloth, and that the King must not be denied. The fisherman's wife easily provided a white neckcloth, by cutting up some of her linen, and Turner declared that he spent one of the pleasantest of evenings in chat with his old Twickenham acquaintance.[61]

Donaldson noted Turner's lack of Italian, and it is true that he was no linguist, but this was not for want of trying. French he began to teach himself as early as 1799 (TB XLIV, G; XLVI, inside cover); and he was evidently prepared to continue with it as late as 1817, for he jotted down the address and fees of a French teacher in London in a sketchbook of that date (TB CLIX, p. 23a). Around 1830 he made a serious attempt to learn German,[62] and there are phrases in these languages, as well as in Dutch and Italian, scattered throughout the sketchbooks, sometimes written in apparently by acquaintances on the road. That he was at least able to follow some simple French is suggested by a snatch of conversation he recorded from his coach journey between Calais and Paris in 1819:

87. J. M. W. Turner, *Sketch on the pass of Mont Cenis*, 1820. Pencil, 13.6 × 10.6 cm. London, Clore Gallery for the Turner collection (TB CXCII, p. 2a).

. . . Conversation in the diligence. the Russe 2 Frenchmen and 2 English Cab 3 Engl. Russe great par example the Emperor Alexander tooit [killed] par tout the French tres bons zens but the English everything at last was bad, Pitt the cause of all, the King's death [and fall?] and Robespierre their tool . . . (TB CLXXIII, p. 1a)

These efforts at learning, however limited, enabled Turner to get closer to those many sorts and conditions of people whose activities he recorded with such ebullience and with such breadth of sympathy in drawings and paintings.

What makes travel of particular importance in Turner's work is not simply that he clearly enjoyed it and did so much of it, but that he made it again and again a subject of art. The full title of the large marine of 1803, *Calais Pier* (BJ 48) makes it clear that he was recording his own arrival on the Continent, of which he noted on one of the sketches, 'our landing at Calais. Nearly swampt' (TB LXXXI, pp. 58–9). The subjects of many other paintings, like *The Dort* (Fig. 160), *Cologne* (Fig. 67), the *Harbour of Dieppe (Changement de Domicile)* (Fig. 43), or the *Now for the Painter (Rope), Passengers Going on Board* (BJ 236), tell the same story of Turner's own progress round Europe; and a number of watercolours, too, make reference to the rigours of his travels, among them the *Passage of the Mont Cenis Jan. 15 1820* (Fig. 69), and the sketch made on another stage of the same journey, with its note of 'Men shovelling away snow for the carriage – Women and Children hugging – the sky pink – the light and the cast shadows rather warm – Trees are all covered with the snow – The Trees in the distance and wood getting darker' (Fig. 87) Turner described this hazardous passage of the Alps in winter in a letter to his friend James Holworthy in January 1826:

Mont Cenis has been closed up some time, tho the papers say some hot-headed Englishman did venture to cross a pied a month ago, and what they considered *there* next to madness to attempt, which honor was conferred once on me and my companion de voiture. We were capsized on the top. Very lucky it was so; and the carriage door so completely frozen that we were obliged to get out at the window – the guide and Cantonier began to fight, and the driver was by a process verbal put into prison, so doing while we had to march or rather flounder up to our knees nothing less in snow all the way down to [Lanslebourg] by the King of Roadmakers' Road, not the Colossus of Roads, Mr MacAdam, but Bonaparte, filled up by snow and only known by the precipitous zig-zag . . .'[63]

The jocular reference to the King of Roadmakers is the key to the whole affair, for without the new road over the Mont Cenis, it is doubtful whether Turner's carriage would ever have reached the summit of the pass at all during the winter season. His enthusiasm is explained by a comment on the same pass in his Italian guidebook by Henry Sass:

The genius of Napoleon seems to have inspired and produced superhuman efforts. Wherever his hand is seen, or his mind is concerned, we are astonished at the grandeur and prodigious magnitude of his ideas. The Alps, whose terrific image has for ages excited the dread of man, have fallen before his power . . . He has cut through some mountains, overturned others, filled up precipices, turned the course of torrents, formed bridges, and made road of the most gentle assent, which avoid all former dangers and inconveniences. On them the traveller moves with ease and delight, and hospitality every where prevails. Although he has been our enemy, every one in passing the Alps must think as I do, and will almost have a feeling of gratitude towards him . . . for in these wonderful works, as in many others, he has been a benefit to the human race.[64]

It was the network of roads built chiefly by Napoleon which made Turner's incessant excursions across Europe a possibility; fast roads brought their dangers, but they were

88. J. M. W. Turner, *Between Quilleboeuf and Villequier*, c.1832. Pen
and bodycolour on blue paper, 14 × 19.1 cm. London, Clore
Gallery for the Turner Collection (TB CCLIX-104). Based on a
sketch in the *Seine and Paris* Sketchbook of 1830.

also the condition of the new tourism; the Grand Tours of the eighteenth century could
rarely be completed in less than a year, and often took several, but none of Turner's
extensive Continental visits lasted more than six months. Just as the new roads speeded
travel by land, so, long before the advent of the railways, sail had given way to steam
by water, and, whether in the English Channel (Fig. 3), on the Seine (Fig. 88) or off
the west coast of Scotland (Fig. 279) Turner was there to record it. But his business was
not essentially with reporting; and even when he seems to be closest to it, he leaves the
spectator perplexed. In 1842, for example, he exhibited at the Academy a marine
painting (Fig. 89), whose published title insisted that it was the direct product of
Turner's experience of modern travel: *Snow Storm – Steam-Boat off a Harbour's Mouth
Making Signals in Shallow Water, and Going by the Lead. The Author Was in This Storm
on the Night the Ariel Left Harwich*. The painter-author amplified his participation in the
event in a conversation with Ruskin's friend, the Rev. William Kingsley: 'I did not
paint it to be understood, but I wished to show what such a scene was like; I got the
sailors to lash me to the mast to observe it; I was lashed for four hours, and I did not
expect to escape, but I felt bound to record it if I did . . .'[65]

Yet no ship called *Ariel* can be associated with Harwich in the early 1840s, nor is

67

Turner known to have visited the east coast during this period, and he had not done so for twenty years.[66] The account of the paddle-steamer in difficulties, and having to take soundings to locate a safe sea-lane, is highly circumstantial; but, although Turner is known to have taken rough seas with relish,[67] it seems very improbable that in his late fifties his constitution could have stood four hours exposure in winter.[68] The painting itself is not documentation, but a work of consummate artifice, with its sharply-contrasted centre, and the spiral of smoke and its reflection playing against the tautly bowed line of the mast. It is difficult to escape the feeling that Turner was simply teasing his critics, who had accused him of painting nothing but 'soapsuds and whitewash', and that the resonance of the name *Ariel* came primarily from its association with Shakespeare's *Tempest*.

Fast roads, steam-boats and, in the last years of his life, railways (Fig. 10), were the condition of Turner's extraordinary mobility, and his methods of working changed to keep pace with them. Turner's procedures as an outdoor painter are by no means clear, but from the rain-spattered watercolour of the summit of Cader Idris (Fig. 91), and from the recently identified oil studies of the late 1790s (Fig. 93), we know that he was a

J. M. W. Turner, *A Beech Wood with Gipsies round a Camp-Fire, c.*1800. Oil on paper, laid on panel, 27 × 19 cm. Cambridge, Fitzwilliam Museum (BJ 2a). This sketch is one of the earliest evidences of Turner's working from nature in oil.

94. J. M. W. Turner, *Sketches in the Loire Valley, with Ingrandes and Montjean*, 1826/30. Pencil, 16.7 × 10.7 cm. London, Clore Gallery for the Turner Collection (TB CCXLVIII, p. 20).

precocious sketcher in both media in the open air. The issue of outdoor oil-sketching in particular was an important pre-occupation of young painters in England in the years around 1800 – Constable is only the best-known of them – and Turner seems to have experimented with it at several periods in his life. About 1807 he even seems to have proposed to paint large pictures substantially out of doors (Fig. 92). But oil-sketching was a slow process, and it is notable that the Devonshire series of 1813 (BJ 213–25) were much smaller than the sketches produced along the Thames and Wey a few years earlier (Fig. 19). One of Turner's companions in Devon, the painter Charles Lock Eastlake, recorded that the artist himself 'remarked that one of the sketches (and perhaps the best) was done in less than half an hour'.[69] Another companion on this occasion, the journalist Cyrus Redding, also stressed the crucial role of memory in the

uses to which Turner put his pencil sketches: they seemed to be 'a species of short-hand which he deciphered in his studio'.[70] It seems entirely possible that even some of the more highly-worked of these small cards were not painted on the spot. Whether or not the Cowes oil-studies of 1827 and some of the Italian studies of 1828–9 were sketched from nature – and this seems unlikely – they certainly represent isolated moments in a career of continuous activity; and after the Italian journey of 1819 there is very little reason to suppose that Turner ever painted on the spot, even in watercolour.

A well-known report that in Naples in 1819 Turner observed that 'it would take up too much time to colour in the open air – he could make 15 to 16 pencil sketches to one coloured',[71] is balanced by another account by a travelling-companion of Turner's earlier in the journey. A young medical student, R. J. Graves, crossed the Alps with the painter, and noticed him using a notebook, 'across the pages of which his hand, from time to time, passed with the rapidity of lightning'. In due course Graves's curiosity got the better of him, and he looked over and saw that Turner was recording the passing clouds.[72] Turner's approach to scenery was increasingly to make rapid pencil notations, often in the process of travelling (Fig. 94), then to flesh some of them out later in colour, on the basis of much more protracted observations which were entirely mental. It was this second stage that was by far the more important to him, and his visual memory became prodigious. Not surprisingly, it was the rapidly changing skies (Figs.

75. J. M. W. Turner, *Venice: Storm at Sunset*, c.1840. Watercolour and body-colour, 22.2 × 32 cm. Cambridge, Fitzwilliam Museum (W 1353).

96. J. M. W. Turner, *The First Steamer on Lake Lucerne*, c.1841. Watercolour, 23.1 × 28.9 cm. London, University College (W 1482).

97. and 98. J. M. W. Turner, *Durham Cathedral with a Rainbow*, 1801. Watercolours, each 17.4 × 12.3 cm. London, Clore Gallery for the Turner Collection (TB LIII, pp. 97, 98). Two consecutive pages of the *Helmsley* sketchbook showing a passing storm.

97–8) which most of all demanded such an approach: he told Effie Ruskin that 'the way in which he studied clouds was by taking a boat, which he anchored in some stream, and then lay on his back in it, gazing at the heavens for hours, and even days, till he grasped some effect of light which he desired to transpose to canvas.'[73] Turner's skies are certainly more complex and various than those of any other artist, and it is notable that in a sketchbook given over entirely to them (TB CLVIII) the emphasis is not, as in Constable, on cloud shapes, but on the change of lighting which their movement represents.[74]

A similarly evanescent subject which attracted Turner's prolonged attention was water. As a lifelong fisherman, Turner must have spent hours observing its subtle shifts of form and colour, and since in fresh water he must have faced the sun to avoid disturbing the fish with his shadow, he will have become familiar with every movement of its light over the surface. On a fishing-visit to Wales, made from Tabley Hall in 1808 (Fig. 99), Turner noticed a particularly striking effect of

A white Body floating down a River the Dee altho' relieved the whole surface from the water which had on its inclinded plane a dun cloud reflected, yet on the same tint the reflection of the white Body had not any light or white reflection, but on the contrary had its reflection dark. (TB CIV, p. 88)

In another Tabley notebook, which was also used around 1820 in London, and includes drafts of ideas on reflection subsequently incorporated into the Perspective lectures, he returned to a favourite theme of the gap between rules, representation and perception:

If the undulating surface of liquids did not by currents, air and motion congregate forms, it would be no difficulty to simplify all rules or attempts at such into a small space by considering it and treating reflections as reflections upon polished bodies – when frequently reflections appear so true but most fallacious, to the great book of nature – when painting art toils after truth in vain (TB V CV, p. 82a)

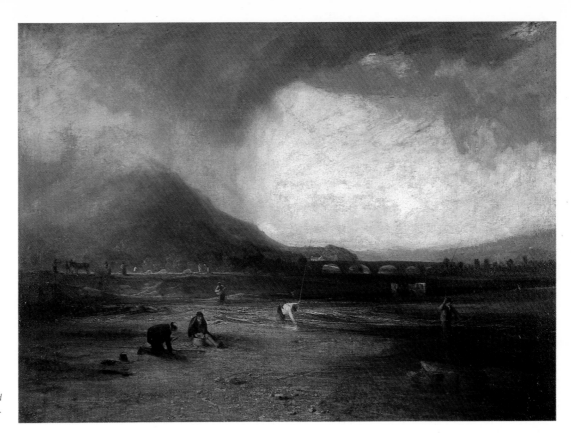

9. J. M. W. Turner, *Trout Fishing on the Dee, Corwen Bridge and Cottage*. Oil on canvas, 91.5 × 122 cm. Turner's Gallery 1809. Cincinnati, Ohio, The Taft Museum (BJ 92).

At the end of his life, too, Turner was discovered on one occasion among the Thames-side wharves beyond the Palace of Westminster, and probably near his Chelsea cottage, 'squatting on his heels at the river's edge and looking down intently into the water'. Half an hour later the same observer saw him still there, 'and apparently the object of his interest was the pattern made by the ripples at the edge of the tide'.[75] It was a subject worthy of a Leonardo da Vinci, but Turner was especially happy that it was one of a class of landscape studies he thought particularly suited to English art. As he wrote in a note for a lecture, probably about 1810,

> In our variable climate, where [all] the seasons are recognizable in one day, where all the vapoury turbulance involves the face of things, where nature seems to sport in all her dignity and dispensing incidents for the artist's study and deep revealing [?] more than any other . . . how happily is the landscape painter situated, how roused by every change of nature in every moment, that allows no langour even in her effects which she places before him, and demands most peremptorily every moment his admiration and investigation, to store his mind with every change of time and place.[76]

It is clear that place as well as time had a vitally important role to play in Turner's approach to his landscape art.

CHAPTER THREE
Colour and Technique: The Role of Engraving

00. (*facing page*) Detail of Fig. 102.

01. J. M. W. Turner, *Colour Circle 2*, *c*.1825. Watercolour, 54 × 4.3 cm. London, Clore Gallery for the Turner Collection (TB XCV-179).

TURNER has come to be regarded as the greatest English colourist, and as a painter who sought to re-inforce his powerful and instinctive grasp of colour relationships and expression by an engagement with the rapidly developing colour-theory of his day. In common with many of his contemporaries, like Constable and West in England, Runge in Germany and Delacroix in France, he looked to theory and to the colour-practice of the great masters of the past to make up for the absence of any technical teaching at the Academy, and even in most of the private schools, where a young artist of the period was obliged to pick up, more or less at random, whatever hints he might. The more informal art training of the Romantic period meant that the traditional apprenticeship system was largely obsolete, and it was replaced by a spate of technical handbooks, whose rather generalised recommendations ensured that Romantic painting was as original technically as it was in the matter of subject and style. Turner was also aware that colour played a great, but usually neglected, role in the articulation of pictorial space; and it was in the context of his perspective lectures at the Academy that he formulated his own ideas about colour over a period of some fifteen years.

> Colour is universal gradation of colour to colour, from the simple pastoral to the most energetic and sublime conceptions of form, combined with chiaroscuro; while light and shade can be classed without colour, producing likewise gradation of tone by comparable strengths of dark to light, colour, possessing the like properties [such] as strength, has others, of combinations productive and destructive of light or distance, as well as an appropriate tone to [express] particular subjects [and] peculiar combinations considered or allowed, called Historic or Poetic colours . . .'[1]

The notion expressed here that colours are not simply a set of hues, but are also functions of light and shade, was one that became more insistent throughout the course of Turner's career; and it is surprising that he does not allow colours any qualities except 'poetic' ones, by which he meant traditional symbolic values. He found himself at odds with the most recent colour-theories offered to artists, which sought to articulate it in terms of the hue-contrasts identified as 'complementary': red against green, blue against orange, yellow against violet; and to suggest that here, at last, was a sure key to colour harmony. In the new series of lectures which he delivered in the course of the 1820s Turner modified the then quite standard colour-circle of primary and secondary hues, which placed these so-called 'complementary' hues opposite each other, with a circle of his own devising, designed to illustrate simply that yellow functions as a light and red and blue as darks (Fig. 101).[2] This value for red, which had

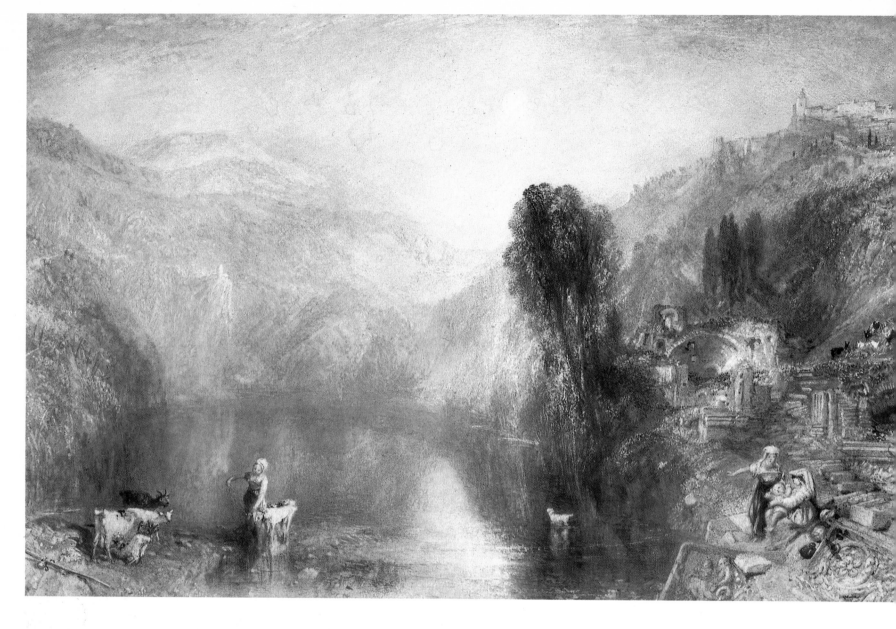

102. J. M. W. Turner, *Lake Nemi*, *c.* 1840. Watercolour, 34.7 × 51.5 cm. London, British Museum (W 1381).

103. Robert Wallis after J. M. W. Turner *Nemi*, 1842. Line-engraving, 24.7 × 35.2 cm. London, British Museum (R 659).

always seemed so striking for its luminosity, is unexpected, and Turner remained ambivalent about it. When an engraver asked him how he was to render a patch of red as a tone, Turner replied 'sometimes translate it into black, and at another time into white. If a bit of black gives the emphasis, so does red in my picture'.[3]

It was in fact in the context of engraving that the term 'colour', referring to chiaroscuro, or the distribution of light and dark, had become common in the eighteenth century, and even his latest, and to our eyes most chromatic works Turner was sometimes content to have reproduced in black and white (Figs. 102–3). The engraver and painter John Burnet recognised the strong tonal structure of his cloud-painting, for example, and wrote of it 'this colour of clouds was always founded upon the basis of chiaroscuro; hence the change into black and white engravings is less injurious to the effect than in the case of other artists.'[4] One telling symptom of his thinking is Turners continued habit of arranging his palette according to the traditional tonal sequence; the fully loaded rectangular palette among the Turner relics at the Clore Gallery, which must have been used to paint the last Academy exhibits in 1850 (Fig. 283), still has this arrangement, from white close to the thumb-hole to black at the far end; and it was an arrangement which reflected an essentially tonal approach to colour organisation.[5]

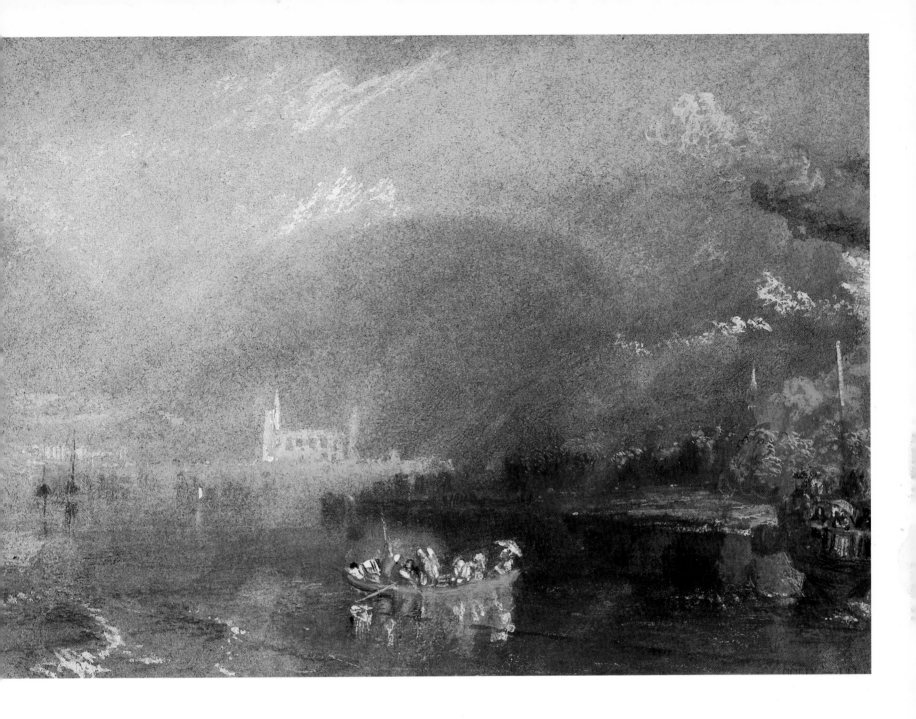

104. J. M. W. Turner, *Jumièges*, c.1832. Bodycolour on blue paper, 4 × 19 cm. London, Clore Gallery for the Turner Bequest (W 961).

105. J. C. Armytage after J. M. W. Turner, *Jumièges*, 1834. Line-engraving, 11 × 15.2 cm. London, British Museum (R463). Engraved for *Turner's Annual Tour – the Seine*.

Yet, as the remarks in his lecture show, as early as 1812 Turner was aware that the creation of atmospheric and spatial effects with colour was not the same as creating them with tone alone. He conceived of engraved reproduction essentially in terms of translation, which is why he became anxious to supervise its production so closely himself (see Figs. 104–5).[6] Perhaps his favourite engraver was John Pye, who recalled,

[Turner] would turn his proofs, after touching them, from side to side and upside down that the key of colour might be maintained and carried into effect. He was wont to say that engravers have only white paper to express what the painter does with vermilion . . . The great principle he was always endeavouring to advance was that of the art of translation of landscape, whether in colour or black and white, [and] was to enable the spectator to see through the picture into space.[7]

It is scarcely an exaggeration to say that Turner's growing understanding of the

77

possibilities of painting was shaped by his experience of engraving, for his professional career was specifically involved with the problems of engraving throughout. We have seen how his first major tour in 1794 was chiefly to gather material for publication, and the same is true of the Isle of Wight tour the following year, which was to issue in a far more ambitious series of engravings by John Landseer, which, for some unknown reason, was never completed.[8] Turner's lectures reveal his familiarity with a wide range of prints after Old Masters, and it is likely that he had a substantial collection of them, as well as of reproductions after his own contemporaries.[9] Professional exposure to print-making naturally led Turner to be curious about its techniques, and from the earliest times we find notes on them in his sketchbooks. Already as a young student in the Antique School at the Royal Academy he seems to have been interested in etching,[10] and it would be interesting to know whether this was line-etching or aquatint, both of which techniques he used from 1807 and 1811 in his own contributions to the *Liber Studiorum*. It may, even in the 1790s, have already given him the cue for his 'stopping-out' method in watercolour, which is analogous to aquatint procedure. By this method, parts of a watercolour were masked with a soluble varnish and painted over, after which the varnish was removed, leaving a sharply-defined patch of light. This device became an important creator of some of the rich textural effects which are such a striking feature of the larger watercolours in the second half of the 1790s.[11] But it was only one of the several methods of achieving an infinitely subtle gradation of tone and depth, which taxed the ingenuity of some of Turner's followers to its full stretch:

> The lights are made out by drawing a pencil [brush] with water in it over the parts intended to be light (a general ground of dark colour having been laid where required) and raising the colour so damped by the pencil by means of *blotting paper*; after which with crumbs of bread the parts are cleaned. Such colour as may afterwards be necessary may be passed over the different parts, a white chalk pencil (Gibraltar rock pencil) to sketch the forms that are to be light – A rich draggy appearance may be obtained by passing a Camel Hair Pencil *nearly dry* over them, which only *flirts* the damp on the part so touched & by blotting paper the lights are shewn partially.[12]

It was no accident that these watercolours were often the works in which Turner attempted to come closest to his most admired models of the moment, Rembrandt or Claude (Figs. 129, 156), for one of the most puzzling aspects of watercolour style and method in the last years of the eighteenth century is precisely the aspiration to rival oil painting in scale, force and brilliance, and Turner was in the forefront of this movement. It was closely bound up with the introduction of watercolours into public exhibitions, where they had to compete with the oils, among which they were often hung. Thomas Gainsborough, whose eccentric use of drawing materials was to have, as we shall see in a later chapter, a decisive effect on Turner's practice, had already in the early 1770s exhibited drawings in imitation of oil pictures at the Royal Academy.[13] It was probably the Gainsborough imitator and collector Dr Thomas Monro who introduced the young artist to the idea that watercolours were not necessarily to be kept, like drawings, in portfolios (which had been the traditional manner of storing them and protecting them from the light) but that they might also be displayed like pictures. In 1797 Farington noted that 'Dr Monro's house is full of drawings. In the dining parlour 90 drawings framed & glazed are hung up – and in the Drawing room 120 – They consist of drawings of Hearne, Barret, Smith, Laporte, Turner, Wheatley, Girtin.'[14] Sometimes Turner's early watercolours were varnished like oils, and his patrons continued to frame them in gold right through his life, as can be seen from the display at the home of B. G. Windus in the 1830s (Fig. 255).[15]

After 1800, Turner exhibited fewer and fewer watercolours, and it might be thought that he had decided to revert to the traditional role of the watercolour drawing merely as a model for engraving, while he concentrated in exhibition pictures on the only medium which could achieve serious academic recognition, namely oil. This would be to overlook the continuously fruitful interaction of the two media in his work. Painting in oils was certainly the condition of election as a Royal Academician, and Turner began to practice it about 1792 (BJ 19a); yet his earliest work in this medium imitated only the style but not the technique of his watercolours of the same date, and it was not until a few years later that he began to explore the possibilities of transparency in oil glazing too. The first large oil was probably the lost *Rochester Castle with Fishermen Drawing Boats ashore in a Gale* (BJ 21), which was perhaps related to a surviving watercolour (Fig. 106). An early commentator described it as 'carefully but thinly painted, in just the manner one might suppose a water-colour artist would paint. [Turner] seems to have used semi-opaque colour to scumble with, in so fluid a state that one may distinctly see where it has run down the picture from his brush . . .'[16] During the ensuing years, Turner brought this transparent technique over a light ground, which he had learned from a French eighteenth-century tradition naturalised in England by De Loutherbourg, to an astonishing pitch of sophistication; and the first exhibited oil, *Fishermen at Sea* (Fig. 107), is a remarkably mature achievement, both in conception and in execution. His interests, around 1797, in Wilson and Poussin, who had made little use of glazes, meant that his oils and watercolours were moving in different directions at this time;[17] but they came together again soon after 1800, when he began to look very closely at the methods of Venetian painting in the sixteenth century.

Venetian technique became a major debating point at the Royal Academy in these years largely as a result of the hoax perpetrated by a young girl on a group of influential Academicians, including the President, Benjamin West, between 1795 and 1797. The 'Venetian Secret', which was far from secret, for it included little that was new, had as its chief tenet the glazing of transparent colours over a dark absorbent ground.[18] In James Gillray's brilliant satire on the hoax, *Titianus Redivivus* (Fig. 108), Turner was included among a number of watercolourists and engravers whose works are being

108. James Gillray, *Titianus Redivivus; or the Seven Wise Men consulting the new Venetian Oracle*, 1797. Etching and watercolour, 54.5 × 41 cm. London British Museum. Turner's name is at the bottom of the list to the left.

defiled by the Ape of Art beneath a decapitated statue of that Ancient Symbol of art itself, the Apollo Belvedere. One of the chief dupes was Turner's mentor Farington, so there is no doubt that the young artist was fully aware of the scandal, and he soon set about establishing the principles of Venetian colour for himself. Early in 1802 he began to use the services of the Italian colourman Sebastian Grandi, who had already supplied materials to Reynolds, and who, during the Venetian Secret controversy had claimed that his own process of laying grounds was the true Venetian one.[19] Grandi had certainly been trained, at least at one remove, by a Venetian master; and during 1801 he had been working as restorer for the dealer in Venetian art Alexander Day. Day was importing a number of very important Titians at this time, one of them was the *Venus*

and Adonis, which was acquired by J. J. Angerstein and is now in the National Gallery in London, and which provided the immediate stimulus for Turner's own thoroughly Titianesque treatment of the same subject about 1803 (Fig. 125).[20] Whether or not Turner was especially encouraged by his dealings with Grandi, a few months later he was studying Titian for himself in the Louvre, and examining especially the effect of various coloured grounds on the tone of the paintings they underlay (Fig. 127).[19] Turner seems on this occasion to have concluded that Titian used darkish-coloured grounds, of the sort Grandi prepared for Turner himself; but, as we shall see shortly, in his later years he adopted the more traditional view of Reynolds that Titian's ground had been a white gesso, and this naturally brought him back to the rationale of watercolour painting on white paper.[22] The Venetian Secret and its aftermath was only the first of many episodes in Turner's life when he sought to solve the elusive and fascinating mystery of the Venetian method of painting.

We may have come rather far from engraving, but during the 1800s two developments in Turner's methods brought engraving again to the centre of his concerns. One was the renewed approximation of his oil technique to watercolour on a light ground, especially notable in some of the Thames beginnings and the pastoral subjects of these years (Figs. 92, 192); and the other was the new use of oil paintings themselves, like *The Shipwreck* (BJ 54), *Pope's Villa* (Fig. 266), *High Street, Oxford* (BJ 102) and its companion, *Oxford from the Abingdon Road* (BJ 125), as the bases for engraved reproductions. Of *The Shipwreck*, engraved in mezzotint by Charles Turner (no relation) (R.751), the painter issued a few impressions coloured by himself, but this was almost his only excursion into coloured prints, which he disliked. In these years, too, Turner became active for the first time as an engraver himself, etching all the outlines for the *Liber Studiorum*, which began publication in 1807, and from 1811 also working up some of the plates in aquatint and mezzotint.

The circumstances of this new departure were of great importance for the development of Turner's style. The economics of print-publishing demanded that each number of a part-work should be issued at a regular interval, to maintain the confidence and interest of the subscribers, who supplied a large part of the considerable capital needed to launch such an undertaking. *Liber Studiorum* was published in parts of five plates each, to be issued at intervals of six months. In 1808 and 1809 Turner quarrelled with Charles Turner, the engraver and publisher of the series, and dismissed him. There was a delay of nearly two years before the publication of the next three parts in 1811, during which time Turner took over the role of publisher again (he had published Part I in 1807), employing a new team of four engravers; and he himself was responsible for three plates.[23] The sensitivity in his handling of these plates suggests that Turner must have been experimenting with engraving techniques for some time, and it is probably no coincidence that from early in 1808 (*Mt St Gothard*, RL.S.9), the *Liber* begins to show a growing number of touched and annotated proofs, indicating the need Turner felt to keep a tight control over the production of each image.[24]

Concurrently with this series, Turner began *Picturesque Views on the Southern Coast of England* for W. B. Cooke, a part-work which was to be published in the very different technique of line-engraving. Mezzotint, the chief technique of the *Liber*, was a method which began by laying down a dark tone over the whole plate, which was then progressively burnished to reveal the lights. It was thus analogous to working in oil or watercolour on a dark ground. Line-engraving, on the other hand, worked from light to dark. Turner's intense involvement with both techniques in the years around 1812 made him sensitive to the possibility of achieving effects simply by the manipulation of contrast; and this is well-illustrated by a teasing game which he played with his engraver Cooke, on the plate of *Lyme Regis*, which was published in the *Southern Coast* series in 1814 (Figs. 109–10). Cooke noted on the third proof,

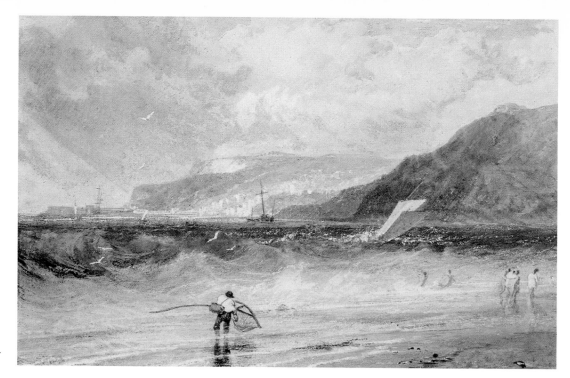

109. J. M. W. Turner *Lyme Regis, Dorsetshire: a squall*, *c*.1812. Watercolour, 15.3 × 21.6 cm. Glasgow Art Gallery (W 451).

On receiving this proof, Turner expressed himself highly gratified – he took a piece of *white chalk* and a piece of *black*, giving me the option as to which he should touch it with. I chose the white; he then threw the black chalk at some distance from him. When done, I requested he would touch another proof *in black*. 'No', said he, 'you have had your choice and must abide by it.[25]

In this instance Turner made extensive use of white retouchings and also used his fingernail to add another white bird and scratch out a broader area of foam; yet even so, the final plate is far darker in its overall tonality than its watercolour model. The exercise demonstrates the extent to which, for him, reproduction was essentially translation; and it also shows how the practice of adding 'effect' to topographical data was now raised to a wholly new level of inventiveness. But the habit of re-working and

110. W. B. Cooke after J. M. W. Turner, *Lyme Regis, Dorsetshire*, 1814. Line-engraving, 15.5 × 23.1 cm. London, British Museum, (R 94, touched proof c).

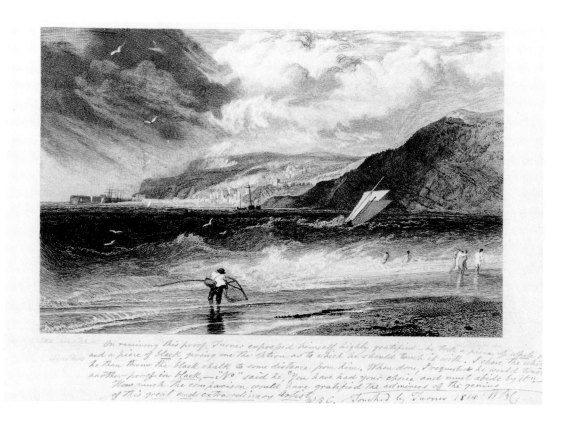

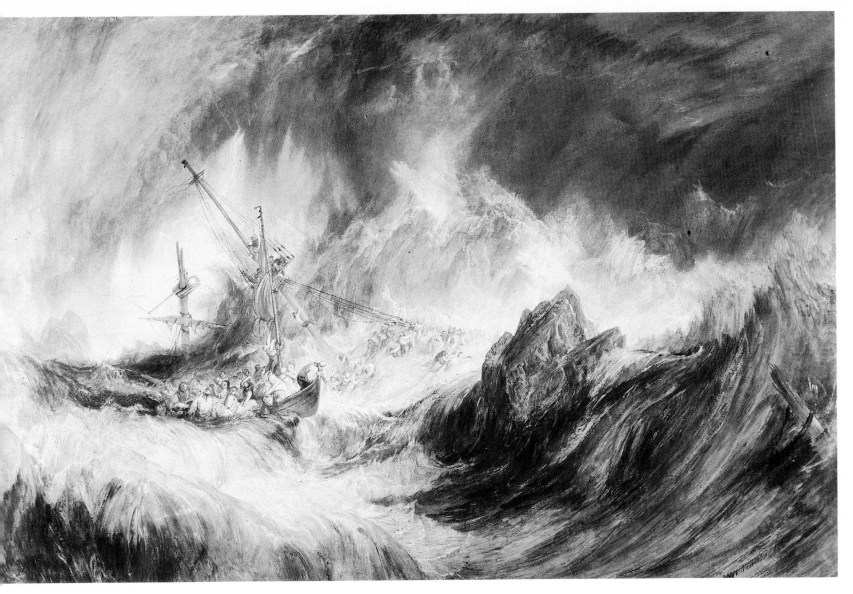

111. J. M. W. Turner, *Shipwreck*. Watercolour, 43.4 × 63.2 cm. London British Museum (W 508).

112. Theodore Gudin, *Coup de Vent du 7 janvier 1831 dans la rade d'Alger*, 1835. Oil on canvas 258 × 418 cm. Paris, Musée de la Marine.

transforming many proofs of the same design, and the need to work swiftly to complete a large number of drawings for a particular commission, was also to have a far-reaching effect on Turner's attitude to painting.

In May 1816 Turner secured his most important single commission to date; he reported to Farington at the Lord Mayor's Banquet 'that He had made an engagement to make 120 drawings views of various kinds in Yorkshire, for a History of Yorkshire for which he is to have 3000 guineas. Many of the subjects required, He said, he had now in his possession. He proposed to set off very soon for Yorkshire to collect other subjects.'[26]

Turner did indeed spend that summer sketching in Yorkshire, based at Farnley Hall, the seat of his old friend, Walter Fawkes. The first twelve watercolours for Whitaker's *History of Richmondshire* – the first part of the *History of Yorkshire* – were delivered to Longman's, the publishers, in April 1817;[27] but at the end of that year one of the engravers was reporting to Farington that Turner's fee had been reduced by a third;[28] Turner only delivered another eight drawings in all, and in the event he received only a quarter of the revised fee (Fig. 113). The lavish publication failed to attract subscribers, and was eventually issued only in a very truncated form in 1822. But it had been a quite new experience for Turner, for, even in its scaled-down form, it meant that he had had to produce more drawings faster than ever before. It is in the *Richmondshire* series that we find, for the first time, numbers of colour-beginnings for several of the designs

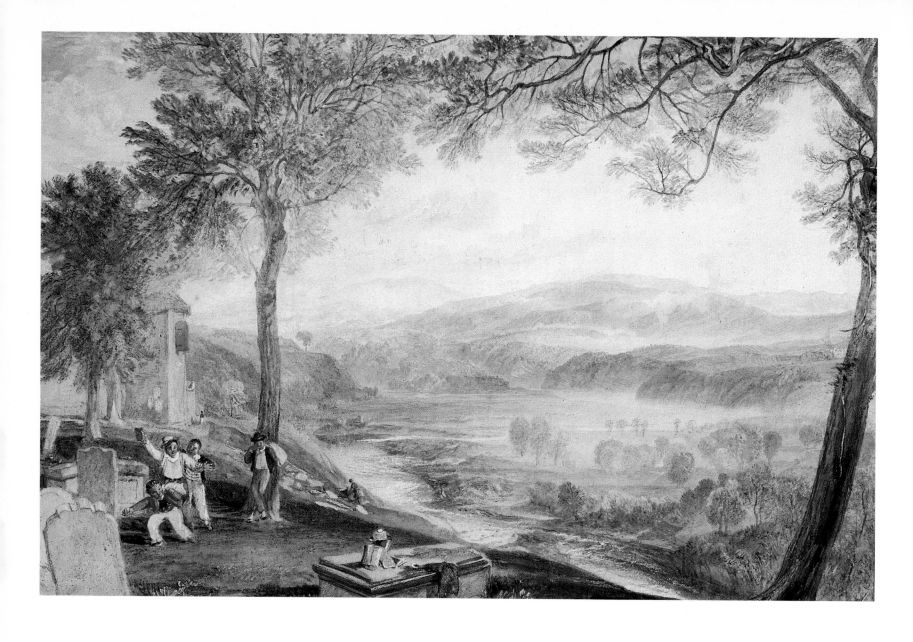

113. J. M. W. Turner, *Kirby Londsdale Churchyard*, c. 1818. Watercolour, 28.6 × 41.5 cm. Private Collection (W 578).

(Figs. 114–15). Colour-beginnings were not, in themselves, a new feature of Turner's working practice; in 1799, for example, he had produced a wonderful series of large studies for a *Llanberis Lake* (Fig. 182), which would probably have been an exhibition watercolour, but was never, so far as we know, completed.[29] But what was here a rather isolated case, became from the time of the *Richmondshire* a steadily developing practice. For Turner now began to work regularly in series; and for each work in the series, a number of sheets would be worked over simultaneously, and perhaps rejected as the conception of the subject developed in Turner's mind towards a completed watercolour. It is tempting to believe that it was a group of the first batch of *Richmondshire* drawings in their early stages, in August or September 1816, which the Fawkes girls had seen at Farnley, when they recalled 'cords spread across the room as in that of a washer woman, and papers tinted with pink and blue and yellow hanging on them to dry'.[30] But several other series of watercolours were made at Farnley too; the fifty-one Rhine drawings may at least have been completed there in 1817, as were the great series of nearly as many views of the house and estate painted between about 1815 and 1824 (Figs. 66, 237).[31]

Turner's new method reached its peak in the 1820s and 1830s, both for single images, like the *Shipwreck* of 1823 in the British Museum (Fig. 111) or the *Grenoble Bridge* at

84

114. J. M. W. Turner, *Kirby Lonsdale Churchyard*, *c*.1818. Watercolour, 39.5 × 48.1 cm. London, Clore Gallery for the Turner Collection (TB CXCVI-V). An abandoned version of Fig. 113.

115. J. M. W. Turner, *Kirby Lonsdale Churchyard*, *c*.1818. Watercolour, 39.5 × 48.1 cm. London, Clore Gallery for the Turner Collection (TB CXCVI-W) An abandoned version of Fig. 113.

116. J. M. W. Turner, *High Street Oxford*. Watercolour, *c.*1832/5. (from top to bottom) A. 30.4 × 48.4 cm. (TB CCLXIII-3), B. 16.2 × 48.6 cm. (TB CCLXIII-4), C. 37.2 × 54.7 cm. (TB CCLXIII-5), D. 35.2 × 51.4 cm. (TB CCLXIII-106), E. 38.2 × 55.8 cm. (TB CCLXIII-362). This sequence of abandoned sheets seems to relate to a possible subject for *Picturesque Views in England and Wales* which was not, so far as we know, either completed as a drawing or engraved. C appears to be the earliest version, followed by B and D, which structure the scene similarly with and without figures. The varying figurative emphases in two of these designs assure us that they were integral to Turner's conception (B, E). The work may have been abandoned because Turner already had an Oxford subject, *Christ Church College* (W 853) among the *England Wales* subjects by 1832, or, as the unusually large number of trials suggests, because he found the design particularly difficult to manage.

Baltimore;[32] and, more extensively, in the *England and Wales* series, which began in 1824, and for which the painter certainly prepared his drawings in batches. Charles Heath, the publisher of this part-work, and the engraver of several of the plates, received the first four of the contracted one hundred and twenty watercolours in February 1825;[33] and it is very probable that among this first batch was one or more of the Yorkshire subjects, such as *Bolton Abbey*, *Rivaulx Abbey*, *Richmond Castle and Town* or *Fall of the Tees*, whose style seems to be rather old-fashioned for the mid-twenties, and was left over from the aborted *Richmondshire* commission.[34] The varied and experimental qualities of these colour-beginnings, which are such a constant feature of the *England and Wales*, can be studied very well in the long sequence prepared for a *High Street, Oxford* (Fig. 116), which was never executed, either because (as the large number of changes suggests) it was an idea with which Turner was never entirely

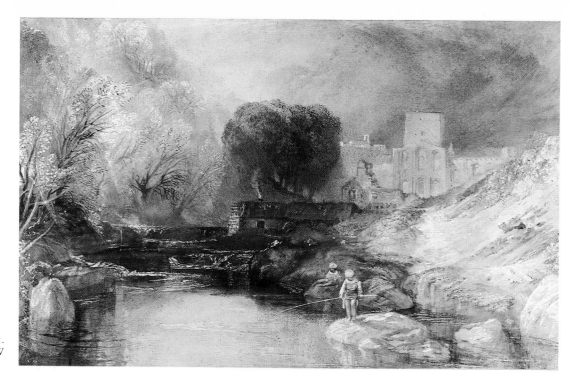

117. J. M. W. Turner, *Brinkburn Priory, Northumberland, c.1831.* Watercolour, 29.2 × 46.3 cm. Sheffield, Graves Art Gallery (W 843).

happy, or, perhaps, because the view already existed as an engraving after the oil-painting of 1810, and may not have been a very commercial prospect. What is most striking about this run of tinted sheets is the purity and luminosity of the colour, and the great simplicity of the underlying wash. There is no longer a sculpturesque manipulation of this wash, or a very marked use of scraping and wiping out, such as was still characteristic of exhibition watercolours as late as the *Chryses* of 1811 or *The Battle of Fort Rock* of 1815.[35] It was essential to this new and lighter style to retain the freshness and simplicity of the early washes, because their transparency often played a decisive role in the final drawing (Fig. 117). The final surface work was also kept to a minimum, both in the interest of an unworried bloom, and of economy of means. The simplified palette of these beginnings was compatible with the understanding of basic prismatic colour which Turner had been exploring in the lecture series of 1818, when he first introduced the topic of colour as a major one, and when he made some colour-notations in his sketchbooks simply in red, yellow and blue (cf. Fig. 118).[36] An eye-witness account of Turner at work on this sort of drawing perhaps refers to *England and*

118. J. M. W. Turner, *Norham Castle, c.1823.* Watercolour, 30.7 × 48.1 cm. London, Clore Gallery for the Turner Collection (TB CCLXIII-22). Possibly an abandoned version of Fig. 120.

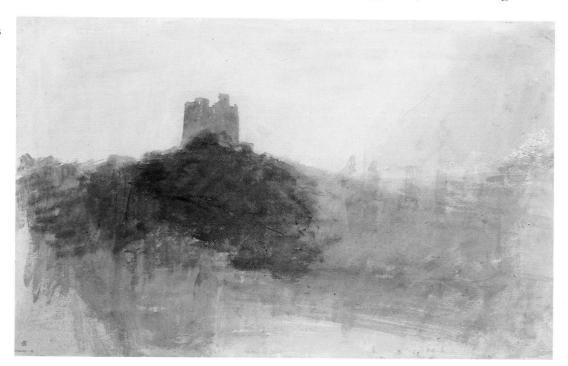

Wales works of the mid-1830s, and it gives a very good idea of how he achieved his effects:

> Leitch, the water-colour painter, told a friend . . . that he had once accompanied Pickersgill to Turner's studio, where he had the privilege of watching the great man at his labours. There were four drawing-boards, each of which had a handle screwed to the back. Turner, after sketching in his subject in a fluent manner, grasped the handle and plunged the whole drawing into a pail of water by his side. Then, quickly, he washed in the principal hues that he required, flowing tint into tint, until this stage of the work was complete. Leaving this first drawing to dry, he took the second board and repeated the operation. By the time the fourth drawing was laid in, the first would be ready for the finishing touches . . .[37]

19. Sir W. H. Newton, *Miss Agnew as a Madonna*, 1817. Swansea, Glyn Vivian Art Gallery. Turner was involved in arranging Newton's miniatures at the R.A. in 1818 (below p. 248).

Here the basic procedure is seen as restricted to three essential phases; and as the purity of the first lay-in was to be maintained, a good deal of the subsequent elaboration was increasingly done with the point of the brush. Turner's development of a technique of stippling, which he handled with such subtlety and virtuosity by the early 1820s (Fig. 120), may well be related to a study of miniature painting, where the method was essential, since the hard, non-absorbent surface, ivory or card, which was traditional to the medium, would not take an even wash (Fig. 119).[38] For Turner stippling and hatching was above all an opportunity for infinite gradations of tone and texture, and for optical, and hence more luminous, colour-mixtures of a refinement hitherto unknown. This was the Turnerian technique which, in the vivid interpretation of Ruskin, became a touchstone for the French Impressionists at the close of the century. The *England and Wales* series, which spans one of the most crucial decades of Turner's working life is also the project in which we can see most clearly the transition from a mature to a late style. If, as I have suggested, it began with some of the unused Yorkshire drawings, in an essentially subdued palette and with an overall richness and complexity of surface treatment, it ended, in watercolours like *Dudley* (R.282) and *Beaumaris* (R.289), with images of extraordinary monumentality and high colour, where the unifying structure of the colour-beginning has reached a peak of control. This new method of taking a subject through a series of discrete changes had shown Turner above all what it was possible to leave out.

By 1820 Turner had discovered a means of preserving the luminosity of the white paper with the fewest possible washes, and of pitching his colours higher than ever without leaving them raw. It is not surprising that he soon sought to adapt the same discoveries and methods to his more ambitious work in oils. If the working up of the late watercolours seemed more and more to fascinate Turner as a process, this was no less so in oils, which, like Matisse's, became a field for essentially perceptual adjustments, and was now carried out increasingly in the public arena of the Exhibition room. He had long made the fullest use of the Varnishing Days set aside for Academicians to make the final touches to their exhibits in the setting in which they were to be seen. In 1811, for example, he worked away on all four of these days, even though he showed only as many pictures.[39] Until the mid-1830s, however, this activity seems to have been confined to toning down or heightening an already completed work, as in the amusing instance of *Helvoetsluys* (BJ 345), shown in 1832 in the small Painting School together with Constable's *Opening of Waterloo Bridge*:

> [Turner's work was] a grey picture, beautiful and true, but with no positive colour in any part of it. Constable's 'Waterloo' seemed as if painted with liquid gold and silver, and Turner came several times into the room while he was heightening with vermilion and lake the decorations and flags of the city barges. Turner stood behind him looking from the 'Waterloo' to his own picture, and at last brought his palette from the great room where he was touching another picture, and putting a round

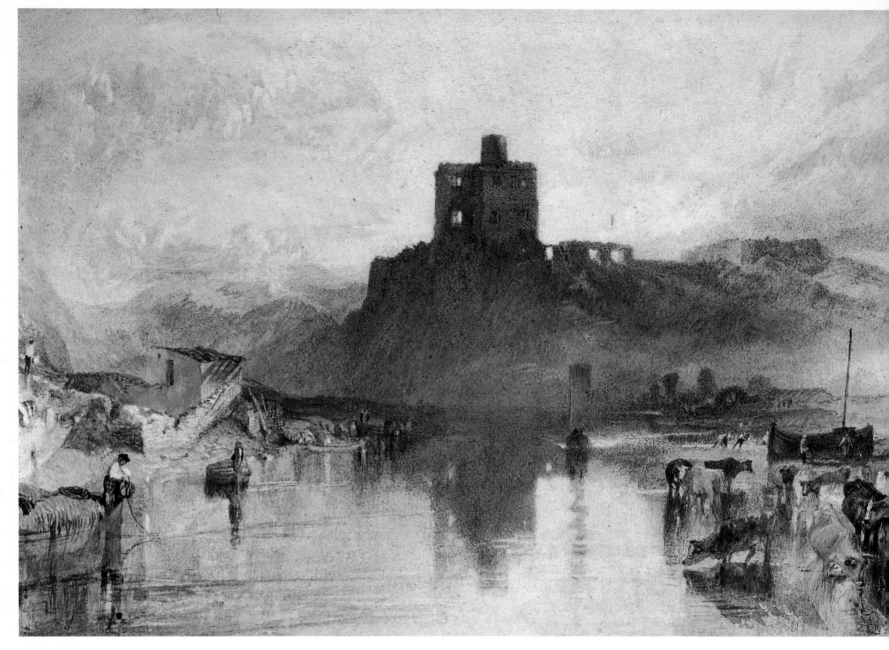

120. J. M. W. Turner, *Norham Castle on the Tweed*, *c*.1823. Watercolour, 15.6 × 21.6 cm. London, Clore Gallery for the Turner Collection (W 736).

121. (*facing page*) Detail of Fig. 120.

daub of red lead, somewhat bigger than a shilling, on his grey sea, went away without saying a word. The intensity of the red lead, made more vivid by the coolness of his picture, caused even the vermilion and lake of Constable to look weak. [C. R. Leslie] came into the room just as Turner left it. 'He has been here,' said Constable, 'and fired a gun'. On the opposite wall was a picture, by Jones, of Shadrach, Meshach and Abednego in the furnace. 'A coal', said Cooper, 'has bounced across the room from Jones's picture, and set fire to Turner's sea'. The great man did not come again into the room for a day and a half; and then, in the last moments that were allowed for painting, he glazed the scarlet seal he had put on his picture, and shaped it into a buoy.[40]

But the following year Turner painted the whole of the small panel, *Venice . . . Canaletti Painting* (Fig. 196) on the walls of the Academy as a manifest demonstration piece, as we shall see in a later chapter; and he was soon to reserve more and more of his painting to this late stage. At the British Institution in 1835, for example, he executed the greater part of *The Burning of the Houses of Lords and Commons* (Fig. 319) in full view of his fellow exhibitors:

Turner was there and at work before I came', wrote one of them, the genre painter E. V. Rippingille, 'having set-to at the earliest hour allowed. Indeed it was quite necessary to make the best of his time, as the picture when sent in was a mere dab of several colours, and 'without form and void', like chaos before the creation . . . Such a magician, performing his incantations in public, was an object of interest and attraction. Etty was working by his side and every now and then a word and a quiet laugh emanated and passed between the two great painters. Little Etty stepped back every now and then to look at the effect of his picture, lolling his head on one side and half closing his eyes, and sometimes speaking to some one near him, after the approved manner of painters; but not so Turner; for the three hours I was there – and I understood it had been the same since he began in the morning – he never ceased to work, or even once looked or turned from the wall on which his picture hung . . . A small box of colours, a few very small brushes, and a vial or two, were at his feet, very inconveniently placed; but his short figure, stooping, enabled him to reach what he wanted very readily. Leaning forward and sideways over to the right, the left-hand metal button of his blue coat rose six inches higher than the right, and his head buried in his shoulders and held down, presented as aspect curious to all beholders, who whispered their remarks to each other, and quietly laughed to themselves. In one part of the mysterious proceedings Turner, who worked almost entirely with his palette knife, was observed to be rolling and spreading a lump of half-transparent stuff over his picture, the size of a finger in length and thickness. As Callcott was looking on I ventured to say to him, 'What is that he is plastering his picture with?' to which inquiry it was replied,' 'I should be sorry to be the man to ask him.' . . . Presently the work was finished: Turner gathered his tools together, put them into and shut up the box, and then, with his face still turned to the wall, and at the same distance from it, went sidling off, without speaking a word to anybody, and when he came to the staircase, in the centre of the room, hurried down as fast as he could. All looked with a half-wondering smile, and Maclise, who stood near, remarked, 'There, that's masterly, he does not stop to look at his work; he *knows* it is done, and he is off.'[41]

The subject of this picture was, of course, a topical one. Turner had witnessed the great fire on the night of 16–17 October, 1834, and, since he had five other paintings to prepare for the Academy exhibition the following May, he may well have been pressed to have this canvas ready for the British Institution by the beginning of February. It seems entirely likely that the second version of this subject (Fig. 320), shown at the Academy, was worked on concurrently with the British Institution canvas, and that they are an early example of that painting in series which became such a characteristic feature of Turner's method in the following decade. But it was the watercolours, and thus ultimately the engravings, that had shown him the way.

Rippingille especially noticed the mysterious finger of 'half-transparent stuff', which Turner was rolling over his picture; and in the next instance of a substantial painting on the British Institution walls, the *Regulus*, a canvas of 1828 which was entirely re-worked there in 1837 (Fig. 309), the operation was essentially a matter of finishing the surface with white (see p. 226–7). White, as the material embodiment of light, was the most important colour for Turner at this stage in his career; and it is remarkable that the only sample of pigment which he brought to George Field, the colour-theorist and manufacturer, for testing, was a 'Roman White', 'whiter than Blanc d'Argent [lead white] . . . much prized by Turner'.[42] Together with the importance of white, as a dense and highly-reflective pigment, went the increasing use of a brilliant white ground, which brought Turner's oil technique at this period even closer to his practice in watercolour. 'Paper as the acting-ground in water colours/White in Oil Colours', he wrote in a note to his copy of Goethe's *Theory of*

Colours about 1840.[43] The most illuminating account of the effect of watercolour on his late oil practice was given by the Redgrave brothers, who were themselves painters, in their history of British painting in 1866:

Water-colour, depending for its lights on the purity and whiteness of its ground, and susceptible of the most infinitesimal gradations of tint and colour by mere dilutions of the pigments with water, has, so far, a wider range than oil is capable of, wherein the tints, when painted solidly – as all the lights must almost of necessity be – are gradated by mixing the coloured pigments with white; this admits of far fewer gradations in scale, and has, moreover, the evil of altering somewhat the nature of the colour by such admixture, making the tint produced in a degree absorbent of light, and far less brilliant than in its transparent state by mere dilution. It is true that by glazing the colour over a light ground, some of the advantages of water-colour are obtained, and some even in a higher degree than in that medium; such as increased depth, brilliancy, and force, far greater from the unctuous richness of oil than in water-colour. But even when thus treated, the gradations are far less delicate, owing to the fluidity of the medium being less; while as there is a sensible colour in all oily media which tinges or tarnishes the delicate tints, the use of oil in this manner is almost precluded.

Turner, in his water-colour art, was led insensibly into these refined gradations; by them he sought detail with great breadth, and managed to give at least the appearance of the multitudinous details of mountain range or extended plain, the effects of air and light, and the mists that are ever floating in our island atmosphere – a manner that no one had thought of before him, much less had accomplished; and this manner he sought to carry out in his oil pictures also. His water-colour practice led him to the use of a white ground. He soon perceived the far greater luminousness thus to be obtained; that works so treated, when seen in a room, had as it were light in themselves, and appeared as if the spectator were looking forth into the open air, as compared with the solid paintiness of the works of his contemporaries. But how to use his colours in sufficiently delicate gradations to achieve the same result on a light ground in oil, as on the paper ground in water-colours, was one of his first difficulties; and he was led to adopt the use of scumbling, that is to say, of driving very fine films of white, or of colour mixed with white, over a properly prepared ground. By this means he not only obtained infinitely delicate gradations, but he successfully imitated the effects of air and mist; the brighter tints beneath being rendered greyer and more distant at the same time by the film of white. This enabled him to make the points of the composition – his figures, or other coloured objects in the foreground – stand out in extreme brilliancy, owing to the employment of transparent colour boldly and purely used over the white.

By these means Turner obtained the whole range of the scale, from white – to him the intensest representative of light – to the purest reds, oranges, blues, purples etc., that use of the transparent pigments in oil permitted. Or by a black object, such as a black hat, a dog, or a cow, the extreme range of his palette from light to dark. Thus he abandoned the old maxim of art – that a painter should reserve his palette, and always have something to enhance the black, the white, or the colour of his picture – and expended all the force of his pigments so as to realize the utmost brilliancy possible.[44]

That Turner was able to do so so effectively was certainly not due alone to his love of water-colour, but came, too, from many years experience with black and white engraving.

Mixed techniques were one of the leading features of Turner's late style, and they were particularly a function of his activity on Varnishing Days. The small box of

colours and small brushes that Rippingille noticed Turner using on *The Burning of the Houses of Lords and Commons* were almost certainly watercolour equipment;[45] for watercolour had long been used to make temporary modifications to exhibition works,[46] and Turner simply extended the practice throughout the structure of his pictures, including particularly the figurative elements on the surface. He did so, for example, if he wished to add figures to an already existing painting, as when he re-worked *Caligula's Palace* (BJ 337) for the engraver in 1842.[47] It is also striking that so many works of the 1840s are on a small scale, and that their figures are usually drawn with the brush-point rather than built up by modelling (Figs. 280, 305), just as they are in contemporary watercolours.

That Turner was able to achieve this close relationship with watercolour technically may have been helped by his use of a new medium, *Miller's Van Eyck Glass Medium for Oil Painting*, which was introduced in 1841, and gave, according to its manufacturer, brilliance and durability comparable to painting in enamel. The medium was to be mixed stiff on the palette with pure poppy oil and would thus 'enable the Artist to lay colour pile upon pile, and dip his pencil [brush] in water or oil at pleasure. It will also dry so hard that it may be scraped with a knife on the following day.'[48] According, too, to George Field, a similar glass or borax medium had been employed by the Venetian painters of the sixteenth century, and this of course is likely to have especially commended its use to Turner.[49] Miller's medium was a development which would allow Turner to work substantially on the Exhibition walls, and in delicate watercolours simultaneously with the more substantial oils. The quick-drying properties of the glass medium would also have been a great help in the painting of oils in series, a practice which is well-documented in Turner's work from the mid-1840s. The six oils which Turner showed at the Royal Academy in 1846, for example, were all pairs, two Venetian subjects, two whaling subjects and two related 'historical' subjects, and it is likely that it was one or more of these pairs which Richard Owen and W. J. Broderip saw Turner working on at his Queen Anne Street studio in August of the previous year. The painter was, according to Owen,

> standing before several easels, and taking his colours from a circular table, which he swung round to get at the paints he required. He was painting several pictures at once, passing on from one to the other, and applying to each in its turn, the particular colour he was using, till it was exhausted.[50]

Certainly a young painter, G. D. Leslie, who witnessed Turner at work in these years, thought that working in series was his usual practice:

> I believe that Turner had for a long time been in the habit of preparing works for future exhibition, laying in, with simple colours, the effect and composition, painting them solidly and very quickly with considerable *impasto*, and allowing the whole to dry and harden together. He would use no fugitive pigments in these preparations, contenting himself with the ochres, siennas, and earth browns, with real ultramarine, black, and a very liberal allowance of white. He must, I think, have had many works thus commenced laid by in his studio, from which he would take one, from time to time, to send to the Academy for exhibition . . .[51]

Yet Leslie was unaware of the peculiar characteristics of the glass medium (although Miller claimed to supply it to his father, C. R. Leslie, as well as to Turner and many other Academicians), and he thought these works would be ruined had they been worked up at the exhibition itself. We have some evidence that many were so worked, if we may believe the recollection of another painter, T. S. Cooper, that in 1846 'some of [Turner's] work was, as usual, only just rubbed in, and it was a common practice of his, when he saw how his pictures were placed, to paint first a little on one, then on

another, and so on until all were finished to his satisfaction.'[52] Even so, the works shown this year were more than usually loosely painted, and came in for some exceptionally vituperative treatment from the critics.

The introduction of Miller's Glass Medium coincided with a renewed interest in the work and techniques of the Venetian School, stimulated, perhaps, by Turner's several visits to Venice in the 1830s and 1840s. His close friend, Charles Lock Eastlake, a painter who became one of the leading authorities on Venetian method, had no doubt about the Venetian character of Turner's late style:

> The finest works of Turner,' he wrote, 'are a very intelligible introduction to one, and that not the least, of the excellencies of Venetian colouring. He depended quite as much on his scumblings with white as on his glazings, but the softness induced by both was counteracted by a substructure of the most abrupt and rugged kind. The subsequent scumbling, toned again in its turn, was the source of one of the many fascinations of this extraordinary painter, who gives us solid and crisp lights surrounded and beautifully contrasting with ethereal nothingness, or with the semitransparent depth of alabaster.[53]

New and authentic accounts of Titian's working procedures had recently been made available to the English public by the collector Sir Abraham Hume, whose late and probably unfinished Titian *Diana and Actaeon*, now in the National Gallery in London was certainly familiar to Turner.[54] In his *Notices of the Life and Works of Titian*, of 1829, Hume gave a special attention to the master's colouring and technique, and he translated the memoir of Titian's pupil, Palma Giovane, which refers in particular to the late work. According to Palma, his master had laid in his underpainting in 'four strokes' and,

> having proceeded so far with a picture, turned it with its face to the wall, where he left it sometimes for months without looking at it; and when he felt disposed to work upon it again, he examined it with as much severity, as if it had been his most capital enemy, in order to discover the defects, and then proceeded to reform every part that did not accord with his feelings . . . Titian went over each picture as the colours dried, laying on the flesh tints from time to time with repeated touches; but it never was his practice to complete a figure at once, observing that 'he who sings off hand, can never compose correct and faultless verses'. In order to bring the finishing touches to perfection, he blended them with a stroke of his finger, softening the edges of the lights with the half tints, and thus uniting them together, which gave force and relief to both. He sometimes put in with his finger a touch of dark in some angle, or a touch of a rich red tint, similar to a drop of blood, – giving by these means a surprising degree of animation to his figures.[55]

Hume also conjectured that the Venetians made extensive use of watercolour (distemper) in their oil paintings;[56] and it is easy to see how fascinating such an account would have been to Turner, who, as we shall see in a later chapter, showed a renewed interest in Venetian style around 1830, and again around 1840.

In 1830, indeed, Turner acquired a group of early prints after Titian;[57] for he was fascinated by this master in a comprehensive way, and as concerned with his designs as he was with his painterly techniques. I have tried to suggest in this chapter how Turner's intelligent curiosity about print-making enabled him to convert the basically economic exigences of engraving into positive developments in his latest style. But he gave as much to British engraving as he received, and in the struggle for the recognition of reproductive print-making as a fully creative art, which was pursued so vigourously by engravers in early nineteenth-century England, his work played a central role. The group of seventeen engravers, led by W. B. Cooke, who sponsored an

exhibition of the art in London in April 1821 included ten who had worked for Turner;[58] and in the exhibition itself, prints after his work were paramount. A reviewer wrote, 'This collection is particularly interesting in the department of landscape; the prints of W. B. and G. Cooke after Turner are remarkable for brilliancy, spirited and scientific etching, airiness, depth and power.'[59] What is particularly surprising is that in a period when new methods of coloured print-making were being developed, with which Turner was thoroughly familiar,[60] he maintained a vital and almost exclusive interest in the methods of black and white engraving. That he did so was not simply due to his traditional belief in the central role of chiaroscuro in painting itself, but also to the increasingly fascinating challenge of translating painted hues into engraved tones. Here, as always, Turner applied his mind to an immediate problem with the most far-reaching of effects.

CHAPTER FOUR
Interpreting the Old Masters

IN one of his early lectures as Professor of Perspective at the Royal Academy Turner referred to his student years, when he sat at the feet of Sir Joshua Reynolds, as 'the happiest perhaps of my days'.[1] Turner's devotion to Reynolds was complete; Reynolds was, wrote an obituarist, with Girtin, the only artist he cared to talk about, and he chose to move to Twickenham, on the Thames west of London, simply 'that he might live in sight of Sir Joshua's house upon the hill'.[2] Richmond Hill, Reynolds's home and a frequent subject for Turner became, in the great canvas of 1819 (Fig. 173) synonymous with England itself. Whether or not Turner was admitted as a boy to study in the President's studio – and it seems that this is likely – he certainly heard his last Discourse, given in December 1790, and he recalled this occasion with emotion in his own opening lecture of 1811:

> . . . surely I cannot be denied the pleasure of recollecting the precepts inculcated by the then President, Sir Joshua Reynolds, whose worth as a man and abilities as an artist were of the most conspicuous kind; whose attention to the interests of this Establishment from its foundation by his most gracious Majesty deserves our [] thanks, and his anxiety for the improvement of the School of Design prove unquestionably the greatness of his mind – who so far from vindicating the line of pursuits he had chosen (but which stands exclusively and irrefrangibly his own) yet stept forth and recommended with his last words in this seat the study of Michael Angelo, to regard only the energetic conceptions of his thoughts, to study the dignified manners of expressing and embodying those thoughts and to attend to the lofty workings of his mind through all his works, in whose name Sir Joshua left to us all a volume rich, full and inexhaustible, illuminated by the powerful imagery of his precepts and works and begirt with the strongest tye he could leave us, his advice . . .[3]

The spate of orotund phrases in this eulogy, and the evidence of many revisions, show that the last quality in Reynolds Turner was capable of emulating was his lucid prose style; but he was perhaps a match for the late President in his delivery, since Reynolds, for all his distinction as a writer, had often been inaudible as a lecturer, and a visitor to Turner's last series of lectures in 1828 characterised it too, as 'almost perfection in mumbling and unintelligibility'.[4]

But Turner did follow the President directly, both in his frugality and in his addiction to work, and, more importantly, he sought to familiarise himself with Reynolds' style at first hand. We have seen that his first purely figurative painting, the

122. J. M. W. Turner, *Vision of Medea*. Oil on canvas, 173.5 × 241 cm. R.A. 1831, with the caption:
'Or Medea, who in the full tide of wichery
Had lured the dragon, gained her Jason's love,
Had filled the spell-bound bowl with Aeson's life,
Yet dashed it to the ground, and raised the poisonous snake
High in the jaundiced sky to writhe its murderous coil,
Infuriate in the wreck of hope, withdrew
And in the fired palace her twin offspring threw.'
 MS Fallacies of Hope

London, Clore Gallery for the Turner Collection (BJ 293).

123. Robert Thew after Sir Joshua Reynolds, *Macbeth and the Witches*, 1790. Line-engraving, with stipple. London, British Museum.

Holy Family (Fig. 47) was conceived in a Reynoldsian vein, and it may have been stimulated by the picture of *The Madonna and Child* by Reynolds which was in the Collection of Turner's friend, the actor John Bannister about 1800 (Fig. 48).[5] At a sale in 1821 Turner acquired three or four Reynolds portrait sketches, and, more significantly, he tried hard to secure one of his Italian notebooks, but without success.[6] Just as he had begun his career as a history-painter with a homage to Reynolds, so one of the most ambitious of his later figurative subjects, the *Medea*, painted in Rome in 1828 (Fig. 122), was clearly related, both in its extravagant witchery and in its exuberant style, to the *Macbeth and the Witches* (Fig. 123) that most animated and uncharacteristic of Reynolds' historical subjects, of whose composition Turner had made a special study,[7] and which he must have looked at repeatedly when he visited Petworth in the late 1820s (Fig. 124).

Yet the fact remains that the most vital and constant influence of Reynolds was in Turner's approach to the art of the past. Turner remained a topographer and a water-colourist, but the transformations he worked both in topography and water-colour are inconceivable without a study of the masters of past art, to whom he returned again and again. Turner's attitude to the Old Masters, which contemporaries sometimes misread as mere imitation, he developed most of all from his reading of Reynolds, who summed it up in the concluding paragraph of Discourse VI:

> Study therefore the great works of the great masters, for ever. Study as nearly as you can, in the order, in the manner, and on the principles, on which they studied. Study nature attentively, but always with those masters in your company; consider them as models which you are to imitate, and at the same time as rivals with whom you are to contend.

The key phrase here is 'the principles on which they studied': imitation was not simply a recapitulation of surface characteristics, but a study of methods; and Reynolds specifically dissuaded his students from the not uncommon practice of painting with an

24. J. M. W. Turner, *Petworth: the square dining-room*, *c.*1828. Bodycolour on blue paper, 13.7 × 18.9 cm. London, Clore Gallery for the Turner Collection (TB CCXLIV-108). Reynolds' *Macbeth and the Witches* (Fig. 123) can be seen in the centre of the wall.

Old Master picture at one's elbow for comparison.[8] His own methods of study, exemplified in the notebooks of his journey to Flanders and Holland (1781), first published in the 1797 edition of his *Works*, presented the same balance of general stylistic characterisation and detailed technical analysis which was adopted by Turner. Of Rubens' altarpiece of the *Cruxifixion* in Antwerp for example, Reynolds had written:

> The bustle, which is in every part of the picture, makes a fine contrast to the character of resignation in the crucified Saviour. The sway of the body of Christ is extremely well imagined. The taste of the form in the Christ, as well as in the other figures, must be acknowledged to be a little inclinable to the heavy; but it has a noble, free, and flowing outline. The invention of throwing the Cross obliquely from one corner of the picture to the other, is finely conceived; something in the manner of Tintoret: it gives a new and uncommon air to his subject, and we may justly add, that it is uncommonly beautiful. The contrast of the body with the legs is admirable, and not overdone . . . It is difficult to imagine a subject better adapted for a painter to exhibit his art of composition than the present; at least Rubens has had the skill to make it serve, in an eminent degree, for that purpose. In the naked figure of the Christ, and of the executioners, he had ample room to show his knowledge of the anatomy of the human body in different characters. There are likewise women of different ages, which is always considered as a necessary part of every composition, in order to produce variety; there are, besides, children and horsemen; and to have the whole range of variety, he has even added a dog, which he has introduced in an animated attitude, with his mouth open, as if panting: admirably well painted. His animals are always to be admired: the horses here are perfect in their kind, of a noble character, animated to the highest degree. Rubens, conscious of his powers in painting horses, introduced them in his pictures as often as he could. This part of the work, where the horses are represented, is by far the best in regard to

colouring; it has a freshness which the other two pictures want . . . The central picture, as well as that of the group of women, does not, for whatever reason, stand so high for colour as every other excellence. There is a dryness in the tint; a yellow okery colour predominates over the whole, it has too much the appearance of a yellow chalk drawing . . . The flesh, as well as the rest of the picture, seems to want grey tints, which is not a general defect of Rubens; on the contrary, his mezzotints are often too grey.

The blue drapery, about the middle of the figure at the bottom of the Cross, and the grey colour of some armour, are nearly all the cold colour in the picture; which are certainly not enough to qualify so large a space of warm colours. The principal mass of light is on the Christ's body; but in order to enlarge it, and improve its shape, a strong light comes on the shoulder of the figure with the bald head: the form of his shoulder is somewhat defective; it appears too round.

Upon the whole, this picture must be considered as one of Rubens's principal works, and that appearance of heaviness which it has, when seen near, entirely vanishes when the picture is viewed from the body of the church, to which you descend from the choir by twenty stairs.[9]

Turner's account of Titian's *Entombment*, which he studied in the Louvre in 1802 (Fig. 127), treats almost exactly the same range of issues in style, subject-matter and especially technique:

This picture may be ranked among the first of Titian's pictures as to colour and pathos of effect, for by casting a brilliant light on the Holy Mother and Martha the figures of Josephe and the Body has a Sepulceral effect. The expression of Joseph is fine as to the care he is undertaking, but without grandeur. The figure which is cloathed in striped drapery conveys the idea of silent distress, the one in vermilion attention while the agony of Mary and the solicitude of Martha to prevent her grief and view of the dead Body, with her own anguish by seeing are admirably described, and tho' on the first view they appear but collateral figures yet the whole is dependent upon them; they are the Breadth of and the expression of the Picture. Mary is in Blue, which partakes of crimson tone, and by it unites with the bluer sky. Martha is in striped yellow and some streaks of Red, which thus unites with the warm streak of light in the sky. Thus the Breadth is made by the 3 primitive colours breaking each other, and are connected by the figure in vermilion to the one in crimson'd striped drapery which balances all the breadth of the left of the picture by its Brilliancy. Thus the body of Jesus *has the look of* death without the leaden colour often resorted unto, and the whole of the half-tints resemble the colour of this Book [i.e. Turner's sketchbook], the lights warmer, more of *oker*. The drapery of the Body is the highest light or more properly the first that strikes the eye. Of great use it is, gives colour to the dead Body and Breadth to the center, for Joseph being draped in dark red and green cuts off all connection with the former Breadth of Mary and Martha. Thus brilliancy and contrast of effect are produced on the left, this shadow is balanced by the broad one upon the Head and part of Body of Jesus, whose countenance is meak, but the shadow obliterates any other ideas and is rather over-charged, for Titian could have balanced Joseph's shadow by other means, viz. the rock above the striped figure, for it [i.e. the shadow on Christ's face] is so sombre that Mary and Martha tells us it must be Jesus and thus hold the very sentiment, and where the eye returns to with sympathy and satisfaction of Titian so obscuring the principal figure.

The flesh is thinly painted, first by a cold color over a Brown ground, so that it is neither purple or green, some red is used in the extremities, and the lights are warm. If he wanted to colour them higher, by a glaze. Thus his brown figures lose in a great

125. J. M. W. Turner, *Venus and Adonis*, c.1803/5. Oil on canvas, 149 × 119.4 cm. Private collection (BJ 150). Turner based his composition on Titian's *St Peter Martyr* (Fig. 126).

126. After Titian, *The Death of St Peter Martyr*. Oil on canvas, 141 × 94 cm Sir Brinsley Ford. A seventeenth-century copy of the altarpiece destroyed by fire in the nineteenth century.

27. J. M. W. Turner, *Copy of Titian's 'Entombment'*, 1802. Watercolour, 12.9 × 11.2 cm. London, Clore Gallery for the Turner Collection (TB LXXII p. 32).

measure the grey colour which in fact is produced by the ground. All the draperies are strongly painted with cold or warm lights and glazed over. The greens are particularly glutinous and the vermilion he sparingly used as it appears heavy unglazed by Lake (TB LXXII, pp. 31a–29b)

The more awkward syntax and spelling in this commentary betray a younger and less articulate artist than Reynolds; and where Reynolds had been concerned with Rubens' decorative use of variety, Turner, significantly, saw Titian's arrangements as subordinate to the expression of his subject. But there is no doubt that they approached their study of these masters of the past with a very similar range of pre-occupations.

Reynolds was not the only stimulus in the 1790s to Turner's growing interest in the art of the past. His early career as a recorder of Gothic architecture might seem to be an unlikely introduction to the classicising tastes of the Academy, but again it was the Professor of Painting, James Barry, who showed in his lecture on chiaroscuro how the handling of light might bring classic grandeur even to the minutiae of Gothic forms:

To descend even to the Gothic churches, many of them are so disposed (whether with intention, or, perhaps, from an unconscious feeling of the beauties and general forms of the ancient colonnades, which they imitated in their own barbarous way; or rather, these general forms were the last things forgotten, and had survived all the smaller particular details which were lost in the gradual corruption of architecture), these Gothic churches are so disposed, I say, that their cloisters, aisles, and the different partitions of their front and lateral views, almost always present the eye with large masses of shade, which give the necessary support and value to the parts

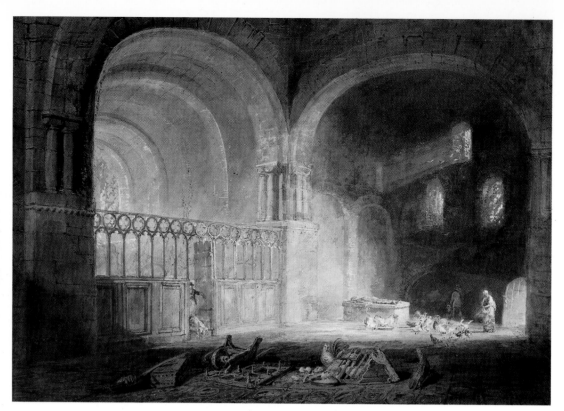

128. J. M. W. Turner, *Trancept of Ewenny Priory, Glamorganshire.* Watercolour over pencil, 40 × 59.9 cm. R.A. 1797. Cardiff, National Museum of Wales (W 227).

129. Attributed to J. M. W. Turner, *Copy of Piranesi's 'Carcere Oscura', c.*1794/7. Pencil and watercolour, 360 × 235 cm. New York, Metropolitan Museum of Art. This seems to be a 'Monro School Copy' of Plate 2 in Piranesi's *Prima Parte di Architettura . . . 1743.* See also Fig. 31).

illuminated, and produce such a rilievo and effect in the totality, as makes a considerable impression of awe and grandeur on the mind, in despite of its very barbarous and defective particulars . . .[10]

Perhaps it was John Henderson of the Adelphi, a close friend of Dr Monro's, who at the same time introduced Turner to the means of achieving this grandeur, in the architectural engravings of G. B. Piranesi, whose dramatic breadth of light and shade were precisely what Turner used to monumentalise his Gothic interiors (Fig. 130).

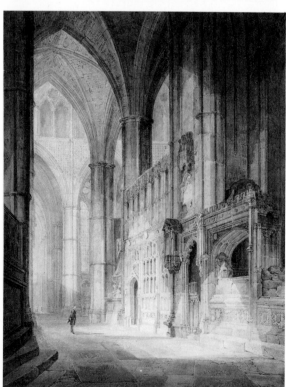

130. J. M. W. Turner, *St Erasmus in Bishop Islip's Chapel.* Watercolour over pencil, 54.6 × 39.8 cm. R.A. 1796. London, British Museum (W 138). The scene is Westminster Abbey; Turner has inscribed WILLIAM TURNER NATUS 1775 on a tomb-slab in the foreground, an early symptom of his ambitions.

32. David Teniers, *Kitchen Interior*. The National Trust, Stourhead.

33. J. M. W. Turner, *Dawn of Christianity (Flight into Egypt)*. Oil on canvas, diameter 78.5 cm. R.A. 1841 with the caption:
That star has risen.
Rev. T. Gisborne's Walks in a Forest
Belfast, The Ulster Museum (BJ 394).

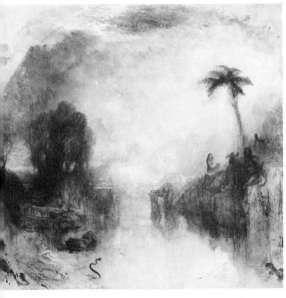

31. *(facing page, bottom right)* J. M. W. Turner, *Internal of a cottage, a study at Ely*. Watercolour over pencil, 19.8 × 27.1 cm. R.A. 1796. London, Clore Gallery for the Turner Collection (W 141).

34. Rembrandt van Rijn, *The Rest on the Flight into Egypt*, 1647. Oil on panel, 34 × 47 cm. Dublin, National Gallery of Ireland.

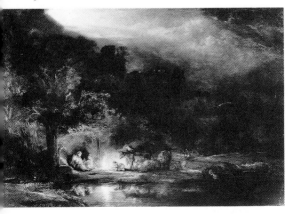

Piranesi's *Carcere Oscura* became a favourite of Turner's, and he used it again about 1811 as the basis for a number of magnificent lecture-diagrams illustrating precisely the grandiose structures of light and shadow (Fig. 31) in the interiors of Neo-classical buildings.

By the middle of the 1790s Turner had begun to extend his range of reference very considerably. *Internal of a Cottage: A Study at Ely* shown at the Academy in 1796 (Fig. 131) is a strikingly neo-classical interpretation of a well-known type of Flemish seventeenth-century Kitchen interior, made popular especially by Teniers (Fig. 132). Turner flattened the deep space of his prototypes into a frieze, and even the characteristic polished pans were now presented more frontally than in the Baroque period. The following year he exhibited an even more remarkable and seminal water-colour, the *Trancept of Ewenny Priory* (Fig. 128), whose far more complex painterly techniques and the palpable treatment of atmosphere and light suggest that he had already made a study of Rembrandt's paintings: certainly an enthusiastic critic writing in the *St James's Chronicle* found it 'one of the grandest drawings he had ever seen, and equal to the best pictures of Rembrandt'.[11]

Rembrandt was the first Old Master Turner encountered for whom he showed a lifelong and constantly-evolving attachment. A brilliant evocation of Rembrandt's style in a lecture of 1811 makes it clear how he related the Dutch master's methods to his own:

> Rembrandt depended upon his chiaroscuro, his bursts of light and darkness to be *felt*. He threw a mysterious doubt over the meanest piece of Common; nay more, his forms, if they can be called so, are the most objectionable that could be chosen, namely, the Three Trees and the Mill, but over each he has thrown that veil of matchless colour, that lucid interval of Morning dawn and dewy light on which the Eye dwells so completely enthrall'd, and it seeks not for its liberty, but, as it were, thinks it a sacrilege to pierce the mystic shell of colour in search of form.[12]

When and how Turner first came to know Rembrandt is still obscure. It is likely that Dr Monro already had a number of prints by or after the Dutch master by the time Turner became his protegé in 1793 or 4, and by 1795 Monro may, in addition, have owned an early painting. He also acquired many drawings, two of which, a *Christ Disputing with the Doctors* and a *Flight into Egypt* Turner himself brought at the Doctor's sale in 1833.[13] These drawings cannot now be traced, but the *Flight* may be reflected in Turner's painting of the same subject of a few years later (Fig. 133), where the inky shadow of landscape and figures is set off against a sky lit doubly by the dawning sun and the starlight, recalling another Rembrandt with a related subject, *The Rest on the Flight* (Fig. 134), which Turner had characterised in his lecture in these terms:

> In no picture have I seen that freshness, that negative quality of shade and colour, that aerial perspective enwrapt in gloom, ever attempted but by the daring hand of Rembrandt in his Holy Family reposing, a small picture at Stourhead . . . Rembrandt has introduced two lights, one of the fire and the other from a window, to contrast the grey, glimmering dawn from gloom . . .[14]

Turner may also have had the opportunity of studying Sir Joshua Reynolds' large collection of some eighteen paintings and more than sixty drawings attributed to Rembrandt[15]; certainly he must have attended the great sale of the President's collection in 1795, when most of them were disposed of.

When he visited the Louvre in 1802, Turner copied two Rembrandt's, *The Good Samaritan* and the *Susanna*, about both of which he made disparaging comments (TB LXXII, pp. 59a–61), but of a third, *The Angel Raphael leaving Tobit and his Family* (Fig. 135), he was more enthusiastic, and was especially struck by the violent action of the

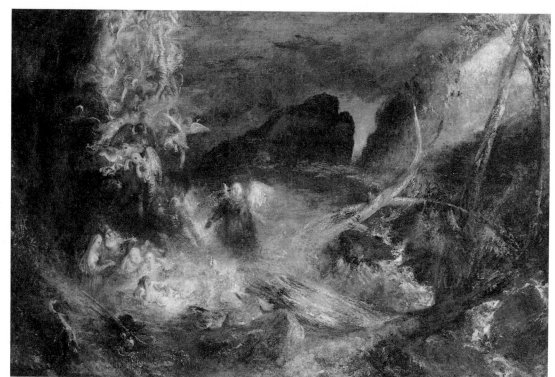

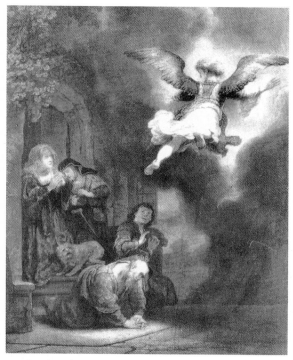

135. Rembrandt van Rijn, *The Angel Raphael leaving Tobit and his Family*, 1637. Oil on panel, 68 × 52 cm. Paris, Louvre.

136. J. M. W. Turner, *The Vision of Jacob's Ladder*, c.1800/30. Oil on canvas, 123 × 188 cm. London, Clore Gallery for the Turner Collection (BJ 435).

137. Detail of Fig. 136.

angel, which he remembered when he was painting the unfinished and now much damaged *Jacob's Ladder* (Fig. 136), where it was surely the model for one of the most brilliantly realised of the angels there (Fig. 137). Turner based the composition of this picture not on Rembrandt, but on *Jacob's Dream*, by Salvator Rosa, at Chatsworth (Fig. 139), which he probably saw on his visit there in 1830,[16] but which had, in any case, been engraved. Reynolds had singled this painting out for praise in Discourse XIV, as in a style possessing the 'power of inspiring sentiments of grandeur and sublimity', but he went on:

> A ladder against the sky has no very promising appearance of possessing a capacity to excite any heroick ideas, [yet the subject] is so poetically treated throughout, the parts have such a correspondence with each other, and the whole and every part of the scene is so visionary, that it is impossible to look at [it], without feeling, in some measure, the enthusiasm which seems to have inspired the [painter].[17]

Turner was evidently touched by Reynolds' strictures about the ladder, and in its place he painted a cascade of angels swimming in a column of light which is very much in the spirit of another *Jacob's Dream* well-known to him, the picture at Dulwich, shown by a recent cleaning to have been signed by Rembrandt's pupil Aert de Gelder, but which in Turner's day was thought to be one of the masterpieces of Rembrandt himself (Fig. 138). A critic wrote of it in 1817:

> We behold a mysterious, solemn twilight on which from a bright refulgence in the heavens, a stream of light beams an immensity from earth to heaven; while 'winged creatures of the element' float on the mysterious beam, obeying their great Creator's ordinances, and impressing the patriarch with their divine mission. It is all profundity and mystery; at a distance we fancy we can make out the figures by approaching, and, in approaching, again retire. It is one of the most poetical and sublime pictures we ever saw.[18]

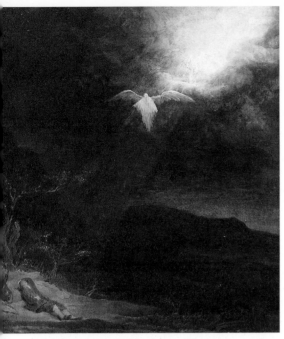

38. Aert de Gelder, *Jacob's Dream*. Oil on canvas, 66.7 × 56.9 cm.
Dulwich Picture Gallery.

39. Salvator Rosa, *Landscape with the Dream of Jacob*, 1660s. Oil on
canvas, 137 × 200 cm. Devonshire Collection, Chatsworth.
Reproduced by permission of the Chatsworth Settlement Trustees.

Around 1830, too, Turner made a number of highly-coloured variants of Rembrandtesque motifs, of which perhaps the most striking is *Jessica* (Fig. 140), probably painted at Petworth. This was Turner's most uncompromising attempt at a large figure subject, and it betrays his weaknesses in anatomy and articulation on this scale. The composition was based on the many subjects of girls at windows by Rembrandt and his circle, but for its gorgeous colour the painter probably had in mind the late *Great Jewish Bride*, now in Amsterdam, but then in the hands of a London dealer. Constable seems to have sensed the reference, for in a letter of 1832 he wrote of Turner:

> . . . nothing can reach him, he is in the clouds
> The lovely Jessica by his side
> Sat like a blooming Eastern bride.[19]

This was the period when Turner was most occupied with 'imitation' in the Reynoldsian sense, and even with direct parody and pastiche, but a decade later the fascination with Rembrandt re-emerged in a much subtler way in the handling and perhaps even the subject of that late masterpiece *Rain, Steam and Speed* (Fig. 10).[20]

Rembrandt, and later Claude Lorrain, were first approached through the medium Turner knew best, and the one which could embody light most readily, namely watercolour. For his earliest models of painting in oil he seems to have needed to look rather closer to home. His first oils owe their technique chiefly to the Franco-English painter P. J. de Loutherbourg; but towards the end of the 1790s Turner began to use a technique – and a style – closely modelled on the most distinguished eighteenth-century English landscape specialist, Reynolds' contemporary, Richard Wilson. It was in these years that Turner was enjoying the patronage of Wilson's former friend and patron, William Lock of Norbury, and the friendship of his most devoted pupil, Joseph Farington. Lock's collection was particularly rich in broad and summary chalk drawings[21], and according to Farington, the general taste of the late nineties was for Wilson's looser and broader paintings and oil sketches.[22] Farington himself disapproved, but this was precisely the aspect of Wilson which particularly attracted Turner, who, in a small sketchbook of about 1797, labelled 'Studies for Pictures. Copies of Wilson', produced on a dark-toned paper some of his freest and most painterly studies to date, (Fig. 145). At the same time Turner was concerned with Wilson's Welsh subject-matter. He visited the painter's birthplace at Penegoes in 1798[23], and in the following year he began to exhibit a series of paintings and watercolours of Welsh castles, of which the finest, *Kilgarren Castle* (Fig. 144) is Wilsonian not simply in the creamy impasto and breadth of brushwork, but also in the monumental abstraction of the composition, which particularly recalls Wilson's *Snowdon from Llyn Nanttle*, engraved in 1775 (Fig. 141).[24] But both in the 'Wilson' sketchbook and in this painting Turner showed a far from Wilsonian concern for atmosphere and conditions of weather and light. He looked to Wilson at this time chiefly as a master of technique; and this was not simply in paintings, but also in drawings. Turner's drawing-styles around 1800 include a use of chalks and white heightening on toned paper which is close both to the sketches and the finished drawings of Wilson in the 1750s (Figs. 143, 147–8); and a Wilson drawing of a Roman Campagna subject which found its way into Turner's collection (Fig. 148) shows a curiously heterogeneous handling; sharp chalk strokes together with broadly rubbed areas of tone, not unlike Turner's own watercolour methods in the 1840s. The number and vigour of the figures is also unusual for Wilson, and we may suspect that Turner had a hand in re-working the sheet.

In his *Backgrounds* lecture, Turner linked Wilson's thwarted aspirations (for he was one of the least successful landscapists of his day) with those of the aging Roman orator,

140. J. M. W. Turner, *Jessica*. Oil on canvas, 122 × 91.5 cm. R.A. 1830 with the caption: Shylock – 'Jessica, shut the window, I say' *Merchant of Venice*. Tate Gallery and the National Trust (Lord Egremont Collection) Petworth House (BJ 333).

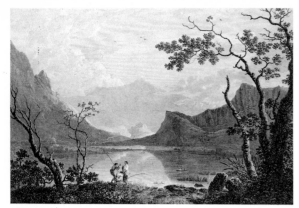

141. William Woollett after Richard Wilson, *Snowdon from Llyn Nanttle*, 1775. Line engraving. Cardiff, National Museum of Wales.

144. (*right*) J. M. W. Turner, *Kilgarran Castle on the Twyvey, Hazy Sunrise, previous to a Sultry Day*. Oil on canvas, 92 × 122 cm. R.A. 1799. The National Trust (on loan to Wordsworth House, Cockermouth) (BJ 11).

142. (*below*) J. M. W. Turner, *Winding river between mountains: Scotland*, 1801. Black and white chalk on toned paper, 34.6 × 49.7 cm. London, Clore Gallery for the Turner Collection (TB LVIII-24).

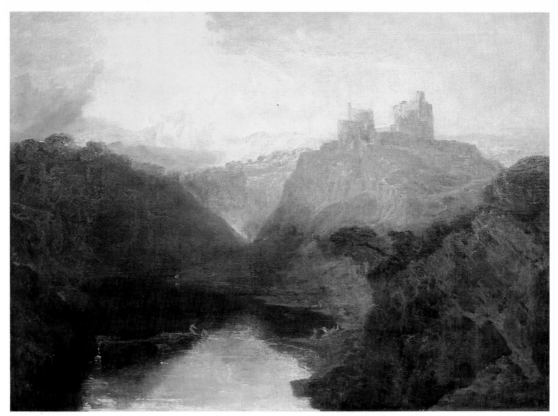

Cicero, who 'sighed for the hope, the pleasures of peaceful retirement or the dignified simplicity of thought and grandeur, the more than solemn solitude that told his feelings'.[25] *Cicero at his Villa*, as well as *Solitude*, had been favourite themes with Wilson, and they were later taken up by Turner himself;[26] but his characterisation of Wilson's ambitions also suggests what he admired most about his art, and prepares us for the pre-eminently Italianate character of that art – its grandeur and simplicity – which became central for Turner. He made a number of copies in oil and water-colour from Wilson's Italian subjects in the late 1790s, and became such a skillful imitator of his style and handling as to have confused connoisseurs ever since.[27] When he visited Italy for the first time in 1819, Turner still looked at the scenery as much with the eyes of Wilson as of Claude: 'Turner said *Wilson* had risen in his estimation from what he there saw', wrote Farington to Sir George Beaumont in December of that year,' and

143. Richard Wilson, *Via Nomentana*, 1754. Black chalk and stump, heightened with white, on grey paper, 27.6 × 42.2 cm. Yale Centre for British Art.

145. (*right*) J. M. W. Turner, *Distant view of London, with St Paul's*, *c*.1797. Watercolour and bodycolour on toned paper, 12.4 × 18.7 cm. London Clore Gallery for the Turner Collection (TB XXXVII, pp. 56–7).

146. J. M. W. Turner, *Academy Study*, c.1800. Black and white chalk on grey paper, 44.4 × 28.3 cm. London, Clore Gallery for the Turner Collection (TB LXXXI, p. 31).

148. Richard Wilson (?and J. M. W. Turner), *Italian Landscape with Figures*. Black and white chalk and stump on blue paper, 41 × 51 cm. London Clore Gallery for the Turner Collection (TB CCLXXX-19).

147. Richard Wilson, *Study for 'The Destruction of Niobe's Children'*, 1752. Black chalk, 33.8 × 51.7 cm. Cardiff, National Museum of Wales.

that Claude and our own great artist were presented to his mind which ever way he looked'.[28] This is born out by many notes in the Italian sketchbooks, in one of which (TB CLXXXII, pp. 28a–29) Turner scribbled *Wilson-Brown Campagna*, and the rich, sombre, brooding quality of some of the Campagna gouaches on toned paper suggest Wilson far more than Claude (Fig. 149). They look forward to that second great series of Italian sketches, the small oils made on Turner's second visit in 1828 (Fig. 153), where the designs are usually Claudian, but the breadth and flatness of the handling and the softness of the colours again recall Wilson.

Early nineteenth-century critics of Wilson liked to compare his work with Claude's, and to prefer it for its greater simplicity and grandeur. Turner's early associate, Edward Dayes, for example, wrote that Wilson's compositions were not, like Claude's,

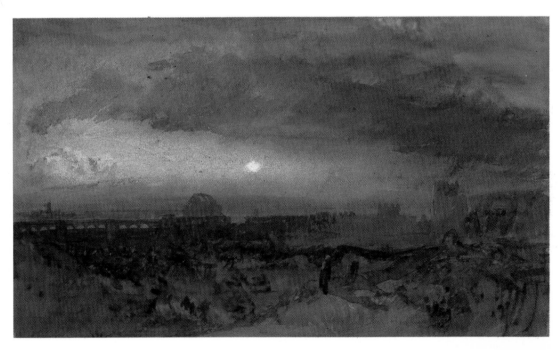

149. J. M. W. Turner, *Rome, the Claudian Aqueduct with the Temple of Minerva Medica*, 1819. Watercolour and bodycolour on toned paper, 23 × 36.8 cm. London, Clore Gallery for the Turner Collection (TB CLXXXIX-36).

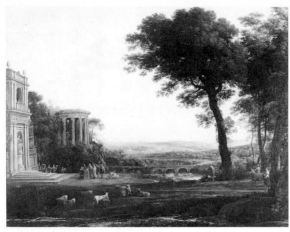

150. Claude Lorrain, *Landscape with the Father of Psyche sacrificing to Apollo*, 1662. Oil on canvas, 175.5 × 223 cm. The National Trust, Angelsey Abbey.

153. J. M. W. Turner, *Ariccia (?), Sunset*, 1828. Oil on canvas, 60.5 × 79.5 cm. London, Clore Gallery for the Turner Collection (BJ 305).

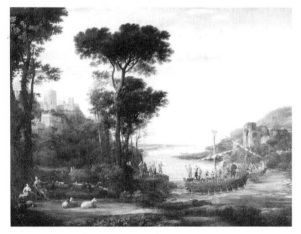

151. Claude Lorrain, *Landscape with the arrival of Aeneas at Pallanteum*, 1675. Oil on canvas, 175.5 × 225 cm. The National Trust, Angelsey Abbey.

152. J. M. W. Turner, *Copy from Claude*, (Fig. 151), 1799. Coloured chalks and watercolour, 14.9 × 22.5 cm. London, Clore Gallery for the Turner Collection (TB LXIX, p. 122).

'encumbered with a multitude of parts'[29], and in his *Backgrounds* lecture of 1811 Turner's own characterisation of Claude was in a similar vein: his pictures were 'made up of bits'.[30] Yet the phrase was not a criticism, for Turner was fascinated by the way in which Claude could pour into his landscapes such an abundance of diverse riches.[31] His first important encounter with the French master had been in 1799, when he went to see the newly-arrived Altieri Claudes (Figs. 150–1) at William Beckford's London home. Among many painters there was the President of the Royal Academy, Benjamin West, who observed:

> that Claude had so contrived his lights that the eye always settled upon the distance & the Center of the picture, – as the eye naturally does in viewing the scenes of nature. – He remarked how carefully Claude had avoided sharp & decided forms in the distance, gradually *defining* the parts as He came nearer to the foreground. – He thinks Claude began his pictures by laying in *simple gradations* of flat colours from the Horizon to the top of the sky, and from the Horizon to the foreground, witht. putting clouds into the sky or specific forms *into* the Landscape till he had fully settled those gradations. – When He had satisfied himself in this respect, He painted in his Forms, by that means securing a due gradation, – from the Horizontal line to the top of his Sky, – and from the Horizontal line to the foreground . . .[32]

This was the system of planning landscapes attributed to the water-colourist John 'Warwick' Smith and also to Wilson's follower Joseph Wright of Derby[33]; but Turner's response on this occasion was far less categorical: 'He was both pleased and unhappy while he viewed it – it seemed to be beyond the power of imitation', a reaction close to Wilson's own in front of another Claude in Rome, which 'makes my heart ache; I shall never paint such a picture as that, were I to live a thousand years'.[34]

Turner was clearly fascinated by these great paintings, which offered him a summary of Claude's most developed styles. *The Father of Psyche Sacrificing at the Temple of Apollo* (Fig. 150) of 1662, which was almost certainly the work analysed by West, is a mellow, subdued work, constructed in a series of carefully gradated planes and handled rather broadly in a palette which in the melting middle-distance suggests

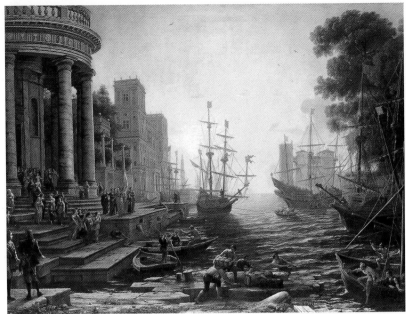

4. J. M. W. Turner, *Caernarvon Castle, North Wales*. Pencil and atercolour 63.3 × 99.4 cm. R.A. 1800. London, Clore Gallery for e Turner Collection (W 263). For the caption see p. 188.

5. Claude Lorrain, *Seaport: the Embarkation of St Ursula*, 1641. Oil a canvas, 113 × 149 cm. London, National Gallery.

some of Turner's 1828 oil sketches. The *Landscape with the landing of Aeneas at Pallanteum* (Fig. 151) of 1675 is painted in a far brighter palette, with a sharper and more refined handling, and introduces the oddly elongated figures characteristic of Claude's late style and the type of attenuated tree which was to appear in Turner's Claudian compositions of the 1810s. Turner visited Beckford's collection again the following day, in the company of Thomas Girtin[35], and, probably when he was workng for Beckford at his country seat at Fonthill a few months later, he made a schematic copy of *The Landing of Aeneas*, rather in the spirit of West's remarks (Fig. 152).[36]

The helplessness that Turner felt in the face of Claude's mastery is further borne out by his reaction to that painter's *Sea-Port with the Embarcation of St Ursula* (Fig. 155) in the collection of John Julius Angerstein, before which he is said to have burst into tears[37].Yet on both these occasions, Turner quickly moved from depression to emulation, and at the Adademy Exhibtion of 1799 and 1800 he showed two views of Caernarvon Castle which clearly reflect his experience of each of them. The first (Fig. 156) was a pared-down version of the *Sea-Port*, with its centrally-laced low sun, and

56. J. M. W. Turner. *Caernarvon Castle*. Watercolour over pencil, 7 × 82.5 cm. R.A. 1799, with the caption:
'Now rose
weet evening, solemn hour, the sun declin'd
lung golden O'er this nether firmament,
Vhose broad cerulean mirror, calmly bright,
iave back his beamy visage to the sky
Vith splendour undiminish'd.'
1allet
rivate Collection (W 254).

157. Willem van de Velde II, *A Rising Gale*. Oil on canvas, 130.3 × 190.3 cm. Toledo Museum of Art, Toledo, Ohio.

was soon acquired by Angerstein himself at an unprecedentedly high price. The second (Fig. 154) was a distant view, built up in a series of interlocking frontal planes and closely echoing *The Father of Psyche Sacrificing* (Fig. 150). Both were large watercolours, for at this stage Turner's command of oil was hardly capable of conveying the dazzling effect of light underlined by the caption, from David Mallet's *Amyntor and Theodora*, which he appended to Fig. 156 in the Academy Catalogue, in which the sun

> Hung golden o'er this nether firmament,
> Whose broad cerulean mirror, calmly bright,
> Gave back his beamy visage to the sky
> With splendour undiminished.

Turner's earliest Claudian excercises in oil, beginning with *The Festival of the Vintage at Macon* (Fig. 62) of 1803, failed to emulate precisely 'the golden orient or the amber-coloured ether, the midday ethereal vault and fleecy skies', which he recognized supremely in this master,[38] and it was not until the 1810s, in masterpieces like *Dido Building Carthage* (Fig. 291) and *Crossing the Brook* (BJ 130) that he began to achieve a comparable refinement and luminosity in that medium.

The twin models of the sea-port and the lush, extensive landscapes – 'resplendent vallies, rich with all the cheerful blush of fertilisation', as Turner put it in his *Backgrounds* lecture – provided the poles of Turner's lifelong infatuation with Claude. The first, with its grand buildings and its busy complement of figures he made essentially the theatre of tragedy: the rise and fall of Carthage, the torture of Regulus, the banishment of Ovid and the hopeless love of Dido and Aeneas (Fig. 283). The latter he felt to be so important and distinct that he made it a separate category of landscape itself, the Elevated Pastoral (EP) of *Liber Studiorum*, an enterprise modelled in style, if not exactly in theme, on the *Liber Veritatis* of Claude (Fig. 203 – see p. 137); and when in the 1840s he returned to the stimulus of this publication, it was this type of subject which provided the focus of his interest (Fig. 202).[39] This was Turner's critical response to a widespread eighteenth-century view that Claude had been a particulariser, and was thus to be associated with a pastoral, or even a simply 'rural' mode of landscape painting.[40]

Reynolds' demand that the great masters of the past should be seen as rivals was given a practical edge around 1800 when a number of collectors began to extend their Old Master collections into the area of modern British painting. One of the first to do so was the Third Duke of Bridgewater, who had recently acquired a large and outstanding group of Italian and French pictures from the Orleans collection dispersed by the French Revolution, and who in 1800 commissioned Turner to paint a pendant to a Dutch marine (Fig. 157). Two of Turner's sea-pieces recently shown at the Royal Academy, but subsequently lost sight of (cf. Fig. 158) had been highly praised by the critics[41], and this is perhaps why Bridgewater chose Turner to execute the commission. In the elevating company of the Bridgewater Gallery, with its Titians, its Claude's and its Poussins, Turner certainly took the opportunity of making his companion-picture, *Dutch Boats in a Gale: Fishermen Endeavouring to Put their Fish on Board* (Fig. 159), larger than its model both physically and in conception. The series of sketches for the picture in the *Calais Pier Sketchbook* show how Turner both simplified and concentrated his central theme by raising the horizon-line and setting the boats back from the picture-plane, and by removing a number of distant ships which he had in his sketches taken over from the Van de Velde.[42] His scheme of light and shade was now so much broader than that of the companion-piece, that the critics were able to speak of the picture in terms of Rembrandt when it was shown at the Academy in 1801; and the greater drama of lighting was in the interests of a greater drama of subject, for the two boats are

158. W. Annis and J. C. Easling after J. M. W. Turner, *The Mildmay Sea-Piece*, 1812. Etching and Mezzotint, 19 × 27.3 cm. London, British Museum (RLS 40). After the lost painting, *Fishermen coming ashore at Sun Set, previous to a Gale* (BJ 3) shown at the R.A. in 1797.

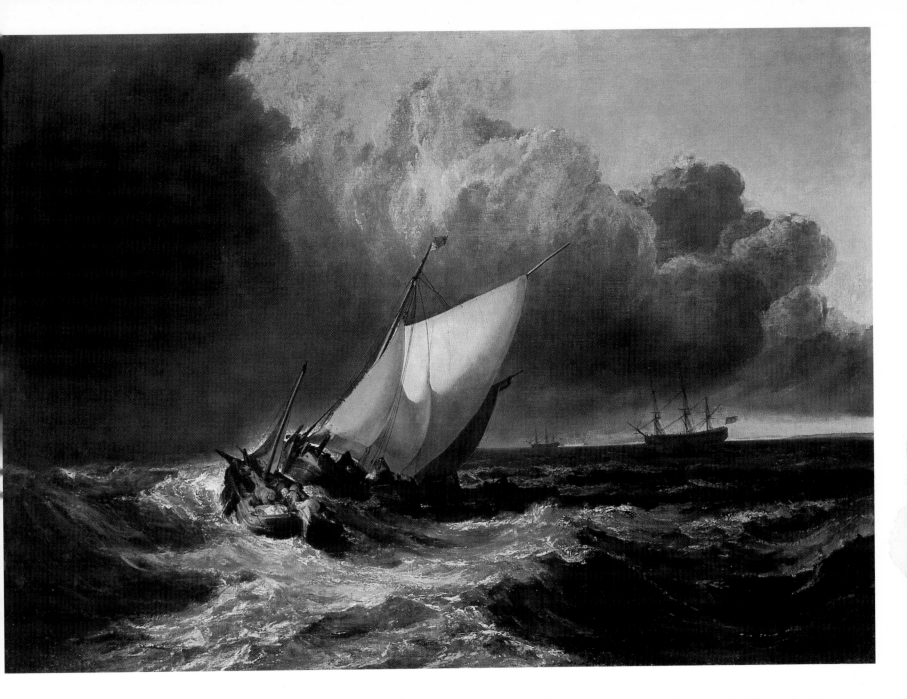

159. J. M. W. Turner, *Dutch Boats in a Gale: Fishermen endeavouring to put their Fish on Board*. Oil on canvas, 162.5 × 222 cm. R.A. 1801. Private Collection (BJ 14).

apparently set on a collision course, and only the gleams of sun on the distant horizon suggest that the outcome will be a happy one.[43] The titles of the lost oils of the late 1790s, *Fishermen Coming Ashore at Sunset Previous to a Gale* (Fig. 158) and *Fishermen Becalmed Previous to a Storm*, had already shown that Turner was interested in a narrative expressed through weather; in the *Bridgewater Sea-Piece* this narrative was taken up very clearly by the figures as well, and the enhanced monumentality of the style makes it clear that he was using the unfamiliar vehicle of a Dutch marine to present a 'history' painting in the grand tradition.

In the small room of the Bridgewater Gallery in which *Dutch Boats in a Gale* was the only modern painting, the company included not only the Van de Velde, but also a picture by the seventeenth-century Dutch master Aelbert Cuyp described by Farington as an 'evening port scene'.[44] This was the large riverscape still in the same collection, now identified as *Prince Frederick Henry at Nijmegen* (Fig. 161), but in Turner's day known as *The Canal of Dort*.[45] It became an especial favourite of Turner's[46] and it served him many years later as the chief model of his own most Cuyp-

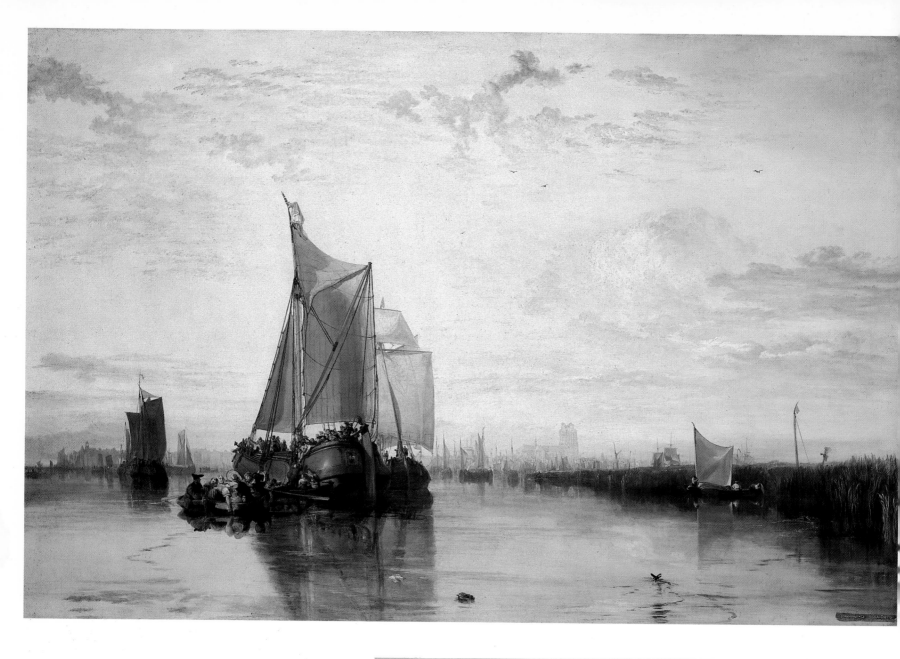

160. (*above*) J. M. W. Turner, *Dort, or Dordrecht, the Dort Packet-Boat from Rotterdam becalmed*. Oil on canvas, 157.5 × 233 cm. R.A. 1818. Yale Center for British Art (BJ 137).

161. (*right*) Aelbert Cuyp, *Prince Frederick Henry at Nijmegen*, mid–1650s. Oil on canvas, 114 × 166 cm. The Duke of Sutherland. Known in Turner's day as – *The Canal of Dort*.

like painting, *Dort or Dordrecht, the Dort Packet-Boat from Rotterdam becalmed* (Fig. 160).[47] As in the case of the *Dutch Boats in a Gale* Turner made his own picture much larger than its prototype, and he made it more monumental by the same devices of raising the horizon, and reducing and pushing-back the number of objects in the composition, setting them in a far larger and more limpid space. The sparkling freshness of an early morning in summer was also contrasted to Cuyp's mellow evening glow. *The Dort* is packed with picturesque and narrative details[48], but it demonstrated above all what Turner said of Cuyp in his *Backgrounds* lecture, that he 'knew where to blend minutiae in all the golden colour of ambient vapour'.[49] And Cuyp came to mean for Turner a particular quality of light which he was able to recognize in nature throughout his life.[50]

Turner's grandiose adaptation of the Dutch landscape masters after 1800 (an interpretation which he shared with several contemporaries, notably John Crome) was only one way in which he sought to appropriate and embellish the art of the past. The first clear sign that he was aspiring to the highest reaches of historical landscape came in 1800 with *The Fifth Plague of Egypt* (Fig. 162), which was immediately recognized as owing a primary debt to Nicholas Poussin. Although Reynolds had found Poussin too austere a master to be imitated, he allowed that he was *the* modern painter who most savoured of the Antique, and, more importantly, that in front of his works, 'the mind was thrown back into antiquity not only by the subject, but the execution'.[51] Turner's own characterisation of the French master in his *Backgrounds* lecture emphasised this same genius for the antique 'which clothes his figures, rears his buildings, disposes of his materials, arranges the whole of his picture and landscape'.[52] Turner had been preparing himself for the tasks of historical landscape by copying works by Poussin since 1798, in a sketchbook (TB XLVI) which includes the first ideas for *The Fifth Plague*; and that Poussin would be an appropriate model for subjects of this type was probably brought home to him by his knowledge of the copy on glass of *The Plague at Athens*, now attributed to Michael Sweerts, but then regarded as a Poussin, in the collection of Dr Monro.[53] Sweerts' design – and that of the Poussin *Plague at Ashdod* in the Louvre, which is related to it – deploys a number of foreshortened figures of the same type as those with which Turner was experimenting in this sketchbook. But although the

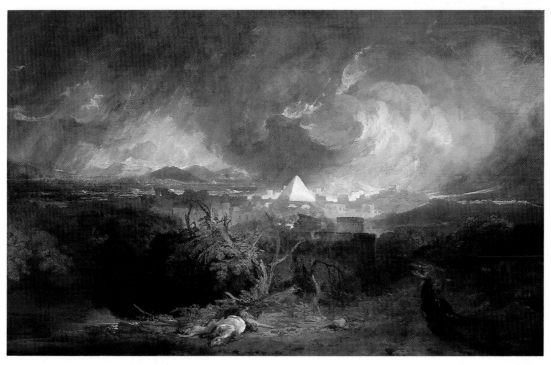

162. J. M. W. Turner, *The Fifth Plague of Egypt*. Oil on canvas, 124 x 183 cm. R.A. 1800, with the caption: 'And Moses stretched forth his hands toward heaven, and the Lord sent thunder and hail, and the fire ran along the ground', Exodus chap. ix. ver. 23. Indianapolis Museum of Art (BJ 13).

163. J. P. Quilley after J. M. W. Turner, *The Deluge*, 1828. Mezzotint, 38 × 57.6 cm. Yale Center for British Art (R.794). After Turner's painting of *c.* 1804/5 (BJ 55).

164. Nicholas Poussin, *The Deluge (Winter)*, 1660/4. Oil on canvas, 118 × 160 cm. Paris, Louvre.

conception of Turner's subject, with its succession of frieze-like layers of space is Poussinesque, the vigorous and astonishingly economical handling of the paint is far more in the tradition of Wilson; and the radically simplified composition, with its centralized, spot-lit pyramid and its lack of framing devices is entirely original, and may reflect the haste with which Turner executed the work for the Exhibition of 1800. He had been elected Associate of the Academy in November 1799 and it is tempting to suggest that this canvas – his largest to date – was a direct response to that signal honour. During the preliminaries to this recognition he had, too, become close to Farington's friend, the history-painter Robert Smirke, who also showed a similar subject, *The Plague of Serpents*, painted in a Poussinesque style the same year as Turner: perhaps it was Smirke's example which gave Turner a further reason for treating this subject in this style.[54] *The Fifth Plague* was a great success with the critics: *The Monthly Mirror* wrote that 'few painters since the days of Nicholas Poussin have given so historical an air to their landscapes'[55], and the lesson of the French master who, in Turner's words 'gave grandeur and sublimity by simple forms and lines'[56] occupied Turner for the next decade in a series of paintings of natural disaster, culminating in the *Hannibal* of 1812. (Fig. 270)

But, of course, the chief actor both in the *Fifth Plague* and in *Hannibal* was not the figures but the weather, and it has been rightly suggested that Turner's treatment of another Poussinesque subject, *The Deluge* (Fig. 163) was an implicit critique of the way in which Poussin had dealt with it in his picture in the Louvre, which Turner allowed to be sublime only in its colour.[57] When he saw this picture in 1802, he was particularly critical of its composition and figures, its 'absurdity as to forms' (TB LXXII, pp. 41a–2), and in his own version he drew rather more from the other Old Master who had particularly engaged him in Paris, namely Titian whose importance for Turner's approach to technique we examined in the last chapter. If Turner studied nine or so paintings by Poussin on that occasion, he copied nearly as many by or after Titian, among which was the *St Peter Martyr* (Fig. 126), now destroyed, of which, soon afterwards, Turner made his most elaborate early *pastiche* (Fig. 125). Titian's picture offered Turner precisely that union of figure and landscape which he had felt was so lacking in Poussin's *Deluge*: 'the characters are finely contrasted', – he wrote – 'the composition was beyond all system, the landscape tho natural is heroic, the figure wonderfully expressive of surprise and its concomitate [*sic*] fear . . .' (TB LXXII, p. 28a); and in a lecture of 1818 he amplified this view into an ecstatic account of the

associated feelings of force [and] continuity, that rushes like *the ignited spark* from earth towards heaven, struggling as the asending rocket with the elements, and when no more propelled by the force, it scatters round its falling glories, seeking again its earthly bourne, while diffusing around its mellow radiance, as the descending cherub with the palm of beatitude sheds the mellow glow of gold through the dark embrowned foliage, to the dying martyr.[58]

Titian's altarpiece was one of the most admired Old Master compositions of the Romantic period, and Reynolds had made it the focus of a discussion of the limits of naturalism. In Discourse XI (1782) he praised the *St Peter Martyr* as a fine example of a landscape background:

The large trees, which are here introduced, are plainly distinguished from each other by the different manner with which the branches shoot from their trunks, as well as by their different foliage; and the weeds in the fore-ground are varied in the same manner, just as much as variety requires, and no more. When Algarotti, speaking of this picture, praises it for the minute discriminations of the leaves and plants, even, as he says, to excite the admiration of a Botanist, his intention was undoubtedly to give praise even at the expense of truth; for he must have known, that this is not the

character of the picture; but connoisseurs will always find in pictures what they think they ought to find: he was not aware that he was giving a description injurious to the reputation of Titian.[59]

Connoisseurs and artists did indeed test Reynolds' assertion for themselves: one of Turner's patrons, Richard Payne Knight, in an article in the *Edinburgh Review*, maintained that 'all the trailing plants, spreading leaves and flowers, which decorate the foreground, are painted from nature with all the accurate truth of a botanist, though with all the light, airy, playful brilliancy and harmony of effect of a great master'.[60] Knight's was the view which came to prevail; it was endorsed by Turner's friend C. L. Eastlake, by Etty and by Constable; and Turner made his rather more enigmatic assessment when he saw the picture again in the Church of SS. Giovanni e Paolo in 1819, in a sketch of *Weeds in F[ront], St Peter Martyr* (TB CLXXV, p. 40a), a clear reminiscence of Reynolds.[61] He was, we may assume, pointing to the same balance of specificity and generalisation which characterises his own topographical sketching of Venice on the same trip (Figs. 71, 72).

Turner's fascination with Titian persisted until the last decade of his life, when it sometimes took the rather trivial form of direct parody.[62] The high key and the summary drawing of the *Bacchus and Ariadne* of 1840 suggest that Turner had come to look on Venetian painting with very different eyes by the end of his life, and the buoyant vortices of *Light and Colour (Goethe's Theory)* of three years later (Fig. 305) offer us clear evidence of a new interest in the Venetian Baroque. He had visited Venice again in 1840, and may well have looked at the decorations of Giambattista and Giandomenico Tiepolo, which were then beginning to come back into fashion, particularly among the English.[63] It seems inescapable that some ceiling like the *Pegasus* by G. B. Tiepolo in the Salone of the Palazzo Labia (Fig. 306), or his son's *Glory of Pope Leo X* in the Church of S. Lio near the Rialto, lies behind Turner's vigorous conception, where Moses has been introduced in the place of, say, God the Father. No style could be more appropriate to the apotheosis of light which is the primary subject of the picture.

This brilliant matching of style and subject had characterised Turner's recognition of the Venetian School since his first encounters with Titian about 1800, but as we saw in the last chapter, there can be little doubt that it was primarily the Venetian mastery of oil painting which sustained his interest and admiration over so many years. In the case of Gainsborough, whose art attracted Turner profoundly for a decade or so of his early career, it was perhaps the uneasy balance between manner and content, and the suspicion of a too exclusively sensual attachment to the act of painting, which made the involvement, however intense, unusually brief.

As a young man Turner was surrounded by the evidences of Gainsborough's mastery both as a painter and as a draughtsman. He was an especial friend of the painter's niece, Sophia Lane, who kept an important collection of Gainsborough's figure-drawings[64]; Dr Monro was an avid collector and gifted imitator of Gainsborough's landscape drawings, as was his (& Turners) friend, the portrait painter John Hoppner. Another painter close to Turner from his 'teens, W. F. Wells, was an authority on Gainsborough's drawings, and reproduced many of them in soft-ground etching in the first decade of the nineteenth century; and the amateur painter, Rev. Henry Scott Trimmer, who became one of Turner's closest friends, also had many of the master's drawings, as well as one of the most important collections of his early landscape paintings, inherited from his grandfather, Gainsborough's friend Joshua Kirby. It is thus no surprise that around 1800 the young artist should have turned to Gainsborough as a model for his earliest treatment of English landscape in a specifically Pastoral mode, in the oil sketches done in or near Wells' cottage at Knockholt in Kent (Fig. 93), or that he should have made pastiches of early landscapes like those in Trimmer's collection (Fig. 165).[65] It was at Knockholt too that Turner

165. J. M. W. Turner, *Landscape with Windmill and Rainbow*, c.1795/1800. Oil on canvas, 70.5 × 90 cm. London, Clore Gallery for the Turner Collection (BJ 45). Partly based on a lost Gainsborough, with windmill and rainbow added.

166. Thomas Gainsborough, *The Watering Place*, c.1776/7. Soft-ground etching, 27.9 × 34.9 cm. London, British Museum.

167. Charles Turner after J. M. W. Turner, *Bridge and Cows*, 1807. Etching and mezzotint, 19.1 × 27.3 cm. R.A. (RLS 2).

experimented with Gainsborough's celebrated 'mopping' method of generating landscape designs in watercolour, when he brought a drawing without foreground to the three Wells children, who were asked to rub their fingers in the three primary colours and paddle them over the paper, after which Turner 'added imaginary landscape forms, suggested by the accidental colouring, and the work was finished'.[66] At exactly this time Turner explained his watercolour method of Farington in terms of the erratic and supremely sculpturesque handling of a wash, so utterly unlike the routines of the day:

> He reprobated the mechanically, systematic process of drawing practised by [John 'Warwick'] Smith & from him so generally diffused. He thinks it can produce nothing but manner and sameness – The practice of [] is still more vicious. – Turner has no settled process but drives the colours abt. till He has expressed the idea in his mind.[67]

It was the blot-like aspect of Gainsborough's handling which had been the nub of Reynolds' celebrated account of his rival's technique in Discourse XIV, and Turner certainly took to heart the President's reservations about the general applicability of the method:

> it is certain, that all those odd scratches and marks which, on a close examination, are so observable in Gainsborough's pictures, and which even to experienced painters appear rather the effect of accident than design; this chaos, this uncouth and shapeless appearance, by a kind of magick, at a certain distance assumes form, and all the parts seem to drop into their proper places; so that we can hardly refuse acknowledging the full effect of diligence, under the appearance of chance and hasty negligence. That Gainsborough himself considered this peculiarity in his manner and the power it possesses of exciting surprise, as a beauty in his works, I think may be inferred from the eager desire which we know he always expressed, that his pictures, at the Exhibition, should be seen near, as well as at a distance.[68]

In this generous appraisal of Gainsborough by Reynolds we may see the seeds of both the more abstract and the more representational elements in Turner's late style.

Turner also evolved the plan of the *Liber Studiorum*, at Knockholt about 1807; and the type of 'pastoral' landscape which appeared in the early numbers of that publication owed most to Gainsborough's example (Figs. 165–6). This period also saw Turner's new interest in Pastoral subjects in painting, some of which, notably *The Forest of Bere* (Fig. 168), are very close to Gainsborough in form and feeling. The picture was immediately bought by the Third Earl of Egremont, whose Gainsborough *Rocky Wooded Landscape with Rustic Lovers by a Pool* (Fig. 169), in a rather sombre, classicising vein, but with a *contre-jour* effect similar to the Turner, was probably already at Petworth.[69] The Petworth Gainsboroughs are among the least naturalistic of his late works, and their idealised rustics contrast markedly with the estate-workers busily barking chestnuts in Turner's *Forest of Bere*. But this was, as I have said, a short-lived phase in Turner's art; his brief notice of Gainsborough in the 'Backgrounds' lecture mentioned only the late style[70], and it was accompanied by the disappearance of the more dense and richly-worked type of pastoral subject from Turner's repertory, to be replaced, in *A Frosty Morning* (BJ 127) by the more austere format of a Crome or a De Wint, both of whom were Turner's contemporaries, and in *Crossing the Brook* (BJ 130) by the style of Claude.

Of the four great English eighteenth-century painters, Reynolds, Hogarth, Gainsborough and Wilson, Turner came last to Hogarth, which is surprising, since from the early 1790s he had shown a sharp sense of the comic aspects of the figure, and Hogarth's reputation was rising. Reynolds, as usual, had thrown down the challenge in

168. J. M. W. Turner, *The Forest of Bere*. Oil on canvas, 88.9 × 119.4 cm. Turner's Gallery 1808. Tate Gallery and the National Trust (Lord Egremont Collection) Petworth House (BJ 77).

169. Thomas Gainsborough, *Rocky Wooded Landscape with Rustic Lovers by a Pool*, c.1774/7. Oil on canvas, 121.9 × 144.8 cm. Tate Gallery and National Trust (Lord Egrement Collection) Petworth.

Discourse XIV by alluding to Hogarth's 'new species of dramatick painting, in which probably he will never be equalled'[71], and Reynolds' pupil, James Northcote, had taken it up with his narrative series, *Diligence and Dissipation* (1796). Two of the greatest Hogarth collectors of the period were closely associated with Turner: J. J. Angerstein, who acquired the series *Mariage à la Mode* in 1797, and John Soane, who bought *The Rake's Progress* five years later and the *Election* series in the 1820s. But Turner's interest does not seem to have been aroused until about 1808, when he read Hogarth's *Analysis of Beauty*, probably in connection with his preparations for the lectures on perspective, for Hogarth had provided an amusing frontispiece on that subject to Kirby's *Dr Brook Taylor's Method*, and this may have led Turner to pursue Hogarth's theory too. In a notebook entirely devoted to drafts of verses, also written about 1808, Turner composed a long poem on *The Origin of Vermilion or the Loves of Painting and Music*, with a refrain which neatly encapsulates the character of the Rococo as Englished by Hogarth in his book:

> As snails trail o'er the Morning Dew
> He thus the lines of Beauty drew.[72]

Turner naturally looked to Hogarth when he was meditating about the same time on the relationship of the Sublime, which had been a staple of his own art since before 1800, and the ridiculous which, as we shall see in the next chapter, had entered it as a specific category only when he became interested in modern *genre* subjects about 1806. A long note on this subject in the 'Cockermouth Sketchbook' concluded with a quatrain alluding to the illustration in Plate I of Hogarth's *Analysis* (Fig. 52 No. 106) where the tile-like beard of Samuel Butler's seventeenth-century burlesque hero Hudibras was held up to ridicule for being against nature:

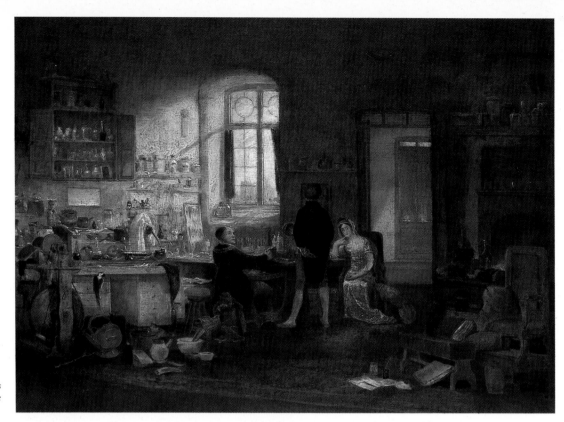

170. J. M. W. Turner, *The Unpaid Bill, or the Dentist reproving his son's Prodigality*. Oil on panel, 59.4 × 80 cm. R.A. 1808. Private Collection (BJ 81).

Speaking of the sublime Tom Paine who we may reasonably conclude to be destitute of all delicacy of refined taste, yet has conveyed a tolerable definition of the sublime, as it is probably experienced by ordinary and uncultivated minds, and even by acute and judicious without or [who] are destitute of the vigour of imagination, says that the sublime and the ridiculous are often so nearly related that it is difficult to class them separately. One step above the sublime becomes ridiculous and one step above the ridiculous makes the sublime again.

> The beard of Hudibras and the bard of Gray
> The spinning of the earth round her soft axle
> Ample room and verge enough.
> So nearly touch the bounds of all we hate.[73]

The context of the note is particularly interesting, for it probably reflects some conversation with Lord Egremont at his northern residence of Cockermouth Castle, and Egremont's favourite painters were the sublime Raphael and the ridiculous, or at least comic, Hogarth.[74] It is very likely to have been this conversation that provoked Turner's note, which drew on Thomas Paine's religious tract, *The Age of Reason* (1793), and on Richard Payne Knight's aesthetic treatise, *An Analytical Enquiry into the Principles of Taste* (1805), both of which Turner may well have found in the Cockermouth library. Knight had recently commissioned Turner to paint his most Hogarthian picture, *The Unpaid Bill* (Fig. 170), and in his book the sublime Raphael had been contrasted with Rembrandt as a ridiculous Dutch painter of low-life subjects.[75] Hogarth, although even he in a high-minded moment had considered Rembrandt to be ridiculous, was clearly the most distinguished English heir to the same Dutch tradition.

One of the Hogarthian devices which Turner used in Knight's *Unpaid Bill* was verbal: the picture includes several papers with writing on them, and in a pair of paintings conceived the following year, *The Artist's Studio* and *The Garretteer's Petition*, the proliferation of verbal cues made the debt to Hogarth even more explicit. *The Artist's Studio*, which exists only in the form of a water-colour (Fig. 172), includes a

172. J. M. W. Turner, *The Artist's Studio*, c.1808. Pen and watercolour, 19.3 × 13.7 cm. London, Clore Gallery for the Turner Collection (TB CXXI-B) Inscribed: *Pictures . . . Judgement of Paris/Forbidden Fruit Old Masters staked on floor. Stolen hints from celebrated pictures . . . crucibles, retorts, labelled bottles mystery varnish.*

173. J. M. W. Turner, *England: Richmond Hill, on the Prince Regent's Birthday*. Oil on canvas, 180 × 334.5 cm. R.A. 1819, with the caption:

'Which way, Amanda, shall we bend our course?
The Choice perplexes. Wherefore should we chuse?
All is the same with thee. Say, shall we wind
Along the steams? or walk the smiling mead?
Or court the forest glades? or wander wild
Among the waving harvests? or ascend,
While radiant Summer opens all its pride,
They Hill, delightful Shene?'

Thomson
London, Clore Gallery for the Turner Collection (BJ 140).

174. (*facing page*) Detail of Fig. 173.

number of inset pictures, one of them, *Forbidden Fruit*, related to the treatment of *Adam and Eve* in the tradition of Raphael.[76] The watercolour also has a caption made up from a version of this quatrain:

Pleased with his work he views it o'er & o'er,
And finds fresh beauties never seen before
While other thoughts the Tyro's soul controul
Nor cares for taste beyond a buttered roll.

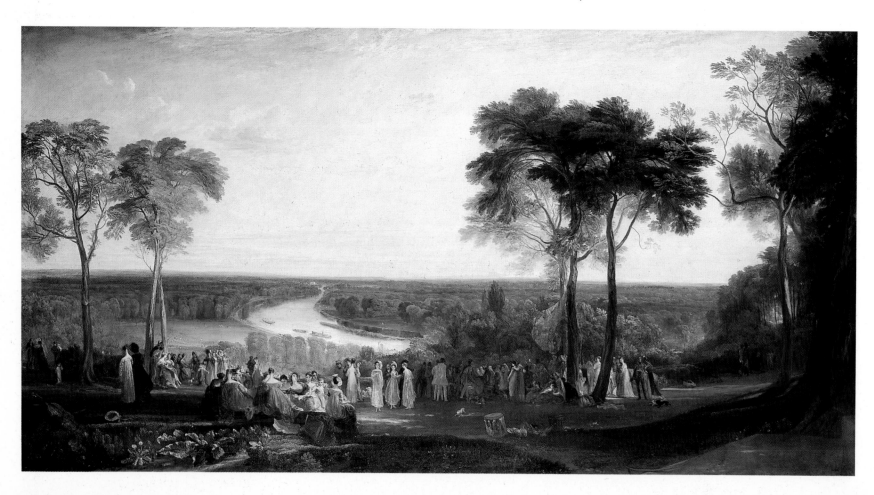

The image thus encapsulates the bathetic contrast between the sublime and the ridiculous. The companion design (Fig. 175) depends very closely on Hogarth's *Distressed Poet* (Fig. 176), and the last line of one of the drafts for a caption, which was not, however, used when the painting was eventually exhibited, includes the lines:

> The hard urged Garretteer . . .
> Inverted looks for inspiration to the ground
> Sinking from thought to thought a vast profound

a reminiscence from Alexander Pope's mock – heroic poem *The Dunciad*, which had been quoted by Hogarth in the caption to his print.[77]

Turner never returned to this density of verbal and visual imagery or to this type of satire until around 1831, in the *Lord Percy until Attainder* (Fig. 177) and in one or two drawings for the *England and Wales* Series (Fig. 292); and it was at this time too that he presented a relic of Hogarth to the Royal Academy (the artist's palette).[78] Perhaps the Hogarthian lesson that lay closest to Turner's beliefs was also the one closest to Reynolds: that genius was little more than a matter of hard work.[79]

Although we may assume that Turner was interested in Hogarth's brilliant technique, it is hardly surprising, given the importance of the *Analysis of Beauty*, and the engravings after his works, which were being much re-printed in the years around 1800, that he appealed to Turner chiefly through his ideas and his subjects. But with Hogarth's older contemporary Antoine Watteau, the last Old Master to have a profound influence on Turner, the case was very different. As we shall see in a later chapter, Turner first absorbed Watteau's style into *England: Richmond Hill on the Prince Regent's Birthday* (Fig. 173) in the hopes of attracting the attention of a royal patron who was known to be interested in it.[80] Here the model was a painting which had been in the collection of Reynolds (who had re-painted it extensively) and was subsequently in that of Turner's intimate friends, James Holworthy (Figs. 178–9).[81] In a conversation with the collector-dealer Noel Desenfans, whose collection formed the basis of the Dulwich Gallery, Reynolds had confessed: 'Watteau is a master I adore. He unites in his small figures correct drawing, the spirited touch of Velasquez, with the colouring of the Venetian School.'[82] and in his Note XLIII to Charles Du Fresnoy's *Art of Painting*, he had charaterised Watteau's method as an excellent example of the

175. J. M. W. Turner, *Study for 'The Garreteer's Petition'*, c.1808. Pen and watercolour, 19.3 × 13.7 cm. London, Clore Gallery for the Turner Collection (TB CXXI-A). Study for the oil (BJ 100) shown at the R.A. in 1809. The drawing is inscribed: *Almanack of Fasts and Moveable Feasts Translations Vida Art of Poetry Hints for an Epic Poem Reviews torn upon Floor and Paraphrase of Job Coll. of Odds and Ends*; and on the reverse, versions of the captions used in 1809.

176. William Hogarth, *The Distressed Poet*, 1736/7. Line-engraving, 32.5 × 39.7 cm. London, British Museum.

177. J. M. W. Turner, *Lucy Countess of Carlisle, and Dorothy Percy's Visit to their Father Lord Percy, when under Attainder upon the Supposition of his being concerned in the Gunpowder Plot*. Oil on panel, 40 × 96.5 cm. R.A. 1831. London, Clore Gallery for the Turner Collection (BJ 338). A companion to Fig. 244. The figures are based on Van Dyck portraits at Petworth, the former seat of the Percy family. The paintings on the wall show the Tower of London (Percy's prison) and St Peter freed from prison by an angel.

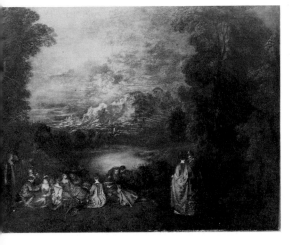

Flemish tradition of handling created by Rubens. When Turner came in 1831 to paint a picture based on the same didactic poem, *Watteau Study by Fresnoy's Rules* (Fig. 244), he thus not surprisingly used the French master as his vehicle. The painting was didactic in a very specific sense, for it included among Watteau's paintings a reversed image of *Les Plaisirs du Bal* at Dulwich (Fig. 247), which Turner, who was Visitor to the Academy Painting School in 1831, may well have been responsible for bringing to Somerset House to be copied by the students. The Painting School had been instituted in 1816 specifically to give instruction in technique through the means of copying Old Masters, and the Dulwich Collection had always been drawn on for this purpose. Constable's friend (and Turner's), the American genre-painter C. R. Leslie, was making a copy of *Les Plaisirs du Bal* on this occasion, and Constable remarked that the Watteau 'looks as if painted in honey – so mellow – so tender – so soft and so delicious . . . this inscrutable & exquisite thing would vulgarise even Rubens & Veronese . . .'[83]

Turner's *Watteau Study* was described by a critic of the 1831 Exhibition as 'full of delicacy and beauty . . . a rich gem'; but unfortunately Turner seems to have followed his model too closely in the matter of technique. By an irony of history, the painting which was to instruct Turner's students in the subtle management of tone, has darkened as irreversibly as some of Watteau's own pictures.[84]

CHAPTER FIVE
The Academy and its Rivals

TURNER's devotion to Reynolds did not mean that he identified himself entirely with the institution of which Reynolds had been the first President and of which Turner so early became a prominent member. In the years following Reynolds' death the leadership of the Academy was already beginning to be challenged, partly through the growing power and influence of patrons, who organized themselves into The British Institution in 1805, and partly through the establishment of rival societies catering precisely for those areas of artistic activity, such as watercolour, which the Academy neglected. It was, Turner confessed at a time when it was increasingly coming under public attack, 'not all that it might be made in regard to art'.[1] For, as we have seen, the Academy left the landscape painter very much to his own devices; and even the landscape draughtsman to whom Turner owed some elements of his early style, Edward Dayes, could only report that the young artist was 'indebted principally to his own exertions for the abilities which he possesses as a painter, and . . . may be considered as a striking instance of how much may be gained by industry, if accompanied with temperance, even without the assistance of a master.'[2] Turner was thus able to enjoy as great a freedom to range among the styles of his contemporaries, even 'the fashionable darlings of the day', against whose seductions Reynolds had specifically warned his students,[3] as he had been among the Old Masters; and many of these favoured contemporaries had no very close associations with the Academy.

One of the first and most abidingly important of Turner's artistic friends was Thomas Girtin, his exact contemporary, who had been a pupil to Dayes. Dayes' strictures about 'temperance' in the passage quoted above were probably directed at Girtin, whose wild life was thought to have been responsible both for his relative lack of success as an artist, and for his early death at the age of twenty-seven. Girtin was regarded very generally as Turner's chief rival in his youth. We have seen that they had worked side by side at Dr Monro's from 1794, and in the mid-nineties their styles were so close that it is difficult to tell them apart. But, almost at once, they diverged: Girtin, almost exclusively a watercolourist, became increasingly concerned with broad, simple effects in a subdued palette on coarse paper, Turner with textural richness and sharper colour and detail. As a reviewer put it as early as 1797, 'Turner's drawings are wonderfully laborious, Girtin's are bolder . . .';[4] and another reviewer of one of Girtin's rare oils, *Bolton Bridge*, shown at the Academy in 1801, continued to link their names but to clearly distinguish their styles:

There seems to be some sort of competition between this artist and MR TURNER. They

181. *(facing page)* J. M. W. Turner, *The Lauerzer See, with the Mythens, c.*1848/50. Pen and watercolour, 337 × 545 cm. London, Victoria and Albert Museum (W 1562).

are both artists of uncommon and surprising merit, considering their time of life, for we understand that they are both very young. In our opinion, however, MR GIRTIN seems to tread with a firm step in the path which leads to the higher excellencies of the art. He is not less bold in his portraits of Nature, and he is more distinct that his ingenious rival . . .[5]

Although the well-known comment attributed to Turner that 'If Girtin had lived, I should have starved',[6] seems improbable, precisely because their work had so little in common by the time of Girtin's death, there is no doubt of Turner's immense admiration for the art of his friend.[7] A Girtin drawing which particularly remained in his consciousness was *The White House at Chelsea* which had been painted in 1800 (Fig. 180). Turner corrected this mezzotint reproduction for the publisher in the 1820s;[8] its dominant motif of a light building casting long reflections onto twilight waters was one which clearly fascinated him, and he noted the name of the drawing on two of his late Swiss sketches (TB CCCXLII, 66, 70), as well as using the idea in several of the latest Swiss subjects of his own (Fig. 181).

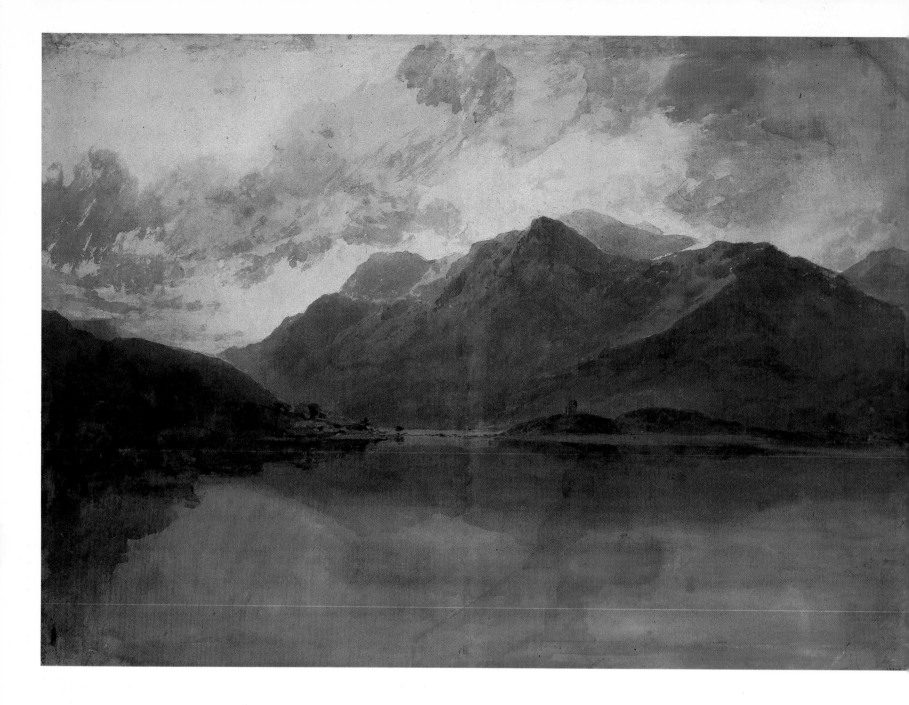

182. J. M. W. Turner, *Llanberis Lake and Dolbadern Castle*, 1799/1800. Pencil and watercolour, 55.3 × 76.1 cm. London, Clore Gallery for the Turner Collection (TB LXX-X).

183. P. J. de Loutherbourg, *Llanberis Lake*, 1786. Oil on canvas, 89 × 140 cm. Strasbourg, Musée des Beaux-Arts.

The close friendship and association with Girtin had a decisive effect upon the early development of Turner's watercolour style, and on his range of architectural subjects; but for an introduction to oil-painting (which, of course, he needed if he were to join the Academy), he turned in a very different direction, to one of the most eccentric figures in the art-life of late eighteenth-century England, the French-born landscapist and scene-designer, P. J. de Loutherbourg, whose taste for the Sublime in landscape became very much Turner's own (Figs. 182–3). But again, as in the case of Girtin, the effect of Loutherbourg's example was more far-reaching than the notion of early training would lead us to suspect. Schooled in the French landscape tradition of Claude-Joseph Vernet, Loutherbourg worked in London in the 1770s chiefly as a theatrical designer, devising spectacular pantomimes for David Garrick at Drury Lane. In the 1780s he became a pioneer in the depiction of the wilder landscape of the British Isles – the Lake District, the Derbyshire Peaks, North Wales – rendered on the grandest scale; and in this he was followed by Turner only a decade later. As a critic wrote in 1809,

184. J. M. W. Turner, *The Battle of Trafalgar*, 1822/4. Oil on canvas,
259 × 365.8 cm. Greenwich, National Maritime Museum (BJ 252).

185. Philip Jacques de Loutherbourg, *The Battle of the Glorious First
of June 1794*, 1795. Oil on canvas, 267.8 × 374.4 cm. Greenwich,
National Maritime Museum.

Loutherbourg, whose prolific and tasteful pencil has ornamented many of our best collections, first asserted that no English painter had occasion to visit foreign countries to study romantic landscape scenery. This artist illustrated his assertion by producing many fine and grand landscapes taken from various parts of Great Britain; and Turner, whose unrivalled talents in the art, give law to his opinions thereon, has said that a landscape painter may find sufficient scope for his pencil by studying the scenery on the banks of the Thames.[9]

It need hardly be said that neither the one nor the other pursued this policy for long.

Loutherbourg's vast range of subjects included those scenes of natural disaster, conflagrations, naval battles and calm early-morning effects which also exercised Turner; and his bright palette was attacked as glaring and unnatural in the 1780s in very much the same terms as was Turner's forty years later. The younger artist had been looking at Loutherbourg's landscapes, and using both their themes and their style in his watercolours and oils since the early 1790s.[10] About 1810, at the end of Loutherbourg's life, they became neighbours at Hammersmith, south-west of London, where Turner was said by the French painter's wife to be always trying to extract her husband's 'secrets' from him.[11] What these 'secrets' were remains unclear at so late a date in Turner's career, although they may refer to the technical 'secrets' which were dear to both painters, but even in the 1820s, Turner's great Royal commission for *The Battle of Trafalgar* (Fig. 184), conceived as a pendant to Loutherbourg's *Lord Howe's Victory* (Fig. 185) led him to adopt an approach to battle-painting very similar to that of his model. In the brochure of 1803 advertising James Fittler's engraving of Loutherbourg's painting of *The Battle of the Nile* (a subject also treated in a lost work by Turner), his treatment was explained in terms which were to become crucial for Turner's notions of historical landscape:

> Mr Loutherbourg has availed himself of the priviledge allowed to Painters, as well as Epic and Dramatic poets, of assembling, in one point of view, such incidents as were no very distant from each other, in regard to time . . . it has been Mr Loutherbourg's plan to compose his pictures with an adherence to the principles of art, not usually consulted in Marine Painting.[12]

But the seamen at the Court of St James's, where Turner's and Loutherbourg's pictures were destined to be hung, were not at all familiar with such principles, and both works were quickly banished to Greenwich, where they remain.

Yet, although the presence of Loutherbourg can be felt in many branches of Turner's art, from book-illustration to the largest of his canvasses, and from the sublime effects of local nature to the elemental significance of classical figure subjects, there was also something about the Frenchman's art profoundly alien to him. His impeccable technique and his emphasis on heavy outline represented an aspect of French style which Turner, in common with many of his contemporaries, affected to despise, for it savoured more than a little of routine. For all its range and verve, there was a certain predictability both in Loutherbourg's subjects and in his treatment of them; and if the painter guyed by Turner in *The Artist's Studio* (Fig. 172) is Loutherbourg, as the iconographic details and the physiognomy of the protagonist suggest he is, then it is clear that Turner is attacking him precisely for the complacency that emanates from so much of his work (see p. 120).

II

Loutherbourg was a distinguished veteran Academician, and already as a student Turner had set his sights on academic status. As the time drew near for this first (unsuccessful) application for associate membership in 1798, he took care to cultivate

186. J. M. W. Turner, *Head of Derwentwater, with Lodore Falls,* 1801. Watercolour, 35.5 × 52.4 cm. Thomas Agnew & Sons (W 282). Signed *JMW Turner Keswick Augt 1801* and inscribed on the reverse: *To Joseph Farington Esqre, with W. Turner's Respects.*

the friendship of other influential Academicians like Farington and Hoppner, both of whom he presented with impressive drawings (Fig. 186). He did the same for Lawrence and Smirke before making his second, and successful application the following year.[13]

George Dance's portrait of 1800 (Fig. 293), made for his collection of profiles of Academicians and other eminent figures, and shown at the Academy exhibition in that year, marks an important stage in Turner's acceptance into the artistic establishment.[14] He now moved from his father's house and set up in Harley Street; and when, in February 1802, he was finally elected a full Academician, the homely and commonplace 'William Turner' became the more imposing 'Joseph Mallord William Turner, R.A.', with the added weight of 'P.P.' on his assumption of the duties of Professor of Perspective five years later. Turner lost no time in joining the social organ of his new protector, the Academy Club, essentially a dining club, and he attended its meetings assiduously for his first year; but almost at once he showed signs of arrogance and bumptuousness, and the older Academicians who had supported him in the late 1790s began to turn against both his person and his art. Farington recalled a conversation with Smirke, Shee and Daniell in 1803, when styles and personalities were under discussion and Turner's were judged to be 'confident, presumptuous, with talent'. A few days later the veteran portrait painter Ozias Humphry 'remarked on the arrogant manners of a new member of Council and of the Academy T[urner]. more like those of *a groom* than anything else; no respect to persons or circumstances.'[15]

In 1804 Turner severed his connection with the Academy Council, on which he was eligible to serve a further six months, after a particularly stormy meeting at which, during the absence of the chairman Farington, Bourgeois and Smirke, he had taken Farington's place, and berated him on his return for leaving the meeting. In his rejoinder, Farington noted that 'His conduct as to behaviour had been cause of complaint to the whole Academy'.[16]

The affair soon blew over, however, and Turner continued to play a major part in the formal and informal life of the institution. He was particularly devoted to

sociability. In a dispute with the Hanging Committee about the placing of his *Hannibal* (Fig. 270), in 1812, for example, he arrived during a lunch-break to threaten the removal of his work, but seeing the Committee 'chearfully seated', he would not make his final decision until later, so as not to disturb the friendly atmosphere.[17] It was Turner, too, who, at the end of December 1836, proposed the farewell dinner at Somerset House, when the Academy moved to the new National Gallery building in Trafalgar Square.[18] On these occasions, Turner could be talkative, and he did not always resist the temptation of formal speech-making, for which he was notably ill-equipped. A younger Academician, W. P. Frith, later made a witty parody of a Turner speech, no doubt in the rich Cockney accent and the deep voice which were native to him, and in which classical sentiments received a far from classic form:

> Gentlemen, I see some – ' (pause and another look round) 'new faces at this – table – Well – do you – do any of you – I mean – Roman History – ' (a pause). 'There is no doubt, at least I hope not, that you are acquainted – no, unacquainted – that is to say – of course, why not? – must know something of the old – ancient – Romans.' (Loud applause). 'Well, sirs, those old people – the Romans I allude to – were a warlike set of people – yes, *they were* – because they came over here, you know, and had to do a good deal of fighting before they arrived, and after, too. Ah! they did; and they always fought in a phalanx – know what that is?' ("Hear, hear", said some one.) 'Do YOU know, sir? Well, if you don't, I will tell you. They stood shoulder to shoulder and won everything.' (Great cheering.) 'Now, then, I have done with the Romans, and I come to the old man and the bundle of sticks – Aesop, ain't he? – fables, you know – all right – yes, to be sure. Well, when the old man was dying, he called his sons – I forget how many there were of 'em – a good lot, seven or eight perhaps – and he sent one of them out for a bundle of sticks. 'Now', says the old man, 'tie up those sticks, tight, and it was done so. Then he says, says he, 'Look here, young fellows, you stick to one another like those sticks; work all together,' he says, 'then you are formidable. But if you separate, and one go one way, and one another, you may just get broke one after another. Now mind what I say', he says – ' (a very long pause, filled by intermittent cheering). 'Now', resumed the speaker, 'you are wondering what I'm driving at' (indeed we were). 'I will tell you. Some of you young fellows will one day take our places, and become members of this Academy. Well, you are a lot of sticks' (loud laughter). 'What on earth are you all laughing at? Don't you like to be called sticks? – wait a bit. Well, then, what do you say to being called Ancient Romans? What I want you to understand is just this – never mind what anybody else calls you. When you become members of this instituion you must fight in a phalanx – no splits – no quarrelling – one mind – one object – the good of the Arts and the Royal Academy.[19]

Turner was also happy to take on the more humdrum duties of Academic life, and he proved a particularly jealous guardian of the Academy's funds. For twenty-two years, between 1824 and 1846 he was an Auditor of the Academy accounts; he showed a curiously passionate desire to prevent the hasty raising of cash by the sale of stock[20], and, even more surprisingly perhaps, the use of Academy funds to invest in art. When Sir Thomas Lawrence's great collection of Old Master drawings became available after his death in 1830, Turner resisted the move, sponsored chiefly by Soane, to acquire them for the Academy, even though Soane offered to contribute £1000 of his own money towards the purchase.[21] In a sketchbook note which seems to refer to this affair, Turner argued that to use funds for the purchase of art was 'subversive' of the principles of the foundation, whose surplus income was intended 'for the relief of Decayed Members and the support of the Art';[22] and Turner had the needs of indigent artists and their families very much at heart.

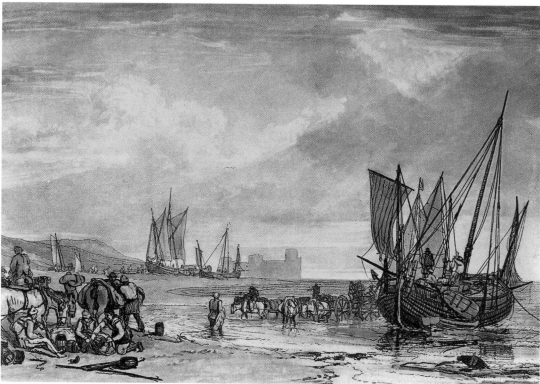

187. A. W. Callcott, *Sea-Coast with figures Bargaining for Fish*, 1806. Oil on canvas, 122 × 183 cm. Private Collection.

188. Charles Turner after J. M. W. Turner, *Scene on a French Coast*, 1807. Etching and Mezzotint, 19 × 22.6 cm. Nottingham Castle Museum (RLS 4).

189. T. F. Hunt, *Design for Almshouses*. Lithograph. From T. F. Hunt, *Designs for Parsonage Houses, Alms House &c.*, 1827, a copy of which was in Turner's library.

The enormous expansion in artistic activities stimulated by the coming of the Academy in the second half of the eighteenth century brought its own problems of social welfare. Art was always a precarious business at which only a very few could hope to succeed, and the Academy had rightly taken it upon itself to provide, in a modest way, for those who did not. In 1815 Turner became a Director of the recently founded Artists' General Benevolent Institution, 'for the Relief of Decayed Artists of the United Kingdom whose works have been known and esteemed by the public; and for affording assistance to their widows and orphans'; where he was soon elected Chairman and Treasurer, positions he held for more than a decade. When he finally resigned as Chairman in 1829, the Directors of the Institution made repeated efforts to change his mind, for they would not, they said, easily replace his 'paternal superintendance & beneficial anxieties'. As late as 1845 they offered him the Chair again, but again he refused.[23]

He had in fact a good personal reason for withdrawing from this public charity, for a few weeks after he resigned he drew up his first will, by which, although he did leave £500 to the Artists' General Benevolent Institution, the largest portion of his substantial fortune was to be used for the establishment of a 'College or Charity' for 'decayed English artists (Landscape painters only) and single men', to be built at Twickenham and to incorporate a picture-gallery to house the collection of his works.[24] As its title suggests, the Artists' General Benevolent Institution was (and still is) very wide-ranging in its charitable bequests. It had, in fact, originated in reaction to the Artists' Joint-Stock Fund, established in 1810, which provided only for contributing members and their families, and had itself been set up principally by a group of non-Academic artists and engravers who were rarely able to draw on the funds disbursed by the Academy to Academicians, former students and their dependents.[25] Now Turner was proposing to cater to the needs of an even more restricted body of artists. In 1839 his bequest to the Artists' General Benevolent Institution was rescinded in a codicil to his will, and in a new will of the following year he further insisted that the beneficiaries of his own charitable institution (to be called

190. Letter from Turner to Sir J. F. Leicester, 12 December 1810. Cheshire Record Office, Tabley Papers. The sketches show *Sun rising through Vapour; Fishermen cleaning and selling fish* (BJ 69), *Fishing upon the Blythe-Sand, Tide setting in* (BJ 87), *Guardship at the Great Nore, Sheerness &c.* (BJ 91) and *The Leader Seapiece* (BJ 206).

'Turner's Gift') must be 'Poor and Decayed Male Artists being born in England of English Parents only and lawful issue'.[26] Later in this same will he reinforced his intention that his Gift 'shall at all times decidedly be an English Institution and the persons receiving the benefits thereof shall be English born subjects only and of no other Nation or Country whatever',[27] and it is very likely that the style of building he now considered was not the neo-classical style he had occasionally practiced himself, but English Tudor (Fig. 189). For it was probably at this time that he acquired a pattern-book by a former pupil of Soane's, T. F. Hunt's *Designs for Parsonage Houses, Alms Houses . . . with Examples of Gables and Other Curious Remains of Old English Architecture* (1827), and he will certainly have been impressed not simply by the Englishness of the style, but also by Hunt's emphasis on its cheapness.[28] In the end, however, the plans for 'Turner's Gift' were thwarted when the family successfully contested Turner's will in the 1850s.

III

Turner's concern for the future welfare of landscape painters in his own old age was matched by a warmth of generosity towards young and aspiring rivals since not long after he had himself become established in the Academy. In 1805 one of the most admired paintings at the Academy exhibition was *A Water Mill* by the twenty-six year-old Augustus Wall Callcott, which was acquired even before the opening by one of the most important patrons of British art at this time, Sir John Fleming Leicester.[29] The following year Leicester commissioned *Sea-Coast with Figures Bargaining for Fish* (Fig. 187), the first of several Callcott marines to enter his collection; and although this work, and its companion, *A Calm, with Figures: Shrimping*, were immediately recognised as having been formed on Turner's style, this was only true of their handling, for the openness and stillness of the compositions has little parallel in Turner's earlier sea-pieces, which had usually been far more dramatic in their emphasis on weather.[30] Now, however under the stimulus of Callcott's success, Turner's range began to expand again, and the first number of *Liber Studiorum*, published in 1807, included a *Scene on the French Coast* (Fig. 188), which is very close to Callcott's design. The two artists became close friends, and Turner voted for Callcott's admission to the Academy as Associate in 1806 and as full Academician in 1810. At the same time he painted several marines in the Callcott manner, four of which he offered, significantly, to Leicester (Fig. 190). If, as Turner wrote in his letter, the subjects might be interesting to the collector for 'their fitness or class', this suitability must have been clear primarily from his patronage of Turner's friend.

The spaciousness and luminosity that Callcott brought to marine subjects was also characteristic of his treatment of pastoral landscape, which shows his liking for the monumentality and the prominent figures of Dutch masters like Cuyp. The large *Cow Boys*, exhibited in 1807 and 1808 and also acquired by Leicester (Fig. 193), seems to be the first sign of a new direction in English pastoral painting which was followed by many painters in the immediately following years, notably J. J. Chalon and William Mulready.[32] A number of Turner's rustic subjects, too, with large-scale figures and cattle (Fig. 192) seem to have been inspired by exactly the same developments, and they testify once again to his sensitivity and responsiveness to the innovations of his younger contemporaries.

Turner's attachment to Callcott persisted, for there can be little doubt that the immediate stimulus for Turner's great *Dort* of 1818 (Fig. 160) was also Callcott, who in the previous two years had exhibited large, Cuyp-like river subjects, one of which, *The Entrance to the Pool of London* (Fig. 191), had been especially praised by the Duke of

191. A. W. Callcott, *Entrance to the Pool of London*, 1816. Oil on canvas, 153 × 221 cm. Trustees of the Bowood Settlement.

192. J. M. W. Turner, *Harvest Dinner, Kingston Bank*. Oil on canvas, 90 × 121 cm. Turner's Gallery 1809. London, Clore Gallery for the Turner Collection (BJ 90). Engraved by Turner for *Liber Studiorum* (RLS 87) but not published.

193. A. W. Callcott, *Cow Boys*, 1807. Oil on canvas, 125 × 102 cm. Coventry, Herbert Art Gallery.

Sussex at the Academy Banquet of 1816. Turner is said to have praised it very highly too, and to have rated its value at a thousand guineas. Callcott was a slow painter: when he saw Turner's *Dort*, he observed that he could not paint one of his own large river scenes in less than six months, 'whereas Turner *wd* paint such as "The View of Dort" in a month'.[33] It has been plausibly argued that Turner phrased his title as *The Dort Packet-Boat from Rotterdam Becalmed* becase he knew that the third of Callcott's large Cuyp-like pictures, *Rotterdam*, commissioned by Earl Grey in 1816 as a result of the sensation caused by *The Pool of London*, was still far from completed.[34] It was this spirit of friendly rivalry and banter which was to characterise Turner's relations with Callcott until well into the 1820s, but in this case it was responsible for a masterpiece.

Callcott's closeness to Turner in these years, and the effect of his and of Turner's pastoral landscapes on a number of other young painters like William Havell and William Daniell,[35] made it possible for the first time in England to talk of an English landscape 'school'; and they were in fact labelled at the time the 'white painters', because of their high key of colouring and relative lack of total contrast, by the connoisseur and painter Sir George Beaumont. They might as well have been called 'The Thames School', for their distinct liking for subjects upriver from London. Turner had a reputation as the leader of the 'whites' until nearly the end of his life;[36] but it should be remembered that it was Callcott's work of 1806 which first led Beaumont to coin the term.[37]

The remarkably reciprocal relationship which Turner and Callcott maintained until the 1820s was repeated more or less during that decade by Turner's engagement with the work of a young landscape painter Richard Parkes Bonington, whose supremely accomplished style, both in watercolour and in oil, was the sensation of the day. Bonington worked in France, but he had already exhibited French coastal scenes and

132

94. J. M. W. Turner, *Calais Sands, Low Water, Poissards collecting Bait*. Oil on canvas, 73 × 107 cm. R.A. 1830. Bury Art Gallery and Museum (BJ 334).

195. Richard Parkes Bonington, *Shore Scene*. Oil on canvas. Royal Collection.

Venetian views in London by the mid-twenties, and he had shown himself to be by far the most brilliant artist to have schooled himself on Turner's mature landscapes. At the close of his short life, which ended in 1828, he enjoyed the special protection of the President of the Royal Academy, Sir Thomas Lawrence. Bonington's studio sale in June 1829 revealed to the English public the extraordinary range and sophistication of his work, and he became one of the most sought-after landscapists in this country. It is no surprise that Turner rose to the challenge, and in a number of beach-scenes of around 1830 he emulated the vast spaces and florid palette of some of Bonington's work with this type of subject (Figs. 194–5).[38]

Bonington was also the first important English discoverer of Venice, which he visited in 1826, and he had exhibited paintings of Venetian subjects two years later in London, where they had been much admired. His own most gifted English follower, Clarkson Stanfield had, in his turn, visited the city in 1830, and used sketches made there for a moving diorama of the area, which was shown in a Christmas pantomime at Drury Lane the following year.[39] More importantly, about the same time Stanfield was commissioned by Lord Lansdowne to paint ten Italian subjects, including a number of Venetian views, to decorate the Adam Dining Room at his country seat,

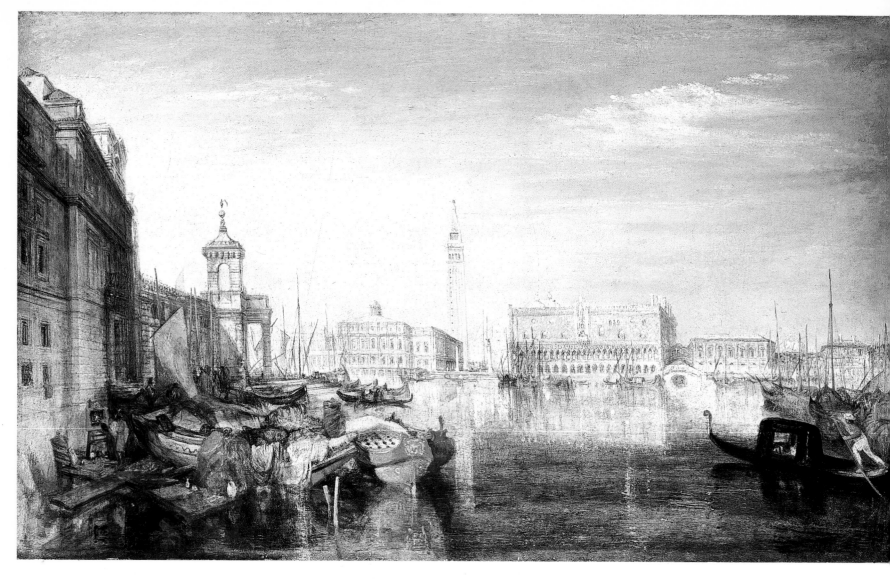

196. J. M. W. Turner, *Bridge of Sighs, Ducal Palace and Custom-House, Venice: Canaletti painting*. Oil on panel, 51 × 82.5 cm. R.A. 1833. London, Tate Gallery (BJ 349).

197. Clarkson Stanfield, *Venice from the Dogana*, 1833. Oil on canvas, 130 × 166.5 cm. The Earl of Shelburne.

Bowood near Bath; and Lansdowne had also been an admirer of Bonington's Venetian work, buying heavily at the 1829 sale. Coming as it did only shortly after Stanfield had been patronised by King William IV, this new and lucrative commission aroused a good deal of resentment in the Academy, to which Stanfield was elected an Associate member only at the end of 1832, and Turner determined to teach him a lesson. When one of the Lansdowne Venetian subjects was submitted and accepted for the 1833 Exhibition (Fig. 197), Turner painted his own small version of the same view during the Varnishing Days: 'In two days, then,' wrote a critic

> Turner produced that splendid work which tended so much to obscure the merits of Stanfield's picture. And, however ill-natured or invidious such a circumstance may be considered, as personally concerning Stanfield, it cannot be denied that the public were gainers, inasmuch as they were better enabled to judge of the respective merits of the two, by a close examination and comparison of their paintings. The juxtaposition brought out more glaringly the defects of Stanfield and illustrated more strongly the fine powers of Turner. For, viewed from whatever distance, Turner's work displayed a brilliancy, breadth and power; whereas on the contrary Stanfield's looked opaque, heavy and devoid of all effect, even near, or at a distance.[40]

Turner had already produced a very similar view for Rogers' *Italy* (Fig. 198); but the allusion to Canaletto in his 1833 title served to remind the public of the well-known painting by that artist in the Royal Collection, which had been engraved by Visentini (Fig. 199), and to suggest that there had, after all, been great painters of Venice long before Stanfield, or even Bonington, were heard of. Now, with the arrival of Turner as an interpreter of the Venetian scene, even Canaletto was to be upstaged.

Turner's spiteful gesture in 1833 did not prevent his soon becoming a firm friend of the younger painter, who shared a boat with him to observe the great fire at the Palace of Westminster in October 1834; and in the following year Stanfield was elected to full membership of the Academy.

An exact contemporary, Francis Danby, a Bristol landscapist of Irish descent, also enjoyed a remarkable rise to fame in London in the 1820s. Like Bonington, he enjoyed the patronage of Lawrence, was elected Associate of the Academy in 1825, and narrowly missed full membership (Constable being chosen instead) four years later. When, in 1827, a quarrel between Turner and W. B. Cooke led to the withdrawal of the painter from the projected publication of further views on the English coasts,

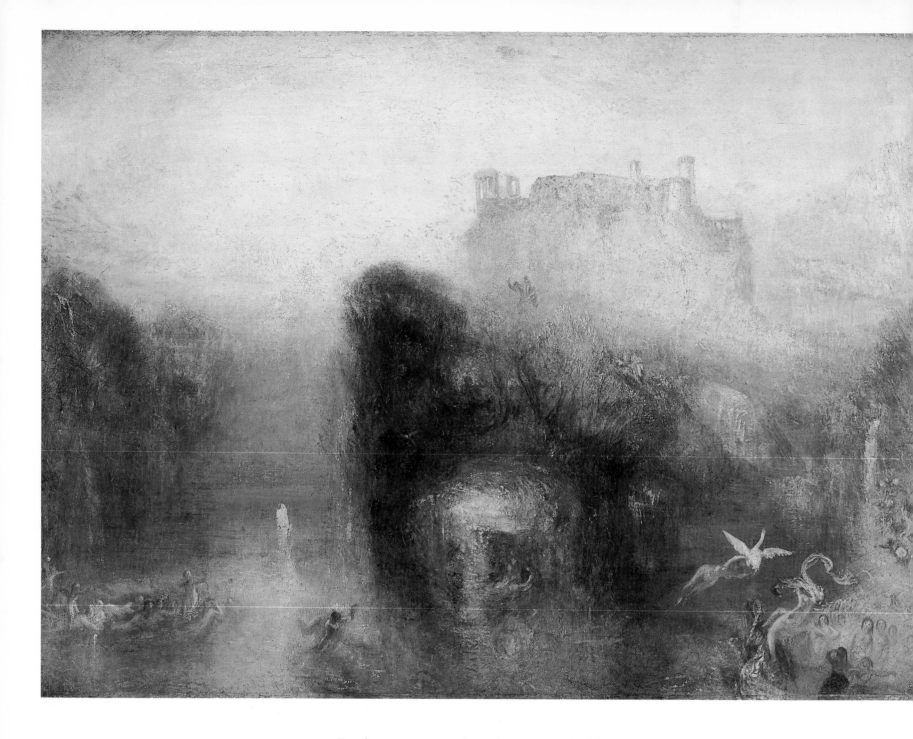

201. G. H. Phillips after Francis Danby, *The Enchanted Island*, 1841. Mezzotint, 22 × 34.1 cm. London, British Museum.

Danby was among the artists approached by Cooke to continue the series.[41] He was the toast of the Academy banquet in 1828, when Lawrence in a speech coupled his name with that of Turner himself.[42] Danby's early Bristol work consisted of local topography and *genre* in a highly individual style, but his London career was based on extravagant florid sunsets and Apocalytic subjects closely related to the sensational and very popular works of John Martin; indeed, he came to be seen as the Academy's answer to Martin, who had never applied for membership. Some of Turner's more strident sunsets over sea (e.g. *Fort Vimieux*, 1831, BJ 341), perhaps owe something to Danby, whom he defended on one occasion as a 'poetical painter'.[43] It was indeed for a poetical subject that he was most indebted to Danby: the *Queen Mab's Cave* (Fig. 200), which Turner showed at the British Institution in 1846, was, with its swans and bathing nymphs and unearthly light clearly a re-working of an idea used by Danby in his *Enchanted Island*, exhibited at the Academy in 1825, and reproduced as a mezzotint for a

second time in 1841 (Fig. 201). Danby had spent the 1830s abroad, but he returned to London in 1840 with the vast *Deluge*, now in the Tate Gallery, which may have stimulated Turner's return to this subject shortly afterwards (Figs. 302–3).

Turner's caption to *Queen Mab* was a characteristic confection of his own:

> Frisk it, Frisk it, by the Moonlight Beam
> Midsummer's Night's Dream
> Thy Orgies, Mab, are manifold.

Indeed they were, for the 1840s was the great period of 'Fairy Painting' in England, associated particularly with the names of Daniel Maclise, Richard Dadd and John Noel Paton. In the same year as *Queen Mab* Turner showed at the Academy a subject based on the German Romantic Fairy-Tale *Undine* (BJ 424), a subject which had perhaps been inspired by Maclise's painting from the same story, exhibited two years earlier, and bought by Queen Victoria for her German husband, Prince Albert. Turner, however, for all his wish to impress the Royal couple, had no interest in the fashionable Germanic precision of the younger artists; his aesthetic remained firmly wedded to the painterly handling which had seen its last great flowering with Bonington and his followers in the 1820s. No matter what his response to changing fashions, Turner was never prepared to barter his essential responses as a painter, which is why his versions of the themes of the moment always remain unmistakably his own.

IV

Turner was well suited to become the leader of landscape groups, and the master of individual landscape artists not simply because of the power of his painterly style, but also because he was concerned to spread his views on landscape among the widest possible public. In a codicil to his will, added in 1832, Turner mentioned his wish 'for a Professor [*sic*] in Landscape to be read in the Royal Academy elected from the Royal Academicians or a Medal called Turner's Medal ... for the best Landscape every 2 years ...'[44] The Academy opted for the medal (see Fig. 50), but the wish for lectures was probably closer to Turner's heart, for he had mooted them as early as 1811,[45] and his first great series of engravings, *Liber Studiorum* can, as its title, 'Book of Studies', indicates, be seen as part of a sustained campaign to make landscape an important teaching subject there. The origins of the *Liber* go back to Turner's friendship with the watercolour painter W. F. Wells, who was, according to his daughter,

> constantly urging Turner to undertake a work on the plan of Claude's Liber Veritatis. I remember over and over again hearing him say – 'For your own sake Turner you ought to give a work to the public which will do you justice – if after your death any work injurious to your fame should be executed, it then could be compared with the one you yourself give to the public.[46]

Claude's *Liber Veritatis* ('Book of Truth') had been designed by the artist as a record of his pictures and their purchasers, as some kind of guarantee against forgeries; and it had been reproduced rather indifferently in mezzotint in the 1770s by Richard Earlom. It was certainly this reproduction which Wells had in mind, but from the first, although the style of sepia etchings and mezzotints was close to Earlom's, Turner's *Liber* was to have quite a different function, and in fact only a small proportion of the plates were reproductions of existing works. The character of the work as it emerged was essentially a didactic one; its purpose, according to an early advertisement was 'to attempt a classification of the various styles of landscape, viz. the historic, mountainous, pastoral, marine and architectural.'[47] This was a thoroughly original

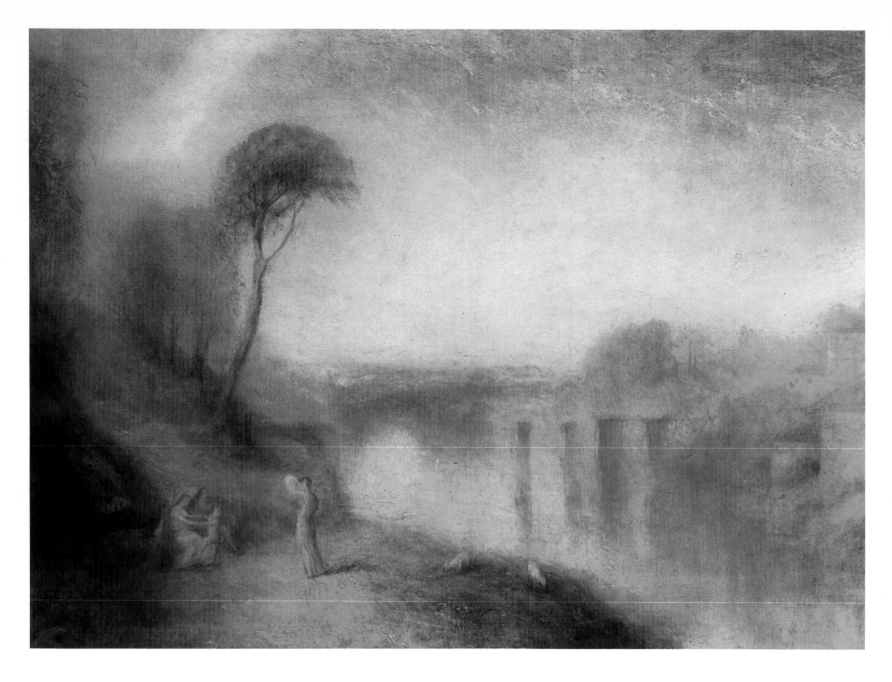

202. J. M. W. Turner, *Landscape: Woman with Tambourine*, c.1845. Oil on canvas, 88.5 × 118 cm. Mrs M. D. Fergusson (BJ 513).

203. Charles Turner after J. M. W. Turner, *The Woman and Tambourine*, 1807. Etching and mezzotint, 19.2 × 27.6 cm. Nottingham Castle Museum (RLS 3).

enterprise, for Turner was to show himself uniting the powers of all the traditional branches of landscape, from the highest, the historic, to the most humble, the architectural, and to present them together on the same plane. The inclusion of an architectural category is especially interesting, because it was a branch which, by 1806, Turner had effectively left behind him, and his interest may well have been rekindled by the discussions among architects in the Academy about the need for a teacher of perspective to succeed Edward Edwards, who had died in that year.[48] Turner, of course, assumed this post on the more elevated level of Professor in 1807, and it is clear from the closing lecture of the course that eventually began in 1811 that he was concerned to make propaganda for the range and competence of the genre very much on the lines of the *Liber Studiorum*.[49] Clara Wheeler recalled that it was her father, W. F. Wells, who 'arranged the subjects, Pastoral, Architectural, &c.&c. as they now stand';[50] and certainly the notions that lie behind the most interesting of Turner's categories, the Pastoral, also bear the stamp of Wells' mind and practice.

To transfer the concept of 'pastoral' from poetry to landscape-painting was something of a novel enterprise in the Romantic Period: but it had, significantly,

recently been used in the context of Gainsborough.[51] Wells was an authority on Gainsborough; he had just helped to engrave a series of fine facsimile reproductions after Gainsborough drawings, so that it is not surprising that among the first set of Turner's *Liber* plates to be published, the 'P' (Pastoral) subject *Bridge and Cows* (Fig. 167) was very much in Gainsborough's idiom. But Turner was not content with this humbler pastoral of domestic subjects; he also introduced a new category, 'E.P.', which he particularly associated with Claude.[52] The precise meaning of 'E.P.' has been much discussed, and the idea that Turner intended 'Epic Pastoral' has recently been revived by some commentators. At this time, however, Turner was deep in the theory of poetry, and he will certainly have known that Epic is a narrative form. None of the published 'E.P.' subjects embodies a narrative, which Turner reserved for the category 'H' (History), and it is almost certain that he used 'E.P' as the abbreviation of 'Elevated Pastoral', since 'elevation' in topography was one of the aspirations of landscape which, as we saw in the first chapter, he discussed in an important letter of 1811 to John Britton.[53] Although the first 'E.P.' subject, *Woman and Tambourine* (Fig. 203) was entirely modelled on Claude, and shows a typical scene in the Roman Campagna, most subjects in this category presented English topography, although in a thoroughly elevated, Claudian manner, with classical figures, which was also very much in the spirit of Wells' classicising approach to real landscape:

> I should certainly be delighted in taking a grave sentimental sort of ramble with you' – wrote Wells half-facetiously to a friend in 1812 – 'on the bold romantic beach you have so well described. I should like to watch the gradation of the rosy tints of evening, passing from the cool grey surface of the Scarborough crags till they rested on the more glowing & animated countenances of the Naiades & Dryades, whom I presume occasionally cheer your evening's walk, & for a *moment* call your attention from the towering rocks, the raging sea or the castled cliff . . .[54]

The progress of *Liber Studiorum* was a chequered one. We have already seen how a quarrel with the engraver Charles Turner led to a gap of eighteen months in publication, and the enrollment of a new team of engravers including J. M. W. Turner himself. In the 1810s there was a three-year break between the issuing of Parts 12 and 13; and about 1819, the date of the last published Part, matters seem to have come to a head. Of eight plates which Turner proposed to issue in January 1819, only three were ready for publication by that date (TB CLIII, p. 2a), and from a list of about the same time of possible subjects in the six categories (TB CLIV(a), pp. 25a–31), it seems that the painter was beginning to run out of ideas. *Pastoral* was unusually well provided-for: Turner was proposing to engrave not only existing paintings like *A Frosty Morning* (BJ 127), but also specially drawn subjects like hay-making, harvesting (cf. BJ 227) and potato-digging. Similarly, Turner had a fund of historical landscapes in mind, from *Hannibal* (Fig. 270) and *Carthage* (? BJ 131 or Fig. 290) to new subjects like *Cambyeus in the Desert* and *Elisha. Valley of Bones*.[55] However, not surprisingly, he was very short of Architectural subjects. As early as 1808 he had been obliged to move *Dunstanborough Castle* (RLS 14) from the Marine to the Architectural category; there are no clearly architectural subjects among the many unpublished plates; and Turner's last architectural contribution, the *Interior of a Church* (RLS 70), was engraved by him in 1816 from an unfinished and now barely legible early oil (BJ 24). No more plates were published after January 1819; although at least one of the unpublished subjects (Fig. 204) is based on experiences gathered on the Italian journey later that year, and the last date concerned with any plate is 1823.[56]

If the *Liber Studiorum* was essentially a didactic publication, closely associated with Turner's Academic teaching – and contemporaries certainly looked upon it as such[57] – it is ironic that neither the Royal Academy nor the British Museum acquired a copy

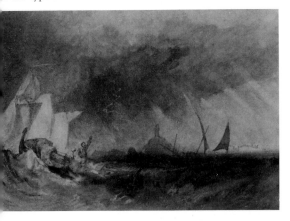

04. J. M. W. Turner, *The Felucca*, c.1820/3 (RLS 82). See Fig. 205 or this type of vessel.

05. J. M. W. Turner, *The Bay of Naples*, 1819. Pencil, 12.2 × 19.8 m. London Clore Gallery for the Turner collection (TB LXXXVI, p. 19) See Fig. 204.

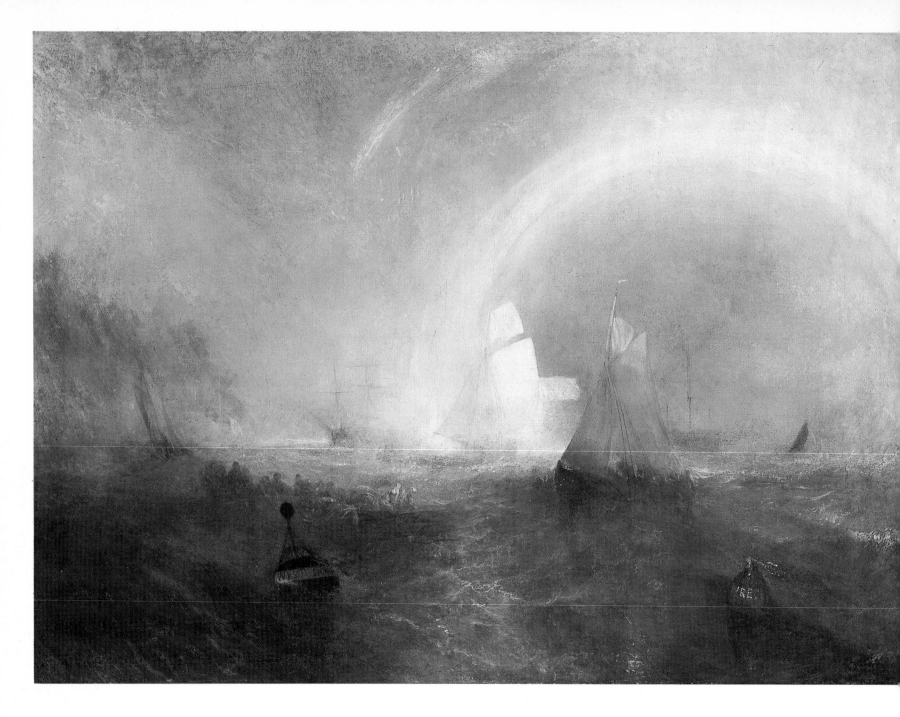

206. J. M. W. Turner, *The Wreck Buoy*, *c.*1807/49. Oil on canvas, 92.7 × 123.2 cm. R.A. 1849. Liverpool, Walker Art Gallery (BJ 428).

207. *(facing page)* Detail of Fig. 206.

until well after the painter's death.[58] It is unlikely that in the early years he sold above a hundred copies of all fourteen parts,[59] but in the 1840s sales did begin to pick up and, significantly, in 1844, a copy was acquired by the Society of British Artists, an exhibiting body established twenty years earlier.[60] This may have impressed Turner enough to have a further fifteen copies printed in 1845, although he held large stocks of unsold early impressions amounting to some seventy sets.[61] At the same time he turned again to the *Liber* for inspiration: the *Glaucus and Scylla* of 1841 (BJ 395) and *The Eve of the Deluge* of 1843 (Fig. 302) had both been *Liber* subjects, although they remained unpublished (RLS 73, 88), and about 1844 or 1845 Turner embarked on a number of large canvasses based on the series which was never completed or shown (BJ 509–15, 518–19; Figs. 22, 202).[62] Most of the subjects chosen for these paintings were in the 'E.P.' category, and even those which were not, the *Norham Castle, Sunrise* (P.), the *Europa and the Bull* (H.) and the *Inverary Pier* (M.) were treated to a warm, bright palette and a luminous Italianate atmosphere which takes us back to the Claudian

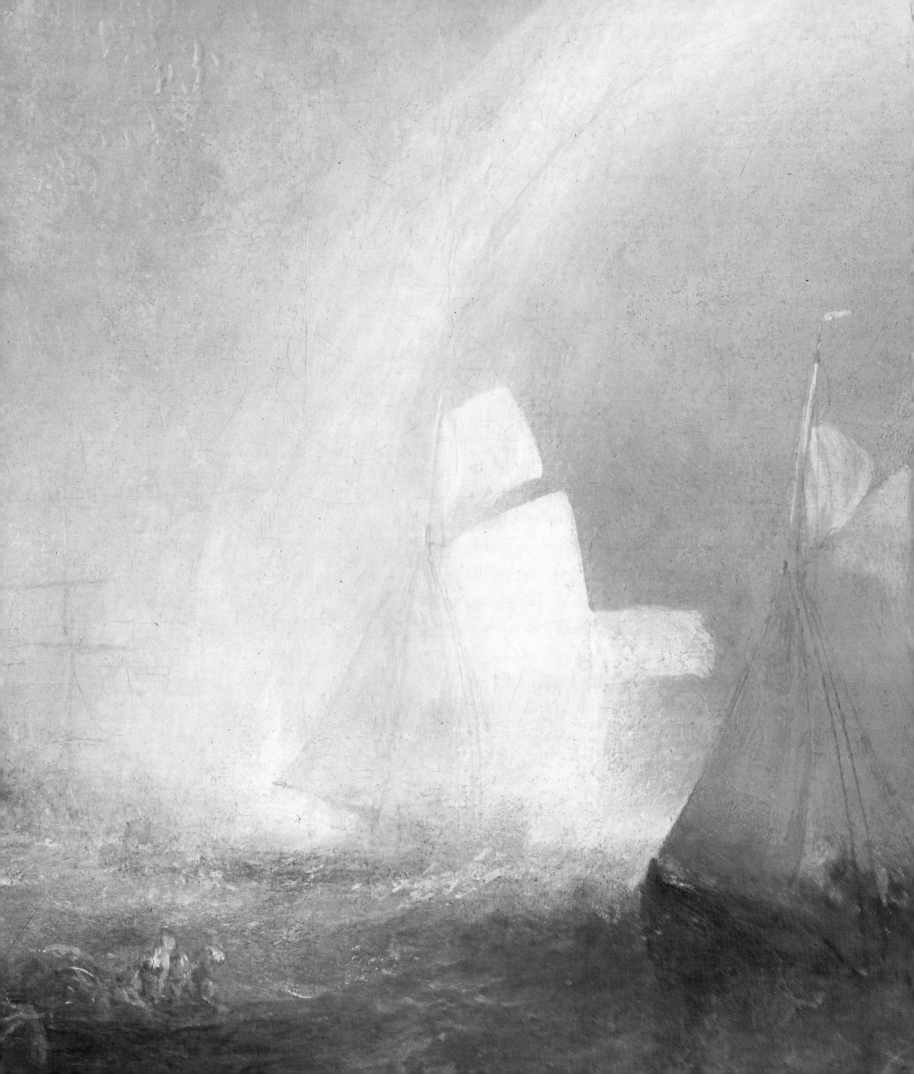

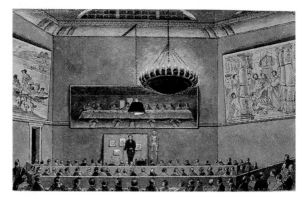

208. Edward Bell, *Mr. Green Lecturing at the Royal Academy*, c.1825/37. Pen and watercolour, London, British Museum. The drawing shows the Great Room at Somerset House as Turner will have lectured in it in the 1820s. The Professor of anatomy is flanked by two of Sir James Thornhill's copies of the Raphael Cartoons, and behind him is Marco d'Oggiono's copy of Leonardo's *Last Supper* (see p. 239).

origin of the *Liber* itself.[63] This series of cavasses is a dazzling testimony to the enduring power of that great but aborted enterprise and it was probably only Turner's failing health after 1846 which prevented him from making it an even more complete expression of his grandiose and magnificent conception of the role of landscape in contemporary art.

V

1811, the year of Turner's appearance as an engraver of *Liber Studiorum*, was also the year he began to deliver his lectures on perspective, and it was precisely at this time, too, that he first proposed a Professorship of Landscape for the Royal Academy.[64] Certainly he attempted to introduce a far more extensive consideration of landscape problems into his successive series than was usual in the teaching of this essentially technical subject; and by 1812 Soane was complaining that the lectures 'seemed . . . for the Professors of Painting and Architecture, the word Perspective hardly mentioned'.[65] Taking his cue from a discussion of backgrounds in the lecture on 'Invention' which Fuseli had delivered as Professor of Painting in 1805, Turner concluded his early series with a whole lecture devoted to landscape and architectural settings, into which he introduced both a potted history of landscape art, and his most important assessments of Old Master paintings, some of which I have already had occasion to quote. 'By the choice and scenery of the background', Fuseli had argued, 'we are frequently enabled to judge how far a painter entered into his subject, whether he understood its nature, to what class it belonged, what impression it was capable of making, what passion it was calculated to rouse: the sedate, the solemn, the severe, the awful, the terrible, the sublime, the placid, the solitary, the pleasing, the gay, are stamped by it . . .'[66] This sounds almost like a programme for *Liber Studiorum*, which was conceived only a year later; and in his own *Backgrounds* lecture, Turner was anxious, like Fuseli, to assimilate landscape and architecture primarily to the practice of history-painting:

> To select, combine and concentrate that which is beautiful in nature and admirable in art is as much the business of the landscape painter in his line as in the other departments of art. And from the earliest dawn of colouring, of combinations from nature, there can be traced . . . the value of attending to a method of introducing objects as auxiliaries by which each master endeavoured to establish for himself a different mode of arrangement by selecting what appeared most desirable in nature and combining it with the highest qualities of the Historic school either as a part of the subject, or even at times allowed [it] to be equal in power to the Historic department . . .[67]

Throughout this most important of his lectures there is a sense of urgent anxiety for the well-being of the British School of painting, and Turner concluded it with an exhortation to his students very much in the manner of Reynolds:

> To you therefore, young gentlemen, must the nation look for the further advancement of the profession. All that have toiled up the steep ascent have left, in their advancement, footsteps of value to succeeding assailants. You will mark them as positions or beacons in your course. To you, therefore, this Institution offers its instructions and consigns their efforts, looking forward with the hope that ultimately the joint endeavours of concording abilities will in the pursuit of all that is meritorious irrevocably fix the united Standard of Arts in the *British Empire*.[68]

Where Reynolds' parting words had been the name of his personal hero Michelangelo,

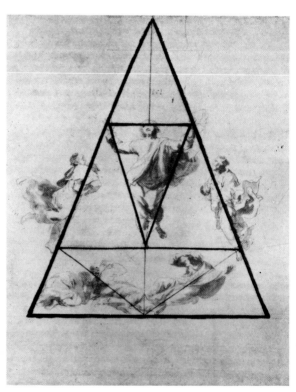

209. J. M. W. Turner, *Diagram of the upper section of Raphael's Transfiguration*. 73.8 × 53.8 cm, British Museum (T.B.CXCV No. 163). Turner used the diagram in his first lecture.

210. J. M. W. Turner, *Interior of Brocklesby Mausoleum*, c.1818. Watercolour, 63.5 × 48.2 cm. London, Clore Gallery for the Turner Collection (TB CXCV-130). A diagram used for Lecture V in 1818. Turner had visited the Mausoleum which James Wyatt had designed for Lord Yarborough at Brocklesbury Hall, Lincolnshire, about 1798 (see TB LXXXIII and CXXI-U).

211. J. M. W. Turner, *Glass Balls partly filled with Water*. Watercolour 45.4 × 68.1 cm. London, Clore Gallery for the Turner Collection (TB CXCV-177). A lecture-diagram illustrating types of reflection.

212. J. M. W. Turner, *The fall of the Clyde, Lanarkshire: Noon-Vide Akenside's Hymn to the Naiads*. Watercolour, 74.5 × 105.8 cm. R.A. 1802 Liverpool, Walker Art Gallery (W 343). This drawing was used as an illustration in the *Reflexes* lecture of 1818.

Turner, in the last desperate years of the Napoleonic campaigns, gave his an echo of the patriotic struggle.

Like others among his distinguished colleagues, Turner was an appalling public performer;[69] and a critic wrote in 1816:

> Excellent as are Mr Turner's lectures, in other respects there is an embarassment in his manner approaching almost to unintelligibility, and a vulgarity of pronunciation astonishing in an artist of his rank and respectability. Mathematics he perpetually calls 'mithematics', spheroids, 'spearides', and 'hairing', 'towaards' and such like examples of vitiated cacophany are perpetually at war with his excellencies. He told the students that a building not a century old was erected by Inigo Jones; talked of 'elliptical circles'; called the semi-elliptical windows of the lecture-room semi-circular, and so forth. Mr Turner should not in lectures so circumscribed as perspective, dabble in criticism; he is too great a master in his own art to require eminence in polite literature, but would confer a more essential service on his pupils and his country would he begin with the ABC of perspective . . .[70]

Another auditor, however, writing shortly after Turner's death, could afford to be more generous:

> [Turner] was often at a loss to find words to express the ideas he wished to communicate. To aid his memory, he would now and then copy out passages, which, when referred to, he could not clearly read . . . But when the spirit did stir within him, and he could find utterance to his thoughts, he soared as high above the common order of lecturers as he did in the regions of Art. His language was often elegant, his ideas original and most instructive, and it is to be regretted that copies of his graphic diagrams, as sketched on the lecture-boards, were not preserved with his notes.[71]

The chaos and illegibility of many of the lecture manuscripts confirm the negative assessment, but their content often substantiates the positive one.

Turner's long practice as a landscape painter had made him particularly aware of the shortcomings in earlier treatments of perspective, and he saw his own particular contribution as lying in the exploration and exposition of shadow-projection under various conditions of lighting, and the nature of reflection from various surfaces, topics which were, as we have already seen, productive of some exceptionally beautiful diagrams (Figs. 210–11), which fully justify the enthusiasm of the audience, some of whom, like the old Academy librarian Thomas Stothard, who was nearly deaf, thought that they were the only reason for attending. 'There is so much to *see* at Turner's lecture', he said, 'much that I delight in seeing, though I cannot hear him.'[72] Yet even the beauty of these diagrams, and the watercolours or paintings which Turner occasionally brought into the discussion (Fig. 212) could be a source of irritation, for according to one critic in 1819, they were 'hastily placed on and removed from the board, and the whole business of the lecture gone through like a matter of course, and as if the audience were already fully acquainted with the subject.'[73] Turner was generally very sensitive to these criticisms, and he constantly reworked both the shape and content of his successive lecture series. In the 1820s they became increasingly schematic and obscure, dealing with the intricacies of colour-theory as well as perspective itself, and by 1828 the Professor had lost his audience entirely. During the 1830s he began to develop a much more practical attitude towards teaching in the Life and Painting Schools at the Academy, and also on the Varnishing Days before each Exhibition.[74]

The arduous and wide-ranging preparations for the perspective lectures thus had little effect, except on Turner's own work, where they introduced him to a body of

213. Sir David Wilkie, *The Blind Fiddler*, 1806. Oil on panel, 58 × 78 cm. London, The Tate Gallery.

214. J. M. W. Turner, *A Country Blacksmith Disputing on the Price of Iron, and the Price Charged to the Butcher for Shoeing his Poney*. Oil on panel, 55 × 78 cm. R.A. 1807. London, Clore Gallery for the Turner Collection (BJ 68).

ideas which profoundly affected his approach to literature and to colour (see pp. 186–7). During the thirty years in which he held the office of Professor of Perspective, Turner had managed to deliver only twelve series of lectures, and although he continued to hope that he might resume them as late as 1832,[75] he never did. This omission was seized upon by a Radical group in the new reformed Parliament, which was using the pretext of the move from Somerset House to a new, publically-funded, National Gallery building in Trafalgar Square, to call the whole institution of the Academy into question. During the hearings of the Select Committee on Arts and Manufactures of 1835–6, which was the result of this Parliamentary agitation, the President of the Academy, Sir Martin Archer Shee, was asked a pointed question about the conduct of the teaching in Turner's subject, and he admitted that

216. J. M. W. Turner, *Harvest Home*, c.1811. Oil on panel, 90.5 × 122.8 cm. London, Clore Gallery for the Turner Collection (BJ 209).

215. J. M. W. Turner, *Lord Essex's 'Harvest Home'*, c.1811. Pen and brown-grey wash, 19.3 × 23.8 cm. London, Clore Gallery for the Turner Collection (TB CXX-C). A study for Fig. 216. For the inscription see p. 145.

The Academy have foreborne to press on the professor of perspective the execution of his duties as strongly as they might perhaps be expected to do partly because many of the members consider the process of lecturing as ill-calculated to explain the science of perspective; and partly from a delicacy which cannot perhaps be perfectly justified, but which arises from the respect they feel for one of the greatest artists of the age in which we live.[76]

It was almost certainly as a result of this public examination of the Academy that Turner finally resigned the Professorship soon after the move to Trafalgar Square in 1837.

VI

An openness and a sensitivity to the various categories of art which is so fully demonstrated in the *Liber Studiorum* also led Turner to sense and appropriate another major development in contemporary painting which had barely occupied him in his youth. The years between 1804 and 1820 were one of the greatest periods of British *genre* painting: that class of figure-subjects which stood low in the Academic estimation of art. The arrival of the brilliant young Scot, David Wilkie, in London in 1804; the conversion of the no less brilliant young Irishman, William Mulready, from landscape to *genre* about 1807; and the appearance of the well-established provincial painter Edward Bird at the Academy for the first time in 1809, brought a complete re-valuation of the significance of this type of subject, which now came to enjoy both the most distinguished and the most lucrative patronage, notably that of the Crown. Turner's response was characteristically swift: in 1807 he exhibited *A Country Blacksmith Disputing upon the Price of Iron and the Price Charged to the Butcher for Shoeing his Poney* (Fig. 214), his first major venture in this direction, and very similar in conception to Wilkie's *Village Politicians*, which had been a great success at the Royal Academy the previous year. A dispute about prices was particularly germane to the new fashion, for *genre* was commanding very substantial figures: when Sir John Leicester enquired of Turner the price of his painting, 'Turner answered that he understood Wilkie was to have 100 guineas for *His Blind Fiddler* (Fig. 213) & he should not rate His picture at a less price'.[77] In the series of paintings of this type in which Turner followed Wilkie over the next few years, the satirical element was heightened in an increasingly un-Wilkie-like way (Figs. 170, 175), and in what is perhaps the last of them, *Harvest Home* (Fig. 215), probably commissioned by the Earl of Essex as a companion to *Cassiobury Park: Reaping* (BJ 209a), but, like that panel, subsequently abandoned, the sense of the unruly, teeming rural life is unmatched in any of Turner's other work before the 1820s. On a sketch for the picture (which was probably stimulated by Wilkie's *Village Festival*), Turner outlined his conception of the subject (Fig. 217):

> Candles and Lanthorn and Chafing dish for the pipes. Horns, Mugs, Pudding dishes, Water pots for Beer-Sow and Pigs – Ducks – Shepherd – Boy and Dog – Master of the feast demanding Silence at the head of the table with large bowl – those around him looking eager and cunning at the hope of taking it next – Four men half drunk wanting more beer at the Barrel. Woman watching [?] her husband at the B.[78]

This strong element of caricature in a multi-figure subject was also close to the Bristol painter Edward Bird's *Country Choristers* of 1810 (Fig. 218). Bird's arrival on the London scene the previous year had led to his immediate identification as a rival of Wilkie, and the *Choristers* accentuated this rivalry when it was acquired by the Prince

17. Sir David Wilkie, *The Village Festival*, 1811. Oil on canvas, 93 × 127 cm. London, The Tate Gallery.

18. Edward Bird, *The Country Choristers*, 1810. Oil on canvas, 2.9 × 92.7 cm. Royal Collection.

219. J. M. W. Turner, *Cottage Steps: Children feeding Chickens*. Watercolour, 66.1 × 46.3 cm. Turner's Gallery 1809. Private Collection (W 490) Exhibited at the R.A. in 1811 as *May: Chickens*.

Regent for £250. In 1811, when he was on the Hanging Committee for the Academy exhibition, Turner is said to have improved the placing of one of Bird's pictures (perhaps *The Reading of The Will Concluded*, now at Bristol) by moving one of his own.[79] Nonetheless, possibly incensed at the Royal favour extended to this humble category of art, he composed about this time a low satirical ditty in a very similar vein to the pictures themselves:

> Came Flattery, like a Gipsey came
> Would she were never heard
> And muddled all the fecund brains
> Of Wilkie and of Bird
> When she call'd either a Teniers
> Each Tyro stopt contented
> At the alluring half-way house
> Where each a room hath rented.
> Renown in vain taps at the door
> And bids them both be jogging
> For while false praise sings to each soul
> They'll call for t'other noggin.[80]

Turner himself now abandoned *genre* until about 1820, when, as we shall see in the next chapter, he was also attempting to gain the attention of the Crown.

The great success of painters of *genre* at the R.A. in these years was matched and even surpassed by those who treated the same range of subjects in watercolour. The foundation of the Society of Painters in Watercolour in 1804 helped to encourage a marked expansion in the range and ambition of watercolour specialists, who increasingly included historical and *genre* subjects in their repertory. In 1808 one of the founder-members, Joshua Cristall, showed at the Society's exhibition a large subject-watercolour of *The Fish-Market, Hastings* (Victoria and Albert Museum), this started a fashion for beach-scenes bustling with fisher-folk which was soon taken up by Turner, and resulted finally in the enigmatic *Fish-Market, Hastings* of 1824 (Fig. 296).[81] Cristall's most considerable follower was Thomas Heaphy, who in 1809 showed a *Fishmarket* – also at Hastings – which is now lost, but which fetched 400 guineas at the time, more than Turner ever received for any but his largest works in oil. It was regarded by the critic of *The Beau Monde* as Heaphy's masterpiece: 'The characters and expressions of the figures are minutely faithful to nature, and the grouping and colouring of the fish are admirable. Nobody who would see this kind of art in perfection should omit seeing these fish. The mackerel in particular glisters with all the vivid and various hues of nature herself...'[82] Heaphy made fish something of a speciality, and at the Academy in 1812 and 1813 he showed several detailed studies of them, one of which was acquired by Turner's patron, Walter Fawkes. It may have been Fawkes's liking for Heaphy and Cristall that persuaded him to buy Turner's, *May: Chickens* (Fig. 219), which was so closely modelled on Heaphy's subjects (Fig. 220), just as its companion, *November: Flounder Fishing* (w. 491) was in the style of Cristall. Turner's return to the Academy exhibition of 1811 as a watercolourist, with three other large drawings besides these two, in a range of styles representative of the Water-Colour Society, was almost certainly related to the debate initiated by the President of the Academy, Benjamin West, who was a great supporter of Heaphy, and who had suggested the previous year that the law which prevented exclusively watercolour painters from becoming Academicians should, in the light of these important modern works, be repealed.[83] One of Turner's exhibits of 1811, *Windsor Park: with Horses by the Late Sawrey Gilpin, Esq.R.A.* (Fig. 221) was, in fact, a work of collaboration with another Academician who was also an outstanding watercolourist, and Turner seems to have been indicating

222. Thomas Stothard, *Sans Souci*, c.1817. Oil on panel, 78 × 50 m. London, Tate Gallery.

223. J. P. Quilley after J. M. W. Turner, *Boccaccio: The Bird Cage*, 1830. Mezzotint, 57.4 × 42.7 cm. Yale Center for British Art (R 797).

220. *(facing page, middle)* Thomas Heaphy, *Inattention*, 1808. Pen and watercolour over pencil, 64.5 × 50.2 cm. Yale Center for British Art.

221. *(facing page, bottom)* J. M. W. Turner, *Windsor Park: with Horses by the late Sawrey Gilpin Esq. R.A.*, c.1805/7. Watercolour, 54.8 × 75.6 cm. R.A. 1811. London, Clore Gallery for the Turner Collection (W 414).

his view that watercolour should not be the specialist medium fostered by the new Society.[84] West's suggested reform in fact came to nothing; Heaphy applied unsuccessfully for membership of the Academy in 1812; and, for its part, the Water-Colour Society had the same year to yield to public pressure and falling sales and admit oil paintings to its exhibitions as well.

During the 1820s a new fashion in *genre* painting arose in England, and again Turner did not hesitate to make it his own. It was a fashion for small and brightly-coloured scenes from Renaissance and seventeenth-century history and fiction, in which two of the key figures were the veteran illustrator Thomas Stothard and the patron Samuel Rogers. Both of them directed Turner's attention to the painting of Watteau. We shall see in the next chapter that Turner's first use of a Watteauesque idiom, in the *Richmond Hill* of 1819, was probably directed by his wish to impress the Prince Regent, but it was Stothard who, about the same time, came to be the most vigorous follower of Watteau in England (Fig. 222). In 1815 he had visited Paris with Turner's friend Francis Chantrey, and it was probably the Watteau's he saw there which stimulated him to paint a number of park-scenes in the style of the French painter, one of which, *Fête Champêtre*, among his largest paintings, was exhibited at the Royal Academy in 1818 and at the British Institution the following year, and acquired by Turner's patron, Lady Swinburne.[85] But Stothard's exhibition pictures were usually very small, and it was a picture very much in this style, *What You Will* (Fig. 224), one of the smallest paintings that Turner ever exhibited, which appeared at the Exhibition in 1822 and was bought by Chantrey, at whom it was almost certainly aimed.[86] The characters from Shakespeare's *Twelfth Night (or What You Will)*, Olivia with her attendants, Sir Toby Belch, Sir Andrew Aguecheek and Maria, were all associated with Stothard, who had illustrated the play for several publishers and exhibited a series of the characters at the Academy in 1813. But in his playful use of the alternative title for the play Turner was also punning on the name of the French artist, and what was probably his Cockney pronunciation of it.

In the mid-1820s Turner became involved with Stothard in a collaboration for Rogers on the new luxury edition of the patron-poet's *Italy*, which finally appeared in 1830. Rogers had long been one of Stothard's most important supporters, and he was also a major collector of Watteau's work: one of the Watteau's from his collection, *La Lorgneuse*, was reproduced by Turner in his 1831 tribute to the master, *Watteau Study by Fresnoy's Rules* (Fig. 244). In his large exhibition picture of 1828. *Boccaccio Relating the Tale of the Birdcage* (Fig. 223), Turner paid a double tribute to Stothard and to Rogers, for it was closely modelled on the *Sans Souci* (Fig. 222) and the scenes from Boccaccio, versions of which were in the poet's collection.[87] It was while he was working on the *Boccaccio* on one of the Varnishing Days at the Academy that Turner remarked to C. R. Leslie, 'If I thought [Stothard] liked my pictures as well as I like his, I should be satisfied. He is the Giotto [*sc.* Watteau] of England'.[88] In 1830 Turner went with Rogers to the sale of one of the most important collectors of Stothard's work, Robert Balmanno, where he bought a group of engravings after the master, and an oil of the garden scene from *Romeo and Juliet*.[89]

VII

Even after the disgrace of the perspective lectures, Turner remained deeply involved in Academy affairs. Yet, although he was still auditor of the accounts, and hence closely involved in what came most directly under Parliamentary attack during the 1830s, his attitude towards the call for public accountability remains ambiguous. He was not, for example, among the thirty-odd Academicians and Associates who in 1839 presented

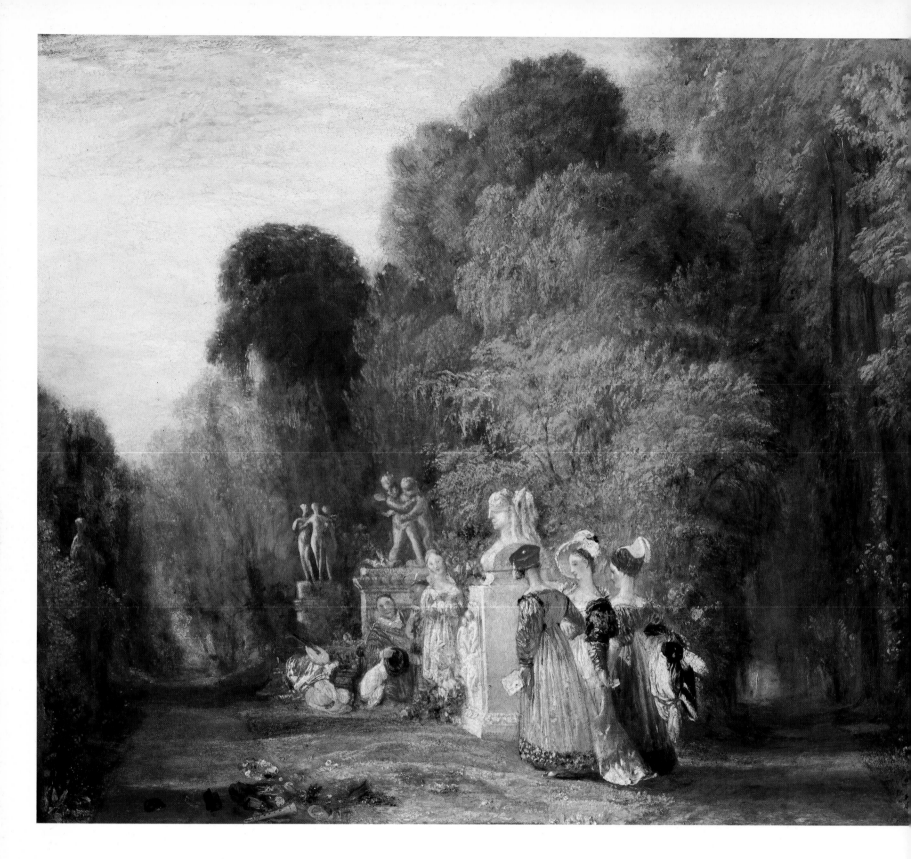

224. J. M. W. Turner, *What You Will!* Oil on canvas, 48.2 × 52 cm. R.A. 1822. Sir Michael Sobell (BJ 229).

225. *(facing page)* Detail of Fig. 224.

Parliament with a petition against the demand to provide it with details of the Academy's financial affairs.[90] What is clear, however, is that when Sir David Wilkie (who had been the closest contender against Shee for the Presidency of the Academy in 1830) died in 1841, Turner was ready to commemorate him with a pair of paintings which embodied many allusions to these Academic struggles of the previous decade. (Figs. 226, 228). In making his last tribute to his dead friend in *Peace, Burial at Sea* (Fig.

226. J. M. W. Turner, *Peace – Buriel at Sea*. Oil on canvas, 87 × 86.5 cm. R.A. 1842. With the caption:
'The midnight torch gleamed o'er the steamer's side
And Merit's corse was yielded to the tide'.
— *Fallacies of Hope*
London, Clore Gallery for the Turner Collection (BJ 399). A pendant to Figure 228.

227. Benjamin Robert Haydon, *Napoleon Musing at St Helena*, 1831. Oil on canvas, dimensions and whereabouts unknown. Wordsworth wrote of this painting in a sonnet, 'I applaud those signs of thought, / That give the true poetic thrill'. Haydon painted between twenty-five and forty replicas of it, one of which was in the collection of Turner's patron Samuel Rogers and another, with the framed dimensions of 429.7 × 384.8 cm, was shown at the British Institution in 1844. A smaller version is at Chatsworth.

226), Turner must have been conscious of his debt to the artist, who at the Academy's General Assembly of 10 February 1838 had moved a resolution expressing the 'extreme upset [the Academicians] feel upon the loss of the services of a Professor who, by precept and example, has done so much to advance the cause of Perspective in the English School.'[91] Conversely, the companion picture, *War, The Exile and the Rock Limpet* (Fig. 228) made a direct allusion to the very popular *Napoleon Meditating on St. Helena* (Fig. 227) by another close friend of Wilkie's, Benjamin Robert Haydon, who was at the same time the most embittered enemy of the Academy, and had played a major role as advisor to the Radical group, led by William Ewart and Joseph Hume, which was the spearhead of the Parliamentary attack. Haydon had been a prominent witness before the Select Committee of 1835–6,[92] and a petitioner for the prosecution in the last and abortive attempt to call the Academy to order three years later.[93] When this unfortunate artist died by his own hand in 1846, Turner's laconic and disparaging comment was 'he stabbed his mother', meaning the Academy itself.[94]

Napoleon, like Haydon (and like Turner himself), was a small man with large ambitions, and in Turner's picture he is reduced to comparing his own lot with the good fortune of a mere rock-limpet who is able to live out his life in his chosen home. The imperial conqueror is set against one of Turner's bloodiest sunsets which, reflected in the wet sand, shows by the painter's extraordinary elongations that even the stature of this superman was nothing but a mirage.

It was at this time that Turner reached what was to be the summit of his academic

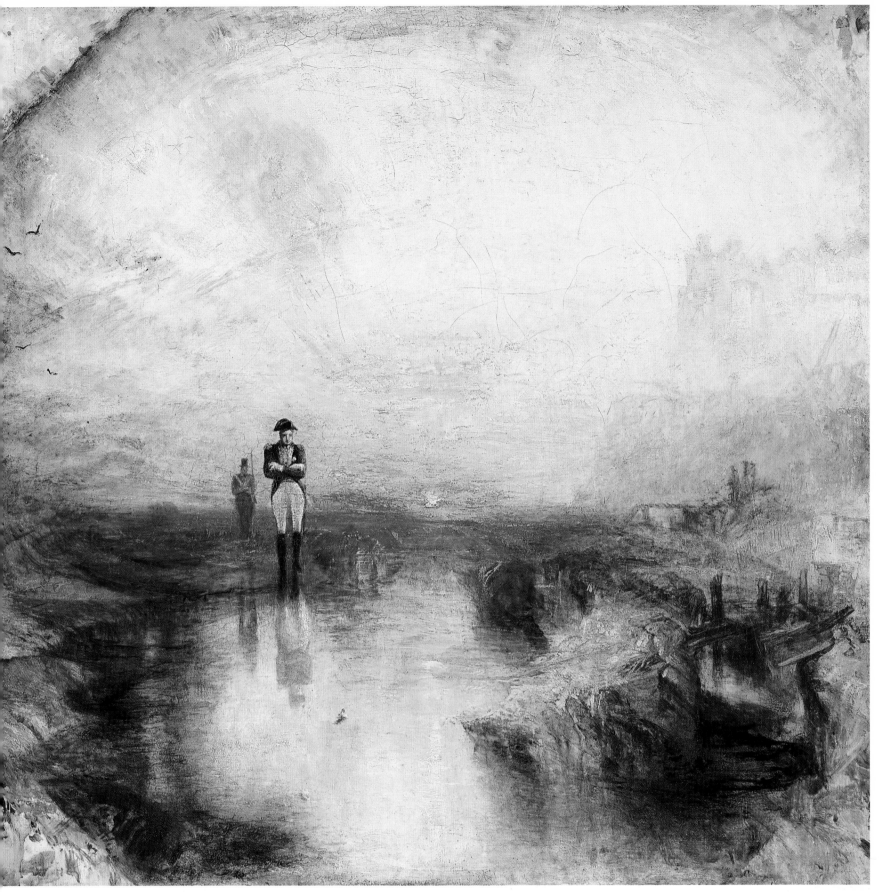

228. J. M. W. Turner, *War. The exile and the Rock Limpet.* Oil on canvas, 79.5 × 79.5 cm. R.A. 1842. With the caption:
'Ah, thy tent-formed shell is like
A soldier's nightly bivouac, alone
Amidst a sea of blood –
but you can join your comrades.'
– *Fallacies of Hope*
London, Clore Gallery for the Turner Collection (BJ 400). A pendant to figure 226.

career. Shee had been exhausted by the events of the 1830s; early in 1845 his health finally broke down completely, and he was obliged to retire. There was, as usual, great agitation among the rest of the Academicians about who should succeed him; the most likely candidate seemed to be Turner's old friend Charles Lock Eastlake, but even Turner declared that he was not prepared to serve under any other President than Shee.[95] As the oldest Academician, and a member of the Council, he had in fact been deputising for the President since February of that year; Shee formally offered his resignation in May; but at the end of July the body of Academicians, under Turner, begged him to withdraw it and act through deputies until his health was restored.[96] In the event, Turner held the office of Deputy President ('Pro Pre') until the end of his term on the Council in December 1846, and it is likely that he intended the copy of Michelangelo's poems which he presented to the Academy in May of that year to stand as a memento of this service.[97] Shee never returned to the Academy and after his death in 1850 he was succeeded by Eastlake.

But the two years as Deputy President also took their toll of Turner's health. He was ill in May 1845 and had to leave London to recuperate on the coast, in Margate and in France.[98] Writing to John Ruskin in December 1846 Turner referred to his relief that the 'unpleasant duty' was at least coming to an end, and to Francis Hawksworth Fawkes he confessed

> sorry to say the tiresome and unpleasant duties of [presiding] during the continued illness of our President for two years – viz my rotation of Council – and being senior of the lot made me Pro Pre – it distroyd my happiness and appetite [so] that what with the business and weak[ness] I was obliged to give [up] my Summer's usual trip abroad.[99]

Certainly the quality of Turner's exhibition pictures in 1845 and 1846, especially the Venetian subjects (BJ 416–9, 421–2) suggest carelessness and a lack of concentration, and these were the last new works in oils to be completed before 1850.

VIII

The pressure of affairs in London seems to have made Turner long to escape from his house and gallery, and in the autumn of 1846 he began to look around for smaller quarters with a view over the river.[100] William Etty, whose rooms in Buckingham Street attracted Turner's attention, conjectured that it was the delapidation of the Queen Anne Street house that had finally made Turner decide to move. The house, gallery and studio had certainly been in a state of chaos for many years: and a visitor in 1842 has left a vivid account of this delapidation:

> The house had a desolate look. The door was shabby, and nearly destitute of paint, and the windows were obscured by dirt. When I rang the bell the door was opened a very little bit, and a very singular figure appeared behind it. It was a woman covered from head to feet with dingy whitish flannel, her face being nearly hidden. She did not speak, so I told her my name, and that Mr Turner had given me permission to see the pictures. I gave her my card and a piece of silver with it, on which she pointed to the stair and to a door at the head of it, but she never spoke a word, and shutting the door she disappeared.
>
> I felt a strange lonely feeling come over me as I looked about before going into the gallery. The hall was not like that of an ordinary London house. It had a square empty appearance; no furniture in it, a dingy brown colour on the walls, and some casts from the Elgin marbles inserted in the upper part. Everything was covered

with dust, and had a neglected look. When I entered the gallery and looked at the pictures I was astonished, and the state in which they were shocked me. The skylights on the roof were excessively dirty, many of the panes of glass were broken, and some were awanting altogether. It was a cold wet day in autumn, and the rain was coming in through the broken glass, on to the middle of the floor; and all the time I was there – fully an hour – I had to keep my umbrella up over my head . . . two of the finest [of the pictures], 'The Rise of Carthage' and 'Crossing the Brook' were in anything but a good condition. The sky of the first was in a very unsatisfactory state. It was cracking – not in the ordinary way, but in long lines, like ice when it begins to break up. Other parts of the picture were peeling off – one piece, I recollect, just like a stiff ribbon turning over . . . There were also a few of Turner's very recent pictures, placed on easels about the gallery, and these I did not like at all. Their general appearance was whitish, with one or two singular prismatic bits of colour, concentrated in a very wonderful manner certainly, but with no natural forms, no local colour, and no tangible shapes – such as trees or buildings or mountains. I had no sympathy with them, and I could hardly believe that they were painted by the same person who had done the magnificent works I have noticed. . . . I walked backwards and forwards in the gallery, feeling cold and uncomfortable – no sound to be heard but the rain splashing through the broken windows upon the floor, where it must have been dripping for three hours. I at last found a common, and very dirty chair, and sat down in the middle of the room, with my umbrella over my head, and I became abstracted in contemplating the finest of the pictures. From this state I was brought back to myself by feeling something warm and soft moving across the back of my neck; then it came on my shoulder, and on turning my head I was startled to find myself confronted by a most peculiarly ugly broad-faced cat of a dirty whitish colour, with the fur sticking out unlike that of any other cat. The eyes were of a pinky hue, and they glared and glimmered at me in a most unearthly manner, and then the brute moved across my chest, rubbing its head and shoulders against my chair. I put up my hand to shove the creature away, and in doing so let my umbrella fall, and this startled four or five more cats of the same kind, which I observed moving about my legs in a most alarming way. I did not like the thing at all, and to tell the truth I was frightened. So I picked up my umbrella and made for the door, and got to the foot of the stair as fast as I could. On looking back I saw the cats at the top glaring at me, and I noticed that every one of them was without a tail. As I could see nothing of the housekeeper, I opened the door for myself, and shut it after me with a bang, so that she might hear I had gone.[101]

In the event Turner settled on a small cottage overlooking the Thames off the Cremorne Road at Chelsea (Fig. 229). It belonged to a widow he had known at Margate, Sophia Booth, whose 'Admiral Booth' he became, living there more or less incognito for the rest of his life. 'The top of the house is flat', wrote J. W. Archer, who visited it shortly after Turner's death, and made a watercolour of it

229. James Wykeham Archer, *Turner's House at Chelsea*, 1852. Watercolour, 37.3 × 27.2 cm. London, British Museum. 6 Davis Place was Turner's home between 1846 and his death in 1851.

and this space he had railed in, and there he would be often at daybreak watching the scenery of the river. The upper or western view he called the English view, and that down the river the Dutch view. During his last illness the weather was dull and cloudy, and he often said in a restless way, 'I should like to see the sun again.' Just before his death he was found prostrate on the floor, having tried to creep to the window, but in his feeble state he had fallen in the attempt. It was pleasing to be told that at the last the sun broke through the cloudy curtain which so long had obscured its splendour, and filled the chamber of death with a glory of light.[102]

The sun was certainly for Turner an important source of solace and inspiration during the Chelsea years; both of the watercolours that can be directly associated with

230. J. M. W. Turner, *Sunset*, *c.*1846/51. Watercolour and bodycolour on grey paper, 17.8 × 26.4 cm. Cambridge, Fitzwilliam Museum (W 1418). Given, according to an inscription on the back, to Turner's last doctor, W. Bartlett, by the painter's Chelsea landlady, Sophia Booth, in 1855.

his last days, since they were given by Mrs Booth to the surgeon who attended the painter on his deathbed, are studies of sunlit clouds and water (Fig. 230) (w. 1417–8). Turner also spent time on the river, where he was ferried by the father of Whistler's later companion, Walter Greaves;[103] and it was at Chelsea that he found a young man, Francis Sherrell, to help with the cleaning and arranging of the works in the Queen Anne Street Gallery.[104] But he did very little new work in oil. At the Academy in 1847 he showed only one painting (BJ 427), which was a hasty re-working of a much earlier canvas; and he seems to have devoted more time and energy to touching on the works of his younger neighbours, painting in part of the rainbow for Maclise's *Sacrifice of Noah* (Leeds City Art Gallery), and advising the new Associate J. R. Herbert on his painting of *Our Saviour subject to his Parents at Nazareth* (replica in Guildhall Art Gallery, London).[105] In 1848 Turner had no exhibits, and the following year he borrowed an early sea-piece from Munro of Novar and again transformed it with a rainbow and other details into *The Wreck Buoy* (Fig. 206). Although he appeared occasionally in London society and at the Academy, these last years were essentially ones of retreat, and it is with some surprise that we find the painter returning with great force at the Exhibition in 1850 with four paintings on the theme of Dido and Aeneas (Fig. 283).

These are the only oils we know Turner painted at Chelsea, for Mrs Booth watched him working on them 'set in a row and he went from one to the other, first painting on one, touching on the next, and so on, in rotation'.[106] This was Turner's last appearance as an exhibitor, although in 1851, a few months before his death, he attended at least one Varnishing Day and the Academy Dinner. It is characteristic of the man that, to the last, he should have supported his institution for itself, and not simply as a platform for his own work and his own ideas. In the end he was buried in St Paul's Cathedral beside Reynolds, Opie and Fuseli, the founding President and two Professors of Painting, as he put it in his will, 'among my Brothers in Art'.

CHAPTER SIX
The Uses of Patronage

231. John Henderson Snr. *A Watermill*, 1794. Soft-ground etching. London, British Museum.

DURING the second half of the eighteenth century the public for art in England was enormously expanded by the institution of regular public exhibitions, notably these mounted by the Royal Academy each summer in London. Turner from his earliest youth took full advantage of these opportunities; he exhibited at the Academy from the age of fifteen; soon after he became established as an Academician he opened his own private gallery; and when a rival exhibiting body to the Academy, (the British Institution), was founded by a group of amateurs and collectors in 1805 as he began to send his work there too. These were direct channels of access to the public which eroded the traditional relationships of private patronage; and yet for all his distaste for patrons as a class,[1] Turner continued throughout his life to work for them on commission and to deal directly with them over long periods on terms of intimacy more reminiscent of the High Renaissance than of the nineteenth century. What did private patronage offer him that could not be supplied by the wider public?

In one of his more extended attacks on the ambition and influence of the critic and the 'man of taste', Turner accused them of fostering amateurs rather than artists.[2] By 'amateur' Turner understood the unprofessional art-fancier in general, but in his day many such amateurs were also dilettante artists, who sometimes showed at the Royal Academy under the title of 'Honorary Exhibitor'. Turner's earliest patrons included several amateurs of this sort, notably Dr Monro, whose 'Academy', described in Chapter One, served, among other things, to develop the practical skills of the doctor himself and later of his sons, three of whom became artists of greater or lesser distinction.[3] Monro's own style and techniques remained closest to Gainsborough, but those of the sons, and of his intimate friend and neighbour John Henderson, an amateur artist whose outlines were among those copied by the young painters at Monro's, were very much more in tune with what was developing in the 'Academy' in the mid-nineties. Henderson may even have been in the vanguard, for his soft-ground etching of a mill (Fig. 231), dated 1794, shows precisely the type of obviously 'Picturesque' motif and crumbling outline which was first used by Turner in the same year (Figs. 232–3).[4] But what was probably even more important to Turner than the examples and the rather meagre remuneration offered him by the Monro School, was its atmosphere of enthusiastic activity and discussion, based on Monro's collection of works by many old and recent masters; and he continued to visit it long after he had ceased to be a *protegé* in any formal sense.[5]

Monro also brought Turner into touch to a wide range of collectors and patrons, some of whom proved to be important to the young artist in later years. The first of

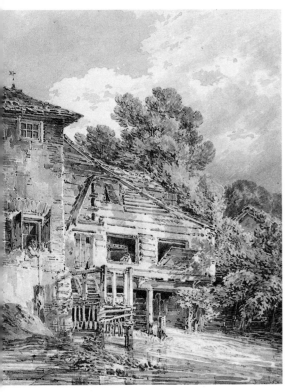

32. J. M. W. Turner, *The Old Watermill*, 1794. Watercolour over pencil, 25.1 × 18.7 cm. University of Manchester, Whitworth Art Gallery (W 83).

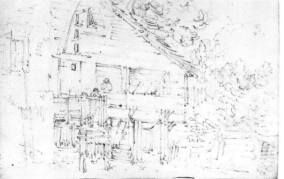

33. J. M. W. Turner, *The Old Watermill* 1794. Pencil, 16.1 × 10.8 cm. London, Clore Gallery for the Turner collection (TB XX, pp. 18a–19).

these was probably the banker William Lock of Norbury Park, near Leatherhead in Surrey, who became a neighbour of Monro's when the doctor began to rent a cottage at nearby Fetcham in 1795. Turner was working at Norbury soon after this, and Monro acquired several of his drawings of Norbury subjects (W 153–5). I suggested in an earlier chapter how Lock's great collection of paintings and drawings by Wilson must have been important to Turner at the turn of the century, and Lock's close friendship with a fellow-banker John Julius Angerstein gave Turner his most likely *entrée* to the collection of Old Masters, including the superb Claudes, which Angerstein had gathered. It was Angerstein who first forced Turner's prices up by offering him forty guineas for the watercolour of *Caernarvon Castle* (Fig. 156), which, the painter said, 'was much greater than [he] would have asked'.[6]

Among the older artists in the Monro circle during the late 1790s was the portrait-painter John Hoppner, formerly a pupil of Reynolds, whom, as we have seen, Turner was particularly anxious to court in his progress towards membership of the Royal Academy. Hoppner had long been a friend to the Lascelles family of Harewood House in Yorkshire, and in 1797 Edward Lascelles junior acquired his first Turner watercolour (W. 138) and presumably invited the painter to work the same summer at Harewood, where he made a large number of sketches which were developed into watercolours for the family (W 217–223).[7] Lascelles also commissioned what are the first major surviving oils executed by Turner for a private patron, two views of Plompton Rocks on the Harewood estate, which were installed as furnishings in the library about 1798 (BJ 26, 27). This was a traditional eighteenth-century function for landscape painting, but Turner never lent himself to it again until in the late 1820s he executed a comparable series for the Carved Dining Room at Petworth (Fig. 248). Nevertheless, although the Lascelles family continued to buy both watercolours and oils from Turner well into the nineteenth century, they seem to have had little direct contact with him, and to this extent they remain untypical of the pattern of patronage he developed.

The art-boom of the Romantic period also had a very practical dimension in teaching, and for watercolour painters in particular the chief alternative to topographical work for publication was the profession of drawing-master in schools or private families. Hoppner tells us that Edward Lascelles practiced a little, but he does not say who his master was, which makes it unlikely that it was either Turner or Thomas Girtin, who also worked at Harewood in the late 1790s. Turner did teach in this way for a time, although he soon abandoned this career, ostensibly on the grounds that he could never earn more than a few shillings a lesson.[8] But he maintained his contact with a number of his former pupils, and even continued to teach in an informal way for many years.

One such pupil was Julia Bennett, whom Turner was teaching regularly as late as 1797, and who in the 1820s, as Lady Willoughby Gordon, was responsible for commissioning a number of small oils from him. One of these (Fig. 235), shown at the Royal Academy in 1826, was a view from her seaside villa at Niton, on the Isle of Wight, and was, as the Academy catalogue made clear, based on her own sketches (cf. Fig. 234).[9] She has, indeed, just left the scene, abandoning her paintbox and palette on the grass. We do not know how vigorously Turner sustained the connection with this family in the intervening years, but Lady Gordon was the sister-in-law of Sir John Swinburne of Capheaton in Northumberland, who was an important patron of Turner's in the 1810s, and whose son Edward, was also an amateur artist of some distinction (Fig. 236), and continued to patronise him into the 1840s.[10] The Swinburnes in their turn were close friends of two other amateur artists who were also patrons of Turner, Sir William Pilkington, of Stanley in the West Riding of Yorkshire and, most important of all, Walter Fawkes of Farnley, Turner's most substantial friend and

235. (right) J. M. W. Turner, *View from the Terrace of a Villa at Niton, Isle of Wight, from Sketches by a Lady*. Oil on canvas, 45.5 × 61 cm. R.A. 1826. Boston, Mass., Mr William A. Coolidge (BJ 234).

234. Lady Willoughby Gordon, *Sketch at Niton*. Watercolour, Private Collection. See Fig. 235.

236. Edward Swinburne, *Coniston Beck*. Watercolour, University of Manchester, Whitworth Art Gallery.

237. J. M. W. Turner, *The Woodwalk, Farnley Hall, c.*1818. Watercolour and body-colour on grey paper, 29.2 × 40 cm. Cambridge, Fitzwilliam Museum (W 602).

supporter during the first half of his career.[11] Fawkes, who had bought six oils, including *The Dort* (Fig. 160) and about two hundred and fifty watercolours by the time of his death in 1825 (Figs. 63, 65–6), was perhaps Turner's dearest friend, and his house, not far from Leeds, became a second home to the painter, who made annual visits of a month or so from about 1808. It was also a second studio, and the Fawkes children were among the few outsiders permitted to witness Turner at work. It is from their accounts that we learn most of his virtuoso performances as a watercolour artist, in particular of the making of *A First-Rate Taking in Stores* (Fig. 238) in November 1818:

One morning at breakfast Walter Fawkes said to [Turner], 'I want you to make me a drawing of the ordinary dimensions that will give some idea of the size of a man of war'. The idea hit Turner's fancy, for with a chuckle he said to Walter Fawkes' eldest

238 J. M. W. Turner, *A First-Rater taking in Stores*, 1818. Watercolour over pencil, 28.6 × 39.7 cm. Bedford, Cecil Higgins Museum (W 499).

son, then a boy of about 15, 'Come along Hawkey, and we will see what we can do for Papa.', and the boy sat by his side the whole morning and witnessed the evolution of 'The First-Rate Taking in Stores'. His description of the way Turner went to work was very extraordinary; he began by pouring wet paint on to the paper till it was saturated, he tore, he scratched, he scrabbled at it in a kind of frenzy and the whole thing was chaos – but gradually and as if by magic the lovely ship, with all its exquisite minutia, came into being and by luncheon time the drawing was taken down in triumph.[12]

We have already seen the importance of the periods Turner spent at Farnley for the development of his late style.

In the early years of the century Fawkes' relationship with Turner was on a normal professional footing: he acquired works by commission or from exhibitions, and on the basis of pre-existing sketches. But as their friendship ripened, and as Turner spent more and more time at Farnley Hall, so the character of his work for Fawkes changed. It became more intimate and more autobiographical, recording the house and the

239. *(facing page)* Detail of Fig. 238.

240. J. M. W. Turner, *A Dead Black Cock*, c.1815/20. Watercolour and bodycolour over pencil on toned paper, 25.8 × × 23.1 cm. London, British Museum (W 632).

241. J. M. W. Turner, *Study of Fish*, c.1825. Watercolour over pencil, 27.5 × 47 cm. London, Clore Gallery for the Turner Collection (TB CCLXIII-339).

242. J. M. W. Turner, *Grouse Shooting*, c.1813. Watercolour, 28 × 39 cm. London, Wallace Collection (W 535).

estate, as well as the sporting activities there, in which Turner himself took a vigorous part. Turner visited Farnley chiefly in the shooting season, and, just as he had done for Fawkes' friend Pilkington (Fig. 242), he documented activities in the field. Patronage for Turner came to mean not simply a question of economics but also of entertainment, and it introduced him to a style of country life to which he had certainly not been born. And in the case of another of Fawkes' friends, Sir John Fleming Leicester, of Tabley Hall in Cheshire (whence Turner probably made his first excursion to Farnley in 1808), it likewise meant sport as well as art. According to a *protegé* of Leicester's, Henry Thomson, R.A., Turner spent most of his stay at Tabley in 1808 fishing, rather than painting the two large views of the lake and grounds which were the object of his visit. And since Sir John was a devoted angler as well as an amateur painter and lithographer, who proposed to illustrate his own treatise on British fishes, it is conceivable that some of Turner's own studies of fresh-water fish (Fig. 241) were related to this unrealised project. Only some very undistinguished prints by Leicester, made in the 1820s, are known at present, but he had been a pupil of Paul Sandby, and the journalist William Jerdan recalled an episode at Tabley during one of Turner's visits which shows that life there was not just a matter of sport:

> In the drawing room stood a landscape on an easel on which his Lordship was at work as the fancy mood struck him. Of course, when assembled for the tedious half hour before dinner, we all gave our opinions on its progress, its beauties and its defects. I stuck a blue wafer on to show where I thought a bit of bright colour or a light would be advantageous; and Turner took the brush and gave a touch, here and there, to mark some improvements. He returned to town, and – can it be credited! – the next morning at breakfast a letter from him was delivered to his Lordship containing a regular bill of charges for 'Instruction in Painting'. His Lordship tossed it across the table indignantly to me and asked if I could have imagined such a thing; and as indignantly, and against my remonstrances, immediately sent a cheque for the sum demanded by 'the drawing-master'.[13]

We should dearly like to know what Turner thought of charging for 'teaching' at this late stage in his career.

The relaxed atmosphere of banter and artistic gossip was even more characteristic of Petworth House in Sussex, the chief seat of the third Earl of Egremont, whom we have already met at Cockermouth Castle. Egremont had been a major patron of Turner's from the beginning of the century; during the 1810s their friendship cooled, but when it rekindled in the late 1820s the Earl soon came to fill the place in Turner's affections left by the death of Fawkes. Yet, although he spent substantial periods at Petworth nearly every year between 1827 and Egremont's death ten years later, and although he executed large numbers of works at the house, some of which relate specifically to the family history and collections (Figs. 177, 248), Egremont never again became Turner's patron in the narrowest sense. Whereas Fawkes at the time of his death was indebted to Turner to the tune of some thousands of pounds, none of Turner's Petworth works, including the long series of miniature evocations of the interiors and the company (Figs. 124, 243, 246), seem to have been commissions, and all remained in Turner's hands.

Egremont was not, so far as we know, a practising amateur, but his mistress (and subsequently wife) Elizabeth Ilive, certainly was,[14] and from an early date the Third Earl does seem to have regarded his role as sponsor of art to be rather in providing working facilities for artists than commissions as such.[15] This was an emphasis not at all uncommon in Romantic patronage. Constable's close and life-long relationship with Sir George Beaumont, who never acquired any of his paintings, also reflects the view of a distinguished amateur that it was pleasant and instructive to cultivate the company of professionals for its own sake; and it was an important prelude to the greatly

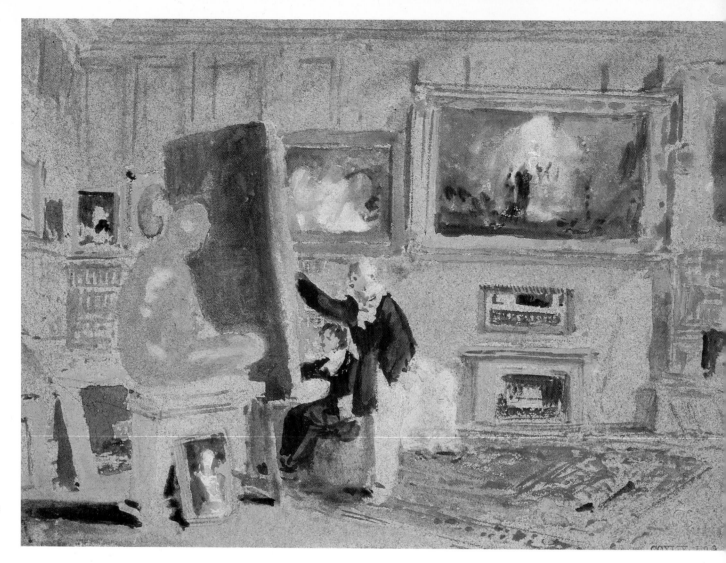

243. J. M. W. Turner, *Petworth: the Old Library*, c.1828. Bodycolour on blue paper, 13.9 × 18.8 cm. London, Clore Gallery for the Turner Collection (TB CCXLIV-103). This room was Turner's studio at Petworth; see also Fig. 246.

244. J. M. W. Turner, *Watteau Study by Fresnoy's Rules*. Oil on panel, 40 × 69.5 cm. R.A. 1831, with the caption:
'White, when it shines with unstained lustre clear,
May bear an object back, or bring it near.
 Fresnoy's Art of Painting 496'
London, Clore Gallery for the Turner Collection (BJ 340). The composition included copies of Watteau's *La Lorgneuse*, then in the collection of Turner's patron Samuel Rogers, and of Fig. 247.

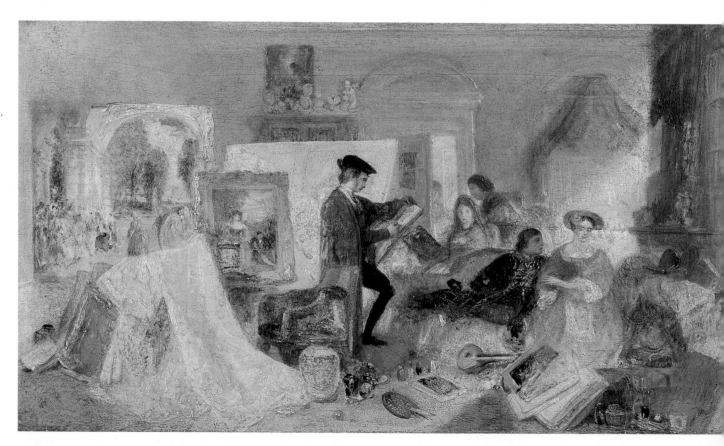

245. (*facing page*) Detail of Fig. 244.

246. J. M. W. Turner, *Petworth: The Old Library*, c.1828. Bodycolour on blue paper, 14 × 18.9 cm. London, Clore Gallery for the Turner Collection (TB CCXLIV-102). Another view of Turner's Petworth studio (see Fig. 243).

247. Antoine Watteau, *Les Plaisirs du Bal*. Oil on canvas, 52.6 × 65.4 cm. Dulwich Picture Gallery.

enhanced social standing of artists in the Victorian period. With its busy atmosphere and bohemian life-style Petworth, as it is presented by Turner (Figs. 243, 246), came, indeed, to have something of the character of an informal academy. We saw in Chapter Four how Egremont's interests at Cockermouth came to engage Turner in an aesthetic debate as early as 1809; now in the years around 1830 the painter's debt to these very personal stimuli was even more unmistakable. A family tradition has it that *Jessica* (Fig. 138) was painted in response to a challenge to Turner from some other painters staying at Petworth that a figure could not be painted on a yellow background. The plausibility of this story is reinforced by the fact that one of several models for the painting, the *Woman with a Rosebud*, then regarded as an imitation of Rembrandt, hung in the 1830s in the Old Library, which was Turner's Petworth studio and which, as his gouaches show, was also the resort both of artists and of the company in general.[16] One of these drawings (Fig. 246) shows a demonstration of painting on a large scale in this room, bringing up to date the same theme that was presented in Turner's first didactic subject from the life of an artist, the *Watteau Study* of 1831 (Fig. 244). This painting, which embodies a lesson in the use of white and black, used not only a general evocation of the Petworth setting, but also a quantity of its furnishings, including the Chinese vases which the American painter C. R. Leslie, who was much at Petworth in these years, regarded as a model for the colourist.[17] Both the formal content of the painting, and its ostensible subject, are redolent of the discussions and exercises for which Petworth became famous.

The Third Earl was himself prepared to take issue on the subjects, if not the styles, of the painters under his roof. When the watercolourist G. P. Boyce visited Petworth in 1857 he heard from the old butler how his master had disputed with Turner the likelihood that the vegetables strewn across the foreground water in *Brighton from the Sea* (Fig. 248) could in fact float and hence form part of the composition: '[Turner] asked for a tub of water and some of the identical vegetables and found the latter all sank. They were evidently too useful in his picture to be removed.'[18] Boyce was right, but in defence of Turner's realism it should be said that the estate-grown vegetables provided by the Earl were probably too fresh for the painter's purposes: he was, after all, painting garbage.

48. J. M. W. Turner, *Brighton from the Sea*, *c*.1829. Oil on canvas, 3.5 × 132.1 cm. Tate Gallery and the National Trust (Lord gremont Collection) Petworth House (BJ 291).

When Egremont died in November 1837 Turner was deeply affected. He never returned to Petworth except for the Third Earl's funeral ten days later, an occasion of great pomp and solemnity which the painter wanted to commemorate in a pair of canvasses which for some reason he left unfinished (Figs. 249–50). In the first, a group of mourning figures seems to whisper together in a sombre interior which has something of the character of the Marble Hall at Petworth House; in the companion picture the same interior has been transformed by light. The mourners have left, and Egremont's coffin stands open and empty. The Third Earl's presence is marked only by the burst of blinding light through the central archway, which has scattered the splendid furnishings in confusion while – and this is the most poignant and most Turnerian touch of all – one of the many dogs who were Egremont's constant companions raises himself in a sudden movement, looks up, and howls. His loss is as great as any, for, as another of the Earl's many artist-beneficiaries, Benjamin Robert Haydon, wrote on his death, 'the very animals at Petworth seemed happier than in any other spot on Earth – better fed, and their dumbness & helpless dependence on Man more humanly felt for . . .'[19]

Turner's loss was equally acute, but there is reason to think that he quickly sought to find some replacement for the sort of stimulus he had enjoyed at Petworth, and earlier at Farnley. In a letter written a few weeks after Egremont's death to the surgical-instrument maker and amateur artist and journalist John Hornby Maw, Turner thanked him for his 'offer to fill up in part' this loss; and two years later Maw made him a more practical offer of 'a large Painting Room & Studio', probably at his new home in Hastings.[20] Maw was a minor collector and copyist of Turner's drawings, and was on intimate terms with many watercolour artists, who enjoyed his hospitality. He had also been a founder-member of one of the several artists' *conversazioni*, or workshops, meeting in London in the early 1830s. The topographical watercolourist Samuel Prout

249. J. M. W. Turner, *Mourners at Petworth (Dinner in a Great Room with Figures in Costume)*, c.1837. Oil on canvas, 91 × 122 cm. London, Clore Gallery for the Turner Collection (BJ 445). A pendant to Fig. 250.

250. J. M. W. Turner, *The Apotheosis of Lord Egremont (Interior at Petworth)*, c.1837. Oil on canvas, 91 × 122 cm. London, Clore Gallery for the Turner Collection (BJ 449).

wrote that Maw had 'a rich store of art' and could 'talk with draw[in]gs as with the artist, disentangling all the science & process', and he was indeed the author of a treatise on landscape painting, so that he is likely to have been able to afford Turner, on a far more modest scale than either Fawkes or Egremont, something of the congenial *ambiance* he had so long enjoyed with them. But nothing seems to have come of Maw's offer, and in the mid-1840s Turner had to make his own retreat at Chelsea, where he was able to live in seclusion for the remaining years of his life.

The last of Turner's major patrons was a wealthy young Scottish laird, Hugh Andrew Johnstone Munro of Novar, who had acquired about thirteen oils and some one hundred and thirty watercolours by the painter at the time of his (Munro's) death in 1864. Turner's relationship with Munro became particularly close; we first hear of him in a letter of 1826 to their mutual friend James Holworthy, which already suggests some warmth of affection; and in the 1840s Munro was the most important collector of the great Swiss watercolours which Turner disposed of through his dealer Thomas Griffith (Fig. 85). Munro was not only Turner's patron but also his companion; he had been encouraged by the painter to develop his own talents as an artist, which an obituarist thought might have won him a high place in the Academy had he chosen to make them his profession.[21] In 1836 Turner and Munro travelled together to the Val d'Aosta, where they sketched side-by-side; and Turner was quite uncharacteristically free with his drawings, making a number in Munro's own sketchbooks and allowing him to keep them afterwards.[22] The detailed history of Munro's large collection of Old Masters, as well as works by modern English artists has still to be unravelled, but his tastes certainly coincided with Turner's on several points. The collection included a version of Titian's *Venus of Urbino*, on which Turner's own unfinished *Reclining Venus* of 1828 (BJ 296) was based; and it is worth remarking that in 1830 Munro acquired, as his first major Turner oil, the Titianesque *Venus and Adonis* of about 1803 (Fig. 125).[23] Munro, like his friend Holworthy, also had a particular affection for Watteau, and for his English follower Thomas Stothard: he owned a dozen works attributed to Watteau, and twice that number of Stothards; and we have seen how much both these masters were in Turner's mind in the years around 1830. Munro was also much interested in Dutch marine painting of the seventeenth century; he owned two rare sea-pieces attributed to Jacob Ruisdael, whose reputation as a marine painter was alluded to by Turner in paintings of 1827 and 1844.[24] Munro's second major acquisition from Turner was the *Rotterdam Ferry Boat*, now in Washington (BJ 348), and one of his last the *Ostend* in Munich (BJ 407), whose cool tonality is very much in line with the marines by Willem van de Velde, Backhuisen and Jan van de Capelle which were also in his collection. Among his English landscapes were many Wilsons, and paintings and drawings by Richard Parkes Bonington to whom we have seen Turner was, again, particularly indebted to in the late 1820s and early 1830s.

Even in the matter of major acquisitions, Turner showed towards Munro the relaxed attitude of an intimate friend. In a letter to Ruskin Munro wrote of three paintings shown by Turner in 1836, *Rome from Mount Avetine* (BJ 365), *Juliet and her Nurse* (BJ 366) and *Mercury and Argus* (BJ 367), as if they had been destined for him by some informal arrangement which never became a firm commission. He did acquire the first two, but *Mercury and Argus*, although according to Munro it embodied some Scottish topography close to his estate, he declined to buy, not because he did not like it, but because, as he said 'I was ashamed of taking so large a haul'.[25] The picture remained on Turner's hands for nearly a decade. His handling of the sale of *Modern Italy – The Pifferari* (BJ 374), shown in 1838, is even more indicative of this friendly attitude. The picture had been painted for another young friend, the Rev. E. T. Daniell, who is best known as a gifted amateur artist. Daniell, however, could only afford £200, and the painting was in Turner's usual 250 guineas format. The painter appears to have

agreed to lower his price for a close and impecunious friend, but the affair dragged on, and a year after the exhibition the work went away to an engraver to be reproduced, and remained with him for three years. Daniell in the meantime had gone to the Holy Land, where he died in 1842. Munro had already bought the companion picture, *Ancient Italy – Ovid Banished from Rome* (BJ 375) from the Academy in 1838, and after Daniell's death he hoped to own the other work too. Turner hesitated, saying that he wanted to keep it, but eventually he allowed Munro to have it at the same low price, 'saying he should stand in poor Daniell's shoes. I can't make money by that picture.'[26]

This brief account of Turner's relationship with some of his most important patrons illustrates three recurrent themes. They were often to be found in the same circles of friends; they sometimes owned substantial collections of Old Master paintings; and, most important of all, they were often practising artists. The repeated complaint of critics in the 1830s and 1840s that Turner was a 'painters' painter', and could only be understood by artists thus points to an important truth, for he was often working for collectors who were themselves practically involved in matters of technique, and interested in the issues that it raised.

II

But it was not only the grander collectors among the aristocracy and gentry to whom Turner catered, and he did not always act as his own agent. His lifetime saw a vast expansion in the role of the art-dealer in England, and this expansion was helped by the rise of many newer collectors from the merchant and manufacturing classes, who were interested more or less exclusively in modern British art, and among whom Turner found an enthusiastic reception. It will be instructive to look a little more closely at the economic mechanisms of Turner's successful career.

Although the characteristic pattern of Turner's economy in the 1790s was the production of watercolours for private individuals or engravers, his work also appeared for sale on the open market from a very early date. His later disciple and friend Augustus Wall Callcott, recalled seeing his first Turner, a drawing of a watermill, in the window of a frame-maker, stationer and colourman, Henry Brookes in Coventry Street, Haymarket, who also ran a kind of circulating library for the loan of drawings to copy.[27] It was an upright drawing, about ten inches high, and was priced at half a guinea, which was more than Callcott could afford. It must have been very like the sheet now in Manchester (Fig. 232), and it price seems very modest, since this episode cannot be much earlier than 1794, and in that year Turner seems to have received $2\frac{1}{2}$ guineas directly from the purchaser of a watercolour of *Llanthony Abbey* only slighter larger than this *Mill*.[28] But during this decade Turner usually dealt directly with his clients, and by the time of his election to full Academician his prices had already become very high. The forty guineas payed by Angerstein for *Caernarvon Castle* (Fig. 156) was something of a sport, but by 1799 Turner was regularly receiving ten guineas for small drawings and twenty-five for large.[29] The price of the earliest surviving oil (BJ 1) seems to have been ten pounds in 1796, but only a year later the rate for this size of picture had more than doubled.[30] The large *Fifth Plague of Egypt* (Fig. 162) was sold to Beckford for 150 guineas in 1800, and the following year Turner received 250 guineas for *Dutch Boats in a Gale* (Fig. 159) – for which he tried unsuccessfully to secure another twenty guineas for the frame. By 1804, 300 to 400 guineas was a standard price for Turner's largest canvasses, like *The Festival upon the Opening of the Vintage at Macon* (Fig. 62), and 100 guineas for his standard small ones. These figures were very high if we compare them with, say, Gainsborough's charges both for portraits and landscapes, which had never exceeded five hundred guineas by

the time of his death in 1788. Callcott later recalled the very shrewd way in which Turner established his prices at this time:

> When Turner first opened his Gallery [in April 1804] He hesitated whether he shd ask one or two hundred guineas for about a *Half length* size picture; and determined on the *larger sum*, as in that case if He sold only Half the number He might otherwise do His annual gain would be as much & his trouble less.[31]

Yet this calculation contrasts markedly with Turner's behaviour towards a sympathetic patron, the banker Samuel Dobree in the same year, when the painter presented him with a small canvas to supplement two which Dobree had bought, and asked him to set his own price for them, 'for you know my feelings and opinions on that score'.[32]

It would, however, be entirely wrong to assume that Turner's great fortune was amassed solely through the sale of his work at such elevated prices. He never received more than six hundred guineas for a picture, and that in the single case of the gigantic *Battle of Trafalgar* (Fig. 184); and his income was, in fact, derived as much from investments as it was from art. In 1798, a year of acute depression for the arts in England,[33] Turner was advised by Farington to start saving, and that he took this advice is attested by the large number of Government Stock certificate numbers which begin to appear in his sketchbooks from that date.[34] By 1810, Turner's ownership of stocks amounted to several thousands of pounds, and many of his receipts from patrons and clients seem to have been invested directly in the Funds.[35] About this time, too, Turner began to purchase property,[36] and by the time of his death he not only owned his house and gallery in Queen Anne Street in London, but also two houses in Harley Street, a cottage in Chelsea, three cottages at Great Missenden, Bucks, near Barking, Essex and in Epping Forest, as well as plots of land at Barkingside and Twickenham, part of which he sold very profitably to the South-Western Railway Company in 1848. He had also inherited a row of cottages at Wapping, in East London, which he converted into a public house, *The Ship and Bladebone*.[37] The rents from these various properties brought Turner a considerable income, and it is against this background that his careless and eccentric handling of later patrons, and his several ventures into ambitious publishing schemes which had little chance of success, must be set.

Not that Turner was unconcerned about the income his art could bring him; he had, indeed, a reputation for close dealing, and in the second half of his career he turned increasingly to the professional picture-dealers for help in the marketing of his work. By far the most important of these was Thomas Griffith, who became Turner's chief agent in the 1840s. Griffith came from a well-to-do family, had been a student at Cambridge and seems to have been destined for the bar; certainly he appears to have conducted a legal business in tandem with his dealing. Already in his twenties he had become a collector of watercolours, and these remained his preferred form of art. This in itself marks him out as an unusual figure in the art-economy of that time. It is not known when or how Griffith began dealing; as late as 1834 he was known to the watercolourist John Sell Cotman simply as a prince among collectors, 'a wholesale purchaser of the *best works* of modern art';[38] but he had been acting as agent for another watercolourist, Peter de Wint, for example, as early as 1830;[39] and a decade later a score of artists, including Turner, presented him with a piece of plate in gratitude for his services to them. Recording this event, *The Athenaeum* described Griffith blandly and misleadingly as 'an amateur of pictures, whose fortune places him above the necessity of dealing, [and] engaged in the delicate task of smoothing the difficulties which occasionally arise between painters and their patrons'; and certainly in the case of Turner there was a good deal of smoothing to be done. When, probably in the 1840s, a syndicate of five or six gentlemen tried to persuade Turner to sell *Dido Building*

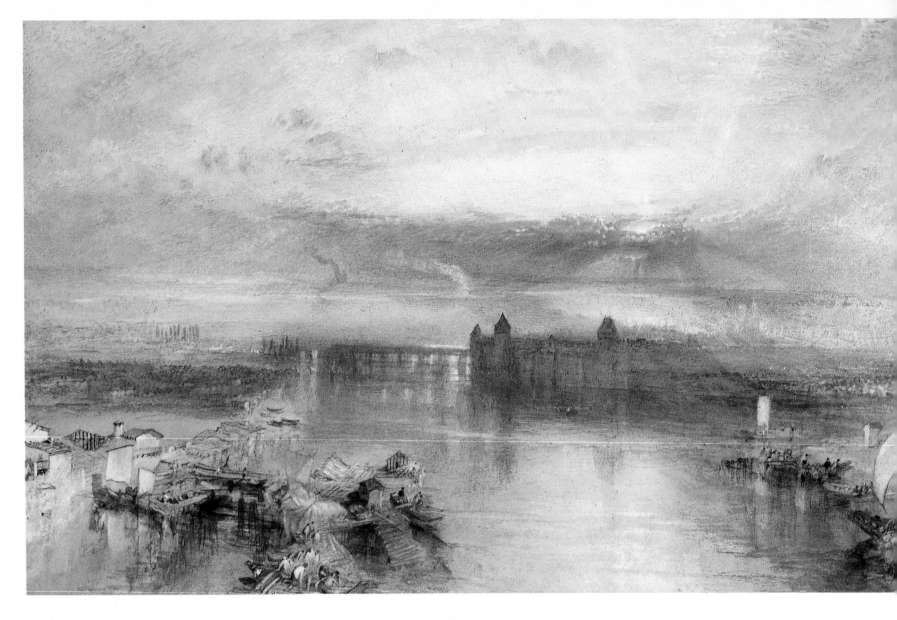

251. J. M. W. Turner, *Constance*, 1842. Watercolour, 30.4 × 45.4 cm. York City Art Gallery (W 1531).

Carthage (Fig. 291) for the National Gallery, they used Griffith as their intermediary, but he had a difficult time of it, for Turner was still aggrieved that it had not been bought when it was originally exhibited in 1815. When Griffith told the painter that the offer was now ten times Turner's original price, 'Turner was much moved and said to himself: "That makes amends, That makes amends" more than once.' He asked for time to write an answer, and, after several months delay, he did so: 'Sir, I decline the offer, but I will leave the picture in the gallery', that is, in his Bequest to the nation.[40]

Griffith was similarly unsuccessful as a negotiator when an American collector offered first £5000 and then a blank cheque for *The Fighting Temeraire* (BJ 377) in 1848; and in his most important transaction, the production of the three series of large watercolours of Swiss subjects in the early 1840s, he was unable to fulfil Turner's own wish to find purchasers for all of them. Early in 1842 Turner gave Griffith a group of fifteen 'sample' sketches, from which he was prepared to make ten large finished works; and he also brought with him four of these finished watercolours to give the dealer an idea of their quality. He reluctantly settled on a price of eighty guineas each, including a 10% commission for Griffith. The dealer could find buyers for only nine drawings: five went to Munro of Novar and two each to Elhanan Bicknell and Ruskin, to whom we are indebted for the details of the commission. Turner could not resist completing the tenth drawing, *Constance* (Fig. 251), and he let

252. J. M. W. Turner, *Zurich: Fête, Early Morning*, 1845. Watercolour over pencil, 29.3 × 74.5 cm. Zurich, Kunsthaus (W 548). One of the last Swiss drawings acquired by Windus through Thomas Griffith. The foreground shows a silk market.

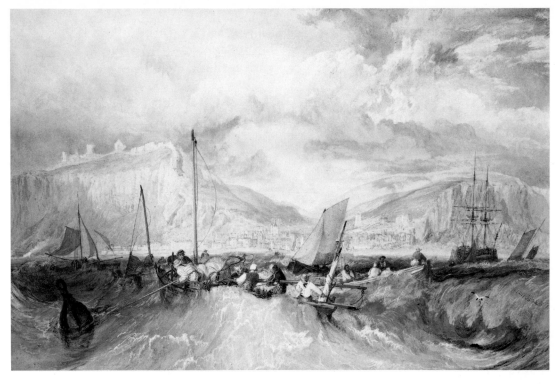

253. J. M. W. Turner, *Hastings from the Sea*, 1818. Watercolour, 39.8 × 59.1 cm. London, British Museum (W 504).

254. *(following pages)* Detail of Fig. 251.

Griffith have it in lieu of his commission. The following year the story was repeated, but this time only two buyers could be found, Munro, who took four, and Ruskin, who again took two of the drawings (Fig. 300). In 1845 a further set was prepared, executed primarily for Munro and Ruskin, but also for B. G. Windus (Fig. 252) who had, according to Ruskin, declined to buy examples of the 'Swiss' series earlier as 'the style was changed, [and] he did not quite like it.'[41]

The Athenaeum had claimed that in dealing with Griffith, 'the artist fixes and receives the whole price for his productions.' In the case of the Swiss drawings this was not quite so; nor was it with paintings, for we know from a letter of Turner's to his dealer in 1844 that for the large oil, *Fishing Boats with Hucksters Bargaining for Fish* (BJ 372) – a significant title – 'any who likes may offer what they please'.[42]

One of Griffith's most constant clients was the collector who had proved such a reluctant purchaser of the Swiss drawings, Benjamin Godfrey Windus, a coach-maker of Tottenham, on the northern outskirts of London. Windus, like another tradesman, John Hornby Maw, was among the first collectors to devote himself almost exclusively to watercolours, of which he had already lent a group to the 'Old' Water-Colour Society's exhibition in 1823. The previous year he had seen Turner's large *Hastings from the Sea* (Fig. 253) at an exhibition arranged by the engraver W. B. Cooke, and seems to have made his first Turner acquisition. Cooke supplied Windus with many other drawings during the 1820s and early 1830s;[43] and in the latter decade he bought several of his superb collection of some thirty-six *England and Wales* drawings from Griffith. Some of them, however, perhaps those supremely economical sheets like *Brinkburn Priory* (Fig. 117), which were lent by Windus to the great exhibition of *England and Wales* at the publishers Moon, Boys and Graves in 1833, seem to have been executed by Turner at Windus's own house, for another painter and collector, James Orrock, recalled, 'I have been informed, on unimpeachable authority, that each of the matchless drawings which were painted for Mr Windus of Tottenham, was executed there in a day.'[44] As we saw in Chapter Three, this would certainly not have been an impossibility, given Turner's extraordinary working methods at this date. By 1840 Windus had collected more than two hundred watercolours by Turner (see Fig. 255), and thereafter he turned his attention chiefly to the late oils (Fig. 132), all of which,

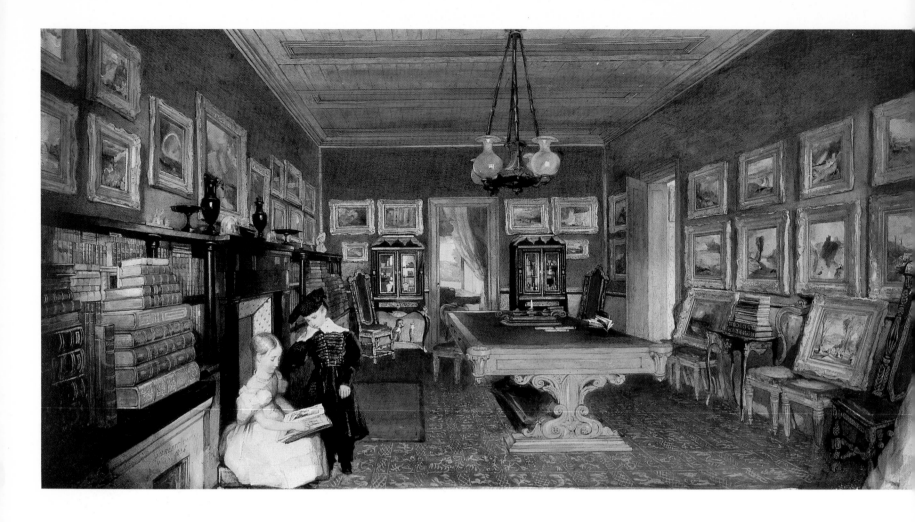

255. John Scarlett Davis, *The Library at Tottenham, the Seat of B. G. Windus, Esq.* 1835. Watercolour, 29.2 × 55.8 cm. London, British Museum. The Windus collection of Turner watercolours is here shown in its original setting.

however, he disposed of shortly after the painter's death, which suggests that he was not entirely comfortable with them.[45] Unlike other mercantile patrons in these years, for example Robert Vernon and John Sheepshanks, whose large and magnificent collections of modern British art were bequeathed respectively to the National (now the Tate) Gallery and the South Kensington (now the Victoria and Albert) Museum, Windus had no particular interest in buying direct from his artists, and unlike them, too, he does not seem to have given commissions, except perhaps for a few of the drawings.

III

In his dedication to one of the early editions of *The Discourses*, which Turner is very likely to have used, Sir Joshua Reynolds had written, perhaps rather surprisingly, that 'to give advice to those who are contending for Royal Liberality has been for some years the duty of my station in the Academy'.[46] The Academy was Royal not least in that it sought to mediate between its artists and the potential or actual Royal collectors, and it would be wrong to end an account of Turner's patrons without looking briefly at the remarkable history of the painter's attempts to attract Royal patronage throughout much of his career, and his meagre success in doing so. George III, under whose aegis the Academy had been founded, had nonetheless shown a rather limited interest in the practical support of British Art; but the Prince of Wales, who was

256. J. M. W. Turner, *Mercury and Hersé*. Oil on canvas, 190.5 × 160 cm. R.A. 1811, with the caption:
Close by the sacred walls in wide Munichia's plain,
The God well pleas'd beheld the virgin train.
 Ovid's Metamorphoses
Private Collection (BJ 114).

Regent from 1811, showed himself to be far more sympathetic. Already in 1810 he was known to be interested in starting a collection devoted specifically to the work of British artists, beginning with Bird's rustic genre painting *Village Choristers* (Fig. 199), which had been much admired at the Academy exhibition earlier in the year.[47] He went on to commission a companion-picture from the younger, but more famous David Wilkie, who had, as we saw, been the object of Turner's jealous emulation for several years.[48] Turner, too seemed destined to benefit from the warmth of this new-found princely munificence. In his *Hastings Sketchbook*, a few pages after his spiteful song about Wilkie and Bird, Turner copied out a glowing notice of *Mercury and Hersé* (Fig. 256), published by his friend, John Taylor in *The Sun* of April 30 1811. The reviewer (probably Taylor himself) had characterised this picture as the best landscape in the Exhibition, in which the artist had 'far exceeded all that we or his most partial admirers could expect from his powers.'[49] At his first Academy Banquet as Regent, a few weeks later, the Prince of Wales made a flattering speech about the standard of the

work on show, which 'very far surpassed any previous display', and he particularly alluded to 'portraits that would not have shamed the pencil of Vandyck and landscapes that even Claude Lorraine could not have seen without delight.' The latter reference was generally interpreted as referring to Turner's very Claudian *Mercury*; and Turner seems to have thought that the prince intended to buy it, for he kept it back for several years, even refusing an offer of 500 guineas from another collector.[50] But in the event nothing happened, and this was only the first of a series of disappointments to Turner's ambitions.

The Prince Regent proved a good friend to the Academy during the 1810s, and towards the end of that decade Turner made a very deliberate bid for his attention in the largest painting he had ever executed, *England: Richmond Hill on the Prince Regent's Birthday*, exhibited in 1819 (Fig. 173). The official birthday of the Regent was April 23, just before the opening of the Academy exhibition, and also, of course, St George's day and Shakespeare's birthday, as well as the day which Turner affected to claim as his own. Richmond Hill commanded an extensive view of the Royal estates of Windsor as well as Kew, and in August of 1818, just before his actual birthday, the prince had ridden up there from Kew Palace. This may well have been the immediate stimulus for Turner to start on this vast canvas, although he had already begun the subject on a smaller scale (BJ 227) in a vein of pastoral which recalls the slightly earlier treatments of Thomas Hofland and Peter de Wint. But Turner also directed his appeal to the Prince Regent on a more personal level. We have already seen how attracted the Prince was to *genre* paintings, and Turner filled his panorama with many touching anecdotes, from the disconsolate boy who has lost his kite on the left to the frisking dogs and their stately owners on the right. We have seen, too that the painter borrowed a whole group of seated ladies to the left of centre from a master of *genre* much loved by the Regent, Watteau (Figs. 178, 179).[51] But this large and florid canvas, like the *Mercury and Hersé* presented in an essentially Claudian format, despite its modern subject, was widely attacked by the critics, and remained on Turner's hands.

A year later, however, when the Prince Regent became George IV on the death of his father, Turner was beginning to come closer to the Royal favour; and it was rumoured that he would bring back some subjects for the Royal collection from his first Italian tour.[52] In 1820 and 1821 he was much occupied with the reconstruction of his gallery, and apart from a brief visit to France, he seems to have done very little directly connected with painting. But in the late summer of 1822 he visited Edinburgh to record the new King's State Visit to Scotland. The series of nineteen oil-paintings recording aspects of this visit, which Turner seems to have planned, but only four of which he began to execute,[53] can only be understood as a commission, and, indeed, Turner referred to it as such in a letter of December 1823 announcing its abandonment.[54] In this letter Turner gave as the reason for not proceeding with the scheme 'the difficulty attending engraving the subjects', probably a reference to their large number and their increasing lack of topicality; but a series in oil on panel was not Turner's usual method of preparing works for engraving, and certainly the anecdotal treatment of one of the most highly-finished of the paintings, *George IV at St Giles's Edinburgh* (Fig. 257) – in which the hush of the cathedral is shattered by the scream of the small boy on the right, whose fingers are caught in the pew door – was directly calculated to appeal to the King's taste for *genre* subjects.

That this remarkable series of oils was, in the event, barely begun, was almost certainly due to Turner's work on by far the largest and probably the most difficult commission he had ever undertaken, *The Battle of Trafalgar* (Fig. 184). We now know that this painting was comissioned by the end of 1822, which makes it even more probable that the ground had been prepared by the State Visit to Scotland series earlier in that year.[55] Turner took great pains with this formidable task, which occupied him

for more than a year. He prepared two large oil sketches – not his usual practice – the first of which (BJ 250) shows such marked differences in the positioning and rigging of the ships that the second (BJ 251) can only have been made after Turner had sought further advice. This second finished sketch probably served as the *modello* to show the King, but we know that during the painting of the final canvas on the walls of St James's Palace, Turner made many further modifications at the suggestion of the many sailors about the court, including the Duke of Clarence, the King's brother, whom Turner later claimed had made the only sensible comments. The result was aesthetically and technically daunting, and it satisfied nobody.

Turner, however, did not abandon his hopes of an important connection with the Crown. When the Duke of Clarence succeeded to the throne in 1830 as William IV, he took up the young marine-painter Clarkson Stanfield – like himself a former sailor – and commissioned to paint views of Plymouth and Portsmouth. It is no accident that Turner's work during the 1830s is characterised by an unusually large number of sea-pieces, one of which, *The Prince of Orange, William III Embarked from Holland, and Landed at Torbay, November 4 th 1688, After a Stormy Passage*, shown at the Academy in 1832 (BJ 343), made a direct allusion to William's predecessor, and another, *St Michael's Mount, Cornwall* (BJ 358), was of the same subject as the picture exhibited by Stanfield four years earlier, which had first excited the interest of the King.[56]

Yet none of these strategies had the slightest effect; Turner remained unpatronised, but when Queen Victoria brought new hope to British art in the form of the connoisseur and scholar Prince Albert, whom she took as her Consort, Turner renewed his efforts, not only with a view of the Prince's castle at Rosenau, near Coburg, which he exhibited a few months after the marriage in 1840 (BJ 392), but also with a succession of Germanic subjects directly calculated to interest him. In 1843 Turner exhibited *Light and Colour (Goethe's Theory)* (Fig. 305), where the allusion to

the great German sage in the title seems otherwise needlessly ostentatious; and in the same year the caption to *The Opening of the Wallhalla* (BJ 401) paid tribute to another great German patron of the arts, King Ludwig I of Bavaria. Finally, in 1846, in his last great burst of painterly activity, Turner exhibited as we have seen, a subject alluding to the German Romantic fairy-tale of *Undine* (BJ 424). Another scene from this story, painted by the young historical painter Daniel Maclise, to whom Turner may already have been close by this date,[57] had been given by Victoria as a birthday-present to Albert in 1843, and shown at the Academy the following year.[58] But Turner's painterly style was even less likely to appeal to the German Prince than to earlier English monarchs;[59] and although we know that Queen Victoria was later to see his work at Petworth and at the South Kensington Museum, she was never more than diplomatic about her country's greatest artist. Turner is prominent among the painters on the Albert Memorial in Kensington Gardens, he is still not represented in the Royal Collection.

Patronage thus meant a good deal to Turner, even when he did not enjoy it; but it was least important perhaps, in relation to his income. Even where, as in the case of the later Egremont and the Royal Family, it was, strictly speaking, barely visible, it still exercised an extraordinarily powerful influence on the character, and especially the subject-matter of Turner's art.

CHAPTER SEVEN
A Poetic Imagination

NOR was [Turner] less careful in choosing the characters of his figures to embellish the several scenes, for even the most trifling incident was pressed into the service that could excite or heighten the association of ideas; this it is that gives the imaginative or poetical stamp to his works. In his Italian compositions, the works of Virgil and Ovid were ransacked to people the scenes restored from the remains of ancient Roman architecture. If the sea-ports of England spring from his pencil, the heroes of Nelson, or the songs of Dibdin, rise before the spectator, enlisting his feelings in the scene . . .

(John Burnet, 1852)[1]

Turner's sketchbooks are also notebooks, and in them he recorded not only what he saw but what he read. Even what he saw was reported not simply in the form of drawings, but sometimes also in writing; we have seen that some of the most summary sketches were themselves a sort of written notation (Fig. 94), and when the experience was itself too complex or too fleeting for a drawing, Turner might extend his record of it into a substantial description. On the journey to Naples in 1819, for example, Turner summed up the character of the folk-dance, the Tarantella in a vivid note as well as in a thumbnail sketch:

Girl dancing to the Tabor or Tamborine. One plays, two dance face to face. If two women – a lewd dance and great gesticulation; when the men dance with the women a great coyness on his part till she can catch him idle and toss him up or out of time by her hip: Then the laugh is against him by the crowd . . .

(TB CLXXXVI, 69a–70).

This is the note of a writer who not only enjoys what he sees, but is able to describe it graphically and economically.

But Turner's notebooks are more consistently a repository of poetry, which he read and wrote with enthusiasm from about 1792, when he recalled some snatches from Robert Blair's *The Grave* on a precocious figure-sketch (Fig. 258),[2] to the last years, when in a sketchbook used on the Kent coast about 1846, he drafted many verses on the theme of loneliness and the sea-shore, one of which closes with an enigmatic line echoing the constant anxiety of the painter who

. . . Balanced hope with love, for stolen joys

(TB CCCLXIII, p. 28a)

It is clear from the frequency with which he turned to it that poetry came naturally to

259. (*left*) Richard Westall, *Landscape: Solitude*, 1811. Oil on canvas. Sydney, Art Gallery of New South Wales.

260. (*right*) J. M. W. Turner, *Wharfedale, Richmondshire*, *c.*1815. Watercolour, 30.9 × 40 cm. Leeds City Art Galleries (W 542).

Turner; and it is equally clear that he had ambitions to publish, although he did so only in the occasional form of captions to his pictures, as printed in the Exhibition catalogues. Yet he was not a good poet, and the uneven quality of his writing has caused commentators to keep it at a distance, even when, like William Michael Rossetti (brother of the painter-poet Dante Gabriel Rossetti) in the nineteenth-century and Chauncey B. Tinker in our own, they have recognized the force and significance of the texts in relation to the paintings.[3] Jack Lindsay, who published the first and only collection of Turner's poetry as *The Sunset Ship* in 1966, was concerned rather to relate Turner's writing to a tradition of Romantic verse than to examine its relationship to his more essential art.[4] Turner's painting places him as a Romantic in the context of Keats, Shelley, Byron, Coleridge and, occasionally, Wordsworth, but his poetry belongs more properly in the company of those many artist-poets, like Fuseli, Lawrence, Henry Tresham, Richard Westall, Thomas Gisborne, Charles Lock Eastlake, or Martin Archer Shee, whose literary achievements, although they were often public ones, fell far below their achievements as visual artists.

Westall was interesting to Turner because he evolved a type of poetic landscape painting which proved particularly congenial to him. The *Landscape: Solitude* of 1811 (Fig. 259), which Turner must have seen at the Academy in 1813, was clearly the model for a number of Turner's own Yorkshire drawings a few years later (Fig. 260).[5] Shee, too was of some concern to Turner, for he was a compulsive writer whose early work he seems to have wanted to promote.[6] Turner had read Shee's *Rhymes on Art* of 1805, and he subjected his later didactic poem, *Elements of Art* (1809) to a more rigorous scrutiny than any other book in his library.[7] Thomas Gisborne, a Derbyshire clergyman who had been a friend and patron to Joseph Wright of Derby and who was both an amateur artist and an amateur poet, was perhaps the most important of these writers to Turner, for his thoroughly Thomsonian *Walks in a Forest* (1794) shaped the formulation of the painter's own subject matter at several stages of his life,[8] from the *Hannibal* of 1812 (Fig. 270) to *The Slave Ship* of 1840 (Fig. 294).

Yet if we compare their poetry with Turner's, we see that, for all their greater correctness and polish, they lack precisely Turner's range of interests and styles. On a far lower level of achievement Turner in his poetry shows very much the same breadth of sympathy that he demonstrates in his paintings, and this is a good reason why the one may be helpful in approaching the other.

The first substantial body of poetry in Turner's notebooks is in a small book used in

1798 (TB XLII), although the poems, which are crowded onto the flyleaves and into blank spaces like afterthoughts, may be from the following year. Lindsay identified two of them as sea-songs by the very popular writer Charles Dibdin,[9] but another, 'Babbling Echo', seems more likely to be Turner's own, and uses some phrases from Joseph Addison's translation of Ovid's story of Narcissus and Echo which Turner was later to give as his caption to the painting of the same subject shown at the Academy in 1804 (BJ 53).[10] The poem runs:

Tell me Babbling Echo why
Babbling Echo tell me why
You return me sigh for sigh
When I of slighted love complain
You delight to mock my Pain.

Bold intruder Night and Day
Busy censor telltale hence away
Me and my care in silence leave
Come not near me while I grieve.

But shield my swain with all his charms
Return to bless my longing arms
I'd call thee from thy dark retreat
The joyfull tidings to repeat.

Repeat Repeat Repeat thy strain
Tell it o'er and o'er again
From morn to night prolong the tale
Let it ring from vale to vale.

What is important about this poem is that it has the form of a glee, and that it dates from about the time when, according to another sketchbook (TB LXIII), Turner showed a technical interest in vocal music: he drew the clefs for soprano, mezzo-soprano, alto, tenor and bass voices (this last was Turner's own register), as well as a number of other musical terms and scales.[11] The cause of this new interest was almost certainly Turner's attachment to the widow of the then celebrated glee-composer John Danby, which resulted in the birth of their first child, Evelina, probably in 1799.[12] Among Danby's glees there was, indeed, a 'Sweet Echo' with a very similar theme to Turner's.[13]

Turner wrote several songs, both lyric and satiric, over a number of years (see p. 146), but he also developed an enthusiasm for much more serious poetic forms. Probably about the time of his election as a full Academician in 1802, he acquired a collection of English poetry, including many translations from the Greek and Latin classics, Robert Anderson's *The Works of the British Poets*, in thirteen substantial volumes.[14] Milton and Thomson had been among the sublimer poets he had already read in the 1790s, and had plundered to provide captions for his pictures, but now Turner began to compose his own verses in their styles. The 'Ode to Discord', which can be related directly to the painting, *The Goddess of Discord choosing the Apple of Contention in the Garden of the Hesperides*, although it was not quoted with it, is, with its Miltonic resonances, Turner's most impressive early essay in the sublime style, and it is entirely appropriate to the Poussinesque painting (Fig. 261):

Discord, dire Sister of Etherial Jove
Coeval, hostile even to heavenly love,
Unask'd at Psyche's bridal feast to share,
Mad with neglect and envious of the fair,

261. J. M. W. Turner, *The Goddess of Discord choosing the Apple of Contention in the Garden of the Hesperides*. Oil on canvas, 155 × 218.5 British Institution 1806. London, Clore Gallery for the Turner Collection (BJ 57).

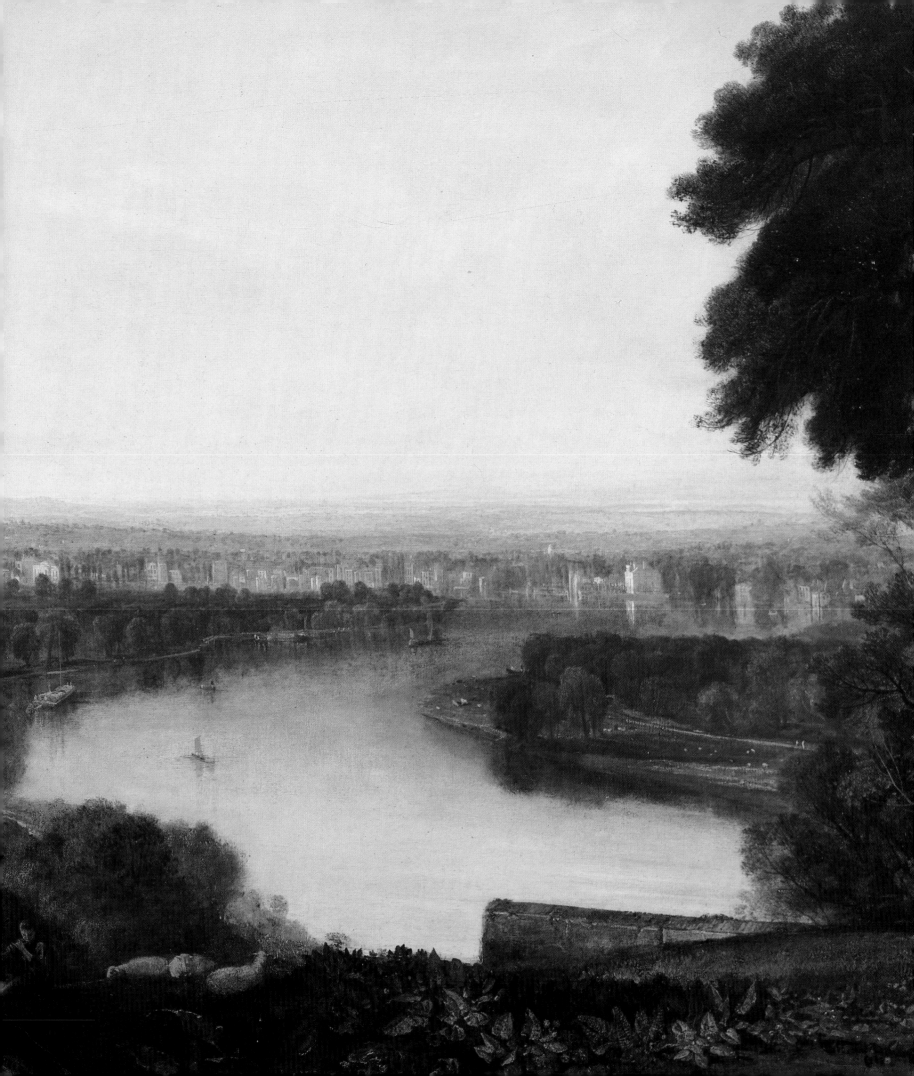

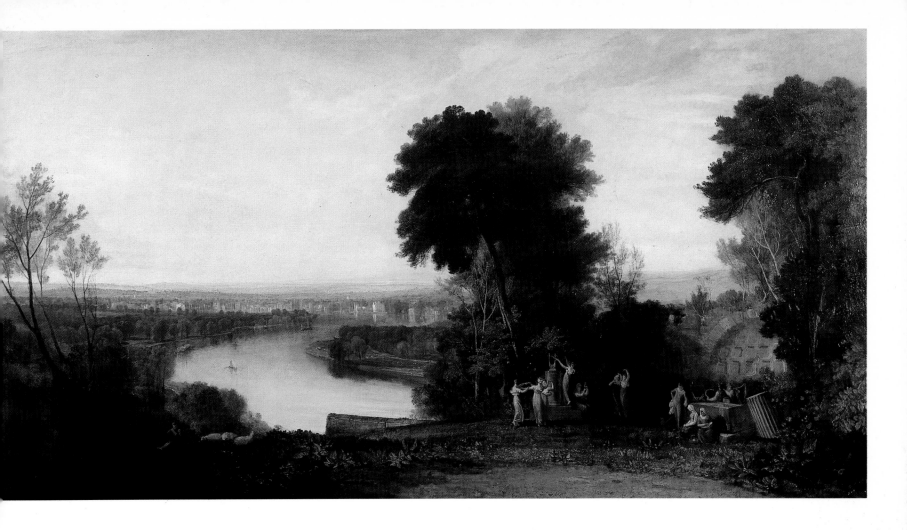

Fierce as the noxious blast thou cleav'd the skies
And sought the hesperian Garden's golden prize.

The guardian Dragon in himself an host
Aw'd with thy presence slumberd at his post.
The timid sisters with prophetic fire
Proffered the final fruit and fear'd thy wrathful ire.
With vengeful pleasure pleas'd the Goddess heard
Of future woes: and then her choice preferred;
The shining mischief to herself she took
Love felt the wound and Troy's foundations shook . . .[15]

The *Ode to Discord* remained in manuscript, but a year or two later Turner was to write
his most perfect pastiche of an eighteenth-century Augustan style, and the longest
poem he ever published. The caption to *Thompson's Aeolian Harp* (Fig. 263) provided,
in its immaculately Thomsonian cadences, a precise equivalent to the essentially
Claudian mode of the painting itself:

<div align="center">

Thomson's Aeolian Harp
To a gentleman at Putney, requesting him to place on in his grounds

</div>

On Thomson's tomb the dewy drops distil,
Soft tears of Pity shed for Pope's lost fane,
To worth and verse adheres sad memory still,
Scorning to wear ensnaring fashion's chain.
In silence go, fair Thames, for all is laid;

His pastoral reeds untied, and harp unstrung,
Sunk is their harmony in Twickenham's glade,
While flows the stream, unheeded and unsung
Resplendent Seasons! chase oblivion's shade,
Where liberal hands bid Thomson's lyre arise;
From Putney's height he nature's hues survey'd,
And mark'd each beauty with enraptur'd eyes.
The kindly place amid thy upland groves
Th'Aeolian harp, attun'd to nature's strains,
Melliferous greeting every air that roves
From Thames' broad bosom or her verdant plains,
Inspiring Spring! with renovating fire,
Well pleas'd, rebind those reeds Alexis play'd,
And breathing balmy kisses to the Lyre,
Give one soft note to lost Alexis' shade.
Let Summer shed her many blossoms fair,
To shield the trembling strings in noon-tide ray;
While ever and anon the dulcet air
Shall rapturous thrill, or sigh in sweets away.
Bind not the poppy in thy golden hair,
Autumn! kind giver of the full-ear'd sheaf;
Those notes have often echo'd to thy care;
Check not their sweetness with thy falling leaf.
Winter! thy sharp cold winds bespeak decay;
Thy snow-fraught robe let pity's zone entwine,
That gen'rous care shall memory repay,
Bending with her o'er *Thomson's* hallow'd shrine.[16]

These two examples shows that, for all his difficulties with syntax, Turner had a remarkable ear. But, as his liking for Dibdin and Danby have already shown, Turner's tastes were by no means confined to the Old Masters of poetry. When a new poetic star, Walter Scott, appeared in the ascendant in the 1800s, Turner was ready both to read and to imitate him, and he did so in a bantering letter to another imitator, the journalist John Taylor, in which Turner used Scott's metre to compare his subjects unfavourable with Shakespeare's:

But let them by their parent Tweed
Still whisper to the fragile reed,
Which growing to the public taste,
Like other things may grow to waste.
Its utmost strength e'en full blown pride
Could not sustain the Avon's tide . . .[17]

Besides Scott, Turner read and later illustrated the modern poets Byron, Rogers and Campbell, and he used them, together with the then far less well-known Shelley, in framing his captions. Yet his own writing, unlike his painting, remained wedded to the idioms of the seventeenth and eighteenth centuries.

II

Just as the demands of the perspective lectures led Turner into a review of the literature of art, so it led him to examine what was a very popular aspect of that literature in the early nineteenth century: the comparison between painting and poetry. It was, indeed,

one of his perspective text-books which put the classical view of the poet's advantages over the painter in its most forceful and simple terms: 'Painters have much less liberty than Poets, for a Poet may allow 24 hours to the Action he represents, but a Painter can only represent the Instant of an Action, and what is seen at one single look . . .'[18] This view had already been contested by Hogarth in his *Analysis of Beauty*, but it was given weighty support by Reynolds, at the beginning of Discourse VIII:

> Poetry, having a more extensive power than our art, exerts its influence over almost all the passions; among those may be reckoned one of our most prevalent dispositions, anxiety for the future. Poetry operates by raising our curiosity, engaging the mind by degrees to take an interest in the event, keeping that event suspended, and surprising at last with an unexpected catastrophe.
>
> The Painter's art is more confined, and has nothing that corresponds with, or perhaps is equivalent to, this power and advantage of leading the mind on till attention is totally engaged. What is done by painting must be done at one blow; curiosity has received at once all the satisfaction it can ever have . . .[19]

Artists of Turner's generation were anxious to reclaim the ground for painting by arguing, on the one hand, for its superior powers of description, which could make a thorough examination far from merely instantaneous, and on the other for its capacity to isolate the 'pregnant moment', that instant in a narrative sequence which might sum up the developments of past, present and future.[20] It was in a marginal note to John Opie's discussion of this first question that Turner began to set out his own position:

> This contrariety of their means intirely separates Poetry from Painting, tho drawn from the same source and both feeling the beauties of nature – but the selection is as different as the means of conveyance diverse: their approximation is nearest when the Poet is discriptive.[21]

4. J. M. W. Turner, *Dolbadern Castle, North Wales*. Oil on canvas, 119.5 × 90.2 cm. R.A. 1800. London, Royal Academy of ts (BJ 12).

But as he came to ponder the problem more deeply, Turner began to see that even the most descriptive poetry, because its chief appeal was to the imagination, was far from the truth to nature to which painting aspired; and in a lecture of 1812 he rejected two passages from Thomson and Milton which, only a dozen years before, he had felt appropriate to accompany paintings of his own: 'Thus poetic descriptions most full, most incidental, and display[ing] the greatest richness of verse is often the least pictorial; and hence hasty practice or choice, to use no harsher term, will lead astray.'[22]

A practical forum for the debate about the respective roles of painting and poetry had for some time been provided by the Exhibitions at the Royal Academy where, from 1798, the printing of often substantial 'descriptions' in the catalogues had been permitted.[23] Turner rose to the occasion, and in that and the following year he accompanied a number of exhibition oils and watercolours with descriptive captions culled from Milton, Thomson and other eighteenth-century poets. Although he was obliged on occasion to edit his sources considerably, the role of these quotations was, broadly, to reinforce in another medium the ideas of time and weather presented in the painted subject. But in 1800 he began to adopt another approach, to introduce by means of the verses more than the image itself could reveal, and to do this more effectively he began to write his captions himself. The verses accompanying *Dolbadern Castle, North Wales* (Fig. 264), shown in that year, runs:

> How awful is the silence of the waste
> Where nature lifts her mountains to the sky.
> Majestic solitude, behold the tower
> Where hopeless OWEN, long imprison'd, pined
> And wrung his hands for liberty, in vain.

The Salvator-Rosa-like soldier in the foreground seems to be speaking these words to the stripped and bound prisoner, while he gestures towards the tower of the castle where the thirteenth-century Welsh Prince Owain Goch was held captive by his brother. Perhaps the prisoner is about to suffer the same fate; perhaps indeed he is Owain Goch himself. The caption simply pinpoints and amplifies the historical significance of the subject as we see it. Another Welsh subject shown the same year, *Caernarvon Castle, North Wales* (Fig. 154), was given a similar poetic accompaniment:

> And now on Arvon's haughty tow'rs
> The Bard the song of pity pours,
> For oft on Mona's distant hills he sighs,
> Where jealous of the minstrel band,
> The tyrant drench'd with blood the land,
> And charm'd with horror, triumph'd in their cries,
> The swains of Arvon round him throng,
> And join the sorrows of his song.

Like the verses to *Dolbadern*, this caption presents few problems to a spectator ordinarily familiar with Welsh history. The Bard and his swains are in the left foreground, and 'Mona's distant hills', the site of Edward III's terror, which he laments, are probably the mountains in the far left distance, beyond the Menai Strait. In both these captions Turner's verses essentially identify and qualify what we can already see.

But Turner's engagement with the theory of poetry and painting in the 1800s led him to take a rather different attitude when he returned to the regular use of verse-captions about 1810. We have seen the long and complex poem to *Thomson's Aeolian Harp* (Fig. 263), which reflects the complexity of the visual imagery. Together with the abstract, allegorical figures of the Seasons and the Graces, who are so prominent in Turner's caption, he has united the more realistic characters of the rustics and the young lover Palemon, from *Autumn*, and in mock-Elizabethan dress, as he and they appear in several illustrated editions of Thomson's *Seasons*, notably those of Stothard and Westall in the 1790s.[24] In the same year Turner showed *London*, a painting of one of the most celebrated views across the city, from Greenwich Park (Fig. 265), with a caption of his own which marks a move away from the descriptive and towards the emblematic:

> Where burthen'd Thames reflects the crowded sail,
> Commercial care and busy toil prevail,
> Whose murky veil, aspiring to the skies,
> Obscures thy beauty, and thy form denies,
> Save where thy spires pierce the doubtful air,
> As gleams of hope amidst a world of care.[25]

The mood is a surprisingly reflective one for such an ostensibly topographical subject; but in subsequent years Turner adapted the same allusive methods to far more imaginative tasks. His astonishing *Fall of an Avalanche in the Grisons* (Fig. 267) was accompanied in 1810 by an arresting fragment of blank verse:

> The downward sun a parting sadness gleams,
> Portenteous lurid thro' the gathering storm;
> Thick drifting snow on snow,
> Till the vast weight bursts thro' the rocky barrier;
> Down at once, its pine clad forests,
> And towering glaciers fall, the work of ages
> Crashing through all! extinction follows,
> And the toil, the hope of man – o'erwhelms.

265. J. M. W. Turner, *London*. Oil on canvas, 90 × 120 cm. Turner's Gallery 1809. London, Clore Gallery for the Turner Collection (BJ 97).

As in the *London*, the concluding allusion to hope moves the picture from a purely physical to a moral plane, and it is surely a reminisence of a passage in the fourteenth chapter of *The Book of Job*, which had been paraphrased by Sir Richard Blackmore early in the eighteenth century:

> As a high hill by stormy weather worn,
> With inbred Tempests, or with Thunder torn,
> Does with its ruins all the valley spread,
> But can no more erect his lofty head;
> Moulder'd to Dust it hopes no more to break
> The Clouds' long order with its snowy Peak.
> As a vast rock by Earthquakes if remov'd
> And from its Base amidst the Ocean shov'd
> Never its shatter'd Pillars after reers,
> Nor thrusts its tow'ring top amidsts the Stars: . . .
> So when thy fatal Darts a Man destroy,
> He shall no more this world's Delights enjoy . . .
> Hard Fate of Man, who either, if he dies,
> Hopeless of e'er reviving breathless lies,
> Or if he lives, must still expect to find
> Pain in his flesh and Anguish in his Mind . . .[26]

Turner is illustrating one of the sublimest metaphors of the Old Testament. In the introduction to his *Paraphrase* Blackmore had emphasised Job's essentially epic character, and his work had been included among the epic paraphanalia of Turner's half-ironic tribute to the grandeur of the poet, *The Garetteer's Petition to his Muse* (Fig. 175). In the exhibited version of this design (BJ 100), a plan of Parnassus, the seat of the Muses, hangs askew on the wall; but there is also the more practical inclusion of an *Almanack of Fasts and Feasts*, for this highly self-conscious poet is taking the advice of the sixteenth-century theorist of poetry, M. H. Vida, and calling for inspiration on his patron-saints:

> Aid me, ye Powers! O bid my thoughts to roll
> In quick succession, animate my soul;
> Descend my Muse, and every thought refine,
> And finish well my long, my *long-sought* line.[27]

Turner chose a thoroughly Rembrandtesque style for his picture as a fitting embodiment of a sublime subject; by comparison with his companion, the painter (Fig. 172), the poet is shown to have a far more elevated calling. This is important, for it was in these years that Turner came to regard the poet as a prophet,[28] and the introduction of a prophetic tone into his captions is a clear sign that he wished to arrogate some of the poet's prophetic functions to himself.

It is significant that the notion of poet as prophet was voiced in the context of the discussion with John Britton about the letterpress to the engraving of *Pope's Villa* (Fig. 266), which had also introduced the idea of 'elevated' topography (see p. 25). The mood of regret at the thoughtless desecration of a national monument (for Pope's villa is being demolished) is re-inforced by a lament for the poet himself, which Turner composed at the same time as the picture, but did not publish:

On the Demolition of Pope's House at Twickenham

Dear Sister Isis tis thy Thames that calls
See desolation hovers o'er those walls,

56. J. M. W. Turner, *Pope's Villa at Twickenham*. Oil on canvas, 1.5 × 120.6 cm. Turner's Gallery 1808. Trustees of the Walter Morrison Picture Settlement (BJ 72).

267. J. M. W. Turner, *The Fall of an Avalanche in the Grisons*. Oil on canvas, 90 × 120 cm. Turner's Gallery, 1810. London, Clore Gallery for the Turner Collection (BJ 109). For the caption, see p. 188.

268. *(facing page)* Detail of Fig. 267.

The scatter'd timbers on my margin lays
Where glimmering Evening's ray yet lingering plays
There British Maro sang by Science long endear'd
And to an admiring country once revered
Now to destruction doom'd thy peaceful grott
Pope's willow bending to the earth forgot
Save one weak scion by my fostering care
Nurses into life which fell on bracken spare
On the lone bank to mark the spot with pride
Dip the long branches in the rippling tide
And sister stream the tender plant to rear
On Twickenham's shore Pope's memory yet to hear
Call all the rills that fed our spacious lawn
Till twylight latest gloom in Silence mourn
Lodona gratefull flows, Alexis all deplore
And flowing murmurs oft Alexis is no more.[29]

269. J. M. W. Turner, *Virgil's Tomb*, 1819. Pencil, 12.2 × 19.8 cm. London, Clore Gallery for the Turner Collection (TB CLXXXV, p. 68).

That the Thames in this poem should name Pope as the British Virgil (Maro) may help to explain why, when he went to Italy in 1819, Turner showed such a detailed interest in the Roman poet's tomb (Fig. 269), for his most important guidebook, J. C. Eustace's *Tour in Italy* of 1813, had compared the neglect of Virgil's grave since classical times, so that even its location was a matter of conjecture, precisely with the scandalous destruction of Pope's house and gardens, 'the seat of genius and of the British muse'.[30]

Turner's prophetic stance was given a new impetus in 1812 with the first appearance of what was to become his most famous poem, 'The Fallacies of Hope,' which does not seem to have been a single composition, but was written *ad hoc* to accompany particular paintings.[31] The first picture to bear an extract from it was *Snow Storm: Hannibal and his Army crossing the Alps* (Fig. 270):

> Craft, treachery, and fraud – Salassian force,
> Hung on the fainting rear! then Plunder seiz'd
> The victor and the captive, – Saguntum's spoil,
> Alike, became their prey; still the chief advanc'd,
> Look'd on the sun with hope; – low, broad and wan;
> While the fierce archer of the downward year
> Stains Italy's blanch'd barrier with storms.
> In vain each pass, ensanguin'd deep with dead,
> Or rocky fragments, wide destruction roll'd.
> Still on Campania's fertile plains – he thought,
> But the loud breeze sob'd, 'Capua's joys beware!'

Here Turner's allusive amplification has taken its fullest form, for we understand from the caption that the subject of the picture is not so much the snowstorm as the moral condition of Hannibal's soldiers, both in the past ('Sanguntum's spoil'), the present ('Plunder seiz'd the victor and the captive') and the future ('Capua's joys beware'). As one of Turner's chief sources, the Roman historian Livy, had put it in his discussion of the Carthaginian defeat at Cannae in central Italy, 'Thus those very men that had triumph over the horrours of the *Alps*, and were not to be broken by any Extremity,

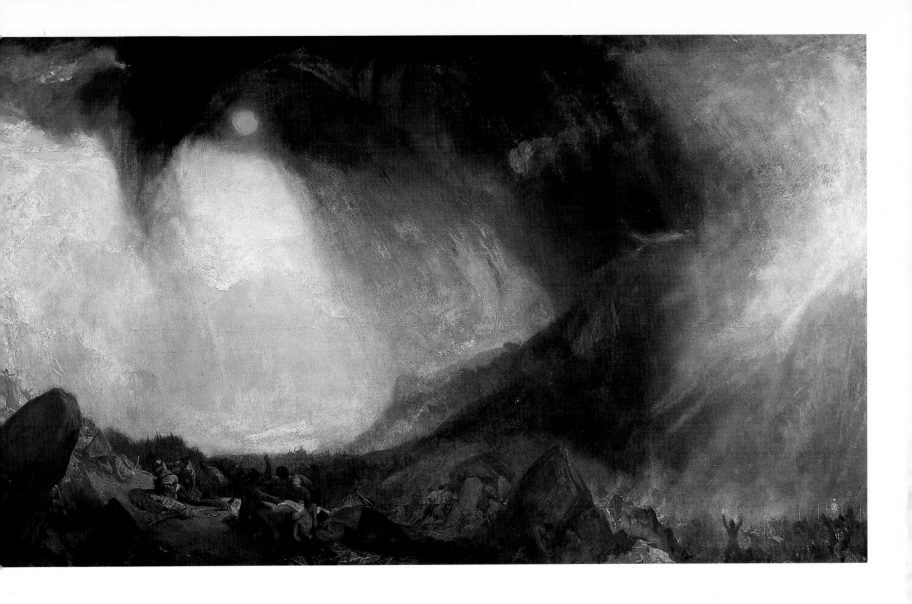

70. J. M. W. Turner, *Snow Storm: Hannibal and his Army crossing the Alps.* Oil on canvas, 146 × 237.5 cm. R.A. 1812. London, Clore Gallery for the Turner Collection (BJ 126).

were spoiled and undone by too good usage, and excess of pleasures'.[32] A number of contemporary critics rightly sensed that the focus of the composition is the sun, and Turner went to considerable trouble to ensure that the painting was hung low, so that the sun should be for the spectator, as it had been for Hannibal, the dominant motif.[33] It is the sun that unites the present and the future in the painting, for it is proleptic of the warm south that led to the Carthaginians' undoing.[34] As the critic of the *Examiner* put it, 'the moral and physical elements are here in powerful unison, blended by a most masterly hand, awakening emotions of awe and grandure'; and the conception of *Hannibal* as a whole is a perfect exempliciation of Fuseli's paradoxical reversal of the traditional spheres of painting and poetry:

> The medium of poetry is time and action; that of the plastic arts, space and figure. Poetry then is at its summit, when its hand arrests time and embodies action: and these, when they wing the marble or the canvas, and from the present moment dart rays back to the past and forward to the future.[35]

But Turner had not been able to achieve this *tour de force* without an ample assistance from poetry itself.

'The Fallacies of Hope' was Turner's most frequent repository of poetical allusion from this date until the end of his life, although he rarely used it so penetratingly as he had in 1812. One of the last important occasions was for his most moving seascape,

193

Slavers Throwing Overboard the Dead and Dying – Typhon Coming On of 1840 (Fig. 294), in which the painter raised his objection to what Prince Albert in the same year called 'that attrocious traffic' to an unprecedented pitch of eloquence:

> Aloft all hands, strike the top-masts and belay;
> Yon angry setting sun and fierce-edged clouds
> Declare the Typhon's coming.
> Before it sweeps your decks, throw overboard
> The dead and dying – ne'er heed their chains
> Hope, Hope, fallacious Hope!
> Where is thy market now?

The superabundance of imagery in this dazzling canvas brings together the fruits of an extraordinarily wide-ranging reading, from Thomson's *Summer* (11.980–1025), in which the shark had been seen to prey both on the slaves and on their captors, to the recently-published second edition of Thomas Clarkson's *History of the Abolition of the Slave Trade*, in which a notorious eighteenth-century case was recounted, where the captain of a slaver disposed of his sick cargo in this manner because insurance could only be claimed for the drowned, not for the diseased. But perhaps most resonant in Turner's mind was a passage from *Summer* in Gisborne's *Walks in a Forest*:

> See in the sable myriads of the West
> The smother'd flame of hate and vengeance fann'd
> By sighs of annual multitudes new brought
> Across the waves to misery and chains,
> Burst with Etnaean rage. Behold yon isle [S. Domingo],
> Her smoking ruins mark, her crimson fields;
> Writhing in agony see every wretch
> Who bears your colour: hear their dying yells
> Proclaim to every circumjacent shore,
> An Empire raised by blood in blood shall fall.

Gisborne also provided a cue for the teeming fishes in Turner's picture, for in the same section of his poem he described the herring migrations, 'when ocean glitters like a field of gems'.

Turner had never been in tropical waters and had never witnessed a typhoon, but he will have found a highly-coloured account of one in Thomas Beale's *Natural History of the Sperm Whale* (1839) and it was at the close of this account that 'The sun rose, appearing to spring out of the ocean, of a crimson hue; wild and tattered seemed the cloud which hung around him, gilded from his effulgence', as it is in *Slavers*. Beale also described the gigantic man-eating sea-squid, whose tentacles are so prominent in the painting.[36]

Here, too, the lengthy title and the poem enable Turner to overcome the limitations of time and space. The typhoon, which is only sighted in the verses is, in the painting, almost upon the ship, whose sails are nearly down, and whose grisly jetsam has washed out on to the nearest waves. The final, hopeless, thought of markets directs our minds forward to the end of the voyage, when all that remained was to collect the insurance for the slaves 'lost' at sea. The poem, too, takes us on board the distant ship, among the shouting sailors, while the painting shows us only the cause of their alarm. Turner is still using poetry in this picture in the spirit of the debates of his youth (see p. 193).

The appearance of 'The Fallacies of Hope' in 1812 is the clearest sign that Turner had come to look upon the poet-prophet as a model, and although he had reservations about purely descriptive poetry, in a lecture of the same year he was prepared to regard poetry and painting as entirely reciprocating arts:

Thus Painting and Poetry, flowing from the same fount mutually by vision, constantly comparing Poetic allusions by natural forms in one and applying forms found in nature to the other, meandering into streams by application, which reciprocally improved, reflect, and heighen each other's beauties like . . . mirrors.[37]

He had already embarked upon what was to become his most ambitious project on these lines, the amplification of his plates in Cooke's *Picturesque Views on the Southern Coast of England* with by far his longest poem. This text was rejected by the publisher as largely unintelligible, and it has never been completely transcribed; but it encompassed an extraordinary range of Turner's poetic styles and interests, and would have turned what is still one of the most impressive collections of his engraved watercolours into a meditation on the state of the nation itself. Sometimes Turner was still happy to double his views with purely descriptive poetry (Fig. 271):

> In oranges, reds and golden glows the rich welkin cheek,
> Blue claims but little share in such a sky,
> While distant hills maintain the powerful dye
> In all its changes, even the russet down embrowned
> By midday sun, or rock or mossy mountain crownd;
> And as [?] sunk hamlet smoke assumes a tone
> That, true to nature, art is proud to own . . .[38]

But, more usually, his poem amplified the meaning of his images as did 'The Fallacies of Hope', by alluding directly to a human dimension which was presented only casually in the plates. The overriding theme of the poem seems to have been the need for effort and industry in the struggle against Napoleon, and Turner saw this industry exemplified less in men's than in women's work. Time and again throughout the series women are busy while the menfolk, often, of course, on leave from active service, take their ease (Figs. 271–2); and Turner made this contrast the theme of particularly poignant episode in his poem:

She tended oft the kine and to the mart
Bore all the efforts of her father's art
And homeward as she bore the needful pence
Whould loiter careless on or ask thro mere pretence
To youth much mischief, for maturely grown
It proved alas a mischief all her own.
Guileless and innocent as she passed along
And cheered her footsteps with a morning song
When craft and lechery and (guile) combined
Proved but to triumph o'er a spotless mind
To guard the coast their duty not delude
By promises as little heeded as th(e)ir good
When strictly follow'd give a conscious peace
And ask at eve of life a just release.
But idleness, the bane of every country's weal,
Equally enervates the soldier and his steel.
Lo on yon bank beneathe the hedge they lie
And watch, cat-like, each female by
One sidelong glance or hesitating step
Admits not of recall who once oerleap
The deep plowd sands are p(i)led up by the main
But time denies, the curse of love or gain,
Deep sinks the curse of lucre in the heart,
And virtue stained o'erpowers the greater part
Wan melancholy sits the once full-blooming maid,
Misanthrope stalks the soul in silent shade,
On the bold promontory thrown at length she lies,
And sea-mews schrieking are her obsequies . . .[39]

The setting for this melancholy tale is perhaps *Plymouth with Mount Batten* (Fig. 272), in the foreground of which a dishevelled marine and a sailor are sizing-up a group of girl

272. J. M. W. Turner, *Plymouth with Mount Batten*, *c*.1816. Watercolour, 14.6 × 23.5 cm. London, Victoria & Albert Museum (W 457).

273. J. M. W. Turner, *Venice: Interior of a Theatre*, c.1840. Watercolour and bodycolour on brown paper, 25 × 31.3 cm. London, Clore Gallery for the Turner Collection (TB CCCXVIII-8).

gleaners or reapers.[40] It is not certain what exactly Turner intended the relationship between his poem and the published text to *The Southern Coast* should be; what is clear is that it is very difficult and unpolished, and that it covers a far wider range of topics and places than were eventually included in the series of engravings, although this ran into the 1820s. The failure of *The Southern Coast* as a composite book probably stimulated Turner, when he came to plan his next important series, *The History of Richmondshire* and *Picturesque Views in England and Wales* (for which he provided no text), to give far more specific roles to the figures in the images themselves.

III

Turner nourished his literary interests not only on poetry and song, but also in the theatre, for he was an inveterate theatre-goer (Fig. 273) and he may, indeed, have heard the Charles Dibdin songs, which he copied down about 1799, in the theatrical entertainments, for which they were originally composed. Certainly, in a teasing mood, he once attributed the inspiration for his greatest classical picture, *Ulysses Deriding Polyphemus* (Fig. 4) to a song which had originally been composed by Charles Dibdin, and later re-used by his son, Tom, in a 'comic spectacle', *Melodrame Mad*, first performed in London in 1819:

> I sing the cave of Polypheme,
> Ulysses made him cry out;
> For he eat his mutton, drank his wine,
> And then he poked his eye out.[41]

This anecdote tells us almost nothing about the character of Turner's handling of his subject, for he also drew heavily on archaeology, Greek mythology and travel literature, as well as on eighteenth-century studies of phosphorescence and volcanic activity.[42] But it does tell us how he encountered the classical past at every turn, and that some of his most important stimuli may have come from the most unlikely directions.

An essentially eclectic approach towards articulating a narrative is also clear in the case of the nearly-contemporary *Vision of Medea* (Fig. 122), which has been shown to depend not only on the tragedy by Seneca, but also, and more importantly, on Mayr's opera *Medea in Corinto*, performed in London between 1826 and 1828 with the great soprano Giuditta Pasta in the title role.[43] Here Turner embodied a series of episodes from the drama in a way which, far more obviously than in *Hannibal*, exemplifies the notion of the 'pregnant moment', but they are pivoted on the tragic gesture of Medea herself, which he took over from Pasta's performance. In 1846 he treated *Undine Giving the Ring to Masaniello, Fisherman of Naples* (BJ 424) in a very similar vein, adapting elements from Deshaye's ballet, *Masaniello*, which had been revived in 1838, and Perrot's ballet *Ondine*, which was performing in London in the year the picture was exhibited, so that one critic was not far from the truth when he referred Turner's subject to 'some ignoble ballet'.[44]

Turner's work was closely related to the sort of sensational effects which were also the stock-in-trade of the popular theatre; and many of his subjects, which seem to have mystified his contemporaries as much as they mystify us, may be traced to this source. In 1844 a satirist came close to the pre-occupations of the middle and late periods when he characterised a typical Turner as

> *A Typhoon bursting in a Simoon over the Whirlpool of Maelstrom,*
> *Norway: with a ship on fire, an eclipse, and the effect of a lunar rainbow*

197

O Art, how vast thy mighty wonders are
To those who roam upon the extraordinary deep!
Maelstrom, thy hand is here.
From an unpublished poem.[45]

The writer was surely confused simply by the context of the Academy exhibition where Turner showed, for these were precisely the effects which were regularly presented to the theatre-going audiences of the day in pantomime, ballet and opera. Exotic settings and breathtaking natural phenomena were the norm, and, even closer to home, the burning of the Houses of Parliament, which Turner made the subject of two of his most clearly theatrical paintings (Figs. 319–20), was seen by many of the throng of spectators in terms of entertainment. Some bystanders, wrote a reporter, were

> so struck with the grandeur of the sight that they involuntarily . . . clapped their hands, as though they had been present at the closing scene of some dramatic spectacle, when all that the pencil [brush] and pyrotechnic skill can affect is put into action, to produce a striking coup d'oeil.[46]

And yet there is something that transcends theatricality in even the most sensational of Turner's subjects. Part of it lies in the thoughtfulness and the complexity of his themes, and part is in the refinement of his observation and his handling; and in this latter respect he repaid his debt to the theatre in full. Even before his own designs were taken as models for scenery, which seems to have happened only after his death,[47] his style had had its effect on scenic art, and on the tastes of the early Victorian public.

> Scenery now becomes a source of attraction', wrote John Burnet in 1848, 'and the rich dresses of the actors mingle in forming a picture which reminds us of some of Paul Veronese's finest works. Now this change we owe to Turner. Notwithstanding all his extravagances, he it was who taught [Stanfield and Roberts], by his example, the art of arranging the hot and cold colours, so as to give distinctness and solidity, without cutting up and destroying the great breadth of light. And though both Roberts and Stanfield have quitted Covent Garden and old Drury [Lane], they have left behind artists who are following in the same track; and the dingy black vulgarities of Richards, Capon, Greenwood and Marchbanks have disappeared – drops, set pieces, and wings – ay, and the dull oily lamps that hung upon them, likewise, to give place to the luminous properties of size-colour and gas-light.[48]

His was certainly a period of developing realism in the theatre, but that Turner recognised how much was still to be achieved by symbolic representations is suggested by a story related by his friend Charles Lock Eastlake to the students at the Royal Academy in 1859. It is a story which also illuminates Turner's intensifying use of symbol in his late works.

> Turner, knowing the difficulty, as every painter must, of clearly expressing an idea distinct from any other, was always ready to appreciate examples of success in this particular, whether in old or modern works of art. He was even an observer of contrivances for the same end on the Stage. He had long maintained that it was not possible to express, on the stage, the bottom of the sea. On hearing that a new attempt of the kind had been made in some pantomime, he inquired particularly what were the means resorted to. Various incidents were enumerated, at which he shook his head. At last he was told that an anchor was lowered from above, by its cable, till it rested on the stage. He reflected for a few moments, and then said, 'That's conclusive'.[49]

4. J. Cousen after J. M. W. Turner, *The Acropolis of Athens*, 823/4. Line-engraving, 10.4 × 14.8 cm. London, British useum (R 408).

5. A. Gilbert after Jacques-Louis David, *Napoleon on the Great St ernard*. London, Victoria & Albert Museum

76. J. M. W. Turner, *Marengo*, c.1827. Pen and watercolour over encil, 12.5 × 20 cm. (vignette). Clore Gallery for the Turner ollection (W 1157) Inscribed: 'Battle MARENCO 18 . . .' and ODI'. The figure of Napoleon is adapted from Fig. 275. The ignette was engraved by E. Goodall for Rogers' *Italy*, 1820.

IV

Given Turner's liking for the ancient and modern British poets, it is surprising that he began to make specific illustrations to their works so late in life, especially since his was a great period in English book-illustration, which had long employed many prominent Academicians, like Westall and Stothard. In 1812 Turner had certainly introduced a (still rather enigmatic) subject from Spenser's *Faery Queene* into *Liber Studiorum* (RLS 36), but it remained quite isolated until, in 1822, his friend Walter Fawkes invited him to make watercolours illustrating passages from Scott, Byron and Thomas Moore, all of whose works the painter was to embellish with engravings over the following fifteen years.[50] From the commercial point of view, the most important stimulus must have come from the publisher John Murray's involvement in a number of publications, like Hakewill's *Tour of Italy* in the late 1810s; for it was Murray who commissioned Turner to make the seven drawings to be engraved for *Lord Byron's Works* about 1823 (Fig. 274),[51] and their format and style was sometimes rather close to the Hakewill series. The recent development of steel-faced engraving, used first by Turner for the Byron illustrations, also favoured the reproduction of his greatly refined watercolour style on a miniature scale, and made substantial print-runs possible for the first time without a great sacrifice of quality, and this, too, may have attracted Turner to the new tasks.[52] Samuel Rogers, the banker-poet, had been a Murray author, and had probably been so impressed by the quality of the Byron engravings as to conceive the idea of a new luxury edition of his own collection of poems and stories, *Italy*, about 1825 or 6 (Fig. 276).[53] The work for Rogers, which was extended to his *Poems* about 1831, is particulary important because it introduced Turner to the circular or oval form of the vignette, and to a scale of working, which was to have great consequences for his late style in painting. It is very likely that it was the poet himself who was the originator of this format, for he was extraordinarily conscious of the needs of book-design, and anxious to adopt the latest innovations.[54]

The illustrations to Rogers' *Italy* were largely topographical in character, so much so that Sir Walter Scott may be forgiven for describing them in a letter to Rogers as

'beautiful specimens of architecture', and for expecting from Turner very much the same treatment of his own writings in the 1830s (Fig. 299).[55] But in Rogers' *Poems* Turner began to introduce more imaginative compositions, and this was a development he amplified in the several other sets of illustrations he provided for luxury editions of Milton's *Poetical Works*, Thomas Campbell's *Poetical Works*, and Thomas Moore's *Epicurean* during the course of that decade. Not that even the topographical subjects in these books were not full of ingenious and witty touches in the handling of the figures and accessories. *Marengo*, for example, (Fig. 276), engraved for 'The Descent' in Rogers' *Italy*, used as its central motif the celebrated portrait of *Napoleon on the Great St Bernard* by Jacques-Louis David, which Turner had seen in that painter's Paris studio in 1802, shortly after he had crossed the pass himself (Fig. 275).[56] The names inscribed on the vignette refer to the Napoleonic victories at Lodi (1796), on the first Italian campaign, and at Marengo (1800), on the second. When the engraver George Cooke published David's portrait of Napoleon in 1807, he included a caption which alluded to Marengo as the triumph of the second campaign, and pointed to the associations with Hannibal and Charlemagne as Alpine conquerors, to which David had also referred by the inscriptions on the rocks at the foot of his picture.[57] Turner was also thinking of Hannibal when he conceived his vignette, for he included an illustration of that general's passage of the Alps in the same book;[58] and when he had visited the Great St Bernard again in 1819 (TB CLCXXIV, p. 41a), he may have seen the huge rock near the hospice there which bore the simple legend, 'Marengo'.[59] He was thus introducing into even the smallest engraving that density of allusion which was becoming standard in his exhibition paintings; and it is no surprise that these tiny and often exquisite images could become the models for many of the small canvasses of the 1840s.

The more purely topographical images in these books also provided Turner with ideas for a number of his finest late paintings, like *Childe Harold's Pilgrimage – Italy* (Fig.

277. J. M. W. Turner, *Childe Harold's Pilgrimage – Italy*. Oil on canvas, 142 × 248 cm. R.A. 1832, with the caption:
'. . . and now, fair Italy!
Thou art the garden of the world.
Even in thy desert what is like to thee?
They very weeds are beautiful, thy waste
More rich than other climes' fertility:
Thy wreck a glory, and thy ruin graced
With an immaculate charm which cannot be defaced.'
Lord Byron, Canto 4
London, Clore Gallery for the Turner Collection (BJ 342).

278. (*facing page*) Detail of Fig. 277.

279. J. M. W. Turner, *Staffa, Fingal's Cave*. Oil on canvas, 91.5 × 122 cm. R.A. 1832. Yale Center for British Art (BJ 347).

277), to which he appended lines from Canto IV of Byron's poem, beginning

> – and now, fair Italy!
> Thou art the garden of the world . . .

and created, with the dancing and picnicking figures, an image of unusual harmony and optimism. It was, wrote the sculptor Richard Westmacott, 'the most magnificent piece of landscape poetry that was ever conceived'.[60] In the same year, he derived the motif of *Staffa, Fingal's Cave*, from Scott's *Lord of the Isles* (Fig. 279). The hazardous journey by steamer to gather material for an illustration to that poem (Fig. 299) was the occasion for recording the crossing and the island, with its curious columns of basaltic rock (see p. 220). The vignette illustrated the same passage in the poem which Turner used to caption his painting:

> – nor of a theme less solemn tells
> That mighty surge that ebbs and swells,

And still, between each awful pause,
From the high vault an answer draws.

But now the 'high vault' has become the dark-edged storm-cloud, whose shape is echoed in the banner of smoke from the steamer, leading the eye eventually to the cave-mouth itself. Turner was not concerned that the haloed sun which, according to his description in a letter, 'burst through the rain-cloud, angry and for wind', to fortell the storm which eventually drove the ship for shelter, could never have been seen at the same time as the cave, which is on the south-east side of the island: what still interested him was to find the 'pregnant moment' of poetry.

But it was the more imaginative vignettes for Rogers, Milton and Campbell which allowed Turner particularly to develop his poetic imagination, and to evolve the new figurative language which he elaborated in a series of enigmatic subject-paintings in the early 1840s. He had been particularly struck by a collection of pseudo-Renaissance fragments which Rogers published under the title *The Voyage of Columbus*. Among his vignettes for this poem, Turner illustrated the vision of a ghostly procession of giant soldiers across the sea (Canto II), and, from Canto XII, the vision of the dark angel who appeared to the discoverer at his death (Fig. 281). Turner's design emphasises the warlike message delivered by the angel, which Rogers, drawing on George Washington's farewell address as President of the United States, had sought to temper with the prophecy of peace. His angel seems to recall the 'Angel of Darkness' in Canto

VI of the poem, who had mentioned (only to disclaim) some even more martial images which impressed Turner so much that he used them to caption *The Angel Standing in the Sun* (Fig. 280) in 1846:

> The morning march that flashes to the sun,
> The feast of vultures when the day is done.[61]

This supremely apocalyptic picture, where the angel of light is also the angel of darkness in reverse, and has the dark function of linking the Expulsion from Paradise with the Last Judgement, embodies several episodes from the stories of Cain and Abel, Samson and Delilah and perhaps Judith and Holofernes in a complex very similar to the vignettes, whose circular structures it also echoes.[62] The imagery is dense, and the theme is still extremely problematic, but it must be clear that in this painting Turner demanded of the spectator the same attention to detail and allusion as he did from the reader of the books of poetry he illustrated; at the end of his life, Turner made no formal distinction between the poetic engraving and the exhibition painting.

282. J. M. W. Turner, *Wreck on the Goodwin Sands: sunset,* *c.*1845/50. Watercolour over pencil, 22.9 × 33.3 cm. Private Collection (W 1426). The inscription reads: *Wreck on the Goodwins | And Dolphins play around the wreck | The man's (?) hope holding all that hoped | Admits the work of the almighty's hand fallacy Hope | for sail.*

283. J. M. W. Turner, *Mercury sent to admonish AEneas*. Oil on canvas, 90.5 × 121 cm. R.A. 1850. with the caption: 'Beneath the morning mist, Mercury waited to tell him of his neglected fleet! – *S Fallacies of Hope*. London, Clore Gallery for the Turner ollection (BJ 429).

In these last years, too, he continued to unite text and image in his own sketches. A small group of slight watercolours, which probably dates from the mid-1840s, shows Turner worrying over the theme of the wrecked vessel as an emblem of the hopelessness of man, a theme which has a long pedigree in the history of emblematic art, as well as in Turner's own. These sheets (Fig. 282) include snatches of writing which continue the theme of 'The Fallacies of Hope', and since they are partly obliterated by the colour, they must have been integral to Turner's conception of the subjects, which are, indeed, all subjects of the imagination.[63] On this informal level, as well as on the public platform of the exhibition works, the last of which, from the story of Dido and Aeneas (Fig. 283), were again accompanied by captions from 'The Fallacies of Hope', Turner continued to feel an urge to unite the visual and the literary, and it should never be supposed that he was, on any level, anything other than a poetic painter. As he proclaimed uncompromisingly to his students in a lecture:

'We cannot make good painters without some aid from poesy.'[64]

205

CHAPTER EIGHT
Comparatively Intellectual

The impression Turner made on me was just that of . . . great *general* ability and quickness. Whatever subject of talk was started, he seemed master of it – books, politics &c. This confirms me in my general view of art – that it is less the product of a special faculty than of a powerful or genial nature, expressing itself through paint or marble. This is Goethe's idea of genius.

(F. T. Palgrave to W. M. Rossetti, *c.*1867)[1]

[The] imagination of the artist dwells *enthroned* in his own recess [and] must be incomprehensible as from darkness.

(Turner, 1818)[2]

284. J. M. W. Turner, *Whalley Abbey: Eight Studies of Ancient Crosses, Sedilia. &c.* 1799/1800. Watercolour, 26 × 19.1 cm. Burnley, Towneley Hall Art Gallery and Museums (W 286).

We have seen in the foregoing chapters how abundantly Turner was prepared and able to exploit the circumstances of his artistic development, the conditions of travel, the economics of patronage and publication, the access to collections and exhibitions, the office of Academician, and the world of poetry which, was for him, so closely related to the world of art. In this last chapter I shall look more generally at the professional company that Turner kept, at the world of ideas and politics, and of scholarship and technology, to see what in this company aroused his curiosity, and what he was able to make his own.

As we might expect, Turner was probably initiated into the wider circles of contemporary thought first of all through his patrons, some of whom were themselves notable members of the intellectual establishment. The first sponsor of Turner as an oil painter, for example, The Rev. James Douglas, who commissioned the *Rochester Castle* (see Fig. 106), was a distinguished geologist and antiquarian, an early identifier of Stone-Age flint tools in Britain, who had carried out excavations at the castle in the 1770s and 1780s.[3] Turner's own antiquarian interests were also far from superficial. Around 1800 he was happy to expend a good deal of patient energy recording ancient fragments for antiquarian illustration, work which could easily have been done by other and more specialised draughtsmen (Fig. 284). While he was gathering material for the same publication, Whitaker's *History of Whalley*, Turner took the trouble to record the lengthy inscription on the Sherburne tomb in Milton Church, Lancashire, which was not, and could not have been used in the drawing that was published.[4] About this time, too, Turner came into the circle of another eminent antiquarian, Sir Richard Colt Hoare, who was probably his most important sponsor around the turn of

 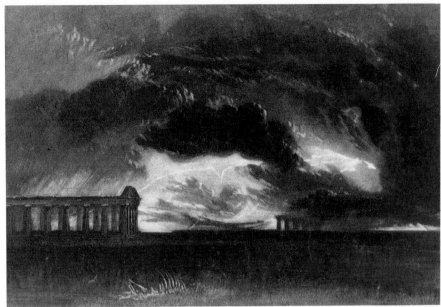

85. (left) J. M. W. Turner, *Stonehenge*, c.1823. Mezzotint, 20.4 × 27.6 cm. Boston, Museum of Fine Arts (RLS 81).

86. (right) J. M. W. Turner, *Paestum*, c.1825. Mezzotint, 15.4 × 21.6 cm. Oxford, Ashmolean Museum (R 799).

the century, both for a long series of watercolour views of Salisbury Cathedral and, more importantly, for Turner's first classical subject, *Aeneas and the Sibyl: Lake Avernus*, which was probably painted with Hoare in mind about 1798 (BJ 34). Colt Hoare was an authority not only on the classical world, but also on ancient British history, and in particular the antiquities of Wiltshire, including the stone circles of Stonehenge and Avebury. His work was part of a wider attempt in the Romantic period to interpret the remains of the ancient civilisations of northern Europe in the light of the history of mediterranean cultures, especially that of Greece; and it is notable that one of the last, and unpublished, plates of Turner's *Liber Studiorum* was of Stonehenge (Fig. 285) and that it was handled in a very similar way to the storm-shrouded *Paestum* (Fig. 286), engraved by Turner about the same time for the so-called 'Little Liber' series.[5] We saw in Chapter Two what a formative effect Colt had on Turner's preparations for his Italian journey in 1819.

One of the most lively branches of contemporary classical study was in what we might broadly term anthropology, and the investigation of comparative religion. In this speciality one of the leading British figures was another of Turner's patrons in the 1810s, albeit a minor one, Richard Payne Knight. It was Knight, rather than Colt Hoare who took up the identification of Stonehenge with the sun-temple described by an ancient Greek historian as being in Britain, and who compared its circular plan with another sun-temple in southern Italy; and in his *Liber* plate, as well as in earlier watercolours and drawings of the scene, Turner silhouetted his trilithons specifically against the setting sun.[6] Knight also wished to uncover the common principles of sexual generation which he perceived beneath the most elevated symbols of the ancients, even the cross, and, conversely, he was anxious to disembarrass the profane subject-matter of much ancient art of the stigma of obscenity, by pointing to its higher symbolic purposes.[7] Turner is likely to have read Knight's erudite antiquarian discourses with as much attention as the read his aesthetic works;[8] and in the same years, around 1808, he also looked more widely at comparative mythology in the writings of the classicist and orientalist Sir William Jones.[9] Knight's sustained attention to a wide range of sun-cults, including that of the Druids at Stonehenge, will have struck a particularly sympathetic chord in an artist whose deathbed utterance is said to be have been 'The sun is God';[10] and his discussion of symbolism may well have fuelled Turner's choice and treatment of a number of subjects, including *Apollo and Python* (Fig. 17), of which Knight wrote

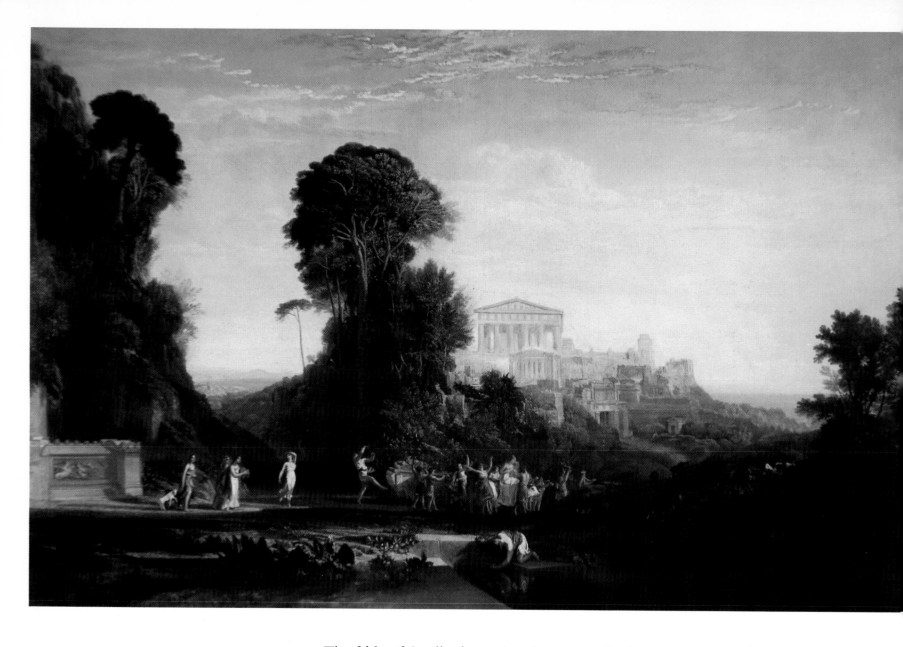

288. J. Pye and S. Middiman after J. M. W. Turner, *The Temple of Jupiter Panellenius Restored*, 1828 (detail). Line engraving, proof state. London, British Museum. See Fig. 287.

The fable of Apollo destroying the serpent Python, seems . . . to have originated from the mythological language of imitative art; the title Apollo signifying . . . the destroyer as well as the deliverer . . . the lizard, being supposed to exist upon the dews and moistures of the earth, was employed as the symbol of humidity; so that the god destroying it signifies the same as the lion devouring the horse, and Hercules killing the centaur; that is, the sun exhaling the waters . . .[11]

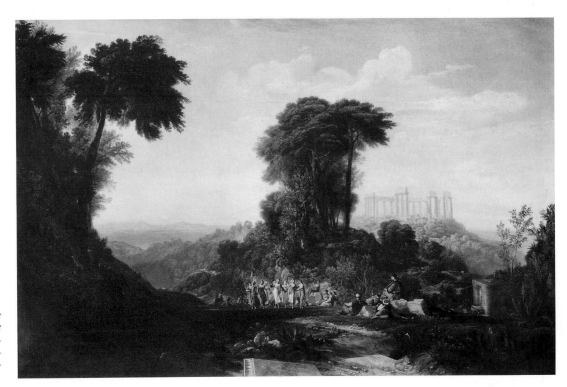

Another passage in Knight helps us to interpret a curious detail in one of Turner's first, and finest, purely Greek landscapes, *The Temple of Jupiter Panellenius Restored* (Fig. 287), which he executed about 1814. To the far left is a sculpted low relief set in the wall (Fig. 288), depicting a haloed charioteer, whose name ANNIKERIS, inscribed next to the panel, suggests one of the titles of the Roman sun-god Mithra. He is about to be crowned by a winged Victory. The association of this inset scene with the nuptials which are the main subject of the picture may be based on Knight's view that

> The Greeks, among whom the horse was a symbol of humidity, placed [the personifications of the sun and moon] in chariots, drawn sometimes by two, sometimes by three, and sometimes by four of these animals . . . The vehicle itself appears likewise to have been a symbol of the passive generative power, or the means by which the emanations of the sun acted; whence the Delphians called Venus by the singular title of the Chariot; but the same meaning is more frequently expressed by the figure called a Victory accompanying; and by the fish, or some other symbol of the waters under it . . .[12]

Turner has drawn on Knight's classicising view of the union of the male (active) and the female (passive) powers, and introduced them in an emblematic form into this more anthropological development of the Apollo and Python theme: the elemental struggle of the sun and the water.

The Temple of Jupiter Restored was painted as a pair to a view of the same building in its ruined state (Fig. 289), which had been executed for, and based on a sketch by, the poet and traveller Henry Gally Knight (no relation to Payne Knight). Gally Knight was in Athens in 1811 and there met Lord Byron, who was working on the second Canto of *Childe Harold's Pilgrimage,* in which he lamented the decadence of modern Greece under the Turkish yoke. Turner took the general character of his 'Modern' view of the temple, as he had taken its reconstruction, from the archaeologists (Figs. 32–4); but its specific, and political, subject derived from a dramatic poem by Gally Knight himself, which had in its turn been inspired by Byron:

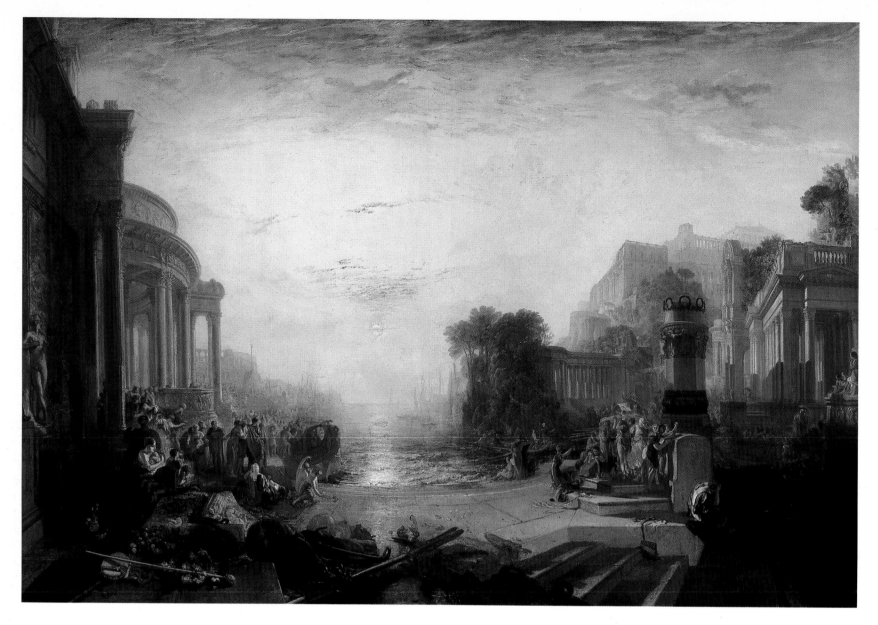

290. J. M. W. Turner, *The Decline of the Carthaginian Empire – Rome being determined on the Overthrow of her Hated Rival, demanded from her such Terms as might either force her into War, or ruin her by Compliance: The Enervated Carthaginians, in their Anxiety for Peace, consented to give up their Arms and their Children.* Oil on canvas, 170 × 238.5 cm. R.A. 1817, with the caption:
'. . . At Hope's delusive smile,
The chieftain's safety and the mother's pride,
Were to th'insidious conqu'ror's grasp resign'd;
While o'er the western wave th'ensanguin'd sun,
In gathering haze a stormy signal spread,
And set portentous.'
London, Clore Gallery for the Turner Collection (BJ 135).

Full soon, beneath the plane, the virgin band,
In wonted dance advancing, join'd the hand:
The youths, divided from the fair, apart
Trod the same maze, but wanted all the art.
Met in a solemn knot the archons sate
And o'er the pipe prolonged the grave debate;
The matron train, loquacious in their glee,
Range in a line, to gossip and to see;
Th'ignobler crowd are scattered o'er the ground;
And, join'd in troops, the children sport around.
Smiles all the scene, and gives to Fancy's eye
One glimpse of ancient Greece and Liberty.[13]

Byron, Gally Knight and Turner were joining in a debate on the relationship of ancient to modern societies which had been given a good deal of impetus in England by Edward Gibbon's *Decline and Fall of the Roman Empire* (1776–88) but which was conducted in the early nineteenth century increasingly in anthropological terms. Turner's association of an ancient Greek wedding and the modern dance of the Romaika may have been suggested to him by an anthropological essay which included

291. J. M. W. Turner, *Dido building Carthage; or the Rise of the Carthaginian Empire – 1st Book of Virgil's Aeneid*. Oil on canvas, 155.5 × 232 cm. R.A. 1815. London, National Gallery (BJ 131). In 1829, Turner decided to bequeath this picture to the new National Gallery, to hang beside a Claude *Seaport*, probably Fig. 155.

these topics by F. S. N. Douglas;[14] and a pair of paintings of 1838, articulating the customs of ancient and modern Italy in a very similar way (BJ 374–5), had also taken its cue from a comparison of ancient and modern folklore by J. J. Blunt, which Turner owned.[15] This comparative method bore its most magisterial fruit at the end of the century in Sir J. G. Frazer's great study of magic and religion, *The Golden Bough* (1890–1915) which, appropriately enough, took as its starting point Turner's painting of the same title (Fig. 53).

Another facet of the comparative method in Romantic historical writing was the rather more traditional wish to use the past as a series of examples for the present. We have seen how the *Hannibal* (Fig. 270) embodied associations with the contemporary history of France; and it was the first of a series of themes from the history of Rome and Carthage in which Turner articulated his belief that modern Britain must see her own fate mirrored in that of the great empires of Antiquity. He found support, and perhaps even a stimulus, for that view among some of his associates of the years which saw *Dido and Aeneas* (BJ 129), *Dido Building Carthage* (Fig. 291) and *The Decline of Carthage* (Fig. 290). One of them was Granville Penn, a grandson of William Penn, the Quaker founder of Pennsylvania, and brother of John Penn, the first owner of one of Turner's finest early oils, *Dunstanborough Castle* (BJ 6), who was Governor of the Isle of Portland,

211

where the painter worked on his western itinerary in 1811. Farington twice met Turner at dinner with the Penn brothers in 1813 and 1814.[16] Granville was a prolific writer on history and geology, and he had not long before published a sublimely ambitious essay on the history of empires, in which he argued that 'The general and perpetual use of History, is to *guide* the PRESENT *generation by* THE EXPERIENCE *of the generations which are* PAST.'[17] If Penn spoke as emphatically as he wrote, Turner, who sat next to him on these occasions, can hardly have failed to get his drift, which was to show that Napoleon had concluded the fifth period of modern history – going back to the foundation of the Imperial Monarchy in ancient Rome – by his extinguishing of the Roman Empire in 1806 and of the Papal Monarchy in 1810. The French Empire was, according to Penn, not distinct, but simply the final manifestation of the Roman Empire itself.[18]

Another associate of Turner's, to whom this sort of argument was congenial was Lord Carysfort, who was perhaps the original begetter of the painter's early *Deluge* (BJ 55 and cf. Fig. 163), although that painting remained on the artist's hands. Carysfort had been a leading parliamentary opponent of the slave-trade, and his sympathies may well have attracted him to the magnificent supportive black who is so prominent in Turner's picture, even if he did not positively inspire the motif. In the 1810s Carysfort turned to poetry, and particularly to classical themes which he regarded as morally instructive. In an afternote to his dramatic poem, *Caius Gracchus*, for example, he wrote

> It seemed to me that such a subject, and such characters, must strongly interest all the friends of virtue, which consists in the steady adherence to principles of duty, and a generous disdain of danger and suffering; and that it should peculiarly interest the British people, whose greatest boast is that they are free. But liberty is not a state of torpid apathy, and virtue exists in activity, not in indolent repose.[19]

This was, I have suggested, a major theme in Turner's *Southern Coast*, where the stoic example of Regulus, a Roman tortured by the Carthaginians, was first introduced by Turner into the context of British history.[20] Carysfort was also attracted to the story of Carthage, and he interpreted the Fall of Carthage, in his play of that name, very much in Turnerian terms:

> Ye cities! and thou, Carthage! Chief, where lull'd
> By soul-corrupting wealth, thy dastard sons
> Upon the altar of luxurious ease
> Have bound their country's glory![21]

This is very close to imagery, and the moral, of Turner's *Decline of Carthage*, exhibited in 1817 (Fig. 290).

In a brilliant chapter on politics and symbolism in his biography of Turner, Jack Lindsay associated the message of *Hannibal* (Fig. 270) with the radical politics of his friend Walter Fawkes, on whose estate in Yorkshire the subject was apparently first conceived about 1810.[22] Turner was of course particularly close to Fawkes, and he decorated with great relish the record of his family's anti-monarchial position during the English Civil War of the seventeenth century.[23] But it would be mistaken to assess Turner's politics simply on the basis of his associations. At the time when he first met the Whig Fawkes about 1800, Turner was also working for Fawkes' neighbours, the Lascelles of Harewood, a family of a very different political colour.[24] And at the height of his friendship with Fawkes in the late 1810s he was also executing very similar commissions for 'Jack' Fuller of Rosehill in Sussex, a Tory M.P. and slave-owner of the extremest kind.[25] Politics were no more a bar to Turner's friendship than they were to patronage: the successor to Fawkes in his affections was Lord Egremont, a Tory who

292. (*facing page, top*) J. M. W. Turner, *Northampton*, *c*.1830. Watercolour, 29.5 × 43.9 cm. Private Collection (W 881).

293. (*facing page, bottom*) George Dance, *William Turner*, 1800. Black, white and pink chalk, 25.5 × 19.5 cm. London, Royal Academy of Arts.

opposed Catholic Emancipation at precisely the time when Turner, who was very close to the Third Earl in the late 1820s, was espousing it in his *England and Wales* subject, *Stonyhurst College, Lancashire* (w 820).[26]

What is clear is that Turner was not a Republican, nor, despite his acute sympathy for the plight of the defeated Napoleon (Fig. 228),[27] did he admire French politics any more than he admired French aesthetics. In contrast to his friend Thomas Girtin, he was not a 'crop' as a young man, one of the many who in the early years of the French Revolution cut their hair short in sympathy with Republican ideals (see Fig. 293). One of Turner's favourite songs seems to have been the patriotic *John Bull Content*, with its anti-French and anti-democratic verses:

> Then the plough and the loom would stand still
> If they made of us gentlemen all;
> If ploughmen were all who would fill
> The parliament, pulpit and hall?
>
> Rights of man make a very fine sound;
> Equal riches, a plausible tale;

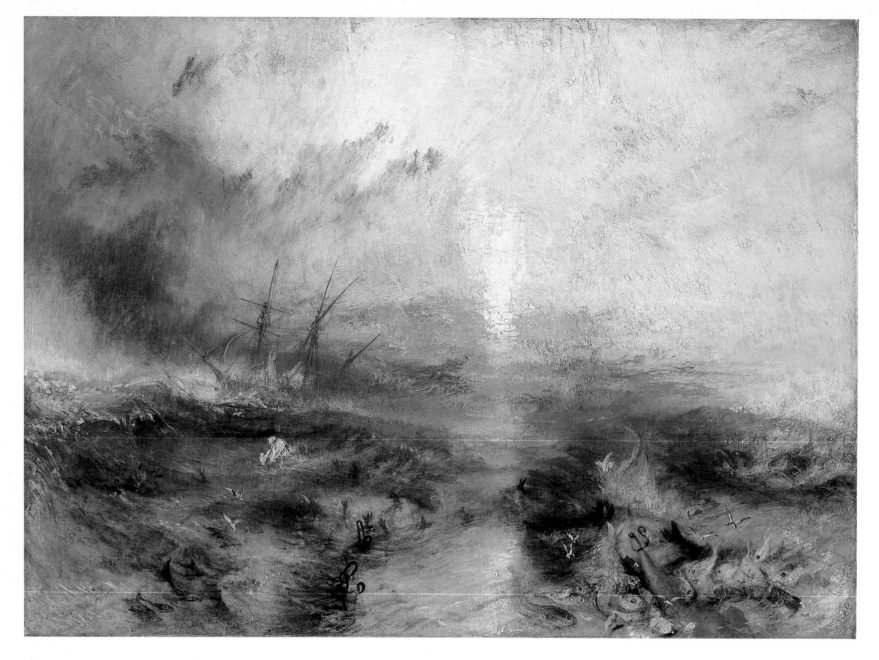

294. J. M. W. Turner, *Slavers throwing overboard the Dead and Dying – Typhon coming in.* Oil on canvas, 91 × 138 cm. R.A. 1840. Boston Museum of Fine Arts (BJ 385). For the caption, see p. 194.

But whose labour would then till the ground?
All would drink, but who'd brew the best ale?

If half naked half starved in the streets,
We were wandering about sans culottes,
Would equality furnish us meat?
Or would liberty lengthen our coats?
<div align="right">(TB CVI, p. 11a)</div>

Turner liked this song so much that he repeated seven verses from it some years later in a sketchbook which he used while staying with Fawkes himself (TB CXLVIII, inside cover). Was it another subject of debate between them?

It was not until 1830 that Turner was able to show that he supported the movement for parliamentary reform in his *England and Wales* subject, *Northampton* (Fig. 292), by introducing Marianne, the personification of the French people who had just brought his old friend Louis-Phillippe to the throne in the second French Revolution. And he equally used his art in the cause of the abolition of slavery (Fig. 294), in the cause of

295. *(facing page)* Detail of Fig. 294.

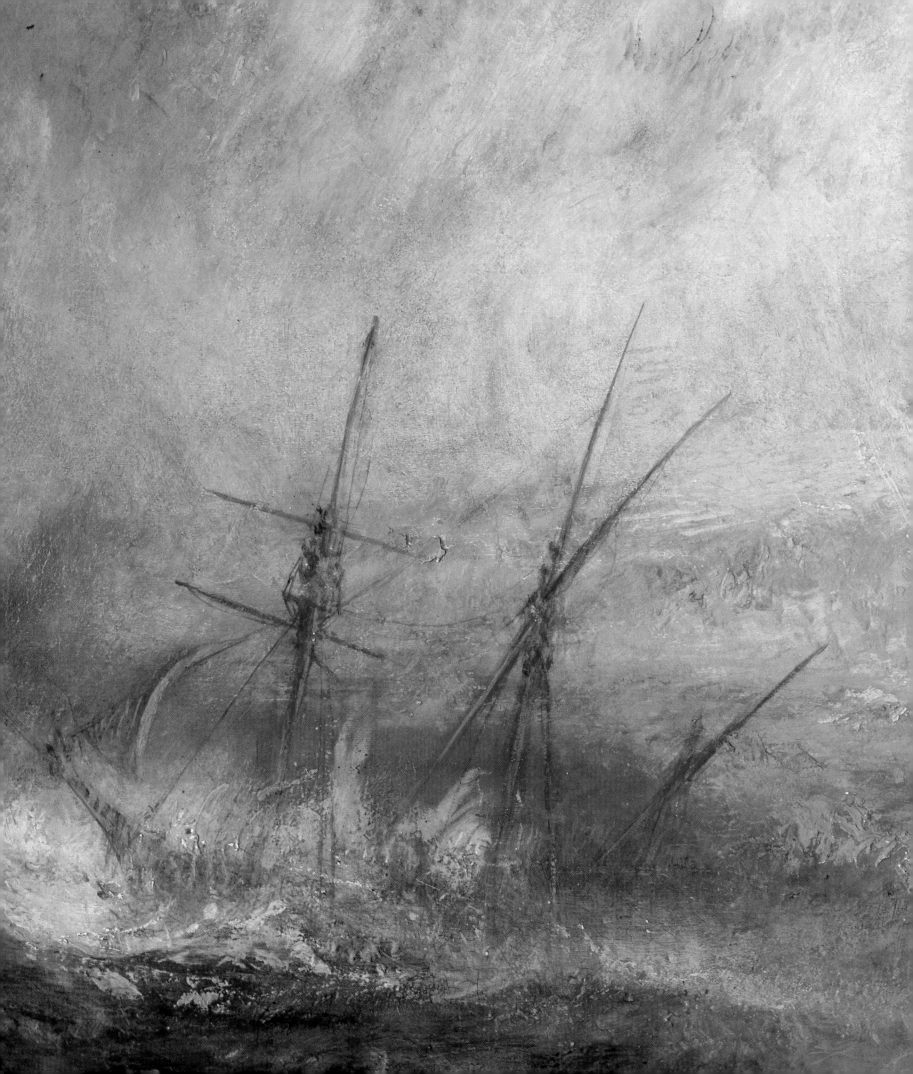

religious toleration, both Protestant and Catholic, and of Greek independence.[28] All of these were broadly humanitarian issues, and they co-existed in Turner with a fierce and proud patriotism. Where Reynolds had ended his last Discourse with the personal reference to Michelangelo, Turner, as we saw, ended his with the name of the British Empire, which he did not wish to go the same way as the empires of the past. It is nonetheless very likely that he endorsed the fears of Eustace, in the *Tour through Italy*:

> Empire has hitherto rolled westward; when we contemplate the dominions of Great Britain, and its wide-extended power, we may without presumption imagine that it now hovers over Great Britain; but it is still on the wing; and whether it be destined to retrace its steps to the East, or to continue its flight to Transatlantic regions, the days of England's Glory have their number, and the period of her decline will at length arrive . . .[29]

What was more important than the precise colour of Turner's politics was his aspiration to bring political and social themes into the centre of landscape art; but it was an aspiration which remained almost entirely lost on his public.

<div align="center">II</div>

Perhaps even more fundamental than patronage for the development of Turner's attitudes were the friendships and associations he made with a range of professional men, and first of all within the Royal Academy. We have already seen some of the contacts he made in his early days there, for example, with the veteran Piedmontese history-painter J. F. Rigaud. Rigaud was an authority on Leonardo da Vinci, whose *Treatise on Painting* he published in an English translation in 1802. Leonardo the artist-scientist became an inspiration to Turner, who quoted his ideas repeatedly in his lectures; and it is very likely indeed that his view of the role of the landscape artist as essentially investigative (see p. 73) was stimulated by his reading of the Florentine master.[30]

In December 1803, when Turner was serving his first period on the Academy Council, the surgeon William Blair approached Farington with a request to be allowed to take the place of the regular Professor of Anatomy, Sheldon, during the latter's illness.[31] It was probably in connection with this appeal that Blair presented Turner with a copy of his new book, *Anthropology*, which was designed as a schematic handbook to accompany his lectures. This, too, was a text which gave Turner much food for thought, and in particular it included an exposition of the nature of causality, a theme which occupied Turner a good deal during the preparation of his own lectures. Blair quoted extensively from Query 28 in Book III of Newton's *Opticks*, on the deduction of causes from effects in a continuous chain leading back to the inscrutable first cause, God; and this was certainly a passage which stayed in Turner's mind.[32] His complicated working procedures as well as his examination of nature made him especially sensitive to the reading of causes from effects and, like Newton, he saw light as particularly exemplifying this process. One of the more intriguing and controversial instances of the recognition of this chain of causation, to which Blair introduced Turner, was however in the new pseudo-science of craniology, popularised around 1800 by the Viennese doctor Franz Joseph Gall. Gall presumed to be able to interpret the surface conformations of the individual human skull as the result of the various features of the brain within it, and these, in their turn, were seen to correspond to the greater or lesser development of a large number of 'organs' for human faculties, or mental characteristics, which Gall located in very specific parts of that brain. Turner will perhaps have been attracted to the system because one of the many 'organs' distinguished by the doctor was 'the organ of painting – the sense of colours'.[33] But,

296. *(facing page, top)* J. M. W. Turner, *Fish-Market, Hastings*, 1824. Watercolour, 44.4 × 66.3 cm. Private Collection (W 510).

297. *(facing page, bottom)* After H. W. Williams, *A Janizary*, 1820; from Hugh William Williams, *Travels in Italy, Greece and the Ionian Islands*, 1820. See Fig. 296.

Lizars Sculp.

like Blair, he came quickly to reject it, and he did so probably under the influence of Sheldon's successor as Professor of Anatomy at the Academy, Sir Anthony Carlisle, whose lectures Turner attended about 1809.[34]

Carlisle was one of Turner's more stimulating Academic colleagues, and he became the painter's doctor.[35] When he retired as Professor in 1824, Turner presented him with the watercolour, *Fish-market – Hastings* (Fig. 296), which embodied a very Turnerian interpretation of the idea of the unity of all creation, for, prominently in the centre of the composition is the entirely unexpected figure of a Greek Janizary, or soldier, tapping a lobster-fisherman on the shoulder. He is unmistakable (Fig. 297), and, as Eric Shanes has pointed out, 1824 was the height of the Greek War of Independence; Byron died at Missolonghi the same year.[36] The Greek is clearly about to argue with the fisherman, for, as Turner had written in *The Southern Coast*, the lobster-catcher was a type of faithless tyrant, who, in the end, was treated to some of his own medicine:

> But here again the sad concomitant of life
> The growth of family produced strife
> Raised from his long content(ed) cot he went
> Where oft he labor(ed) and the ozier bent

298. J. M. W. Turner, *The Bivalve Courtship*, *c*.1831. Pencil, 85 × 11 cm. London, Clore Gallery for the Turner Collection (TB CCLXXIX(a), p. 7).

299. E. Goodall after J. M. W. Turner, *Fingal's Cave, Staffa* 1833. Line-engraving, 13 × 9 cm. (R512).

To form a snare for lobsters arm(ed) in mail
But man more cunning over them prevail(s)
Lured by a few sea-snail(s) and whelks, a prey
That they could gather on their watery way
Caught in a wicker cage not two feet wide
While the whole oceans open to the(ir) pride
Such petty profits could not life maintain
From his small cot he strecht upon the main
And by more daring effort hope(d) to gain
What hope appeared ever to deny
And from his labours and his toil to fly
And so he proved, entrapt and ourpowered
By hostile force in Verdun('s) dungeon lowered
Long murmured gainst his hard thought lot
Rebelled against himself and even his wife forgot . . .[37]

The continuous chain of being which linked molluscs and crustacea to man was thus a notion dear to Turner as well as to Carlisle; and the painter was able to express it in the frequent use of animals in his pictures, to carry the sentiment, culminating in *War: The Exile and the Rock Limpet* of 1842 (Fig. 228).

Another amusing record of Turner's intimacy with Carlisle, and of his conception of natural unity, is in a little pencil drawing of a man chatting to an oyster-seller in a sketchbook of about 1832 (Fig. 298). Turner inscribed it with the title *The Bivalve Courtship*, but during the early nineteenth century bivalves, including oysters, had been regarded as androgynous, until Carlisle, in a remarkable lecture of 1826, in which he performed the amazing feat of dissecting an oyster, showed that in their case, as in that of worms and snails, 'the mutal intercourse of two individuals is required'.[38] It is this assumption which must lie behind Turner's little genre scene, and that he gave it a title at all suggests that he must have been well aware of the novel implications. Turner prized the philosophical cast of Carlisle lectures, which were directed towards demonstrating the wisdom of Providence;[39] and Carlisle, for his part, was scornful of what he saw as the purely empirical bent of English medical thought, seeking in his study of comparative anatomy to uncover the mechanisms which could link the development of all species.[40] It was probably his wide-ranging speculations on the fundamental principles of structure which most appealed to Turner. He arranged that his own course should follow that of the Professor of Anatomy, and in a passage on comparative form in one of his lectures of 1818, he anticipated an idea which Carlisle was to present to the medical students at the Royal College of Surgeons later in the same year:

we cannot evade those Geometric forms in the Bone, the *machinery of all form*, and therefore why [is it] *degrading* to allow *that* to accompany art which pervaded through Nature, the component parts of which Geological research maintains; the vegetable and mineral evade not, but conform [to]; the cell of the Bee and the Bysaltic mass display the like Geometric form, of whose elementary principles all nature partakes.[41]

The introduction of geology in this passage, and particularly the mention of the basaltic structures Turner was later to draw at Staffa (Fig. 299), was highly significant, for in these early years of the century, the study of comparative anatomy and of geology were intimately linked. Carlisle himself had been a member of the Geological Society of London since 1809. Geology was one of the most rapidly advancing sciences during the period, and one of the chief issues which engaged it was the age of the earth, and the interpretation of the fossil record in the establishment of a chronology of

218

creation. A popular account of Granville Penn's 'Mosaical Geology', one of the many attempts to uphold the truth of *Genesis* against the newer developments, suggests a double aspect in the practice of the science which made it particularly interesting to Turner:

> I . . . call Geology romantic, because it not only leads us to travel among the wildest scenery of nature, but carries the imagination back to the birth and infancy of our little planet, and follows its history of deluges and hurricanes and earthquakes, which have left us numerous traces of their devastations. Would you not think it romantic to travel, as must be done by the geological inquirer, among mountains and valleys, where the tempests have bared and shattered the hardest rocks, and where alternate rains and frosts are crumbling the solid materials and mountains, while the springs and rivers wash away the fragments, to deposit them again in the various stages of their course? And would you not think it romantic to discover the traces of the ancient world before the time of Noah, in every hill and valley which you examine?[42]

Penn himself was an Alpinist, and in another book of the 1820s he used the Swiss Alpine landscape as the completest summary of the progress of what he called the 'FIRST REVOLUTION OF THE MOSAICAL GEOLOGY', caused by the flooding of the sea into the burning centre of the earth, and its consequent massive eruption.[43] The conjunction of the sea and volcanoes, which is such an important feature of Penn's system, as well as that of the chemist Sir Humphrey Davy in the 1820s, was illustrated by Turner in *Ulysses Deriding Polyphemus* (Fig. 4), where the Cyclops' volcano lies above a burning cavern on the edge of the sea.[44] Turner also shared Penn's interest in the geological drama of the Alps, and in his most overwrought late watercolour, *Goldau* (Fig. 300), he presented the scene of devastation left by the great avalanche of 1806, which destroyed the village, but at the same time created a rift in the mountain of great geological interest.[45] It is little wonder that in 1840 Thomas Griffith should have invited Turner and Ruskin, who became, though Griffith, the first owner of *Goldau*, and who was himself a keen amateur geologist, to meet the President of the Geological Society, W. H. Fitton, or that Turner should have talked on this occasion, 'with great rapture of Aosta and Courmayeur'.[46]

A geologist who was primarily concerned with the geographical and mineralogical aspects of the science, and who was also close to Turner, was John Macculloch, whom he is likely to have met first about 1814 at the home of W. F. Wells, who was

300. J. M. W. Turner, *Goldau*, 1843, watercolour, 30.5 × 47 cm. Private Collection (W 1537).

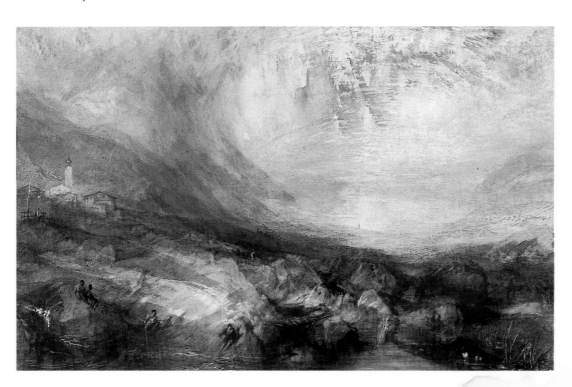

Macculloch's colleague on the staff of the East India Company's Military Seminary at Addiscombe in Kent.[47] Clara Wells recalled a meeting at her father's home at which the geologist remarked of Turner, 'That man would have been great in any- and everything he chose to take up. He has such a clear, intelligent, piercing intellect';[48] and it was probably from Macculloch that Turner acquired the first two volumes of *The Transactions of the Geological Society* (1811–14), which included many articles by him. One of them was 'On Staffa', in which Macculloch referred to the pentagonal and hexagonal sections of the basalt columns, which so interested Turner in his passage on comparative form, quoted above.[49] And when Macculloch came to write at greater length on the island in his *Highlands and Western Isles of Scotland* of 1824, he dwelt on the pleasures to be had from the view inside Fingal's cave, in terms which recall Turner's vignette for Scott (Fig. 299):

> The sides of the cave within, are columnar throughout; the columns being broken and grouped in many different ways, so as to catch a variety of direct and reflected tints, mixed with secondary shadows and deep invisible recesses, which produce a picturesque effect, only to be imitated by carefuly study of every part. As I sat on one of the columns, the long swell raised the water at intervals up to my feet, and then, subsiding again, left me suspended high above it; while the silence of these movements, and the apparently undisturbed surface of the sea, caused the whole of the cave to feel like a ship heaving in a sea-way . . . As the sea never ebbs entirely out, the only floor of this cave is the beautiful green water; reflecting from its white bottom those tints which vary and harmonize the darker tones of the rock, and often throwing on the columns the flickering lights which its undulations catch from the rays of the sun without.[50]

Macculloch's book had been conceived as a series of letters to Sir Walter Scott, who had been a friend of the geologist's since the 1790s. It is more than likely that Scott showed it to Turner when the painter was planning his own visit to Western Scotland, on the poet's behalf, in 1831. Certainly one of the most astonishing landscapes he prepared for Scott's *Poems* was *Loch Coriskin* (Coruisk) (Fig. 301), which had been the subject of a long and poetic description by Macculloch, who claimed that, apart from Scott and himself, probably only half-a-dozen people knew of this remote place. Coming across it suddenly, he said

> I felt as if transported by some magician into the enchanted wilds of an Arabian tale, carried to the habitation of the Genii among the mysterious recesses of Caucasus . . . Never was anything more deceptive than the first sight of this valley. Simple in its form and disposition, admirably proportioned in all its parts, and excluding other objects of comparison, it appeared about a mile in length, and the lake seemed not to exceed a few hundred yards. But when I looked at that solitary birch tree, a mere speck in the void, when I saw a hundred torrents, which, though they almost seemed within my reach, I could not hear, when I viewed the distant extremity, dimly showing through the soft grey of the atmosphere, and when, as I advanced, the ground, that seemed only strewed with pebbles, was found covered with huge masses of rock, far overtopping myself, I felt like an insect amidst the gigantic scenery, and the whole magnitude of the place became at once sensible.[51]

Turner, who was in some danger clambering over the slippery, bare rocks, caught this feeling perfectly, and he included himself among the insect-like figures. Macculloch at Coruisk was induced not simply into a long meditation on the sublimity of silence, but also to identify a new rock, which he called Hypersthene: the double values of a sublime scale and a precision of geological description are also the characteristics of Turner's wonderful drawing.

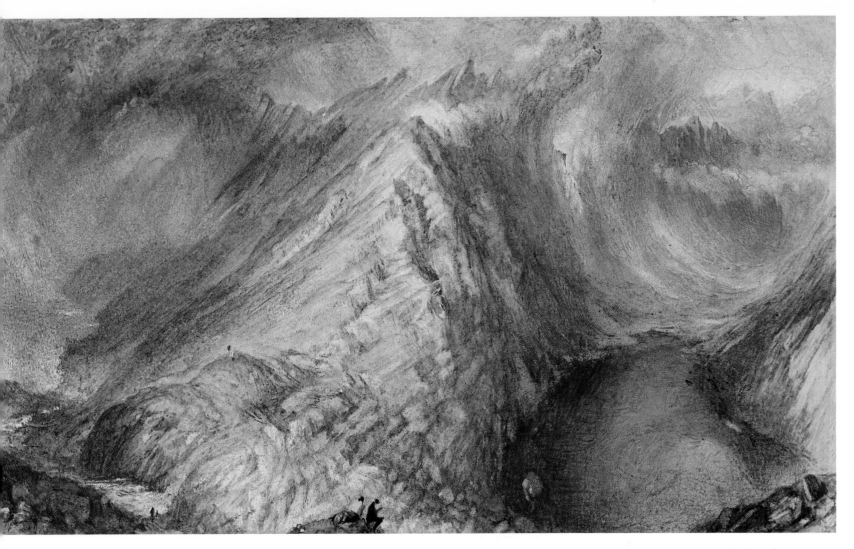

Macculloch was probably the most distinguished descriptive geologist known to Turner; but the painter was also associated with some of the many geologists of the period who were more concerned to reconstruct the origins of the earth on the basis of the fossil record. This was, of course, a highly controversial subject, for it called into question the Biblical chronology, as well as the Mosaic account of the creation of the world in *Genesis*. Already in his *Garden of the Hesperides* of 1806 (Fig. 261) Turner had, in his drawing of the dragon Ladon, shown an uncanny instinct for the shape of things to come, for Ladon's foreparts are very close to the forms of the crocodile-like Ichthyosaurus, whose remains were being identified on the south coast of England in these very years.[52] But Turner's early treatment of the *Deluge* (Fig. 163) suggests no interest in such questions; and it was only when he returned to the theme in the early 1840s that there are signs that the geological controversies which had been shaking the scientific and ecclesiastical establishments over the previous two decades had begun to affect his conception of this sublime Biblical subject.

An early version of *The Eve of the Deluge* (Fig. 304), includes a direct reference to the fossil discoveries in the form of an Ichthyosaur, who looks at the procession of animals towards the distant Ark, perhaps rather wistfully, for these great antediluvian creatures were not among those destined to be saved.[53] Some authorities argued that they had probably not survived even until the time of man; but others, notably Charles Lyell, maintained that they may indeed have survived and were still biding their time in some as yet unexplored corner of the earth; and the many sightings of sea-monsters were adduced by others to show that unidentified prehistoric species were still likely to be discovered alive.[54] Turner was certainly in touch with William Buckland, the

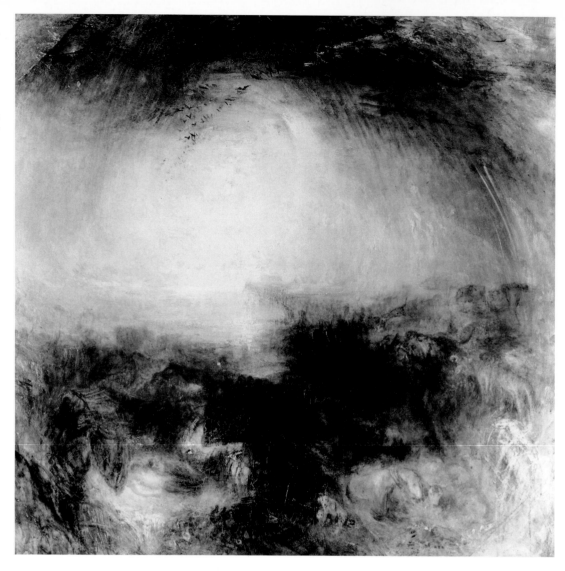

302. J. M. W. Turner, *Shade and Darkness – the Evening of the Deluge.*
Oil on canvas, 87.5 × 78 cm. R.A. 1843 with the caption:
'The morn put forth her sign of woe unheeded;
But disobedience slept; the dark'ning Deluge closed around,
And the last taken came: the giant framework floated,
The roused birds forsook their nightly shelters screaming
And the beasts waded to the ark.'

Fallacies of Hope M.S.
London, Clore Gallery for the Turner Collection (BJ 404). A
pendant to Fig. 305; see also Fig. 304.

303. Edward Goodall after J. M. W. Turner, *The Mustering of the Warrior Angels* engraving, 10.4 × 9.1 cm. Yale Center for British Art (R 598).

Professor of Geology at Oxford, by 1843, when Buckland suggested a subject for Turner to paint,[55] and on this question Buckland was a supporter of Lyell. But in the 1830s he had been increasingly concerned to separate the geological from the Biblical accounts and to allow each their independent validity. In Turner's final version of the Deluge theme, the two pictures shown at the R.A. in 1843 (Figs. 302, 305) the painter, too has taken up precisely this position; by removing the earlier reference to the fossil species, by telescoping the action into a single night, and by placing Moses as narrator firmly in charge, Turner re-asserted the purely human and mythical status of the story of the Flood.

Turner had a ready access to the Geological Society through his friendship with Charles Stokes, who was an early collector of his watercolours and became his stockbroker, and with the sculptor Francis Legatt Chantrey. Both were prominent members of the Society from the early 1810s, and both, a few years later, became closely associated with Turner in the running of the Artists' General Benevolent Institution. But it was probably through Chantrey that Turner made the acquaintance of the most distinguished woman scientist of the day, Mary Somerville, who was a close friend of the sculptor's, and often visited him in the years around 1830.[56] Mary Somerville's experimental work was of particular interest to Turner because it concerned the various powers of the solar spectrum: an early demonstration of the magnetising capacity of spectral colours stayed in the painter's mind until the end of his life.[57] It is likely, too, that the diagram of Galileo's solar system, which he introduced into an early but rejected version of the vignette, *Galileo's Villa* (R 360), for Rogers' *Italy*, and which he did use in his later illustration to Milton, *Mustering of the Warrior*

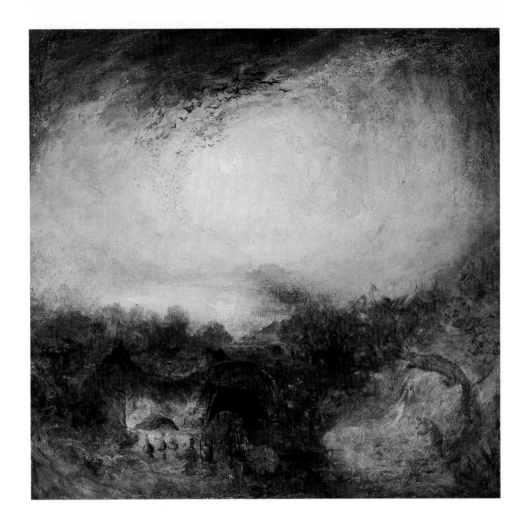

204. J. M. W. Turner, *The Evening of the Deluge, c.*1843. Oil on canvas, 76 × 75 cm. Washington, National Gallery of Art (W 443).

205. J. M. W. Turner, *Light and Colour (Goethe's Theory) – the Morning after the Deluge – Moses writing the Book of Genesis,* Oil on canvas, 78.5 × 78.5 cm. R.A. 1832, with the caption:
'The ark stood firm on Ararat; th'returning sun
Exhaled earth's humid bubbles, and emulous of light
Reflected her lost forms, each in prismatic guise
Hope's harbinger, ephemeral as the summer fly
Which rises, flits, expands, and dies.'
Fallacies of Hope, M.S.
(BJ 405)

206. Giovanni Battista Tiepolo, *Bellerophon on Pegasus,* Palazzo Labia, Venice.

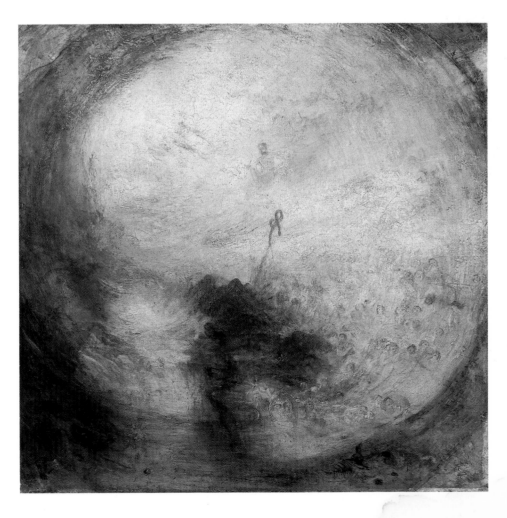

Angels (Fig. 303), was the result of conversations with Mrs Somerville, whose treatise on astronomy, *Mechanism of the Heavens* (1831) he acquired.[58] Milton had visited Galileo in Florence,[59] so the motif was an entirely appropriate one, although the passage from the beginning of Book VI of *Paradise Lost*, to which Turner's imaginative vignette was an illustration, gave no direct cue for this system to be introduced, and it must have been the artist's own invention:

> . . . There is a cave
> Within the mount of God, fast by his throne,
> Where light and darkness in perpetual round
> Lodge and dislodge by turns, which makes through heaven
> Grateful vicissitude, like day and night;
> Light issues forth, and at the other door
> Obsequious darkness enters, till her hour
> To veil the heaven, though darkness there might well
> Seem twilight here . . .

Mrs Somerville was also, perhaps, behind a change which Turner made in one of his most dazzling compositions of the 1830s, *The Fountain of Indolence* (Fig. 307), first exhibited in 1834. The picture took its title and its theme from a poem by James Thomson, *The Castle of Indolence* (1748), in which the intoxicating blandishments of this stronghold of enchantment eventually yield to a Knight of Industry: a theme clearly close to Turner's heart. The castle is furnished with a fountain,

> That in the middle of the court up-threw
> A stream, high spouting, from its liquid bed,
> And falling back again in drizzly dew:
> There each deep draughts, as deep he thirsted, drew;
> It was a fountain of Nepenthe rare:
> Whence, as Dan Homer sings, huge pleasaunce grew,
> And sweet oblivion of vile earthly care,
> Fair gladsome waking thoughts, and joyous dreams more fair.
> (Canto I, xxvii)

Five years later, however, in an uncharacteristic gesture of indolence, Turner exhibited what appears to have been the same canvas, perhaps lightly reworked, under the title *The Fountain of Fallacy*.[60] This time it carried a caption:

> Its Rainbow-dew diffused fell on each anxious lip,
> Working wild fantasy, imagining;
> First, Science in the immeasurable Abyss of thought,
> Measured her orbit slumbering
>
> MS *Fallacies of Hope*

These not altogether transparent verses seem to suggest that, in contrast to the wildness of fantasy, science, or thought, is capable of measuring, although it is itself immeasurable. In the *Mechanism of the Heavens* Mrs Somerville had shown how Newton had succeeded in measuring the orbits of the planets;[61] but there, and again in her second book, *On the Connexion of the Physical Sciences*, (1834), she had also pointed to the inescapable limitations of scientific method:

> A consciousness of the fallacy of our judgement is one of the most important consequences of the study of nature. This study teaches us that no object is seen by us in its true place, owing to aberration; that the colours of substances are solely the effects of the action of matter upon light, and that light itself, as well as heat or sound,

are not real beings, but mere modes of action communicated to our perceptions by the nerves.[62]

It is thus perhaps no surprise that Turner re-christened his brilliant picture *The Fountain of Fallacy*, and captioned it with an extract from *The Fallacies of Hope*. A thoroughly Turnerian touch in this painting is the abandoned fishing-rod over a gold-fish pool in the left foreground, which makes the visionary subject seem, as it were, something of an angler's dream. The aesthetic, scientific and imaginative benefits of fishing were also a common topic in Turner's circle. The chemist, Sir Humphrey Davy, in a book on angling which Turner might well have known, as he knew its author, expanded on the opportunities it offered for the scientific study of fish and weather, and in its 'poetical relations', for the enjoyment of 'the most wild and beautiful scenery';[63] and a minor patron of Turner's, the amateur painter and poet, the Rev. T. J. Judkin, whom he knew in the 1830s, wrote in a similar vein:

> plying thus the angler's gentle part,
> I commune with my inmost self and learn
> More of that mystery, the human heart;
> Or 'neath all shapes of outward things discern
> The indwelling power divine; or, hand in hand
> With Fancy, thread the depths of fairy-land.[64]

What in the *Fountain of Indolence* had represented simply the traditional mockery of the vanity of human wishes, now, with the introduction of rainbows and science and the slumbering orbits which seem to be pictured in a diagram to the right of Turner's painting: the as yet invisible constellations beyond our knowledge; this now became a far more serious indictment of the ultimate futility of calculation. But it was a vision which could only have been achieved on the basis of Turner's deepening involvement with science.

Mrs Somerville's *On the Connexion of the Physical Sciences* was, as its title suggests, concerned chiefly with the fundamental unity of physical principles, a subject, as we have seen, which was very close to Turner's heart. In particular she sought to explain light, heat, sound and the movement of fluids in essentially the same undulatory terms;[65] and this was a line of thinking also cultivated in the 1820s and 1830s by the most distinguished chemist of the day, Davy's pupil Michael Faraday, who was, indeed, one of Mrs Somerville's chief mentors during the preparation of her book.[66] Faraday was also in Turner's circle of acquaintance during the late 1820s; he was a teacher of the lithographer C. J. Hullmandel, who had produced the single early lithograph after Turner's work (R 833) in 1823, and it was at Hullmandel's *soirées*, or *conversazioni*, that Turner and Faraday came together. The chemist's brother-in-law, the watercolour painter George Barnard, recalled:

> At this time we had very pleasant conversaziones of artists, actors and musicians at Hullmandel's, sometimes going up the river in his eight-oar cutter, cooking our own dinner, enjoying the singing of Garcia and his wife and daughter (afterwards Malibran) – indeed, of all the best Italian singers, and the society of most of the Royal Academicians such as Stanfield, Turner, Westall, Landseer . . . My first and many following sketching trips were made with Faraday and his wife. Storms excited his admiration at all times, and he was never tired of looking into the heavens. He said to me once, 'I wonder you artists don't study the light and colour of the sky more, and try more for effect'. I think this quality in Turner's drawings made him admire them so much. He made Turner's acquaintance at Hullmandel's, and afterwards often had applications from him for chemical information about pigments . . .[67]

In the 1840s, when he was working along similar lines to Mary Somerville on the

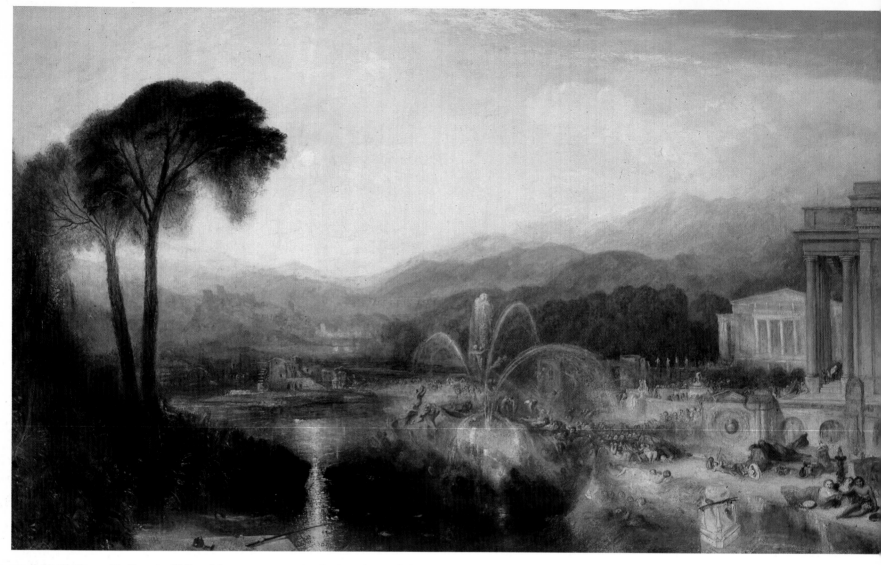

307. J. M. W. Turner, *The Fountain of Fallacy*. Oil on canvas, 101.5 × 162.5 cm Washington British Institution 1839. Fredericton, New Brunswick, Beaverbrook Art Gallery (BJ 376).

308. *(facing page)* Detail of 306.

relationship of the spectral colours to magnetism, Faraday was part of the circle of the Carrick Moore's, Turner's especial friends in that decade.[68]

As early as 1819, when he was still very much under the influence of Davy, Faraday had argued that 'all the variety of this fair globe may be converted into three kinds of radiant matter', namely heat, light and electricity;[69] and this line of thought continued to inform his experiments into his maturity. It is a view of the identity of the forms of matter which throws considerable light on some of the apparently eccentric features of Turner's late style. The painter had long been familiar with the Newtonian notion of light and colour as material substances;[70] and he will have been faced daily with the painter's paradox that light, the most evanescent and transparent of phenomena, could be represented only by white materials which were the most dense and opaque of pigments. In paintings like *The Burning of the Houses of Lords and Commons* (Figs. 319–20), the substantial identity of clouds, fire, water and figures is a powerful exemplification of the homogeneity of the created world; and in the case of *Regulus* (Fig. 309), which was reworked slightly later (see Fig. 310) on the basis of a picture originally painted in Rome in 1828, we can see how the very process of its making embodied the notion that light is the dynamic agent in the creation of visibility and could be materialised on the palette in the form of white. Turner, wrote an eye-witness at the British Institution in 1837,

kept on scumbling a lot of white into his picture – nearly all over it . . . The picture was a mass of red and yellow of all varieties. Every object was in this fiery state. He

226

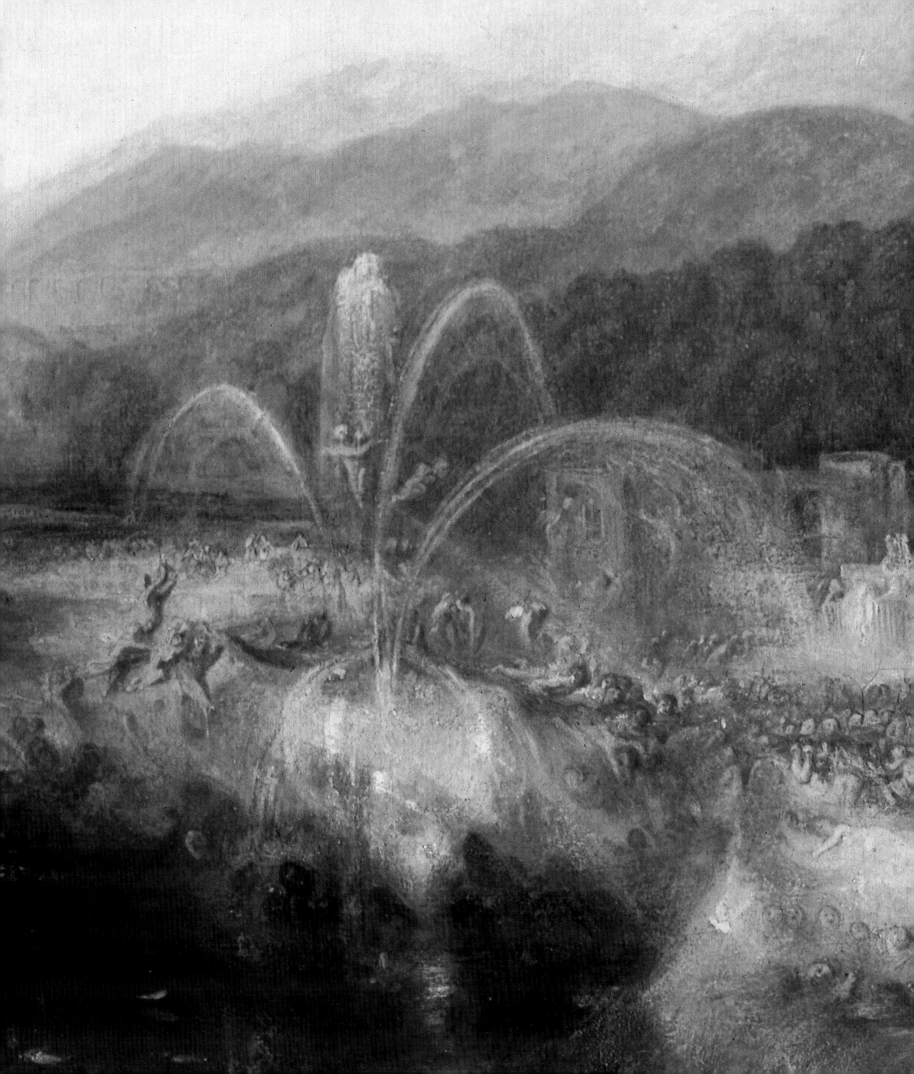

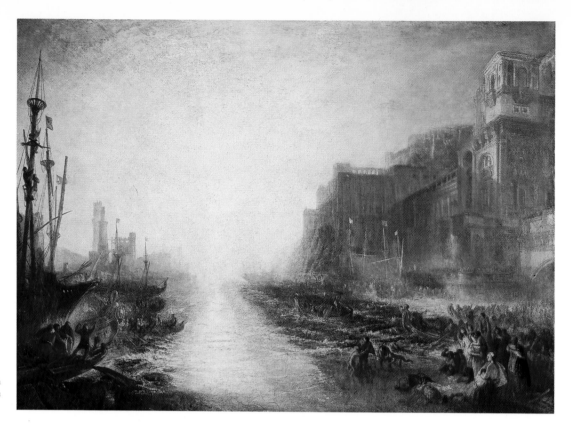

309. J. M. W. Turner, *Regulus*. Oil on canvas, 91 × 124 cm. British Institution 1837. London, Clore Gallery for the Turner Collection (BJ 294).

310. Charles West Cope, *Turner painting 'Regulus'*, 1837. Oil on paper, 16 × 13 cm. London, National Portrait Gallery. Cope showed a number of works at the British Institution in 1837, one of which hung close to Turner's painting.

had a large palette, nothing in it but a huge lump of flake-white; he had two or three biggish hog tools to work with, and with these he was driving the white into all the hollows, and every part of the surface. This was the only work he did, and it was the finishing stroke. The sun, as I have said, was in the centre; from it were drawn – ruled – lines to mark the rays; these lines were rather strongly marked, I suppose to guide his eye. The picture gradually became wonderfully effective, just the effect of brilliant sunlight aborbing everything and throwing a misty haze over every object. Standing sideway of the canvas, I saw that the sun was a lump of white standing out like the boss on a shield.[71]

Light here is not caressing, but compelling; the whole picture is alive with corpuscular energy: as Turner had said of surfaces in a lecture, 'we must consider every part as receiving and emitting rays to every surrounding surface, object, form and plane'.[72] Here, too, the luminous process was particularly poignant, for the subject of the picture is the blinding of Regulus, the Roman envoy, by the Carthaginians for having treacherously failed to negotiate an exchange of prisoners.

III

Turner met Faraday at a *conversazione*, and it was this form of professional sociability, so characteristic of the period, which gave Turner the opportunity of arousing his curiosity in a bewildering number of directions. In the 1820s, *conversazioni* were arranged every Monday between November and June by the Athenaeum Club, founded in 1824 'for the association of individuals known for their scientific or literary attainments, artists of eminence in any class of the fine arts, and noblemen and gentlemen distinguished as liberal patrons of Science, Literature or the Arts', and Turner was a member from the foundation.[73] Gatherings of this sort were also arranged by publishers like John Murray, and Moon, Boys and Graves, at whose evening in honour of his own drawings for *England and Wales* and Scott's *Poetical*

Works in 1833, Turner will have had the opportunity of meeting the traveller and Egyptologist Joseph Sams, and seeing part of his collection of ancient pigments and prepared palettes.[74] Under the Presidency of the 2nd Marquis of Northampton (1838–48), the Royal Society itself developed a regular programme of *soirées*,[75] where, in the late 1840s, Turner, although not a Fellow, put in an appearance from time to time. It was on one such occasion that he encountered his acquaintance the American photographer J. J. E. Mayall, and 'fell into his old topic of the spectrum', which had intrigued Turner in relationship to the Daguerreotype for many years. He had been visiting the photographer's London studio for some time, and Mayall had 'carefully explained to him all that I then knew of the operation of light on iodised silver plates. He came again and again, always with some new notion about light.'[76] The painter was curious to see the effects of each colour of the spectrum on the photographic plate, and he must have been especially impressed with the way that Mayall, unlike other early photographers, was able to maintain a tonal range and balance in his images equal to the best mezzotints. Even when he first encountered the Daguerreotype, about 1840, through his friendship with Samuel Rogers, Turner did not agree with some of his painter friends that it would be a threat to their art: 'We shall go about the country', he said, 'with a box like a tinker, instead of a portfolio under our arm.'[77]

So far from being hostile to technology, Turner was as receptive to it as he was to science. Ever since the 1790s he had shown a lively interest in the industrial scene; one of the most assured of his early watercolours showed the interior of an iron-foundry (Fig. 311) and may be related to a commission from a Welsh iron-master to record his works in four drawings.[78] Perhaps the most interesting and long-lasting of Turner's associations in the second half of his career was with a fertile and versatile inventor, Captain G. W. Manby of Great Yarmouth, who seems to have used the Royal Academy as a platform for some of his schemes. Manby's earliest concern as an inventor was the saving of life at sea, and in 1808 he commissioned the marine painter Francis Sartorius to commemorate an early version of his life-saving apparatus, which involved shooting a cable aboard foundering vessels by means of a mortar.[79] In 1815 and 1816 Manby commissioned marines from Nicholas Pocock and F. L. T. Francia, which were also exhibited at the Academy with lengthy captions explaining their significance (Fig. 313);[80] and soon afterwards he took up the young Yarmouth artists

311. J. M. W. Turner, *Interior of an Iron Foundry*, *c*. 1797. Watercolour over pencil, 24.7 × 34.7 cm. London, Clore Gallery for the Turner Collection (TB XXXIII-B).

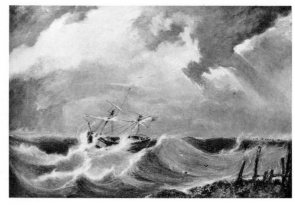

313. François Louis Thomas Francia, *Saving the Crew of the brig 'Leipzig' wrecked on Yarmouth 1815.* Oil on canvas, 50 × 72 cm. R.A. 1816. Norwich Castle Museum.

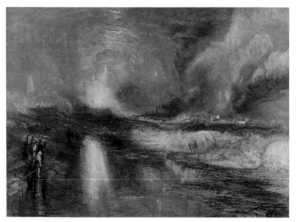

314. Robert Carrick after J. M. W. Turner, *Rockets and Blue Lights (Close at Hand) to warn the Steam Boats of Shoal-water,* 1852. Chromolithograph, 57 × 76 cm. Yale Center for British Art. (R 850).

W. and J. C. Joy and schooled them specifically to record his exploits.[81] It is in this context that Turner's beautiful Yarmouth marine of 1831, *Life-Boat (and Manby Apparatus) Going Off to a Stranded Vessel Making Signals (Blue Lights) of Distress* (Fig. 312) certainly belongs.[82] The, for this period in Turner's work, uncharacteristically circumstantial title leaves little doubt that the painting was a commission from Manby, although in the end he did not acquire it for the small collection of commemorative paintings and prints which he bequeathed to the Norwich Museum in 1841. Perhaps it proved too expensive for him, for Manby was in constant financial difficulties, even though he was supported by the Yarmouth banker Dawson Turner (no relation to the artist). Dawson Turner was himself a close friend of the portrait-painter Thomas Phillips, R.A., one of the artist's Academic colleagues of whom he saw a good deal in the late 1820s. In 1830 Michael Faraday had invited Manby to one of Phillips' lectures on painting at the Academy and the captain had later discussed the work of the Joy brothers with the artist.[83] Dawson Turner and Phillips were both Fellows of the Royal Society, which made Manby a Fellow in June 1831, only a month after J. M. W. Turner's painting was exhibited at the Academy, so that it may also have had a more immediately celebratory function.[84] Manby continued to work on his apparatus, and on the small, buoyant life-boat which is also the subject of Turner's painting;[85] and Turner returned to a similar theme in 1840 with *Rockets and Blue Lights (Close at Hand) to Warn Steam-Boats of Shoal Water* (Fig. 314).[86] One of his last oils was the transformed *Wreck Buoy* (Fig. 206), another life-saving subject, of 1847, and the principal motif of one of the series of vignettes which Turner prepared for a still unidentified book on sea-fishing a few years earlier (Fig. 317).

Manby had perhaps first been attracted to Turner because of his dramatic illustration to the engineer Robert Stevenson's *Account of the Bell Rock Lighthouse* (Fig. 315); for lighthouses were also one of the captain's many interests.[87] But that Turner frequently filled the sea near these light with wreckage[88] suggests that his purpose was no more purely illustrative than it had been in the large oils, for all their documentary connotations. In *Life-Boat* (Fig. 312), the anxious figures prominently in the

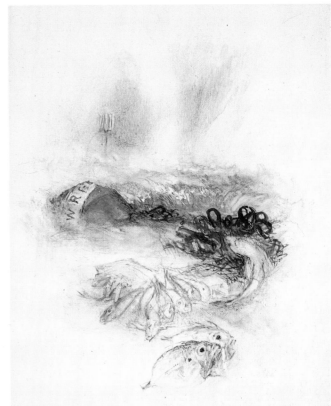

12. (facing page, top) J. M. W. Turner, *Life-Boat and Manby Apparatus going off to a stranded Vessel, making Signal (Blue Lights) of Distress.* Oil on canvas, 91.4 × 122 cm. R.A. 1831. London, Victoria and Albert Museum (BJ 336).

7. J. M. W. Turner, *Four vignettes of Fish and Tackle,* c.1835. Watercolours, each about 21 × 16.1 cm. London, Clore Gallery for the Turner Collection (TB CCLXIII, 342, 343; CCCLXXX, 3.4). Vignettes for an unidentified publication on deep-sea fishing.

15. (facing page, second from bottom) J. Horsburgh after J. M. W. Turner, *Stevenson's Bell Rock Lighthouse.* Line-engraving, 15.8 × 22.7 cm. London, British Museum (R201).

16. (facing page, bottom) J. M. W. Turner, *Eddystone Lighthouse,* c.1816. Watercolour, 19.1 × 24.1 cm. London, Clore Gallery for the Turner Collection (TB CXXXVII, p. 41).

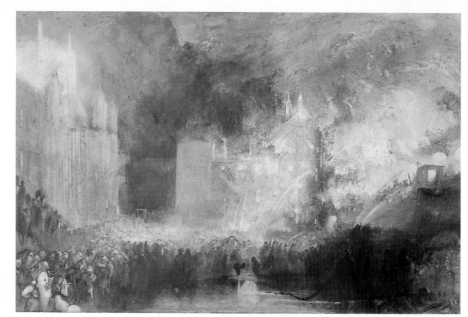

318. J. M. W. Turner, *The Fire in Old Palace Yard, Westminster, 16 October 1834*, c.1834. Watercolour and bodycolour, 29.3 × 44 cm. London, Clore Gallery for the Turner Collection (W 522).

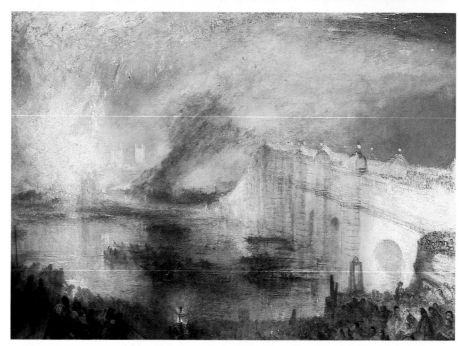

319. J. M. W. Turner, *The Burning of the House of Lords and Commons, 16th October, 1834*. Oil on canvas, 92 × 123 cm. British Institution, 1835. The Philadelphia Museum of Art (BJ 359).

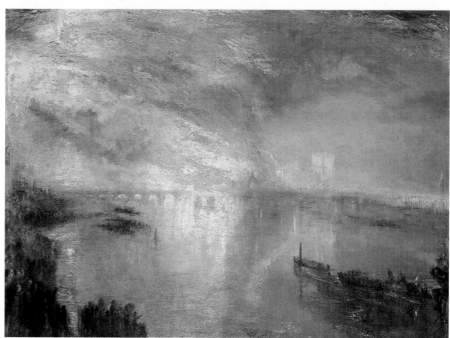

320. J. M. W. Turner, *The Burning of the Houses of Lords and Commons, October 16, 1834*. Oil on canvas, 92.5 × 123 cm. R.A. 1835. Cleveland Museum of Art, Ohio (BJ 364).

foreground, and the lack of reference to a specific vessel, which was the convention in most marine-painting of the period, and certainly in Manby's commissions, give a much more poignant emphasis to the uncertainty as well as the heroism of the subject; and in the lighthouse pictures the triumphs of technology were often shown to be undermined by the strategies of wreckers, who lured ships onto the deadly rocks with their own confusing lights.

Turner's ambivalence about the effectiveness of technological advance is also clear in another series of pictures of the 1830s which were close to Manby's pre-occupations, and may owe some of their emphases to him. On the night of October 16–17 1834 the Houses of Parliament burned down, and Turner and Manby were among the many hundreds of spectators who flocked to Lambeth and Westminster to witness the sublime spectacle.[89] Turner took to the river with a boatful of Academicians and students, but Manby went straight to the source of the conflagration itself, Old Palace Yard, for he was concerned about the co-ordination of the various groups of fire-fighters, a topic he had launched, with the help of Dawson Turner, in his *Essay on the Extinction and Prevention of Destructive Fires*, in 1830.[90] As he wrote to his patron the day after the Westminster fire, he wanted 'to be an attentive observer of the present system used at fires, & what appeared to me would admit of improvement.'[91] The early efforts of the fire-brigades at Old Palace Yard was in fact the subject of an unfinished watercolour made by Turner soon afterwards (Fig. 318). It is the type of colour-beginning which lay behind drawings originally intended for engraving, and it seems very possible that it began as a potential illustration to a pamphlet like Manby's *Plan for the Establishment of a Metropolitian Fire Police*, published in January 1835, in which the recent conflagration was judged to have been so destructive 'for want of one presiding head – for want of well-arranged and pre-concerted arrangements – for want, in one word, of an organized NATIONAL FIRE POLICE.'[92] The fire-services in Britain were still in fact in the hands of the various insurance companies; and in the two paintings of the disaster which Turner exhibited in 1835, he seems to have wanted to draw attention to this. The first (Fig. 317), a view from the southern end of Westminster Bridge, showed St Stephen's Chapel, which housed the Commons, and was one of the first buildings in the complex to be destroyed, at a relatively early stage in the conflagration, because of a shortage of usable water and 'only one or two engines, not very advantageously placed'.[93] The second painting (Fig. 320) gives a bird's-eye view from Waterloo Bridge at a much later stage of the fire, in the early hours of 17 October, when the floating fire-tender of the Sun Fire Office (clearly labelled in Turner's picture) at last managed to get up from Rotherhythe on the rising tide, too late to be of much use in preventing damage, but eventually having a 'prodigious' effect on the burning embers.[94] Here the dominant architectural motif is the silhouetted gable of Westminster Hall, which emerged relatively unscathed, because of the prompt action of the brigades inside and out, although to Manby this was little short of a miracle.[95] And yet the whole structure of this magnificent painting depends on the great banner of fire and the reflection of fire which fills its centre, and gives it a quite Wagnerian scale. We can well imagine that Turner was with those spectators who, when the flames burst through the roof of the Lords, were so exhilarated that they broke into applause (see p. 198).

Turner's interest in technology grew throughout the 1830s, and he must have acquired something of a reputation for it: in 1836 he was included in Lord Euston's informal committee to review the grandiose plans for water-supply of the metropolis drawn up by the painter-engineer John Martin, which produced a surprisingly favourable report, but, as usual, led to nothing.[96] Although the success of Martin's career depended very much on his popular acclaim as a painter of vast scenes of apocalyptic disaster, he also enjoyed some reputation for his technological ingenuity; and he was invited by the engineer Isambard Kingdom Brunel to witness the speed

trials on the Great Western Railway in 1841, at which a specially modified test-locomotive reached the then incredible speed of 90 miles per hour.[97] Turner may have read of these trials or heard about them from Martin himself, or from another acquaintance of these years, Charles Babbage, the inventor of the earliest known computer, who had been employed by Brunel as early as 1838 to devise an apparatus for testing the speed and stresses on trains for this line, and who, in July 1843, travelled with Prince Albert to Bristol on it and recorded on one incline the 'dangerous velocity' of 78 miles per hour.[98] Although Martin was naturally fascinated by rail travel, and included a railway 'by which are arriving the succours to the enemies of Christendom' in his vast *Day of Judgement* of 1854,[99] it was typically left to Turner to celebrate the achievements of Brunel's Great Western in that icon of the Railway Age, *Rain, Steam and Speed*, exhibited in 1844 (Fig. 10).[100]

Yet it was, again, entirely characteristic of him that he should not simply report and applaud. Will the engine run down the hare which is scampering in front of it? Is it, indeed the locomotive 'Greyhound' which was working on this line at the time? Has the railway desecrated the beautiful stretch of the Thames it crosses here at Maidenhead? There is certainly an unease about it which led some early spectators to

> see a deeper meaning in this picture, something analagous to that of the *Téméraire* [BJ 377] – the old order changing, the easy-going past giving way to the quick-living future; and there is something in the contrast between the plough and the steam engine, the ugly form of the railway bridge and train and the beauty and peace of the old bridge and the landscape, which shows that some such thoughts were not absent from the painter's mind.[101]

There is, however, also a light-heartedness about the imagery, much of which was painted into the picture on Varnishing Days; and G. D. Leslie, who witnessed the performance as a boy, was particularly struck by the association between the plough (in the top right corner) and the title of the work, as suggested by the country-dance 'Speed the Plough'. This was a slogan and an emblem which Turner had noticed on a banner introduced into his drawing of the *Northampton Election* (Fig. 292), and it is a witness to the continuously associative temper of his imagination.

Rain, Steam and Speed is one of the finest late examples of the richness of Turner's meanings, a richness which sprang from his consuming curiosity, nourished on every level by reading and by conversation as well as by looking. That Turner was able so readily to find access to the range of contacts that I have sought to typify in this chapter, is a testimony not simply to his fame, but also, and more importantly, to a sociable side to his character which has been neglected by his admirers for far too long.

CHRONOLOGY OF TURNER'S LIFE

1775	Joseph Mallord William Turner born to William Turner, barber and wig-maker and Mary Marshall at 21 Maiden Lane, Covent Garden, London. His birth-date is still uncertain, but he maintained that it was 23 April, the Feast of St George, patron of England, and also Shakespeare's birthday.
1784–5	Turner with his maternal uncle and aunt at Brentford, Middlesex, attending John White's school and colouring engravings. First surviving drawings from nature, in and around Margate, on the Kent coast (W 1–4).
1786	Death of Turner's sister, Mary Ann, aged eight.
1787	First signed and dated watercolour, a copy from an engraving of Bacon's Tower, Oxford (W 5)
1788	? Working with the architectural draughtsman, Thomas Malton, and the architect, Thomas Hardwick.
1789	Sketching from nature while staying with his maternal uncle at Sunningwell, near Oxford (TB II). 11 December: Admitted to the Plaister Academy of the Royal Academy Schools, under the sponsorship of J. F. Riguad, R.A., and after a term's probation.
1790	First exhibit at the R.A., a watercolour of *The Archbishop's Palace, Lambeth* (W 10) ? commissioned by Hardwick to make a replica.
1791	Two watercolours at the R.A. (W 12, 14). Colouring prints for engravers and print-sellers. Sketching in and around Bristol, Bath and Malmsbury while staying with his father's friend, John Narraway, purchaser of W 10. Studying perspective and copying a Gainsborough print.
1792	March: ? First contact with John Soane, the architect. April–June: Scene-painting at the Pantheon Opera House. May: Two watercolours at the R.A. (W 25, 27). 25 June: Admitted to the R.A. Life Class. July/August: Touring in N. and central Wales. ? Earliest contact with the watercolourist W. F. Wells.
1793	27 March: Awarded 'Greater Silver Palette' by the Society of Arts, for a landscape drawing. May: Three watercolours at the R.A. (W 17, 18, 31). First documented contact with Dr Thomas Monro (see W 40) ? First experiments with oil painting (TB XXVIII, H and BJ 19a). Begins to study etching techniques by this date (TB V D).
1794	May: First engraving after a Turner drawing of Rochester, published in the *Copper Plate Magazine* (R.1). A large oil of *Rochester Castle* also seems to date from this year (BJ 21). Five watercolours at the R.A. (W.48, 49, 53, 55, 57), praised in *St James's Chronicle* and *Morning Post*.

First recorded activity as a drawing-master (TB XX, p. 17).

Sells three versions of Llanthony Abbey (W 65) for 2½ guineas each (TB XII, F).

First Midland Tour, chiefly to make drawings for engraving.

Met Thomas Girtin at Dr Monro's evening 'Academy', making joint versions of designs by J. R. Cozens, Thomas Hearne and others.

1795	May: Eight watercolours at R.A (W ?58, 123–6, 128).
	Tours in S. Wales and the Isle of Wight produce commissions for engravers and several private collectors, including Viscount Malden and Sir Richard Colt Hoare.
1796	May: Ten watercolours at R.A., including Fig. 131 the first clear reference to an Old Master style. First exhibited oil, *Fishermen at Sea off the Needles* (Fig. 107) praised by 'Anthony Pasquin' and sold for £10.
	Sketching on the estate of William Lock of Norbury and in and around Brighton.
1797	May: Teaching drawing to Julia Bennett, later Lady Gordon. Two oils and four watercolours, including Fig. 128 at R.A.
	Touring N. of England, including Lake District; working at Harewood.
1798	April: Short tour in Kent with Rev. R. Nixon and the history-painter S. F. Rigaud.
	May: Six watercolours and four oils at R.A., including Fig. 30. Three oils and two watercolours given captions from Milton and Thomson.
	Tour to Malmsbury, Bristol and N. Wales; visits Richard Wilson's birthplace and makes watercolour copies of his paintings (T.B. XXXVII).
	Probable date of two decorative panels commissioned for the library at Harewood (BJ 26, 27).
	Possible date of first classical picture, *Lake Avernus with Aeneas and the Sybil* (BJ 34), painted for Colt Hoare in a Wilsonian style.
1798	November: Competes unsuccessfully for Associate Membership of R.A.
	15 November: Buys large collection of figure-studies by C. R. Ryley.
1799	April: Recommended to Lord Elgin to make topographical drawings in Greece; disagreement over terms and plan dropped.
	May: Goes to see Altieri Claudes at Beckford's London house. Four oils and seven watercolours at R.A.; sells water-colour of *Caernarvon Castle* (Fig. 156) to J. J. Angerstein for 40 guineas, 'much greater than Turner would have asked'.
	July: Has orders for sixty drawings in hand.
	August/September: Working for Beckford at Fonthill.
	Autumn: Tour of Lancashire, sometimes in the company of Fuseli, and North Wales.
	4 November: Elected Associate of R.A.; joins Academy Club; moves to 64 Harley St., London, sharing with marine-painter, J. T. Serres.
	First substantial essays in poetry (TB XLII), including glees of the type written by John Danby, whose widow, Sarah becomes Turner's mistress at this time. ? birth of Evelina, the first of Turner's three children by Sarah Danby.
1800	May: Two oils, Fig. 162 and Fig. 264, whose verse-caption may be by Turner, shown at R.A. with six watercolours, five of them of Fonthill (Fig. 42)
	17 May: Dines with other Academicians at Fuseli's Milton Gallery.
	Summer: Visits Fonthill; commissioned by Duke of Bridgewater to paint companion to a Willem van de Velde II, (Figs. 157, 159)
	27 December: Turner's mother admitted the Bethlem Hospital for the insane, where Dr Thomas Monro is physician
1801	March: Attends Fuseli's Lectures on Painting at R.A.
	April/May: Buys group of 8 drawings of barges by Samuel Scott and large number of Rooker topographical drawings at Rooker Sale (TB CCCLXIX, CCCLXX).
	May: Two oils and four watercolours at R.A. Fig. 159 praised by West, Fuseli and Beaumont as superior to Rembrandt, and sold for 250 gns.
	June/August: Tour in Scotland, perhaps with Nicholas Smith of 42 Gower St., London; returns through Lake District and Chester.
1802	12 February: Elected full Academician; 'W. Turner' becomes 'J. M. W. Turner'.
	May: Three watercolours and three oils at R.A., including *Ships bearing up for anchorage* (BJ 18), acquired by the third Earl of Egremont, and *Jason* (BJ 19), the first exhibited classical subject.

July/October: Visits France and Switzerland, probably with the sponsorhip of the Earl of Yarborough and Walter Fawkes who may have accompanied him; some weeks spent in the Louvre; visits studios of David and Guérin.

November: Attends Girtin's funeral.

December: Applies to be a Visitor (instructor) in Academy Schools.

Presents a dozen silver dessert Spoons to the Academy.

1803	Member of Academy Council and of Hanging Committee (Jury).

February: Reported that 'had no pictures, gone as fast as he paints them, commissions for twenty years'.

February/March: Attending Fuseli's lectures on Painting.

May: Two watercolours and five oils at R.A., including his first Claudian subject, *Macon* (Fig. 62); Beaumont and several Academicians critical of his lack of finish.

First substantial review of Turner's work, by John Britton in *The British Press* (9 May).

August: Visits Truchsessian Gallery in London.

1804 Member of R.A. Council.

15 April: Death of Turner's mother, probably in Bethlem Hospital.

18 April: Turner's Private Gallery opened in Queen Anne St, London.

May: Two oils and one watercolour at R.A.

1805 May: First record of Turner at Sion Ferry House, Isleworth.

May/July: *The Shipwreck* (BJ 54) exhibited at Turner's Gallery; acquired by Sir J. Leicester for £315; the first oil to be engraved and the first large single plate after Turner's work; impressions sold to some 130 subscribers. Other exhibits (unspecified) described by Hoppner as 'like a Green Stall, so rank, crude and disordered'.

22 December: Sketches *Victory* on return from Trafalgar to the Medway

1806 February: Two oils at first exhibition of British Institution.

May: One oil and one watercolour at R.A.; first important signs of a Turner 'School' in the work of W. Havell and A. W. Callcott. *Battle of Trafalgar* (BJ 58) among paintings at Turner Gallery.

15 May: Last record of Turner at Sion Ferry House.

Summer: Staying with W. F. Wells; genesis of *Liber Studiorum*.

7 August: Congratulates Lord Elgin on the acquisition of the Parthenon Marbles.

Winter: Takes a house at 6 West End, Upper Mall, Hammersmith.

1807 20 April: Attends Opie's funeral.

May: Two oils at R.A.

4 May: Buys a plot of building-land at Twickenham. Thames views shown at Turner Gallery; West calls them 'crude blotches'.

11 June: First number of *Liber Studiorum* published.

Oil-sketching from a boat on the Thames and the Wey.

A subscriber to John Opie's *Lectures on Painting* (published 1809).

2 November: Elected Professor of Perspective at R.A.

First independent French notice of Turner in *Magazin Encyclopédique*.

1808 February: Two oils at British Institution (including *Jason*).

May: *The Unpaid Bill* (Fig. 170) at R.A. Long review by John Landseer in *Review of Publications of Art* identifies twelve oils at Turner's Gallery, together with *Liber Studiorum* drawings.

Summer: At Tabley, Cheshire, with Sir J. Leicester; sketches on the River Dee in Wales; studies reflections for Perspective Lectures; visits Farnley Hall, home of Walter Fawkes.

First German notice, in J. D. Fiorillo, *Geschichte der zeichnenden Künste*, V.

1809 March: Helping Soane with the presentation of his Academy lectures on architecture.

May: Two watercolours and six oils shown at Turner Gallery, including *Thomson's Aeolian Harp* (Fig. 263).

Four oils shown at R.A.

Summer: Visit to Petworth, Sussex, home of Lord Egremont.

August: Visit to Yorkshire; possibly with Fawkes at Farnley. ? Visits Egremont at Cockermouth Castle, Cumberland.

December: Shows plans for a new design for lighting R.A. Lecture Room. Visits Oxford in connection with works for engraving.

1810	2 May: Changes London address to 47 Queen Anne St. West by this date.
	Fifteen oils shown at Turner's Gallery, including *Avalanche* (Fig. 267)
	Three oils at R.A.
	Visits Sussex to make drawings for Jack Fuller of Rosehill.
	August: Visit to Yorkshire; probably at Farnley.
1811	Member of Academy Council and of Hanging Committee.
	Reading Sir Walter Scott's poems by this date.
	7 January: First series of six perspective lectures begins.
	8 January: Proposes that a Professorship of Landscape be established at R.A.
	May: Four oils and five watercolours at R.A., including Figs. 219, 221.
	July/September: Touring West Country in search of material for Cooke's *Southern Coast*, for which also writes longest poem. Meets C. L. Eastlake's family at Plymouth and his own father's relatives at Barnstaple and Exeter.
	October/November: Visits Farnley.
1812	Member of R.A. Council; Visitor to Academy Schools.
	January/February: Six lectures on perspective at R.A.
	?Spring: Begins building Sandycombe Lodge, Twickenham, to his own designs.
	May/June: Turner Gallery open; seven oils noticed. Four oils at R.A., including *Hannibal* (Fig. 270).
	November/December: Visits Farnley.
1813	Visitor to Academy Schools.
	May: Two oils, *Frosty Morning* (BJ 127) and *Deluge* (cf. Fig. 163) at R.A.
	? May: Sandycombe Lodge completed and occupied (first rated in July). Constable visits Turner Gallery; and, sitting next to him at R.A. Banquet, is impressed with his 'wonderful range of mind'.
	Summer: Tour of Devon, partly with Eastlake, A. B. Johns and Cyrus Redding.
	November: Staying at Farnley.
1814	January/February: Six perspective lectures at R.A. First instalments of *Picturesque Views on the Southern Coast of England* (without Turner's text). Submits *Apullia in Search of Appullus* (BJ 128) to British Institution landscape competition; is disqualified, but the work is exhibited.
	May: *Dido and Aeneas* (BJ 129) shown at the R.A. William Hazlitt's first notices of Turner.
	Summer: ? Tour of Devon.
1815	January/February: Six perspective lectures at R.A.
	May: Shows four oils, including *Dido Building Carthage* (Fig. 291) and *Crossing the Brook* (BJ 130) and four watercolours, including Fig. 63 at R.A.
	August: May have been considering marriage to Clara Wells. Visits Farnley.
	November: Exhibits *Bligh Sand* (BJ 87) and *Jason* (BJ 19) at Plymouth. Haydon visits Turner Gallery with Canova, who calls Turner a 'grand génie'.
	1 December: Turner attends dinner in honour of Canova at R.A.
	Reading Byron's *Childe Harold's Pilgrimage* by this date.
1816	Chairman of Directors of Artists' General Benevolent Institution; Visitor to newly-founded R.A. Painting School.
	28 January: Chairs Fuseli's lecture on painting at R.A.
	January/February: Six lectures on perspective at R.A.
	May: Figs. 287, 289 shown at R.A.
	July/August: Travelling in Yorkshire for *History of Richmondshire*; based at Farnley.
1817	May: Fig. 290 at R.A.
	June: John Sell Cotman proposes collaboration of work on the scenery of Normandy; Turner declines.
	August/September: Visits Belgium, the Rhineland, Holland and makes 51 Rhine watercolours (see Fig. 66), bought by Fawkes.
	October/November: Sketching around Durham and Yorkshire, based at Farnley.
	November: Helps to authenticate a Claude for the collector Gray. Probably starting work on Hakewill's *Picturesque Tour of Italy*.

1818	Chairman and Treasurer of Artists' General Benevolent Institution.

1818 Chairman and Treasurer of Artists' General Benevolent Institution.
January: Six perspective lectures.
April: Attends at least two of Hazlitt's *Lectures on the English Poets*, with Soane.
May: Three oils, including Fig. 160 and one watercolour at R.A.
August: Acquires further land at Twickenham.
October: W. B. Cooke commissions twelve Rhine drawings for engraving; only three executed and not engraved.
October/November: In Scotland to discuss Scott's *Provincial Antiquities of Scotland*.
November: At Farnley.

1819 Member of R.A. Council and Inspector of Academy Library.
January: Six perspective lectures.
30 January: Attends Haydon's exhibition of studies from Raphael Cartoons and Elgin Marbles.
February: Commission from Cooke extended to 36 Rhine drawings.
March: Eight oils shown at Sir J. Leicester's new Gallery in London, including Figs. 144, 214, 266.
April/June: More than sixty watercolours exhibited at Walter Fawkes's London house.
May: Two oils at R.A., including Fig. 173.
August: First visit to Italy, principally in Rome, but also visits Venice and travels as far south as Paestum.
24 November: Elected to honorary membership of the Roman Academy of St Luke, through Canova's sponsorship.
December: Second Gallery under construction in London.

1820 February: Returns from Italy.
Member of R.A. Council; Inspector of the cast collection.
April/June: Fawkes' collection again open.
May: *Rome from the Vatican* (Fig. 81) at R.A.
June: Inherits cottages in Wapping (E. London), which he converts into the *Ship and Bladebone* tavern.
3 July: Sits next to Constable at the King's Birthday Dinner at R.A.
August: Supports purchase of Marco d'Oggiono's copy of Leonardo's *Last Supper*, and Cumberland collection of prints by the R.A.

1821 February/March: Six lectures on perspective.
April: Turner well represented with *Southern Coast* and other engravings in W. B. Cooke's exhibition of modern British engraving.
26 May: Buys three oil sketches by Reynolds at auction, but fails to secure a Reynolds notebook.
Late summer or autumn: Visits Paris, Rouen, Dieppe; makes pencil copies after Claude in the Louvre.
December: First visit to David Wilkie; Christmas at Farnley.

1822 Visitor to the R.A. Painting School.
February/August: 24 watercolours exhibited at W. B. Cooke's
May: First exhibition in Turner's new gallery. *What you Will* (Fig. 224) shown at R.A.
August: Visit to Edinburgh, chiefly to prepare a series of paintings for engraving, recording the Royal Visit to that city.
December: Commissioned by George IV to paint *The Battle of Trafalgar* (Fig. 184) by this date.

1823 Visitor to the R.A. Painting School.
January: W. B. Cooke's second watercolour exhibition, with eleven watercolours.
March/April: Surreptitious pencil copy of Rubens's *Chapeau de Paille*, exhibited in London at this time (TB CCV, p. 44).
May: *Bay of Baiae* (BJ 230) at R.A.
June: First *Rivers of England* engravings published.
September: Sketching English and French coasts from the Channel.
October: At Farnley.

1824 Auditor of R.A. accounts.
January/February: Six perspective lectures.
April: W. B. Cooke's third watercolour exhibition, with sixteen watercolours.

239

	June: One of the foundation members of the Athenaeum Club.
	Sketching on the south and east coasts.
	November/December: Last visit to Farnley.
1825	Visitor to R.A. Painting School, and Auditor of Accounts.
	January/February: Six perspective lectures.
	February: First four drawings for *Picturesque Views in England and Wales* ready.
	May: Fig. 43 and one watercolour (w 496) at R.A.
	August: Tour of Holland and Belgium.
	25 October: Death of Walter Fawkes.
1826	Auditor of R.A. accounts.
	April: First *Ports of England* engravings published.
	May: Figs. 67, 235 at R.A. with two other oils. Last *Southern Coast* engraving published.
	7 May: Meets Washington Allston and John Martin at Fawkes' London house.
	19 June: Sandycombe Lodge sold.
	August: 29 watercolours, mainly from Farnley, shown at Northern Society in Leeds.
	August/November: Visits Meuse, Moselle, Brittany, Loire.
	Makes first vignette for Rogers' *Italy* (w 1158).
1827	Auditor of R.A. accounts.
	January/February: Four perspective lectures.
	May: Five oils at R.A., including Fig. 12.
	7 July: Buys back two of his early paintings at de Tabley sale.
	July/September: With John Nash at East Cowes Castle.
	October: At Petworth with Rogers; makes last *Italy* vignette (w 1176).
1828	Member of R.A. Council and Hanging Committe; Auditor of Accounts.
	January/February: Last series of six perspective lectures.
	May: Four oils at R.A. Two watercolours from Swinburne collection shown at Northern Academy of Arts, Newcastle.
	August: Visits Rome, via Paris, Lyon, Avignon, Florence.
	18 December: Shows two paintings at the Palazzo Trulli, via del Quirinale, Rome: ?*Regulus* (Fig. 309) and *Orvieto* (BJ 292), later adding *Medea* (Fig. 122); exhibition widely attacked.
	Study in the Sistine Chapel.
1829	Feb: Return to England via Loreto, Ancona, Bologna, Turin, Mont Cenis, Mont Tarare, Lyon.
	Member of Academy Council; Inspector of Cast Collection; Auditor of Accounts.
	May: One watercolour and three oils, including *Ulysses deriding Polyphemus* (Fig. 4) at R.A.
	June/July: Charles Heath shows 36 *England and Wales* watercolours at the Egyptian Hall, Piccadilly, plus two used in his *Annuals* and three for 'a work on Italy' which was never published. Six works later shown at Birmingham Society of Artists.
	August/September: Visits Paris, Normandy, Brittany.
	Early September: At Petworth.
	21 September: Death of Turner's father.
	30 September: Turner's first Will, providing for a Professorship of Landscape at the R.A., a Turner Gold Medal for landscape painting, and a College or Charity for decayed English landscape artists; also leaving *Dido Building Carthage* (Fig. 291) and *Decline of Carthage* (Fig. 290) to the National Gallery, to hang beside Claude's *Sea-Port* and *Mill*.
	December: Resigns as Chairman and Treasurer of Artists' General Benevolent Institution.
1830	Visitor to the Life Academy and the Painting School; Auditor of R.A. accounts.
	May: One watercolour and six oils at R.A., including *Orvieto* (BJ 292) *Jessica* (Fig. 140) and *Calais Sands* (Fig. 194).
	Two works shown at Birmingham Society of Artists.
	July: Publication of Rogers's *Italy*.
	August/September: Tour of the Midlands.
	November: Turner opposed to the acquisition of the Lawrence collection of Old Master drawings by R.A.
1831	Visitor to the Life Academy and Painting School; Auditor of Accounts.

January: Heath shows *England and Wales* drawings at *Artists' and Amateurs' Conversazione*.
?March: Visit to Petworth.
May: Seven oils at R.A., including *Life-Boat and Manby Apparatus* (Fig. 312) and *Medea* (Fig. 122).
Two watercolours shown at Liverpool Academy.
10 June: Second Will, changing *Decline of Carthage* to *Sun Rising in a Mist* (BJ 69)
15 July: Buys many sketches by the portrait painters John Jackson and William Owen at the Jackson Sale, together with palettes of Reynolds and Hogarth, and 'a cast from the skull of Raffaelle'.
July/September: Tour of Scotland in connection with illustrations to Scott's *Poems*; stays at Abbotsford

1832
January: Presents Hogarth's palette to R.A.; Auditor of Accounts.
March: Moon, Boys and Graves exhibit twelve watercolours for Scott's *Poems*.
May: Six oils at R.A., including, *Childe Harold's Pilgrimage – Italy* (Fig. 277) and *Staffa, Fingal's Cave* (Fig. 279).
June: Member of committee to discuss the space to be given to the Royal Academy in the new National Gallery in Trafalgar Square.
20 August: New codicil to Will speaks of keeping Turner's pictures together.
October: Visits Paris and environs to gather material for illustrations to Scott's *Life of Napoleon*; probably visits Delacroix on this occasion.
December: At Petworth; Christmas at East Cowes Castle with Nash and John Martin.

1833
Auditor of R.A. accounts.
May: Six oils at R.A., including *Quilleboeuf* (BJ 353) and first two Venetian subjects (BJ 349, 352).
June: Publication of *Turner's Annual Tour: Wanderings by the Loire*. Moon, Boys and Graves exhibit twelve Scott drawings and 66 *England and Wales* drawings.
30 June: Turner buys two drawings ascribed to Rembrandt, figure and landscape studies by Hoppner, and thirteen lots of drawings by or attributed to himself, at the Monro sale.
September: Probably visits Venice, travelling via the Baltic, Berlin, Dresden, Prague and Vienna.
October: Three earlier works shown at Society of British Artists.
December: Publication of *Turner's Annual Tour: Wanderings by the Seine* and Rogers's *Poetical Works*.

1834
Visitor to the R.A. Life Academy and Auditor of Accounts.
January: Drawings from Tomkinson collection and *Annual* drawings shown at the Artists' and Amateurs' *Conversazione*.
March: First instalments of Finden's *Landscape Illustrations of the Bible*.
May: Five oils at the R.A., including *The Golden Bough* (Fig. 53). Three earlier works shown at the Birmingham Society of Artists.
July: Visit to Oxford; tour of Meuse, Moselle and Rhine in connection with a proposed sequel, *Great Rivers of Europe*, to the *Annual Tours*.
Illustrations to Byron exhibited at Colnaghi's.
September: At Petworth.
16 October: Studies the fire at the Houses of Parliament from a boat on the Thames (see Figs. 319, 320).
December: Four early oils shown at the Society of British Artists. Last volume of *Turner's Annual Tours: the Seine* published.

1835
Visitor to the Life Academy and the Painting School; Auditor of Accounts.
February: *Burning of the Houses of Lords and Commons* (Fig. 319) shown at the British Institution.
May: Five oils at R.A., including Fig. 320.

1836
Visitor to the Painting School; Auditor of Accounts.
February: Second version of *Burning of Houses of Lords and Commons* (Fig. 320) at British Institution.
March: Served on committee to assess John Martin's plans for the water-supply of London, which reported favourably.
May: Three oils, including *Juliet and her Nurse* (BJ 365) at R.A.
August: Tour of France, Switzerland and Val d'Aosta with Munro of Novar.

October: Ruskin writes his first defence of Turner against the critic of *Blackwood's*; Turner dissuades him from publishing.

December: Turner persuades the R.A. to hold a farewell dinner at Somerset House, before the move to Trafalgar Square.

1837 Member of Academy Council and Hanging Committee; Visitor to Life Academy; Auditor of Accounts.

February: *Regulus* (Fig. 309) shown at British Institution. Presents J. F. Rigaud's portrait of Bartolozzi, Carlini and Cipriani to R.A.

May: Four oils at R.A. Duke of Bridgewater lends *Dutch Boats in a Gale* (Fig. 159) to 'Old Master' exhibition at British Institution, with the Van de Velde to which it was a companion.

October: At Petworth.

11 November: Death of Egremont.

28 December: Resigns Professorship of Perspective.

Publication of Thomas Campbell's *Poems*, with twenty illustrations by Turner.

1838 Member of R.A. Council and Hanging Committee; Visitor to Life Academy and Painting School; Inspector of Library and Cast Collection; Auditor of Accounts.

February: One oil at British Institution.

May: Three oils at R.A.

Last *England and Wales* plates published.

1839 Visitor to R.A. Painting School, Auditor of Accounts.

February: *Fountain of Fallacy* (Fig. 307) at British Institution.

May: Ceases to be a Trustee of Artists' General Benevolent Inst. Five oils, including *Fighting Temeraire* (BJ 377) and *Ancient Rome* (Fig. 35) at R.A.

42 Farnley drawings exhibited at Leeds.

August: Tour of Belgium.

December: The collector and amateur artist J. H. Maw offers Turner a large 'Painting Room and Studio' at Hastings, but it is not known whether he accepted.

1840 February: One oil at British Institution.

May: Seven oils at R.A., including *Slavers* (Fig. 294).

22 June: Meets Ruskin for first time.

August/October: Visit to Venice, travelling via Rotterdam, and the Rhine, and returning via Munich and Coburg.

1841 Auditor of Accounts.

February: Two oils at British Institution.

May: Six oils at R.A.

August/October: Tour of Switzerland, visiting Lucerne, Constance, Zurich.

1842 Visitor to R.A. Painting School; Auditor of Accounts.

Presents the R.A. with a cast of Belvedere Torso.

Makes series of ten Swiss watercolours to be sold through his dealer, Griffith; only nine sold.

May: Five oils at R.A.: Figs. 77, 79, 89, 226, 228.

August/October: Tour in Switzerland, via Belgium and Rhineland.

1843 Visitor to R.A. Painting School; Auditor of Accounts.

January: Offers to make ten more Swiss drawings for sale through Griffith, but can attract only five commissions.

May: First volume of Ruskin's *Modern Painters* published. Six oils at R.A., including Figs. 302–3.

?August/November: Visits Tyrol and N. Italy.

1844 Auditor of Accounts.

May: Seven oils at R.A., including *Rain, Steam and Speed* (Fig. 10).

June/July: Attends Charles Dickens's farewell dinner with Clarkson Stanfield.

August/October: Last visit to Switzerland; Lucerne, Thun, Interlaken, Grindelwald, returning via Heidelberg and the Rhine.

8 October: Sees Louis-Philippe land at Portsmouth for visit to Queen Victoria.

1845	Member of R.A. Council and Hanging Committee; Auditor of Accounts.
	20 February: Appointed Acting-President of R.A. during illness of Shee.
	May: Six oils at R.A.
	One earlier oil at Liverpool Academy, two at Royal Manchester Institution (including Fig. 289) and two at Royal Scottish Academy.
	Short visit to Boulogne and environs.
	June: Resignation of Sir Martin Archer Shee P.R.A.; Turner, as oldest Academician, elected Deputy President (until December 1846). Plans last visit to Venice.
	Reprinting *Liber Studiorum* although has many early impressions on his hands.
	August: Sends *Opening of the Walhalla, 1842* (1843; BJ 401) to the Congress of European Art at Munich, where it is abused by the German critics.
	September/October: Last visit abroad to Dieppe and coast of Picardy; stays with Louis-Philippe at Eu.
1846	Deputy President of R.A.; Auditor of Accounts.
	Presents a volume of Michelangelo's *Rime* (1817) to R.A.
	February: *Queen Mab's Cave* at British Institution (Fig. 200).
	May: Six oils at R.A.; two earlier oils at Royal Scottish Academy and one at Royal Hibernian Academy.
	August: Looking for alternative quarters about this time.
	29 August: First mention of Sophia Booth, the housekeeper of a cottage in Chelsea, in a codicil of his Will, which also directs that he be buried in St Paul's Cathedral 'among my Brothers in Art'.
1847	May: One oil (an older picture repainted) at R.A.
	One earlier oil at Birmingham Society of Artists and two at Royal Scottish Academy (including Fig. 289).
	Winter: Discussing technical questions with the photographer J. J. E. Mayall.
1848	Takes on Francis Sherrell as pupil and assistant.
	January: Fig. 77 hung in National Gallery to represent Vernon Bequest.
	One earlier oil shown at Royal Scottish Academy.
	2 August: A new Codicil of his Will refers to the Bequest and exhibition of 'finished pictures', providing for a change of display every one or two years.
1849	Asked by the Society of Arts if he will permit a retrospective exhibition of his work to be organised; declines 'from a peculiar inconvenience this year'.
	May: Repaints an early picture as *The Wreck Buoy* (Fig. 206) for R.A. and shows it with another early work (Fig. 125).
	BJ 357 shown at Royal Scottish Academy.
	Wreck of a Transport Ship (BJ 210) and *Macon* (Fig. 62) shown at British Institution 'Old Master' exhibition.
1850	Presents silver sugar-tongs to R.A.
	May: Four oils on the subject of Dido and Aeneas shown at R.A. (Fig. 283).
	Three early watercolours shown at Society of Painters in Water-Colours.
	One earlier oil shown at Liverpool Academy.
1851	Possibly year of last watercolours, *Lake of Thun*, *Florence* and *Genoa* (W.1567–9).
	January: Visits Crystal Palace, under construction for Great Exhibition.
	May: Present at R.A. Varnishing Days, the Private View and the Academy Banquet, although has no exhibits.
	7 May: Present for the last time at a dinner of the Academy Club.
	Macon (Fig. 62) and *Wreck of a Transport Ship* shown at Royal Scottish Academy.
	October: Takes to his bed at his cottage in Chelsea.
	19 December: Death of Turner at Chelsea.
	30 December: Buried in St Paul's Cathedral.

NOTES

Notes to the Introduction

1. J. Ruskin, *Notes on the Turner Gallery at Marlborough House*, 1856/7.

2. L. Gowing, *Turner, Imagination and Reality*, 1966, pp. 11, 33.

3. J. Gage, 'Turner and the Picturesque', *Burlington Magazine*, CVII, 1965; Gage, 1969, Chapter III.

4. J. D. Fiorillo, *Geschichte der zeichnenden Künste*, V, *Geschichte der Mahlerey in Grossbrittanien*, 1808, pp. 831–2. Fiorillo's description of BJ 15 reinforces Joll's suggestion that this was the painting shown at the Academy in 1802. For a brief general account of Turner's reputation in Germany, A. Haus, 'Turner im Urteil der deutschen Kunstliteratur', in *J. M. W. Turner: Maler des Lichts*, Berlin, 1972, pp. 95ff.

5. [J. Landseer] *Review of Publications of Art*, I, 1808, p. 152.

6. A. Pichot, *Voyage historique et littéraire en Angleterre et en Écosse*, I, 1825, pp. 1604.

7. J. Gage, '"Le roi de la lumière": Turner et le public français de Napoléon à la seconde guerre mondiale', in *J. M. W. Turner*, Paris, Grand Palais, 1983/4, pp. 44–6. Gudin later became an enthusiast for the Turners in the collection of Munro of Novar (*Art Union*, IX, 1847, p. 253).

8. *John Bull*, VII, 27 May 1827, p. 165.

9. E. C. Parry III, 'Thomas Cole's "The Titan's Goblet": a reinterpretation', *Metropolitan Museum Journal*, IV, 1971, pp. 128ff; also L. Noble, *Life and Works of Thomas Cole*, 1964, p. 81. Cole somewhat undermined the force of this assessment by being perfectly able to analyse the chiaroscuro, as well as the colour, of *Ulysses* in a sketch (Parry, p. 129, Figs. 5, 6).

10. A. Vollard, *La Vie et L'oeuvre de P. A. Renoir*, 1919, pp. 147–8. Renoir claimed that he was first attracted by Turner to London, but he is not known definitely to have visited that city, since a plan to go with Duret in 1881 came to nothing (*Renoir*, London/Paris/Boston, 1985–6, p. 300), and a possible excursion from Guernsey in 1883 (*The Impressionists in London*, London Hayward Gallery, 1973, p. 67) has not been verified. In any case, Renoir's remarks to Vollard must be treated with caution (*Renoir*, *cit.* p. 13).

11. Sir Wyke Bayliss, *Olives: The Reminiscences of a President*, 1906, p. 34.

12. For his constantly repeating 'Eggs and Spinach' after one such review, W. H. Harrison, 'Notes and Reminiscences', *University Magazine* (Dublin), I, 1878, p. 546.

13. W. P. Frith, *My Autobiography*, I, 1887, pp. 130ff.

14. The most detailed discussion of Ruskin's early approach to Turner is Van Akin Burd, 'Ruskin's Defence of Turner: the Imitative Phase', *Philological Quarterly*, XXXVII, 1958, pp. 465–83; id. 'Background to *Modern Painters*: the tradition and the Turner Controversy', *Publications of the Modern Languages Association of America*, 74, i, 1959, pp. 254–64.

15. J. Ruskin, *Modern Painters*, V (1860) Pt. IX, ch. XI, 31 note.

16. The article has recently been attributed to the watercolourist and journalist W. H. Pyne (J. Ziff, 'William Henry Pyne's "J. M. W. Turner, R.A.": a neglected critic and essay remembered', *Turner Studies*, VI, i, 1986).

17. 'British School of Living Painters: J. M. W. Turner, R.A.' *Arnold's Magazine of the Fine Arts*, NS, I, 1833, pp. 316–7.

18. *ibid.* p. 318.

19. See Gage 1980, pp. 280–2.

20. P. Blanchard (ed. and trans.) *John Ruskin sur Turner*, 1983. But see also Sir F. Wedmore, *Turner and Ruskin. An Exposition of the Work of Turner from the Writings of Ruskin*, 1900, and E. T. Cook (ed), *Ruskin on Pictures*, I, *Turner at the National Gallery and in Mr Ruskin's Collection*, 1902.

21. Gage 1969, p. 104.

22. On Blechen and Turner, W. Vaughan, *German Romantic Painting*, 1979 p. 154 and note 11.

23. B. R. Haydon in 1843: *Correspondence and Table-Talk*, II, 1876, p. 198; P. Mérimée, Les Beaux-Arts en Angleterre', *Revue des Deux-Mondes*, XXVII ii pér. XII, 1857, pp. 867ff; P. Cunningham in J. Burnet, *Turner and his Works*, 1852, p. 45. See also R. Muther, *The History of Modern Painting*, revised edition, 1907, II, p. 270.

24. Finberg 1961, p. 444n.

25. D. Robertson, *Sir Charles Lock Eastlake and the Victorian Art World*, 1978, pp. 301ff. Also M. Butlin in BJ pp xxii–xxiii.

26. J. C. L. Dubosc de Pesquidoux, *L'École Anglaise 1672–1851*, 1858, p. 198.

27. R. Ménard, 'Institution de South Kensington, III' *Gazette des Beaux-Arts* ii pér. VI, 1872, p. 283.

28. *Correspondance de Camille Pissarro*, ed. Bailly-Herzeberg, I, 1980, p. 175.

29. Gage, 'Le roi de la lumière', *cit.* pp. 49–50.

30. For Monet and Turner's painting, Gage, *Turner: Rain Steam and Speed*, 1972, pp. 68ff.

31. W. Bürger, *Trésors d'art en Angleterre*, (1857), 1862, pp. 424ff.

32. W. Bürger, *L'École Anglaise*, in C. Blanc, T. Gautier, P. A. Jeanron (eds) *Histoire des peintres de tous les écoles* (1863): *J. M. W. Turner*, p. 16.

33. The signatories were Degas, Monet, Boudin, Pissarro, [John Lewis] Brown, Renoir, Cassatt, Morisot and Sisley. The letter was first published in an English translation in the thoroughly unreliable book by J. Anderson, *The Unknown Turner*, 1926, p. 17, where it was dated 1877. But the following year, as Eric Shanes kindly pointed out to me, it was published in French and as of 1885 by Clive Bell, *Landmarks of Nineteenth-Century Painting*, 1927, p. 136, where the original was said to be in the hands of the Bond Street dealer Knoedler. The Grosvenor Gallery had shown a substantial loan exhibition of Turner water-colours in 1878, and in 1888 it included eleven oils, chiefly early ones, in the exhibition *British Art 1737–1837*.

34. J. K. Huysmans, *Certains*, 1889, pp. 201ff. For the exhibition, Gage, 'Le roi de la lumière', *cit*, p. 52.

35. E. de Goncourt, *Journal*, 12 August 1891.

36. On the Groult Collection, Gage, 'Le roi de la lumière', *cit.* p. 52.

37. Gage, 1969, p. 193.

38. Ensor's relationship to Turner has been sketched briefly by L. M. A. Schoonbaert, in Royal Academy of Arts, London, *Ensor to Permeke*, 1971, p. 32. A detail from Ensor's copy from *Ulysses deriding Polyphemus* (Fig. 4), in the Royal Museum in Antwerp, is reproduced in P. Haesaerts, *James Ensor*, 1957, p. 68.

39. Gage 1969, p. 269 note 13.

40. H. Matisse, *Écrits et propos sur l'art*, ed. Fourcade, 1972, p. 290. Matisse's idea is unwittingly close to Turner's late practice of confining his visitors for a few minutes in the dark hallway before allowing them up to view his collection (R. S. Owen, *The Life of Richard Owen*, I, 1894, p. 263).

41. Gage 1969 pp. 193–4.

42. *ibid.* p. 194.

43. M. Brion, *Turner*, Paris 1929. Brion did not differentiate between finished and unfinished works in his illustrations.

44. For the 1938 exhibition, Gage, 'Le roi de la lumière', *cit.* p. 55.

45. L. Stainton, *British Landscape Watercolours*, British Museum, 1985, No. 101.

46. H. R. Tedder, *The Times*, 16 February 1924, p. 14. It should, however, be said that Turner also tried (in vain) to institute an Artists' Dinner at the Athenaeum (Gage 1980, p. 7).

47. B. Venning, 'Turner's Annotated Books – I', *Turner Studies*, II, i, 1982, pp. 38–9.

48. C. R. Cockerell, *Diary*, 11 December 1821. Published by courtesy of Mrs B. J. Crichton and the R.I.B.A., where the diary is housed.

49. L. Gowing, Turner, *Imagination and Reality*, 1966, p. 7.

Notes to Chapter One

1. W. Sandby, *The History of the Royal Academy of Arts*, 1862, I, p. 319; Thornbury 1877, p. 26. In *Colour in Turner* (p. 227 n. 28) I sought to relate Turner's training with Malton to the *Picturesque Tour of the Cities of London and Westminster* of the early 1790s; but Malton had been working on the project as early as 1785, when he showed views of *The North Front of St Paul's* (cf. *Tour*, pl. 55, 1798) and *The North Front of Westminster Abbey* (cf. *Tour*, pl. 12, 1793) at the Academy. The *D.N.B.* states that Turner (and Girtin) studied perspective in a school run by Malton in Conduit St., between 1783 and 1787, although the Academy catalogues show that he was sending in from an address in Carlisle St., Soho during that period.

2. For Gandy, Gage, 1969, p. 107; for Turner as Professor, below, Chapter Five.

3. T. Malton, *A Compleat Treatise on Perspective*, 2nd ed., 1779, p. 35; J. Kirby, *Dr Brook Taylor's Method of Perspective Made Easy*, 1754, I, pp. 20–21.

4. Gage 1969, pp. 40. 114. For similar contemporary views, J. B. Malchair (1729–1812), *Observations on Landscape Drawing*, I. Fleming-Williams in M. Hardie, *Water-Colour Painting in Britain*, III, 1968, p. 235; J. Reade, *Experimental Outlines for a New Theory of Colours*, 1818, p. 78. An ingenious variant of this theme was suggested by an acquaintance of Turner's, William Brockedon, in a lecture at the Royal Institution in 1830, where he likened the radiated membrane of the eye to a diffraction grating, which also generates a spectrum (*The Athenaeum*, 1830, p. 363).

5. M. Akenside, *The Pleasures of Imagination* (1765 version), II, pp. 132–8. For Turner's use of this passage, J. Gage, 'Turner and the Greek Spirit', *Turner Studies*, I, ii, 1981, pp. 25–31. Kirby's diagram, which as he explained (1754, 1760, p. 58) 'contains all the Rules and Principles of Perspective' was published on the page before the etching by Gainsborough, described as 'an Example of a Landskip by a very great Genius in that way', which was, however, dropped from subsequent editions.

6. J. Gage, 'Turner and the Greek Spirit', p. 21.

7. The only firm dates for the association with Hardwick are Turner's watercolour of *Wanstead Old Church*, now known only through a copy of 1887, but said to be dated 1788 (*Essex Review*, X, 1901, pp. 131–2) and that of another Isleworth Church which was based on a sketch of 1789 (TB II, p. 22). For these drawings, A. J. Finberg, *Notes on Three of Turner's Architectural Drawings*, 1920. Hardwick also owned a version of Turner's *Lambeth Palace* (w 10), which, according to Thornbury, who saw it in the Hardwick collection in the 1850s, was earlier than the drawing exhibited in 1790 (1877, p. 31); and a version of the *Pantheon Ruins* of 1792 (w 28).

8. The accounts of Turner's work for William Porden given by Lovell Reeve (*Literary Gazette*, December 27 1851, p. 924), or Alaric Watts (*Turner's Liber Fluviorum*, 1853, p. 13), or for John Dobson, as told by S. & R. Redgrave, *A Century of British Painters*, (1866) ed. Todd, 1947, p. 252 (cf. F. M. Redgrave, *R. Redgrave: A Memoir compiled from his Diary*, 1891, pp. 231 ff) have still to be substantiated; but Wilton and Morris have published a number of drawings of the 1790s done in collaboration with other architects (w 327–333; S. Morris, 'Two Perspective Views: Turner and Lewis William Wyatt', *Turner Studies*, II, ii, 1983, pp. 34–6).

9. P. Youngblood, 'The Painter as Architect: Turner and Sandycombe Lodge', *Turner Studies*, II, i, 1982, p. 2off. R. Wornum, *The Turner Gallery*, 1872, p. xiii, attributed the whole of the Queen Anne Street house to Turner's design.

10. J. Gage, 'Turner and the Greek Spirit', pp. 18ff.

11. Gage 1969 p. 23.

12. Farington, 1 ff November, 17 December, 1795.

13. Farington 7 November 1803. For Gandy, Architectural Association, *Joseph Michael Gandy*, 1982.

14. J. Soane, *Lectures on Architecture*, ed. Bolton, 1929, p. 88. Soane was rather less complimentary about Turner's 'almost caricatural representations' of the Admiralty and Carlton House Screens (?TB CXCV, 169–73) in his pamphlet, *An Appeal to the Public occasioned by the Suspension of the Architectural Lectures in the Royal Academy*, 1812, p. viii n.

15. J. Gage, 'Turner and the Greek Spirit', cit. p. 25.

16. For a fuller discussion of this pair, see 'Turner and the Greek Spirit', pp. 16–18 and *J. M. W. Turner*, Paris, Grand Palais, 1983–4, No. 32. Turner noted in his diary on 18 May 1816 that Turner had returned his copy of Revett's *Antiquities of Ionia*, on which the reconstruction of the Temple of Jupiter, as well as the companion-picture, were partly based (Diary in Sir John Soane's Museum).

17. For the background to *Ancient Rome*, see *J. M. W. Turner*, Paris, 1983–4, No. 64.

18. T. G. Wainewright, *Essays & Criticism*, ed. Hazlitt, 1880, pp. 115–6. For Wainewright as poisoner, see Oscar Wilde, 'Pen, Pencil and Poison' *Complete Works*, ed. Holland, 1976.

19. Lecture IV, On Invention (1805), in J. Knowles, *Life & Writings of Henry Fuseli*, 1831, II, pp. 217–8.

20. Letter 43.

21. Y. O'Donoghue, *William Roy: Pioneer of the Ordnance Survey*, 1977.

22. Farington, 30 December 1794, 12 November 1798. For Hearne, see *Thomas Hearne 1744–1817*, Southampton Art Gallery, 1985.

23. T. Girtin & D. Loshak, *The Art of Thomas Girtin*, 1954, pp. 26ff.

24. The best account of the problems surrounding the Monro School is now A. Wilton, *The Art of Alexander and John Robert Cozens*, 1980, pp. 59ff.

25. Monro Sale, Christie, June 28 1833, lot 52. That this topographical convention continued to be a feature of Monro School practice is suggested by a plate of *The Priory Church at Dunstaple* (1803) made by Hearne for Byrne's *Brittannia Depicta*, to which Turner also contributed. The drawing was based on an outline by Henry Edridge, a later protégé of Monro's.

26. Letter 273 (1844).

27. [Lansdown] *Recollections of the Late William Beckford*, 1893, p. 15. A reference to the lake and as the hills 'which give me an idea of Cumberland', suggests that the drawing in question was the *Afternoon View* then (1838) in the Allnutt Collection (w 335). Wilton mentions five drawings as commissions from Beckford, but Turner told Farington (10 July 1800) that seven had been made. Beckford claimed that there were six drawings, three of them disposed of at Fonthill sale. One of the three remaining to Beckford is described by Lansdown (p. 22) in a way which suggests the *East View* now at Brodrick Castle (Fig. 42).

28. Henry Crabb Robinson in BJ 231. The emphases are taken from the typescript of his diary in Dr William's Library. The most sympathetic account of Turner's poetic treatment of topography is in one of the earliest studies, R. & S. Redgrave, *A Century of British Painters* (1866) ed. Todd, 1947, pp. 258–9.

29. J. Barry, *Works*, 1809, I, p. 497; see also the passage on aerial perspective on p. 489. Lecture V, On Chiaroscuro was first given in 1787 (W. L. Pressly, *The Life and Art of James Barry*, 1981, p. 218 n4).

30. In a letter to the press in 1855 it was claimed that Lowe was the artist who 'first recognized, befriended and saved [Turner] to art' Falk 1938, pp. 24–5. Falk is the only biographer to have referred to Lowe's connexion with Turner, and his suggestion that it was Turner who, as a member of the Academy Council in 1803, pressed the case of his widow and daughters for charity, is incorrect, since Mrs Lowe, under the sponsorship of West, had long been in receipt of help.

31. The fullest treatment of his work is in N. C. Pressly, *The Fuseli Circle in Rome*, Yale Center for British Art, 1979, pp. 71–2.

32. See the long description on the tablet recorded in *Gentleman's Magazine* 1834, I, p. 489 and the account by J. Northcote, *Memoirs of Sir J. Reynolds* 1813, pp. 294–6. The painting survived at Sutton Place, near Guildford at least into the 1830s. The introduction of a lion (?) into Francis Danby's large *Deluge* of 1840, now in the Tate Gallery (E. Adams, *Francis Danby: Varieties of Poetic Landscape*, 1973, No. 47, Fig. 65) may owe something to Lowe.

33. Turner's use of that great Baroque dictionary of symbolism, Ripa's *Iconology* in the 1709 English edition has recently been documented by W. Chubb, 'Minerva Medica and the Tall Tree', *Turner Studies*, I, ii, 1981, pp. 30–1. Chubb also shows that such sources were against the grain of neo-classical criticism and practice.

34. Eric Shanes, *Turner's Human Landscape*, 1986.

35. Finberg 1961 pp. 17, 365. The painting is now in the National Portrait Gallery. For Rigaud as a decorator, E. Croft-Murray, *Decorative Painting in England 1537–1837*, II, 1970, pp. 268–9.

36. S. Hutchison, 'The Royal Academy Schools, 1768–1830', *Walpole Society*, XXXVIII, 1960–2, p. 130.

37. Finberg 1909, pp. 7, 24. There are several gaps in the surviving registers now in the library of the R.A., which do not begin until July 1790, and end in November 1799.

38. B. Venning, 'Turner's Annotated Books, III', *Turner Studies*, III, i, 1983, p. 40. Ryley seems to have been in the circle of Turner's early mentor, Rigaud (Farington 7 December 1798); for his work Croft-Murray, *op. cit.*, p. 273.

39. Farington 10 December 1802.

40. Hutchison, 'The Royal Academy Schools', p. 126.

41. Farington 10 December 1795. Although he was a friend of Bourgeois, Turner seems to have had a low opinion of his figures (Farington 24 December 1803).

42. Barry, *Works*, I, p. 557; Farington 1 December 1797.

43. Farington 27, 30 November, 4 December 1799; Whitley, I, pp. 12–13. One of the reforms instituted at this time was to confine the period of study to ten years.

44. In the event, the sculptor Charles Rossi, who was also on the Council, was elected one of the Visitors (Farington 10, 14 December 1802).

45. See Farington, 8 January 1811.

46. *True Briton*, May 6 1803: see BJ 49. As late as 1805 Turner could still be characterised as a painter of historical subjects, without reference to landscape (J. Feltham, *The Picture of London for 1805*, p. 271).

47. Whitley, I, p. 262. Turner had been an Inspector of the Cast Collection in 1820, 1829 and 1838, and on this last occasion he may have found something lacking in the Royal Torso.

48. Sir J. Reynolds, *Discourses*, ed. Wark, 1975, pp. 177ff. W. Hogarth, *The Analysis of Beauty*, ed. Burke, 1955, p. 5. For the history of the Torso, F. Haskell & N. Penny, *Taste and the Antique*, 1981, No. 80.

49. TBE 1974–5, No. B112.

50. R. & S. Redgrave, pp. 256–7, also Redgrave, 1891, p. 57. Richard Redgrave was a student at the Academy from 1826. For the study by Etty, see the recollection by D. Maclise in A. Gilchrist, *Life of W. Etty R.A.*, 1855, II, p. 59. See also Turner's own 'life' study of the Venus de' Medici, BJ 298.

51. In her study of Mulready, Kathryn Heleniak showed surprise at the choice of such a design (K. Heleniak, *William Mulready*, 1980, p. 28). For the final medal, designed by Daniel Maclise with a more obviously landscape motif, Royal Academy 1974–5. Nos. B 59, 60.

52. F. Cummings, 'B. R. Haydon and his School', *JWCI*, XXVI, 1963, p. 374. In 1819 Turner visited Haydon's exhibition of drawings from Raphael and the Elgin Marbles (ib. p. 372). See also Letter 17 for Turner's enthusiasm for the Marbles, casts of which he later owned (Gage 1969, p. 131).

53. Farington 20, 30 June, 30 July 1808. For Carlisle's doctrines, 'On the connexion between Anatomy and the Arts of Design', *The Artist* No. XVII, 1807, pp. 1ff and

Farington 22 July 1807. Turner referred to these ideas in his first lecture at the Academy (British Library, Add. MS 46151, K, p. 5). For Turner's friendship with Carlisle, below, Chapter 8.

54 'Mons^r Roland the fence master exhibited himself' at Carlisle's first lecture of the 1812 season (J. Soane, *Diary*, 9 November 1812; Sir John Soane's Museum), and the practice became notorious in later years (Whitley II, pp. 17–18).

55 T. Moore, *Memoirs, Journal and Correspondence*, ed. Russell, III, 1853, p. 74. Turner first seems to have used classical statuary in this way in *What you Will* (Fig. 224) where, as Ziff was the first to notice, he peopled his garden with sculptural groups from the Vatican collection. This painting was, of course, a pastiche in the style of Watteau, who had often made his garden-sculpture take part in the action.

56 S. Smetham & W. Davies, (eds) *Letters of James Smetham*, 1902, p. 289; A. Elmore (who entered the Academy Schools in 1832) in *Report of the Commissioners Appointed to Inquire into the Present Position of the Royal Academy . . .* 1863, p. 367. C. L. Eastlake, who served with Turner as a Visitor in 1831 noticed in the same report Turner's original practice of placing the model on a white sheet (p. 65).

57 See BJ 355. For another life-drawing of a similar date, and a view of what may be the life-class itself, G. Wilkinson, *Turner's Colour Sketches, 1820–1834*, 1975, p. 71.

Notes to Chapter Two

1. R. & S. Redgrave, *A Century of British Painters*, ed. Todd, 1947, pp. 263–4.

2. Turner's Margate sketches, which may be as early as 1784, were first published in Wilton, 1979, Nos. 1–4. They were given by Turner's mother to Jane Taylor (Hunt) of Bakewell, Derbyshire. For the Oxford sketches of 1787–9, W 6, TB II, III.

3. In his *History of the Royal Academy of Arts* (1862, I, p, 316), William Sandby stated that Turner went to stay with his aunt at Brentford, and to White's school 'in his tenth year' and to school at Margate after this. Marshall later claimed that he had supported Turner for three years (Farington 12 May 1803).

4. [Mr Beavington Atkinson] 'Turner at Bristol', *The Portfolio*, 1880, pp. 69–71.

5. Finberg, 1961, p. 27.

6. For this tour, A. Wilton, *Turner in Wales*, Llandudno/Swansea, 1984, pp. 35–8. The diary of slightly later tour in Wales, published in Gage 1980, pp. 11–19, has now proved to be by another author.

7. See TB XIX and w.89–118. Inside the front cover of the sketchbook Turner wrote a list of seven larger subjects for the *Copper-Plate Magazine* (w 90–5, 97).

8. See TB CCXXXIX which refers on pp. 20a–21 to Hathersage, the village where Holworthy had settled in 1824. A note inside one cover referring to a series of possible subjects including *Sunrise* and *Evening Sunset* recalls the caption to the lost *Scene in Derbyshire* (BJ 240), shown at the R.A. in 1827, which might suggest a date in 1826 for the book. References to Holworthy in Letters 116, 119, 122, however, suggest that Turner had not managed to visit him by the end of April 1827; and a poem on the Evening Star on p. 70 may have been stimulated by Etty's painting at the R.A. in 1828.

9. Farington 19 June 1801.

10. J. Moore, *A List of Principal Castles and Monasteries in Great Britain*, 1798; TB XL, front cover and flyleaf, XLVI, pp. 119–119a. I am indebted to Dr S. Smiles for pointing out this source. An exception to this procedure is Cornwall (Moore, p. 61; TB XLVI, p. 119), none of whose monuments were starred.

11. See Gage, 1980, p. 302. As Dr C. Powell has kindly pointed out to me, Yarborough stood sponsor for Turner's first passport (P.R.O. FO 610/1 No. 550). The

other 'nobleman' may have been Lord Hawkesbury, who was apparently also involved in the issue of Turner's passport (Farington 4 October 1802).

12. Farington 22–23 November 1802.

13. Rev. H. F. Mills, *Elegaic Stanzas on the Death of Walter Fawkes*, 1825.

14. TB CXXXVII, inside cover and p. 1. The notes in TB CXI, inside cover and pp. 3a–4a are also likely to come from the same book, which has not been identified, although its range is similar to W. G. Maton, *Observations Relative Chiefly to Natural History, Picturesque Scenery and Antiquities of the Western Counties of England*, 1797, which Turner was certainly using in 1813 (Gage, 1980, p. 54).

15. TB CXXIII, partly printed in Thornbury, 1877, pp. 205–17 and in a more fragmentary but more correct form by Lindsay, *Sunset Ship*, 1966. For its rejection by Cooke, see Gage 1980, p. 55f. The series of watercolours has been reproduced in Shanes 1981. The poem is discussed in greater detail on pp. 195–7.

16. Thornbury 1877, p. 206. Notes and sketches made at Egham, Staines and Windsor, near Runnymede, are in TB CXXIII, pp. 1, 9a, 12a. See also Turner's characterisation of Runnymede in 1846, Letter 294.

17. Perhaps the first signs that Turner was contemplating an Italian tour are in a letter to Holworthy of September 1816 (Letter 68) and a note of an Italian primer in TB CXLI, p. 17.

18. TB CLIX, p. 29.

19. C. Campbell, *Traveller's Complete Guide through Belgium and Holland*, 2nd, ed. 1817, p. 178. For Turner's use of this book, A. G. H. Bachrach, 'The Field of Waterloo and Beyond', *Turner Studies*, I, ii, pp. 8f.

20. The fullest account of the Rhine series is in K. H. Stader, *William Turner und der Rhein*, 1981.

21. J. Gage, 'Turner and Stourhead: the making of a classicist?', *Art Quarterly*, XXXVII, 1974, pp. 71–5.

22. Two pages from this sketchbook, including the Temple of Clitumnus, mentioned below, are reproduced by G. Wilkinson, *The Sketches of Turner R.A.*, 1974, p. 179. Turner's notes from Eustace are on pp. 4–16a, and range over most of that lengthy text, concentrating on the classical architecture and not including Venice at all, although Eustace (1813, I, pp. 67–80) had devoted the best part of a chapter to that city, and, as we shall see, his attitudes were important for Turner. Turner noted 'vol. 2' just before his notes on Procida, which suggests that he was using the two-volume edition of 1813 or 1814, rather than the four-volume versions which began in 1815, although in both early editions the Procida chapter was in volume I.

23. For a colour reproduction of *Tivoli*, Wilton 1979, p. 155 and for the *River Stour*, *J. M. W. Turner*, Paris, Grand Palais, 1983–4, No. 135. It has been assumed that *Tivoli* (dated 1817) was painted for John Allnutt, but his ownership is not recorded before the mid-1820s, and the earliest record of the ownership of the *River Stour*, in the Morrison collection is not before 1841 (A. Raczynski, *Histoire de l'art moderne en Allemagne*, 1841, III, p. 507). It seems entirely possible that they were both painted in 1817 with Colt Hoare in mind.

24. The Hakewill commission has been discussed most fully by C. Powell, 'Topography, Imagination and Travel: Turner's Relationship with James Hakewill', *Art History*, V, 1982, pp. 408ff.

25. These pencil drawings are now in the British School at Rome.

26. TB CLXXI, p. 1. Turner's annotated copy of Reichard is TB CCLXVII.

27. See T. S. R. Boase, 'English Artists in the Val d'Aosta', *JWCI*, XIX, 1956, pp. 287–8.

28. H. Sass, *A Journey to Rome and Naples*, 1818, pp. 54–5. It is also possible that Turner wished to visit Turin, which he had been too pressed to do in 1802 (Farington 22 Nov. 1802): he certainly spent some time there on this occasion (TB CLXXIV, CXCII).

29. TB CCXCIV, p. 60a. This sketchbook also includes sketches of Mont Cenis, and it is not clear exactly where Turner recollected his poem. It is certainly possible that the 1836 visit to the Val d'Aosta was stimulated by William Brockedon's anonymously published extracts from his journal of a climbing expedition there: 'Extracts from the Journals of an Alpine Traveller', *Blackwood's Edinburgh Magazine*, 39, 1836, pp. 131, 138, which had begun with Brockedon's perennial wish to plot Hannibal's route. See next note.

30. TB CCXLVIII, p. 17. Finberg's transcription is misleading; mine runs: 'No matter what bit Hannibal Elia [?] preferred the Alps Sept 3 1844 WB and JMWT'. 'Fombey' is on the lower part of the sketch and remains mysterious; it could represent a mis-hearing of Pommat or Formazza (cf. W. Brockedon, *Journals of Excursions in the Alps*, 1833, pp. 336ff.) Brockedon had been a student at the R.A. and seems to have been well-known to Turner (Letters 147, 154).

31. Sass, *op. cit.* pp. 267–8. We have seen (note 22) that Turner made no notes on Venice from Eustace's *Tour*.

32. Henry Coxe, *A Picture of Italy, being a Guide to the Antiquities and Curiosities of that Interesting Country*, 2nd ed. 1818, pp. 475ff. This is probably the 'Cox's Italian Tours' of TB CLXIII, p. 1.

33. E.g. *The Approach to Venice* (BJ 412), with the clearly labelled Doge's barge in the foreground, and *Venice, the Piazzetta with the Ceremony of the Doge Marrying the Sea* (BJ 501), whose subject relates to Byron's lines on the discontinuing of this ceremony after the French occupation (*Childe Harold's Pilgrimage*, IV, xi, quoted by Coxe, *op. cit.* p. 488).

34. T. Roscoe, *The Tourist in Switzerland and Italy*, 1830, p. 187. A copy of this work was in Turner's library.

35. The scene of excavation in the Hakewill plate was Turner's own addition to Hakewill's drawing: see C. Powell, *loc. cit.* in note 24, Figs 32–3. Even J. C. Hobhouse, whose *Historical Illustrations to the fourth Canto of Childe Harold* (1818) was frequently cited in Hakewill's text, and whose account of the excavation of ancient Rome was the fullest available to Turner, although he had little respect for the depredations of earlier Popes, admitted that the French example of scientific excavation had been usefully followed by the most recent Pontiff (pp. 166ff.).

36. Thornbury 1877 pp. 138–40. Thornbury's story of Turner's interest in Thomson's 'Venetian' technique is given rather differently by their Scottish friend H. A. J. Munro of Novar in a note in his copy of Thornbury's *Life*: 'When Mr Munro returned to London from Scotland, Turner jocosely asked him, what news from Modern Athens – reply – why Thomson they tell me has discovered Titian's secret . . . Well says Turner, does he paint then like Titian, that's what I want to know' (Note to p. 196; collection of Professor Francis Haskell).

37. Gage 1969, p. 134.

38. See particularly the accounts in D. & F. Irwin, *Scottish Painters at Home and Abroad*, 1975, chapter 12.

39. H. W. Williams, *Travels in Italy, Greece and the Ionian Islands*, 1820, I, p. 107. For Turner's copy, J. Ziff, 'Copies of Claude's Paintings in the Sketchbooks of J. M. W. Turner', *Gazette des Beaux-Arts*, LXV Jan. 1965, pp. 55–6.

40. Williams, *ibid.* p. 314. Turner's sketch is TB CXCIII, p. 4.

41. Williams, *ibid.* II, pp. 106–7.

42. Williams, *ibid.* I, pp. 299f. Byron's moonlight scene in the fourth Canto of *Childe Harold's Pilgrimage* was noted by A. Wilton, *Turner Abroad*, 1982, pp. 23–4.

43. Williams, *ibid.*, I, p. 172. For Turner's copy, Gage 1969, p. 101 and for the painting itself, Arezzo, Galleria Communale d'Arte Contemporanea, *Mostra Pietro Benvenuti*, 1969, pp. 21ff and Nos. 10–13.

44. Williams, *ibid.* I, p. 111. For Turner's list, Gage 1969, pp. 245–6.

45. Gage 1969 pp. 100ff.

46. Williams, *ibid.* I, pp. 332ff. It is interesting that an English

critic in 1820 should have linked Williams' and Turner's names as the reformers of landscape so much needed on the Continent (Gage 1969, p. 102).

. Williams, *ibid.* II, pp. 368f. I have discussed a number of other links between Williams' and Turner's treatments of Greece in 'Turner and the Greek Spirit', *Turner Studies*, I, ii, 1981, pp. 14, 23.

. See *Turner en France*, Paris, Centre culturel du Marais, 1981 and N. Alfrey, 'Turner en France', in *J. M. W. Turner*, Paris, Grand Palais, 1983–4, p. 37.

. For the committee of 1832, Finberg 1961, p. 337; for the tour, H. George, 'Turner in Europe in 1833', *Turner Studies*, IV, i, 1984, pp. 2ff. Turner was able to make extensive use of another guidebook which he acquired: M. Starke, *Information and Directions for Travellers on the Continent*, 7th ed. 1829.

. *Murray's Handbook for Travellers in Switzerland*, 1838, p. 52.

. TB CCCXLIV, 124–5, 128–9; CCCLXIV, 313, 338, 342, 354, 378; A. Wilton, *Turner Abroad*, 1982, p. 64 and No. 97.

. Sir J. Mackintosh, *Memoirs*, ed. R. J. Mackintosh, 1835, II, pp. 302ff., cited in *Murray's Handbook*, pp. 55ff. Mackintosh's views affected Rogers on the trip itself (J. Hale (ed.) *The Italian Journal of Samuel Rogers*, 1956, p. 148) and in his anthology, *Italy*, which Turner illustrated (see Chapter Eight).

. Letter 275. In February of the following year Turner noted the 'sad news' from Switzerland in a letter to J. J. Ruskin (Letter 280).

. Wilton, 1982, No. 106; *Murray's Handbook*, pp. 40ff.

. H. Matthews, *The Diary of an Invalid*, 1820, pp. 351ff.

. *Murray's Handbook*, pp. 46–9. For Turner at the *Swan*, Wilton 1982, p. 66. When asked in 1844 to make a drawing from the top of the Righi, Turner said he would have to use his memory of the terrain and the Swiss Panoramic Prints which he may well have bought at Meyer's shop near the *Swan*, recommended for such articles by Murray (Letter 273; *Murray's Handbook*, p. 37).

. See Catherine Bicknell's MS *Diary* in the National Library of Scotland. (S. Whittingham, *Turner Studies, V*, II 1985 p. 51).

. For the Holy Land, Gage 1980, p. 298; for Ireland, Finberg, 1961, p. 353ff; for deathbed plans, *ibid.* p. 437.

. For the Kent tour of 1798 and the Scottish tour of 1801, see p. 236. For France and Switzerland in 1802 and the Val d'Aosta in 1836, see pp. 42, 169. For the Rhineland and Venice in 1840, Letter 236 and W. Callow, *An Autobiography*, ed Cundall, 1908, pp. 66–7. For Italy in 1819 and Switzerland in 1844, pp. 71, 246. For an unidentified Val d'Aosta tour with one Newby Lowson, R. Wornum, *The Turner Gallery*, 1872, p.ix n.

. Dr J. Percy, MS note of 1885 in his *Catalogue of Drawings*, British Museum Print Room, MS 6.7, p. 72–1. Donaldson's name and address appear in TB CLXXX, p. 81a.

. R. & S. Redgrave, *A Century of Painters of the British School*, ed. Todd, 1947, pp. 253f.

. See the two annotated books in Turner's library: Comtesse de Genlis, *Manuel du Voyageur or the Traveller's Pocket Companion* (English and German) 1829; Dr F. Atin, *Handbuch der englischen Umgangssprache*, 1834. See also TB CCCVII, pp. 1–4 (1833). Turner's command of German remained slight and in 1845 he had to enlist the help of Mrs Richard Owen to translate the programme of the Congress of European Art in Munich, to which he sent *The Opening of the Walhalla* (BJ 401): R. Owen, *The Life of Richard Owen*, 1894, I, p. 263.

. Letter 112; cf. also the *Messieurs les Voyageurs* of 1829 (W 405), the subject of which Turner also described vividly in Letter 147.

. Sass, *op. cit.* pp. 52–3.

. See the text to BJ 398.

. Charles Ninnis has sought to relate the picture to the then well-known fate of the Naval Survey ship *Fairy*, which left Harwich in November 1840 and was lost in the violent storms which broke out that month (*Turner Society News*, No. 20, 1981, pp. 6–8). That ship was certainly not the paddle-steamer in the present picture, which looks much more like the packet *Ariel* operating out of Dover at that time. It may not be fanciful to detect Shakespeare Cliff, near Dover, beyond the second steamer in our painting. Turner does not, of course, state in his title that he was *at* Harwich.

67. See Cyrus Redding on the 1813 Devon tour in Finberg, 1961, pp. 198–9.

68. It has been suggested by Dr A. Holcombe that Turner was here applying to himself the story of the French eighteenth-century marine painter Claude-Joseph Vernet, which was well known in England. Samuel Rogers, for example, who had complained of the rough weather on his return from France in 1803, was told it by William Gilpin (C. P. Barbier, *Samuel Rogers and William Gilpin*, 1959, p. 75.).

69. Cited in BJ, p. 132.

70. C. Redding, *Past Celebrities I Have Known*, 1866, I, pp. 47–8. Redding mentions the millboard oil-sketches here, but he may be confusing them with the pencil notes, which he compared to 'writing' rather than 'drawing'.

71. John Soane Jr. to Soane, 15 Nov. 1819, in Finberg, 1961, p. 262.

72. W. Stokes, in R. J. Graves, *Studies in Physiology and Medicine*, 1863, p.xi, cit. W. Armstrong, *Turner*, 1902, p. 96. See also William Lake Price's account of Turner at Lucerne in the 1840s, cit. A. Wilton, 'La technique de l'aquarelle chez Turner', Paris, Grand Palais, *J. M. W. Turner*, 1983–4, p. 163.

73. J. G. Millais, *Life and Letters of Sir J. E. Millais*, 1902, I, p. 158. A similar story was told to Mary Lloyd by Turner, with details which suggest that it was a practice begun in early youth (M. L. *Sunny Memories*, 1880, p. 33). See also John Pye in Gage, 1980, p. 276, and the account of a sunset watched by Turner 'for a long time in silent contemplation' in J. Burnet, *Turner and his Works*, 1852, p. 58.

74. In this sketchbook pp. 38–32 seem to be a sequence, as do pp. 48–51, 52–4 and 55–64. P. 48 has a note 'yellow', although the sketch is in blues, which suggests that artist was too hurried to mix the appropriate tint (for illustrations, G. Wilkinson, *The Sketches of Turner R.A.*, 1974, p. 177, *Turner's Colour Sketches*, 1975, pp. 20–1). See also TB CCVI, pp. 21–3 and TB CVIII, pp. 84a–87 which has a written note of the development of a sunrise.

75. Armstrong, 1902, p. 131.

76. Gage, 1969, p. 213. The MS is now British Library Add MS 46151, BB f. 27.

Notes to Chapter Three

1. Gage 1969, p. 200. I have slightly modified the punctuation. James Barry seems to have been one of the first to recognize the role of colour as opposed to chiaroscuro in creating relief: see his account of a Veronese in *Works*, 1809, II, p. 83.

2. Gage 1969 pp. 209ff.

3. *ibid.* p. 52.

4. J. Burnet, *Art Journal*, 1852, p. 48.

5. It was this standard tonal arrangement which probably allowed Turner to leave the setting of his palette to an unskilled assistant (Thornbury, 1877, pp. 125, 363–4; Pye in Armstrong, 1902, p. 182). The only historical study of the arrangement of palettes is still F. Schmid, *The Practice of Painting*, 1948.

6. For the element of translation in reproducing Turner see especially Gage 1969, pp. 51–2.

7. Gage 1980, p. 276.

8. The fullest account of this project is in Gage 1965, pp. 22–3.

9. Eric Shanes has kindly pointed out to me the many print albums and portfolios in the background of Charles Turner's portrait of the painter (R. W. Walker, 'The Portraits of J. M. W. Turner', *Turner Studies*, III, i. 1983, No. 33). A systematic study of print-sale catalogues might help to establish some of his collection: he bought, for example, several lots of Old Master and modern prints at the Balmanno Sale, Sotheby 4–11 May 1830, lots 143, 190, 258, 553.

10. See the notes on laying an etching ground on TB V,D, verso and other notes on the endpapers of TB XXX (*c.* 1796).

11. The link with aquatint was first suggested by. C. F. Bell, *The Exhibited Works of J. M. W. Turner*, 1901, pp. 15–16; see also A. Wilton, 'La technique de l'aquarelle chez Turner', *Turner*, Paris, Grand Palais, 1983/4, p. 158.

12. Farington, 28 March 1804, describing the work of Thomas Daniell in 'Turner's manner'.

13. J. Bayard, *Works of Splendor and Imagination: The Exhibition Watercolor 1770–1870*, Yale Center for British Art, 1981, p. 15. This is the best study of the subject.

14. Farington 14 April 1797.

15. For varnished drawings, see especially, W. G. Rawlinson & A. J. Finberg, *The Watercolours of J. M. W. Turner*, 1909, p. 11; for gold frames and mounts, Gage 1969, p. 163.

16. Gage 1969, p. 229. This picture, which was painted for the Rev. James Douglas, has, until recently, been confused with another one, also lost, painted for Turner's friend the Rev. Nixon, from whom it passed to his son, later Bishop of Tasmania. According to the *Catalogue of the Art Treasures Exhibition held in the Legislation Council Chamber, Hobart Town, Tasmania in the year MDCCCLVIII*, No. 157, this was a *View of Snowdon, North Wales*, and was also thought to be Turner's first oil (I am grateful to Dr Joan Kerr for drawing my attention to this catalogue). Turner's first recorded visit to Snowdon was in 1798, but he may, of course, have used a sketch by another artist.

17. This is best exemplified in the oil and gouache versions of *Caernarvon Castle* (Gage 1969, Figs. 5, 6).

18. Anne Mary Provis claimed to have discovered a manuscript revealing the secrets of sixteenth-century Venetian painters, of which she sold copies to interested academicians at £10 each. The fullest published account is in J. Gage, 'Magilphs and Mysteries', *Apollo*, LXXX, 1964, pp. 38–41. That article was based on the MS in the Royal Academy Library (5172 25A), partly in Farington's hand, as transmitted by Anne Mary Provis. What may be an earlier version, signed 'A.J.P.' is in the collection of Dr J. Whiteley, and puts an even greater stress on glazing. An Anne Jemima Provis exhibited miniatures at the Academy in the 1780s, and must be the same person as Anne Mary Provis. I am grateful to Dr Whiteley for allowing me to see his MS, and to Mrs Damaris Palmer for showing me her thesis on the 'Secret' (La Trobe University, 1983).

19. Farington 20 March, 21 May 1797, and Gage 1969, pp. 33f, 230. The bone-grounds, which could be coloured and for which Grandi was awarded a medal in 1806, were, he claimed, 'in the old Venetian stile' (*Transactions of the Society of Arts*, XXIV, 1806, p. 85).

20. For Grandi and Pistrucci, Farington, 1 December 1797, and for his work for Day, *ibid.* 13 March 1801 (cf. also 4, 9 March, 9 May 1801.).

21. TB LXXI, p. 62a, LXXII, pp. 24–23a, 30, 51a.

22. W. Cotton, *Sir Joshua Reynolds' Notes and Observations on Pictures*, 1859, p. 28.

23. Turner also used a plate which Charles Turner had presumably completed before the quarrel (RLS.26). The fullest account is in A. J. Finberg, *The History of Turner's Liber Studiorum*, 1924, but the annotations are given more completely by W. G. Rawlinson, *Turner's Liber Studiorum*, 2nd. end. 1906.

24. The best account of Turner and his engravers is still that by C. F. Bell, in C. Holmes, (ed.) *The Genius of Turner*, 1903.

25. Gage 1969, p. 44. The many marked proofs for the *Southern Coast* have been catalogued by A. J. Finberg, *Introduction to Turner's Southern Coast*, 1929. The

surviving watercolours have been published by E. Shanes, *Turner's Rivers, Harbours and Coasts*, 1981.

26. Farington, 17 May 1816. Smirke had told Farington the previous day that the publisher was to be Longman's.
27. D. Hill, *In Turner's Footsteps: Through the Hills and Dales of Northern England*, 1984, p. 25. This is the fullest account of the commission.
28. Farington 20 December 1817. This note is not mentioned by Hill.
29. A. Wilton, *Turner in Wales*, 1984, Nos. 87–91.
30. Gage 1969, p. 32.
31. The only 'colour-beginning' related to the Farnley series which has so far been identified is the *Wharfedale and Farnley from the West Chevin* (*Turner in Yorkshire*, 1980, Nos. 41–2).
32. *The Shipwreck*, with three beginnings, is Fig. 111. *Grenoble Bridge* (w 404) was illustrated in colour with three of its beginnings in *Turner en France*, Paris, Centre Culturel du Marais, 1981, Nos. 164–7. Since that exhibition a further beginning has been identified (TB CCLXIII, 391).
33. E. Shanes, 'New Light on the *England and Wales* Series', *Turner Studies*, IV, i, 1984, p. 52.
34. These drawings are reproduced in E. Shanes, *Turner's Picturesque Views in England and Wales*, 1979, Nos. 2, 5, 7, 10.
35. For a colour-reproduction of *Chryses* (w 492), Paris, Grand Palais, *Turner*, 1983/4, No. 119, and for Fort Rock (w.399), A. Wilton, *Turner in the British Museum*, 1975, pp. 68–9.
36. Gage 1969, pp. 111ff.
37. W. Shaw Sparrow, in Holmes (ed.) *The Genius of Turner*, 1903, pp. vii–viii. See also Gage 1969, p. 32 for a similar account from Leitch which, however, does also mention scraping and dragging as well as hatching and stippling. Leitch first met Turner after his return from Italy in 1837, so that these drawings must have been later than the *England and Wales* series, which was concluded in 1836 (A. MacGeorge, *W. L. Leitch*, 1884, pp. 57, 79ff.)
38. In April 1818 Sir W. H. Newton asked Farington to intercede with Turner, who was on the Academy Hanging Committee that year, so as to secure good places for three of his miniatures at the Exhibition (Farington 14 April). A complaint from Callcott that Turner had re-arranged Shee's hanging may refer to this incident (Farington 22 April). There are also particularly striking uses of stippling and hatching in the miniatures of J.-B. Isabey, who was working and exhibiting in London about 1820, and may have been in contact with Turner (J. Gage, 'Le Roi de la Lumière', *Turner* Paris, Grand Palais, 1983/4, p. 46f.)
39. Farington 22–25 April 1811. The paintings are BJ 114–7. For the general background, Gage 1969, pp. 166–8.
40. C. R. Leslie in text to BJ 245. A colour reproduction of *Helvoetsluys* is BJ pl. 347, and of Constable's picture, G. Reynolds, *The Later Paintings and Drawings of John Constable*, 1984, pl. 819.
41. Text to BJ 359. E. W. Cooke (Diary, 5 February 1835, Cooke Family Papers) noted Turner at work on the picture two days before the opening of the exhibition.
42. G. Field, *Practical Journal* (begun 1809), f. 375 (MS on loan to The Courtauld Institute). Field states that the sample was 'from Rome', and it may have been acquired by Turner on his visits there in 1819 or, more probably, 1828–9. On the identity of Blanc d'Argent, G. Field, *Chromatography*, 2nd ed. 1841, p. 130. It is remarkable that no white pigments were found in Turner's studio at his death: N. W. Hanson, 'Some Painting Materials of J. M. W. Turner', *Studies in Conservation*, I, 1954, pp. 171–2 (but see Thornbury 1877, p. 363).
43. J. Gage, 'Turner's Annotated Books: Goethe's *Theory of Colours*' *Turner Studies*, IV, ii, 1984, p. 42.
44. R. & S. Redgrave, *A Century of Painters of the British School*, ed. Todd, 1947, pp. 260–1.
45. Such a box was identified as 'water-colour' by the American painter Thomas Sully in use at the British Institution on the *Dutch Boats* of 1838, now in Chicago: see text to BJ 372. For a surviving watercolour box, dated 1842, W. T. Whitley, 'Relics of Turner' *The Connoisseur*, 88, 1931, p. 198.
46. See Farington, 11, 21, 23 April 1796.
47. See text to BJ 337. According to the engraver's son, Turner felt the extra figures had to be added to balance the new architecture, introduced when the composition was heightened for engraving (W. G. Rawlinson, *The Engraved Works of J. M. W. Turner*, II, 1913, pp. 336–7).
48. Miller's advertisement was published in the *Art Union*, III, 1841, p. 194, and IV, 1842, pp. 2, 34, 66, 90, with Turner among the long list of artists who had tried and approved his medium. Its composition was discussed in an article in *ibid*. III, 1841, p. 132 (cf. Miller's advertisement in *ibid*. Sept. 1841, p. 145). Alexander Dunluce, chief restorer at the Tate Gallery, kindly informs me that no medium of this type has yet been identified in Turner's oils. It is worth noting that John Burnet saw that Turner used far less oil in his vehicle in the late works (*Art Journal*, 1852, p. 48).
49. *Art Union*, III, 1841, p. 197.
50. R. S. Owen, *The Life of Richard Owen*, I, 1894, p. 263. The circular paint-box was still in use at Turner's death (Thornbury 1877, p. 363).
51. G. D. Leslie, *The Inner Life of the Royal Academy*, 1914, pp. 146–7.
52. T. S. Cooper, *My Life*, 1890, II, pp. 2–3. Cooper mentions only four works at this Academy Exhibition (1846).
53. C. L. Eastlake, *Materials for a History of Oil Painting*, II, 1869, p. 281.
54. Turner's unfinished *Mountain Glen with Diana and Acataeon* (?) of the late 1830s seems to be based on this work: see text to BJ 439.
55. A. Hume, *Notices of the Life and Works of Titian*, 1829, pp. 112–3.
56. *ibid*. p. 116.
57. Balmanno Sale, Sotheby, 4 May ff. 1830, lot 190.
58. I am grateful to Ian Bain for showing me the prospectus prepared by Cooke, in the Bewick Papers at Newcastle.
59. [J. Britton?] *The Magazine of the Fine Arts*, I, 1821, p. 73.
60. For colour-engraving, Gage, 1969, pp. 47ff.

Notes to Chapter Four

1. Gage 1969, p. 33.
2. Gage 1969, p. 230 n. 73.
3. British Library, Add MS 46151 J, p. 1. Other versions of this passage are given by D. S. McColl, 'Turner's Lectures at the Royal Academy', *Burlington Magazine*, XII, 1908, p. 346, and Ziff, 1963, p. 127.
4. For Reynolds, W. T. Whitley, *Artists and their Friends in England*, 1928, II, p. 135; for Turner in 1828, Gage, 1969, p. 128.
5. For this picture, now at Petworth, J. Adolphus, *Memoirs of John Bannister*, 1839, II, pp. 197–9.
6. For the sketches, BJ 548. This *portrait of a Lady* may have been lots 17 or 23 in the sale of Turner's own collection, Christie's, 25 July 1874, although BJ describe it as having come 'by descent' to Miss M. H. Turner. Portraits attributed to Reynolds were also in lot 27 of the Turner sale, and lot 18 'Sir Thomas Lawrence, *Head of a Gentleman – a sketch*', which Christie's marked catalogue qualifies as 'Keppel', may be the *Admiral Lord Keppel, a sketch*, bought by Turner as a Reynolds in lot 10 of the 1821 sale. For the notebook, Whitley II, p. 14. Reynolds's palette, which Turner acquired at the Jackson Sale, Christie's 16 July 1831, lot 174, and presented to the new President, Shee (cf. Christie's, 25 March 1851 and *Athenaeum*, 27 December 1851, p. 1383), was in a miscellaneous lot including Hogarth's palette (subsequently presented by Turner to the Academy) and 'a cast from the skull of Raffaelle'.
7. British Library, Add. MS 46151 T, p. 20, where the *Macbeth* is used to illustrate 'Vitruvian man'. Turner also used Reynolds' other Boydell subject, *The Death of Cardinal Beaufort*, likewise at Petworth, to illustrate another compositional idea at this point.
8. See Sir Francis Bourgeois to Farington, 2 August 1809. Artists who did follow this practise included Sir Geroge Beaumont and John Glover, who received a short answer from Turner when he proposed that they should collaborate, probably on Glover's London exhibition of 1820–4 (J. L. Roget, *A History of the 'Old' Water-Colour Society*, I, 1891, p. 405). For Glover's practice in his landscape painted between a Poussin and a Claude in the Louvre in 1814, Victoria & Albert Museum Library, *Press Cuttings on the Fine Arts*, III, p. 882; D. & T. Clifford, *John Crome*, 1968, p. 85; Whitley I, p. 270. For the exhibition in which he introduced pictures by Claude and Wilson for comparison with his own, *Magazine of the Fine Arts*, I, 1821, pp. 68, 127.
9. Sir J. Reynolds, *Works*, 1797, II, pp. 33–5. It is impossible to be sure which editions of Reynolds' writings Turner knew, apart from the 1809 edition of the *Works* in his library. His references to the *Discourses* in TB CVI p. 71a correspond to no known edition of the period.
10. J. Barry, *Works*, 1809, I, p. 555.
11. Finberg 1961, p. 43.
12. Ziff, 1963, p. 145. I have discussed Turner's interest in Rembrandt more fully in Gage, 1972, Chapter 2. Here Turner refers to the well known etching *The Three Trees* (Bartsch 212) and to *The Mill* now in the National Gallery of Art, Washington, which is no longer attributed to Rembrandt.
13. Gage, 1972, p. 88, no. 36. The Rembrandt drawings bought by Turner were lot 77 in the Monro Sale, 26 June 1833.
14. Ziff, 1963, p. 141.
15. C. White, D. Alexander, E. D'Oench, *Rembrandt in Eighteenth-Century England*, 1983, pp. 8ff., 11ff., 107ff.
16. See TB CCXXXIX, pp. 43a–45, and for the Rosa, Arts Council, *Salvator Rosa*, 1973, No. 42.
17. Sir J. Reynolds, *Discourses*, ed. Wark, 1975, pp. 256–7.
18. *Annals of the Fine Arts*, I, 1817, pp. 387ff. For the picture, P. Murray, *Dulwich Picture Gallery: A Catalogue*, 1980, No. 126. The American painter Washington Allston painted a *Jacob's Dream* (1817–19) for Egremont, also based on this picture, and wrote a sonnet about the 'Rembrandt' (W. Gerdts & T. Stebbins, *Washington Allston*, 1979, pp. 97ff. also *Annals of the Fine Arts*, III, 1818, p. 529). The Allston is reproduced in Turner's water-colour of the Old Library at Petworth (Fig. 243).
19. *John Constable's Correspondence*, ed. Beckett, III, 1965, p. 69. For the origins of the picture, BJ 333; and for the related 'Rembrandtesque' works around 1830, Gage 1972, pp. 49–54.
20. Gage, 1972.
21. See Farington 31 August 1809 and B. Ford, *The Drawings of Richard Wilson*, 1951.
22. Farington 24 February 1798, 17 January 1799.
23. Cf. Letter 307.
24. A version of this composition seems to have been in the collection of Sir Watkin Williams-Wynn (W. G. Constable, *Richard Wilson*, 1953, p. 186) and Turner visited his collection in 1798 or 1799 (J. Ziff, 'Turner and Poussin', *Burlington Magazine*, CV, 1963, p. 316).
25. Ziff, 1963, p. 147.
26. See W. Chubb, 'Turner's "Cicero at his Villa"', *Burlington Magazine*, CXXIII, 1981, pp. 417f; and on Wilson's *Solitude*, D. Solkin, *Richard Wilson*, 1982, pp. 70ff. Turrier's *Solitude* is *Liber Studiorum*, R.53 and BJ 515.
27. See, for example, the *View of Tivoli*, BJ 545, now given to Wilson himself. Chubb suggests (*op. cit.* p. 417) that this is a copy by Turner of a painting once in the collection of his friend the Rev. Henry Scott Trimmer, and may have been done as a companion to BJ 44, which is perhaps a copy of another View of Tivoli in Trimmer's collection. The problem is complicated by the fact that BJ 545 is also very

close to the Wilson *View of Tivoli* in the Dulwich collection, which was owned by Dr Monro in the late 1790s (P. Murray, *op. cit.* No. 171). Turner also began to collect Wilson about this time (see Farington, 10 June 1801): five works attributed to him, one identified as a view of Sion House, were in the Turner Sale, Christie's, 25 July 1874, lots 20, 21, 24, 25. Lot 25, *River and Cloud*, is the only one traced so far (Constable, *op. cit.* p. 231).

. D. Sutton, *Notes & Queries*, 15th ser. 175, 1938, pp. 165ff., kindly brought to my notice by Dr M. Pidgely. Farington was repeating what he had heard from Lawrence (Gage, 1980, p. 263).

. Constable, *op. cit.* p. 126.

. Ziff, 1963, p. 144.

. I have here followed M. Kitson 'Turner and Claude', *Turner Studies*, II, ii, 1983, p. 4, which is the fullest discussion of the relationship.

. Farington 8 May 1799.

. Farington 28 October 1796, 25 January 1802.

. D. Howard, 'Some Eighteenth-Century English Followers of Claude', *Burlington Magazine*, CXI, 1969, p. 732.

. Farington 9 May 1799.

. This was first identified by J. Ziff, 'Turner et les grands maîtres', *J. M. W. Turner*, Paris, Grand Palais, 1983–4, p. 26. Finberg 1909 I, p. 170ff. dates this sketchbook '1800–1802', but it includes studies related to Beckford's *Fifth Plague* of 1800 (pp. 22–3), so it must have been in use earlier. I have suggested in Gage 1969 p. 31 that Turner also made use of the schematic idea in preparing his Fonthill drawings.

. Gage 1980 p. 4. Kitson, *op. cit.* p. 5 has pointed out that this could be the only one of Angerstein's three sea-port paintings in question, since the other two were acquired after 1800.

. Ziff, 1963, p. 144.

. For 'E.P.', see below, pp. 000.

. For the 'rural' and 'scientific' Claude see especially, R. Earlom, *Liber Veritatis*, 1777, I, pp. 8, 10; C. Bucke, *The Philosophy of Nature; or the influence of Scenery on the mind and heart*, 1813, II, p. 360; J. Young, *A Catalogue of the Celebrated Collection of Pictures of the late J. J. Angerstein*, 1823. p. 14. Reynolds, on the other hand, had already regarded Claude as a much more elevated artist in the 1770s (Discourse IV).

. See BJ 3, 8 and in general, L. Herrmann, 'Turner and the Sea', *Turner Studies*, I, i, 1981, p. 5. In 1786 Dominic Serres had shown two marines at the Academy 'in the style of Vanderveld, by the particular desire of a Gentleman'.

. For these sketches, A. G. H. Bachrach, 'Turner's Holland', *Dutch Quarterly Review of Anglo-American Letters*, VI, 1976, pp. 98ff.

. Bachrach's detailed analysis ('Turner's Holland', *cit.* pp. 94–5) is by far the fullest one.

. Farington, 5 May 1802, gives a diagram of the pictures in the gallery. By about 1818 the Turner and the Van de Velde had ceased to be hung together or considered as pendants (W. Y. Ottley & P. W. Tomkins, *The Most Noble the Marquis of Stafford's Collection of Pictures in London* IV, 1818, Nos. 7, 125 and cf. plan in I, pl. 9).

. S. Reiss, *Aelbert Cuyp*, 1975, No. 103. For the picture's high reputation among English artists, Farington 18 June 1806.

. J. Burnet, *Art Journal*, N.S., IV, 1852, p. 47. Burnet used the painting as an illustration of the mastery of aerial and linear perspective in his *Essay on the Education of the Eye with Reference to Painting*, 1837.

. M. Cormack, ('*The Dort*: Some further Observations' *Turner Studies*, II, ii, 1983, p. 38), following BJ 137, has suggested that *The Maas at Dordrecht* now in Washington, was the most influential model, but, although it was available to Turner at the British Institution in 1815, it was not the Bridgewater picture. Cormack is right to show that Turner was drawing on his knowledge of many Cuyps. He may have been especially reminded of the

Bridgewater Cuyp at this time because it had recently been published in Ottley and Tomkins, *op. cit.* III, p. 84 as 'one of the finest works of Cuyp which this country can boast, and . . . in the most perfect preservation'.

48. See especially A. G. H. Bachrach, 'Turner, Ruisdael and the Dutch', *Turner Studies*, I, i, 1981, pp. 26ff. and Cormack, *op. cit.*

49. Ziff 1963, p. 146.

50. See the examples cited by A. G. H. Bachrach *Turner and Rotterdam, 1817, 1825, 1841, 1974*; *Kent Sketchbook*, 1845/6 (TB CCCLXIII, p. 27). The 'Turner' copying one of the three Cuyps, none of them a river scene, shown at the British Institution in 1823 (*Somerset House Gazette*, I, 1824, p. 54) may not be our artist.

51. Sir J. Reynolds, *Discourses*, ed. Wark, 1975, p. 88.

52. Ziff, 1963 pp. 143ff. See also for the whole question, J. Ziff, 'Turner and Poussin', *Burlington Magazine*, CV, 1963, pp. 315ff.

53. See Monro Sale, Christie's, 24 March 1804, lot 88:N.Poussin, *The Plague at Athens . . . Plate Glass*. For the painting, formerly in the Cook Collection and sold at Christie's in July 1984, V. Bloch, *Michael Sweerts*, 1968, p. 214 and pl. 13.

54. For Turner and Smirke, Farington 8 July 1799, 7 August 1820. Smirke's *Plague of Serpents* is now lost, but it was described as a successful imitation of Poussin by the critic of the *Monthly Mirror*, X, 1800, p. 11.

55. *Monthly Mirror, cit.* pp. 18–19.

56. Ziff 1963, p. 143.

57. Ziff, 'Turner and Poussin', *cit.* pp. 319f. This was a common response to Poussin's picture: see R. Verdi, 'Poussin's *Deluge*: the Aftermath', *Burlington Magazine*, CXXIII, 1981, pp. 390–3, 397ff.

58. Gage, 1969, p. 203.

59. Reynolds, *Discourses*, ed. Wark, 1975, pp. 199f.

60. 'The Works of James Barry', *Edinburgh Review*, XVI, 1810, p. 300.

61. C. L. Eastlake, *Contributions to the Literature of the Fine Arts*, 2nd. ser. 1870, pp. 49–50 (1815); Etty in 1822, *cit.* E. Forssmann, *Venedig in der Kunst und im Kunsturteil des 19 Jh.*, 1971, p. 108 n (Sketchbook in York City Art Gallery); *John Constable's Discourses*, ed. Beckett, 1970; pp. 46–7 (1833). In the decade of the Pre-Raphaelites, Richard Redgrave claimed that the weeds and plants were 'complete generalisations' (F. M. Redgrave, *op. cit.* p. 202); but Ruskin at the same time noted Turner's speaking 'with singular delight of the putting in of the beech leaves in the upper right-hand corner' (J. Ruskin, *Pre-Raphaelitism, and other Essays and Lectures*, ed. Binyon, 1906, p. 32).

62. See the whimsical variations on Titian's National Gallery *Bacchus and Ariadne* (1840, BJ 382).

63. H. Brigstocke, *William Buchanan and the Nineteenth-Century Art Trade*, 1982, pp. 29, 37, and in general, F. Haskell, *Rediscoveries in Art*, 1976, especially pp. 138f. Turner may also have been stimulated by other Baroque ceilings, for example those of Piazzetta and Maulbertsch, which he could have seen in Venice or Vienna in these years.

64. W. Sandby, *History of the Royal Academy of Arts*, I, 1862, p. 322. For the Lane collection, J. Hayes, *The Drawings of Thomas Gainsborough*, 1971, I, pp. 96–7.

65. Turner's picture is an elaboration of part of Gainsborough's *Wooded Landscape with Figures, Cows and Distant Flock of Sheep*, c. 1746–7 (J. Hayes, *The Landscape Paintings of Thomas Gainsborough*, 1982, No. 15 and pp. 254–7). Trimmer also owned the unfinished early Gainsborough *Landscape with Gypsies* in the Tate Gallery (Hayes 43), and another Turner *Landscape with Cattle in the manner of Gainsborough* (Christie's 17 March 1860 lot 16).

66. P. G. Hamerton, *Life of J. M. W. Turner*, new ed. 1895, pp. 190–1. For Gainsborough's 'moppings', Hayes, *The Drawings, cit.* I, p. 24.

67. Farington 16 November 1799.

68. Sir J. Reynolds, *Discourses, cit.* pp. 257ff.

69. Hayes, *Landscape Paintings, cit.* No. 115. It is not known when this picture, first recorded in the 1850s, was acquired. There is a smaller copy, by one Butterfield, also at Petworth. Egremont's other, later Gainsborough, also a *Woody Rocky Landscape with Rustic Lovers* (Hayes 178) was at Petworth by 1814. See also BJ 82–3 for Gainsborough-like treatments of pastoral subjects.

70. Ziff 1963, p. 146. Turner did, however, refer warmly to *The Cottage Door* now in the Huntington Collection (Hates 123).

71. Sir J. Reynolds, *Discourts*, ed. Wark, 1975, p. 254.

72. J. Lindsay, *The Sunset Ship: Poems by J. M. W. Turner*, 1966, pp. 121–2, and his discussion on pp. 71ff. For Hogarth's 'Line of Beauty', *Analysis of Beauty*, ed. Burke, 1955, pp. 68ff. Hogarth gave leaves, flowers and shells as examples of nature's variety and beauty in form and colour (see Fig. 52).

73. TB CX p. 1a from T. Paine, *The Age of Reason*, II, (1795) in *works* 1818, p. 89n., Hogarth, *Analysis, cit.* p. 136 and P1 I, 106.

74. For Turner at Egremont's, TB CX, p. 22; and for Egremont's taste, C. R. Leslie, *Autobiographical Recollections*, 1860, I, p. 105. Egremont owned one painting attributed to Raphael, a portrait of the Duke of Urbino, which may have been a version of one of the two pictures identified as such and now in the Uffizzi in Florence, and three attributed to Hogarth, one of which, the so-called portrait of Peg Woffington, is still at Petworth. The others, *A Midnight Modern Conversation* and *A Connoisseur's Quarrel* are no longer traceable, although there is a version of the former in the Mellon Collection. See the Inventory by H. Phillips (1835), Victoria and Albert Museum Library MS 86 FF 67, Nos. 183, 212, 43, 349.

75. R. P. Knight, *Analytical Enquiry into the Principles of Taste*, 1805, pp. 410ff. 'Both drew from nature; but the one drew the general energies and perfections of mankind, and the other their individual peculiarities and perversions: whence the compositions of the one are sublime and those of the other ridiculous.' For the *Unpaid Bill* and its probable source, *The Alchemist's Laboratory*, now attributed to Gerard Thomas, M. Clarke & N. Penny (eds.) *The Arrogant Connoisseur: Richard Payne Knight*, 1982, No. 197. An earlier version of the title: *The Unpaid Bill, or an old Dentist reprobating his son's extravagance*, appears inside the back cover of the verse-book in the collection of Mrs R. Turner, which also contains *The Origin of Vermilion*, thus re-inforcing the Hogarth Connection.

76. Marc Antonio Raimondi's engraving of *Adam and Eve*, after Raphael, was sometimes known as *Forbidden Fruit* in the early nineteenth century, and the most recent treatment of the subject in a Raphaelesque vein had been James Barry's *Temptation of Adam* (1767–70), which was also engraved in 1776 (W. Pressly, *op. cit.* Paintings, No. 7; Prints No. 6).

77. This was not the caption used when Turner exhibited the painting of this subject in 1809 (BJ 100; see below p. 189). The drawings were first discussed by Ziff 1964, pp. 207ff; and the Hogarthian element in the quotation from Pope by A. Wilton in *Turner Bicentenary Exhibition*, 1974–5, Nos. 120–1.

78. It should, however, be noted that Turner had acquired this palette in a miscellaneous lot at the Jackson Sale, and was anxious to match Constable's earlier gift of a Reynolds palette. Turner's knowledge of the Hogarth *Election* series in the Soane collection may have affected his choice of subject for the *Northampton* plate. See Shanes 1979, No. 53.

79. Hogarth to G. Cooper, *cit.* R. Paulson, *Hogarth, his Life, Art and Times*, 1971, II, p. 141. For Turner, Gage 1969, p. 18, and especially the discussion in B. Venning, 'Turner's Annotated Books, I', *Turner Studies*, II, i, 1982, p. 36ff.

80. Finley has shown that as early as 1806 Turner was borrowing a composition from Watteau, although not

from one of his genre subjects (G. E. Finley, 'Ars Longa, Vita Brevis: The *Watteau Study* and *Lord Percy* by J. M. W. Turner, *JWCI*, XLIV, 1981, p. 247, n. 28).

81. S. Whittingham, 'Watteau's *L'Isle Enchantée*: from the French Régence to the English Regency', *Pantheon*, XLII, 1984, pp. 339ff.

82. N. Desenfans, *A Descriptive Catalogue . . . of the Pictures . . . Purchased for . . . the Late King of Poland.* 3rd. ed., 1802, I, p. 158.

83. *John Constable's Correspondence*, ed. Beckett, III, 1965, p. 41.

84. For the critique of Turner, text to BJ 430; for Watteau's faulty technique, well-known in the eighteenth century, H. Adhémar, *Watteau*, 1950, p. 171.

Notes to Chapter Five

1. C. Redding, *Fraser's Magazine*, XLV, 1852, p. 154. For attacks on the Academy, see Letter 52.

2. *Works of the late Edward Dayes*, 1805, p. 352. Turner was a subscriber to this book. For Turner and Dayes, Wilton 1979, pp. 36–8, and C. Hartley, *Turner Watercolours in the Whitworth Art Gallery*, 1984, No. 1.

3. Reynolds, *Discourse VI*, ed. Wark, 1975, p. 112.

4. Victoria and Albert Museum Library, *Press Cuttings on the Fine Arts*, III, p. 784. See also Farington 9 February 1799.

5. W. T. Whitley, *Art in England 1800–1820*, 1928, p. 21.

6. Thornbury 1877, p. 222.

7 *ibid.* and Turner to a great collector of Girtins, Chambers Hall: 'Never in my whole life could I draw like that, and yet I would at any time have given my little finger to be capable of doing so.' (Anon. 'Early Days of an Artist', *The Month*, February 1866, p. 147)

8. Thornbury 1877, p. 634 (three payments for 'touching' *Chelsea Reach*, and one for 'Girtin's Kirkstall', i.e. *Kirkstall Abbey*, engraved by W. Say for *Rivers of England* (Girtin and Loshak 414).

9. *Ackermann's New Drawing Book of Light and Shadow*, 1809, caption to Pl.V. Falk 1938, p. 33 also quotes a writer of 1802 who also saw Turner as a follower of Loutherbourg; see also [R. Joppien] *Philippe Jacques de Loutherbourg, R.A.*, Kenwood, The Iveagh Bequest, 1973.

10. For watercolours, A. Wilton, *Turner in Wales*, 1984, Nos. 12–14.

11. Gage 1969, pp. 136ff. for a discussion of what these 'secrets' might have been. See also Joppien, *loc. cit.*, No. 62 for a series of Masonic illustrations made by Loutherbourg for the *magus*, Count Cagliostro, about 1787. Farington, 17 August 1810 reports Turner's remarks on his ageing neighbour at Hammersmith.

12. A copy of this brochure is in the British Museum Print Room.

13. For the drawings for Hoppner and Farington w.249, 282, and Farington 24 October 1798. For Lawrence (?w 252), *ibid.* 13 March 1799 and for Smirke (? w 248) *ibid.* 8 July 1799. According to Farington (5 November 1798) Hoppner and himself did vote for Turner in 1798 and the following year Lawrence and Smirke almost certainly did the same, since Turner invited them, together with a number of other supporters, to supper after the election (Farington 4 November 1799).

14. It should however be pointed out that Girtin, never an Academician, had already been drawn by Dance in 1798 (British Museum).

15. Farington 13, 15 May 1803.

16. Farington, 11 May 1804. Finberg, 1961, p. 111 discusses the context of this episode.

17. Farington 11 April 1812.

18. A. Cunningham, *Life of Wilkie*, 1843, III, p. 218. Turner had, however, apparently boycotted the dinner held at the close of the last Somerset House exhibition earlier in

the year (W. T. Whitley, *Art in England 1821–1837*, 1930, p. 319).

19 W. P. Frith, *My Autobiography*, I, 1887, pp. 136ff. Frith states that the speech was made at one of the Academy dinners held at the close of the Exhibition 'for two or three years after I was elected Associate' (i.e. 1845).

20. Letter 136 (1828).

21. Letters 164 (1830), 168 (1831). In 1820 Turner had agreed with Lawrence that George Cumberland's collection of early Italian prints should be acquired by the Academy (Farington, 1, 12 December), but perhaps his period as Auditor from 1824 had changed his attitudes. But see also his and Chantrey's concern about Academy financing from the date of the Cumberland purchase (Farington 13 December 1820, 1 June 1821).

22. TB CCLXV, pp. 1–3. The link with the Lawrence drawings campaign was first noted by C. F. Bell, *Burlington Magazine*, XVI, 1910, pp. 338ff.

23. The fullest account of Turner's relationship with the Artists' General Benevolent Institution is in Gage 1980.

24. Finberg 1961, pp. 329ff. In a codicil of 1849 Turner stipulated that should his pictures not be accepted by the National Gallery, they should be sold, and the proceeds given to a number of charities, including the Royal Academy Pension Fund, and the Artists' General Benevolent Institution (Thornbury 1877, p. 628).

25. The history of these two funds, by a partisan of the Artists' Fund, is given in J. Pye, *Patronage of British Art*, 1845, Chapter VII. For the view of some artists that the Artists' Fund was selfish, and should be replaced by something more wide-ranging, Farington 25 April 1814.

26. Thornbury 1877, p. 622.

27. *ibid.* pp. 623–4.

28. T. F. Hunt, *Designs for Parsonage houses . . .*, 1827, pp. 3–4. For Hunt's training with Soane, W. Jerdan, *Autobiography*, IV, 1853, p. 52.

29. D. B. Brown, *Augustus Wall Callcott*, Tate Gallery, 1981, No. 2. This catalogue has a full discussion of Callcott's relationship with Turner.

30. For Callcott's two pictures, Brown, *op. cit.* Nos. 3, 4. It is ironical that the only visual record of one of Turner's earliest and most Callcott-like marines, *Fishermen becalmed previous to a storm: twilight* of 1799 (BJ 8) should be a thumb-nail sketch made by Callcott at the Exhibition of that year (BJ Fig. 554).

31. Letter 36. The title of one of the pictures offered to Leicester, *Sun Rising through Vapour: Fishermen Cleaning and Selling Fish* (BJ 69), in its emphasis on *genre*, also recalls Callcott's 1806 work.

32. For *Cow Boys*, Brown, *op. cit.*, No. 6. For Chalon, see *Landscape with Cattle and Cowherds*, 1808, in the Westminster Collection (L. Parris, *Landscape in Britain, c. 1750–1850*, Tate Gallery, 1973, No. 239). For Mulready see especially *A Gravel Pit*, c. 1807–8 in K. Heleniak, *William Mulready*, 1980, No. 34.

33. Brown, *op. cit.*, p. 15.

34. It was finished and exhibited in 1819. For the full account of both paintings, on which the above is based, Brown, Nos. 15, 17.

35. For Havell see Spink & Sons, &c, *William Havell 1782–1857*, 1981/2.

36. See, for example, Thomas Sully's MS 'Hints for Pictures', ff.95–6 (1837). Yale University, Beineke Rare Book Library.

37. Farington 16 April 1806.

38. Both *Fort Vimieux* and *Calais Sands* (Fig. 194) derive elements from lot 24 in the Bonington Sale, Sotheby's 29 June 1829: *View at Fort Rouge, Calais*, now in the collection of Rodney T. Gardner. Lindsay Stainton has very appropriately linked the lost *Ducal Palace, Venice* of 1833 (BJ 352), which we know from an engraving, with Bonington's small oils of this type of architectural subject (*Turner's Venice*, 1985, p. 40).

39. Tyne and Wear County Museums, *The Spectacular Career of Clarkson Stanfield, 1793–1867*, 1979, Nos. 126–8.

40. Gage 1969, p. 168. It has been argued that the story is implausible because the painting was listed in the R.A. catalogue and must therefore have been planned by Turner before the Varnishing Days. But we know that catalogues could be printed and reprinted at very short notice. That the picture was, as one observer noticed, hung unusually low, suggests both that it was a late arrival and, of course, at Turner's eye-level. For Stanfield's picture and its background, *Spectacular Career, cit.*, Nos. 174–5. The growing resentment of the Academy and Turner at Stanfield's successes is chronicled in *The Times*, 2 January 1832 and *The Morning Chronicle*, 6 June, 1833, 6 January, 26 May, 1834.

41. E. Adams, *Francis Danby*, 1973, p. 64.

42. W. T. Whitley, *Art in England 1821–1837*, 1930, p. 145.

43. J. Ruskin, *Works*, ed. Cook and Wedderburn, VII, 1905, p. 443n. The episode probably dates from the 1840s: Danby showed sunrises of the type Turner was defending at the Academy in 1845 and 1846, and at the British Institution in 1849.

44. Thornbury 1877, p. 625.

45. Farington 8 January 1811.

46. W. G. Rawlinson, *Turner's Liber Studiorum*, 2nd ed. 1906, pp. xii–xiii.

47. A. J. Finberg, *The History of Turner's Liber Studiorum*, 1924, p. xxxiii.

48. For the background to Turner's perspective lectures, Gage 1969, pp. 106–8.

49. J. Ziff, '"Backgrounds, Introduction of Architecture and Landscape": a Lecture by J. M. W. Turner', *Journal of the Warburg and Courtauld Institutes*, XXVI, 1963, pp. 133–4.

50. See note 46.

51. J. Hayes, *The Landscape Paintings of Thomas Gainsborough*, 1982, p. 131 ('dignified pastoral'). But see also Sawrey Gilpin, c. 1768 in Gage 1969 p. 55.

52. On an early proof of the first Architecture subject to be published, *Basle* (RLS 5), Turner noted a list of other subjects with their categories, including 'Claude EP' (Finberg, *History, cit.*, p. 20).

53. A list of landscape types in TB CXXII, p. 25 (c. 1809/14): 'Epic Compositions/Compositions/Pastoral/Marine/Buildings' could thus be read in *Liber* terms: 'H., E.P., P., M., A.' In a late list of proposed *Liber* subjects, however, *Apullia in Search of Apullus* (BJ 128; RLS 72) is listed among 'E.P' subjects, and this certainly embodied a story (Finberg, *History, cit.*, p. xxxix). A 'Turner' is recorded six times in 1809, 1812 and 1813 as a visitor to The Society for the Study of Epic and Pastoral Design', founded by J. J. Chalon in 1808 (H. Hubbard, 'The Society for the Study of Epic and Pastoral Design', *Old Water-Colour Society's Club*, XXIV, 1946, p. 33), whose title makes the distinction I have suggested Turner wished to preserve. This may be our Turner, but William Turner of Oxford was a founder-member of the Society, and is specifically recorded at its meetings in 1808. For the theory of Pastoral and Epic poetry, H. Blair, *Lectures on Rhetoric and Belles-Lettres*, 4th. ed. 1790, III, Lects. xxxix, xlii; and for Turner's use of this book, TB CVI, pp. 67–8.

54. Gage 1989, p. 296.

55. The 'Tempest' in this list has been interpreted by Finberg (*Inventory* I, p. 410n) as a reference to *The Tenth Plague of Egypt* (RLS 61), but since this is named earlier in the same list, this seems unlikely. It is possibly a reference to the lost *Army of the Medes Destroyed in the Desart by a Whirlwind* (BJ 15).

56. Finberg, *History, cit*, p. lxxxiv. There is a chance that the *Narcissus and Echo* (RLS 90), which exists only as a soft-ground etching by Turner, is even later than this. An impression in Boston bears an inscription by Elizabeth Phillips, the wife of Thomas Phillips, R.A., that it was presented to her at Petworth by Turner. She married in 1814, and the earliest occasion that Turner is known to have been at Petworth after that date is 1827 (Gage 1980,

p. 250). The oil from which this design was taken (BJ 53) was, and is, in the Petworth collection. Finberg's identification of a reference of c. 1818 to 'Egremonts Picture' with this plate (TB CLIII, p. 2a and *Inventory*, I, p. 434n), seems unlikely, since the engraver is given as Say, who did engrave *Apullia* (RLS 72), which was based directly on Egremont's picture of *Jacob and Laban* by Claude.

7. Thomas Phillips recommended Constable 'to study Turner's "Drawing Book" to learn how to make a whole' (Farington 1 November 1819).

8. J. Pye and J. L. Roget, *Notes and Memoranda respecting the Liber Studiorum*, 1879, pp. 96–7.

9. Finberg, *History*, cit. p. lxxxiii.

0. Pye & Roget, *cit.*, p. 97. Turner's gratitude may be gauged from his returning a guinea of the price for the Society's funds.

1. Pye & Roget, *cit.*, p. 71n. It is just possible that this was a consequence of the delapidation of the gallery, which may have prevented access to the old stock of prints.

2. For the problems surrounding the series, BJ pp. 298–9.

3. It is not surprising that *Landscape with Walton Bridges* (BJ 511) and *Inverary Pier* (BJ 519) should long have been thought to be Italian subjects.

4. Farington 8 January 1811. Turner's first lecture was given on the day he remarked on this to John Landseer.

5. Gage 1969, p. 107.

6. J. Knowles, *The Life and Writings of Henry Fuseli*, 1831, II, pp. 221–6.

7. Ziff, *loc. cit.* 1963, p. 133. This lecture is the only one to have been fully published.

8. Ziff, *loc. cit.* 1963, p. 147. For the later dates of this lecture, Gage 1969, p. 249 n. 170. Turner's metaphor may allude to Thomas Pingo's design on the reverse of the Royal Academy Gold Medal, which showed Minerva exhorting a youth to scale a mountain, with the caption, *Haud facilem esse viam voluit* (he does not crave the easy path) (London, Royal Academy, *Treasures of the Royal Academy*, 1963, No. 159).

9. For the poor delivery of Reynolds, above, p. 97. For Soane, Farington 12 March 1813.

0. W. T. Whitley, 'Turner as a Lecturer', *Burlington Magazine*, XXII, 1913, p. 255. For an extreme example of Turner's confusions, see the diagrams TB CXCV, 33, 34, which show triangles within circles, but are clearly labelled as the opposite.

1. T. Miller, *Turner and Girtin's Picturesque Views Sixty Years Since*, 1854, pp. xlii–xliii.

2. R. & S. Redgrave, *op. cit.* 1947, pp. 257f.

3. *British Press*, 5 January 1819. This critic noted the good attendance at this lecture.

4. Turner served for seven years as Visitor to the Life Academy and six as Visitor to the Painting School between 1830 and 1839. I have argued the didactic role of Varnishing Day activities in *Colour in Turner*, pp. 165ff. It is perhaps no coincidence that Turner owned a utopian vision of the 1820s which stressed the importance of teaching without words, and claimed that this was the Greek method (J. M. Morgan, *The Revolt of the Bees*, 1826, pp. 65, 86).

5. Finberg 1961, p. 339.

6. 15 July 1836, 2042, *cit.* M. A. Shee, *The Life of Sir Martin Archer Shee*, 1860, II, pp. 74ff, 370. For the whole affair, W. Sandby, *History of the Royal Academy of Arts*, 1862, II, pp. 78ff; Q. Bell, 'Haydon *versus* Shee', *Journal of the Warburg and Courtauld Institutes*, XXII, 1959, pp. 347; Q. Bell, *The Schools of Design*, 1963, Chapters III, IV.

7. Farington, 8 May 1807. Turner's *Unpaid Bill* of 1808 (Fig. 170) continued the theme of extravagance.

8. TB CXX-C. I have followed the dating proposed by A. Marks, 'Rivalry at the Royal Academy: Wilkie, Turner and Bird', *Studies in Romanticism*, XX, 1981, p. 357, which is the best discussion of the whole topic.

9. Thornbury 1877, p. 272ff. Thornbury refers this incident to the first year of Bird's acceptance at the Academy, but this had been in 1809, when Turner was

not among the hangmen. For the painting, Sarah Richardson, *Edward Bird 1772–1819*, Wolverhampton/London, 1982, No. 73.

80. TB CXI, p. 65a. That this poem dates from 1810 is suggested by the report that the Prince Regent asked Wilkie to paint a companion to Bird's *Choristers* in July of that year (Farington 16 July 1810). Turner was not alone in his opinion: William Owen had already 'sd that Wilkie imitated the Flemish Masters & . . . ought to attempt something more' (Farington 8 April 1807).

81. For Cristall's drawing, B. Taylor, *Joshua Cristall 1768–1847*, 1975, No. 1.; and for Cristall's contact with Turner at the Wells' cottage at Knockholt soon after 1800, J. M. Wheeler, *The Family and Friends of W. F. Wells*, 1970, p. 11. Turner also painted a watercolour of this subject for Walter Fawkes (w.503, A. J. Finberg, *Turner Watercolours at Farnley Hall*, 1912, pl. xxviii). It is signed and dated, but the style supports Wilton's reading of 1810 rather than Finberg's of 1818. See also *St Mawes at the Pilchard Season* of 1812 (BJ 123).

82. W. T. Whitley, *Thomas Heaphy*, 1933, p. 16, and for Heaphy's generally high prices, *ibid.*, pp. 14ff and Bayard, *op. cit.*, pp. 6, 8, 10.

83. Farington 23 August 1810. For West's admiration of Heaphy, see also Whitley, *op. cit.*, p. 16.

84. Turner had also shown a drawing of his with cattle by Gilpin at the Academy in 1799 (w.251).

85. The fullest study of Stothard's use of Watteau is S. Whittingham, 'What you will; or some notes regarding the influence of Watteau on Turner and other British artists, I', *Turner Studies*, V, i, 1985, pp. 7ff.

86. The prominent display of classical statuary in the painting suggests this, and Chantrey did in fact acquire it immediately.

87. [Mrs Bray] 'Reminiscences of Stothard', *Blackwoods Edinburgh Magazine* 39, 1836, p. 683, refers to seeing 'these most beautiful pictures [*Sans Souci* and the *Decameron* subjects], copied by Stothard from his original designs' at Rogers' house. A version of *Sans Souci* was also painted for Robert Balmanno, who had it engraved in *The Bijou* in 1828 (A. C. Coxhead, *Thomas Stothard R.A.* 1906, p. 56). Ziff has also conjectured that Turner's entirely invented subject derives from a random conjunction of references in Rogers' *Italy* (see text to BJ 244).

88. C. R. Leslie, *Autobiographical Recollections*, 1860, I, p. 130. Stothard did admire at least the earlier works of Turner, which 'he said wanted only the mellowing effects of time to be equal to Claude' (Bray, 1836, p. 678, where she mentions a work of 1811 which may be *Mercury and Hersé* (BJ 114)).

89. Sotheby's 4 May 1830, 5th day's sale, lot 553, 8th day's sale, lot 895. The *Romeo and Juliet*, for which Turner payed £4. 10s, was said to have been painted for Heath's *Shakespeare* (1803) but not engraved (marked catalogue in Victoria and Albert Museum Library). Rogers also bought many Stothards at this sale.

90. Shee, *op. cit.*, II, pp. 203–13.

91. Finberg 1961, p. 369.

92. His evidence is reprinted by Shee, *op. cit.*, II, pp. 313–27.

93. Shee, *op. cit.*, II, p. 221.

94. W. P. Frith, *My Autobiography*, 1887, I, p. 333. The fullest account of the background to these paintings is J. McCoubrey, 'War and Peace in 1842; Turner, Haydon and Wilkie', *Turner Studies*, IV, ii, 1984, pp. 2–8.

95. H. W. Pickersgill to Haydon, 12 May 1845 (Haydon, *Diary*, ed. Pope, V, 1963, p. 439).

96. Shee, *op. cit.*, II, pp. 250–8.

97. Michelangelo Buonarotti, *Rime*, 1817. See Royal Academy 1974–5, No. B 112.

98. Letter 282 and TB CCCLVII. Letter 291 may be related to this excursion.

99. Letters 301, 302.

100. W. Etty to J. Gillott, 7 September 1846 (D. Farr, *W. Etty*, 1958, p. 101).

101. A. MacGeorge, *W. L. Leitch*, 1884, pp. 82ff; and in general, Gage 1969, pp. 170ff.

102. J. W. Archer, 'Reminiscences', *Once a Week*, 1 February 1862, p. 166, reprinted in *Turner Studies*, I, i, 1981, p. 36.

103. W. Holman Hunt, *Pre-Raphaelitism and the Pre-Raphaelite Brotherhood*, 1911, II, p. 273n. Hunt states that the walls of Turner's cottage 'were just covered with his sketches'.

104. Gage 1969, p. 171.

105. For Maclise, Jones in Gage 1980, p. 8; for Herbert, diary of C. H. Lear, 3 May 1847, cited R. J. B. Walker, 'The Portraits of J. M. W. Turner: A Checklist', *Turner Studies*, III, i, 1983, pp. 29ff. Both paintings are reproduced by W. Vaughan, *German Romanticism and English Art*, 1979, Figs. 146, 154.

106. Archer, *loc. cit.* Here Mrs Booth referred to only three pictures, but in her similar account to John Pye (Armstrong, 1902, p. 182) she correctly mentioned four (BJ 429–432).

Notes to Chapter Six

1. In a long poem, most of it illegible, scribbled on the flyleaves of *The Artist's Assistant in the Study and Practice of Mechanical Sciences* (n.d.) in his library, Turner characterised patronage as 'accursed', and claimed that 'the sweet fore-finger of the man of taste' was usually withdrawn, to reveal his aggressive knuckle. Nevertheless in a public lecture given in his Perspective course between 1811 and 1816, he did concede that 'the rising ray of patronage is ever ready to discern the deserving and reward the assiduous' (Ziff, 1963, p. 147).

2. B. Venning, 'Turner's annotated books – III', *Turner Studies*, III, i, 1983, pp. 34ff.

3. The fullest available account of the Monro family is by F. J. G. Jefferis in Victoria and Albert Museum, *Dr Thomas Monro and the Monro Academy*, 1976.

4. It is conceivable that Fig. 231 was the soft-ground etching shown by Henderson to Farington on 30 June 1794 as after a sketch by Hearne. The use of Henderson's outlines in the Monro School has been discussed by E. Croft-Murray, 'Pencil outlines of Shipping at Dover of the "Monro School"', *British Museum Quarterly*, X, 1935–6, pp. 40–52. See also A. Wilton, 'The "Monro School" Question: Some Answers', *Turner Studies* IV, ii, 1984, pp. 8–23.

5. Turner is mentioned as visiting the Monros as late as 1811 in E. T. Monro's diary, shown at the 1976 exhibition (see note 3); it has however recently been argued that these references are probably to William Turner of Oxford, who was among the young artists close to the Monros in the 1810s (C. Titterington, *William Turner of Oxford*, Woodstock, London, Bolton 1984–5, p. 16). This seems likely for the note of April 1806: 'Linnel, Hunt and Turner to draw'; but the Mr Turner who called with the Earl of Essex in November 1809 is far more likely to be our artist. It should be noted that the group of sketchbook pages with chalk studies in the Ashmolean Museum, coming from the Monro Collection and attributed by Ruskin to Turner (Herrmann 11–22) may now be confidently ascribed to William Turner of Oxford on the basis of No. 7 (in the Victoria and Albert Museum) in this exhibition.

6. Farington 27 May 1799.

7. D. Hill, '"A Taste for the Arts": Turner and the Patronage of Edward Lascelles of Harewood House', *Turner Studies*, IV, ii, 1984; V, i, 1985. Hill discusses the possible connection between Edward Lascelles junior and the Monro Circle, and his certain friendship with the Earl of Essex, who was close to Dr Monro after the latter's move to Bushey, near the Essex seat of Cassiobury Park, in 1805.

8. Farington 28 November 1798 (5s); 22 October 1799 (5s–7s6d). Lovell Reeve in his obituary raised these figures to 10s and 1 guinea (*Literary Gazette*, 27 December 1851,

p. 924). A list compiled about 1799 lists seven pupils, five of them male, but without a note of fees (TB XXV, p. 1).

9. For Turner's tuition of Julia Bennett, Gage 1969, p. 264, note 132; and for her later practice, R. V. Turley, 'Julia Gordon, Lithographer', *Wight Life*, August/September 1974, pp. 41ff. See also R. J. Hutchings & R. V. Turley, *Young Algernon Swinburne*, 1978, pp. 21ff and BJ 269, 270.

10. Turner seems to have been on the best terms with Edward Swinburne junior, although there is still some confusion because his uncle, a well-known watercolour painter, was also called Edward. The family owned a major oil and five large Turner watercolours by 1820 (D. Hill, 'A newly-discovered Letter by Turner', *Turner Society News*, 23, 1981/2, pp. 2–3).

11. For Pilkington as an artist, Farington, 11–13 June 1804; *Gentleman's Magazine*, NS.XXXIV, 1850, pp. 546–7. The fullest accounts of Turner and Fawkes are now *Turner in Yorkshire*, York, 1980, and D. Hill, *In Turner's Footsteps*, 1984, pp. 17–22.

12. Memoir by Edith Mary Fawkes now in the National Gallery in London. Royal Academy, 1974–5, No. 194. See also above, p. 84.

13. W. Jerdan, *An Autobiography*, II, 1852, p. 260.

14. Farington 18 December 1798. Among the scientific equipment Egremont acquired for her that year was the aid to landscape-sketching, a Claude glass (A. McCann, 'A Private Laboratory at Petworth House, Sussex, in the late eighteenth century', *Annals of Science*, 40, 1983, p. 642).

15. See Farington 22 June 1801 and P. Youngblood '"That House of Art": Turner at Petworth', *Turner Studies*, II, ii, 1983, pp. 18f.

16. See text to BJ 333 and Youngblood, *op. cit.* p. 32 for the 1835 catalogue of works in the Old Library. The *Woman with a Rosebud*, (No. 529 in this list) is now attributed to Koninck. At least one of the paintings listed in the Old Library in 1835, Allston's *Jacob Dream*, was already there when Turner made his sketches of the room (Fig. 243).

17. C. R. Leslie, *A Handbook for Young Painters*, 1855, pp. 177–8; and Youngblood, *op. cit.* (note 15), who shows that Leslie also made much use of the furnishings at Petworth in his paintings. Egremont owned several works attributed to Watteau. See also Whittingham, 'What you Will', *cit.*

18. G. P. Boyce, *Diaries*, ed. Surtees, 1980, p. 17.

19. B. R. Haydon, *Diary*, ed. Pope, IV, 1963, p. 449. The fullest account of Egremont's death and funeral is in Youngblood, *op. cit.* pp. 30–32. BJ 445 and 449 have not usually been associated and the titles and interpretations are given here for the first time. The canvasses are the same size and the compositions are similar although the colour, of course, is not. In the late 1830s Turner began to exhibit pair of contrasted canvasses with light and dark and warm and cool tonalities, the first of which was *Ancient and Modern Italy* (1838; BJ 374–5).

20. Letters 214, 228 (untraced). The latter appeared at Christie's, 22 October 1980, lot 215, and was quoted extensively in the catalogue, but withdrawn before the sale. See also Gage 1980, p. 269 for Maw.

21. *Gentleman's Magazine*, NS XVIII, 1865, p. 118. Munro's own details have not been traced, but a correspondent of the *Art Union* saw at his London house 'elegant crayon drawings and oil pictures, chiefly of female heads' by him (*Art Union*, IX, 1847, p. 255).

22. Gage 1980 pp. 272–3; Finberg 1961, pp. 359ff. W. E. Frost & H. Reeve, *A Complete Catalogue of the Paintings, Water-Colours Drawings and Prints in the Collection of the late H. A. J. Munro*, 1865, Nos. 51–3, 61–2, were sketches alleged to have been done by Turner in Munro's company on the return from Italy in 1836, three of them on the Rhine; but Munro stated that they separated at Turin.

23. For the Titian *Venus*, G. Waagen, *Treasures of Art in great Britain*, II, 1854, p. 131. It was not mentioned in an earlier account of Munro's collection (*Art Union*, IX, 1847, pp. 253–5), but this was a very partial survey.

24. Turner's early biographers John Burnet and Peter Cunningham attributed the stimulus directly to one of Munro's pictures, but this has rightly been questioned by Joll (see BJ 237, 408).

25. H. A. J. Munro to J. Ruskin, 14 October 1857 (Bembridge, Ruskin MSS 54/C).

26. See the text to BJ 374 for the somewhat divergent stories of this transaction. The fullest account of Daniell's life is now J. Thistlethwaite, *The Etchings of E. T. Daniell*, 1974.

27. A. W. Callcott, *Dictionary of Anecdotes*, Oxford, Ashmolean Museum MS AWC IIb, f. 348r.

28. See TB XII F and w 66; also A. Wilton, *Turner in Wales*, 1984, Nos. 3, 17.

29. See especially TB XXXVIII, p. 52, and the drawing now in the Whitworth Gallery (w 271), which must date from about 1802; also Letter 8.

30. TB XXV, p. 1 and BJ 3; cf. TB XXXVIII, p. 50a and BJ 141.

31. Farington 8 June 1811.

32. Letter 6. The notes in TB LXXXIV, p. 66a show that Turner's price was 100 guineas for Dobree's *Bonneville*.

33. W. T. Whitley, *Artists and their Friends in England*, 1928, II, pp. 219–20.

34. Farington 24 October 1798. The first lists seem to be TB XL, flyleaf and XLVI cover, certificates dated from May 1798–June 1799. The early account by S. F. Rigaud according to which Turner already had money in the Funds by the time he was 21 (i.e. 1796) is not confirmed by the sketchbooks (Finberg 1961 p. 46).

35. See especially the documents enclosed in the Finance Sketchbook (TB CXXII) and BJ 104, 108, 111–113.

36. The first indications of this are in TB CII, p. 1; TB CXXII, p. 8a.

37. Falk 1938, p. 228, and Thornbury 1877, pp. 339ff for the Twickenham sale.

38. Gage 1980 p. 258, on which most of the following depends.

39. H. Smith, *Peter de Wint*, 1982, pp. 81, 190ff.

40. Griffith to J. C. D. Coleridge, quoted in *The Times*, 27 December 1951. See text to BJ 131 for earlier efforts to buy the picture, which shows that Turner had never priced it as low as £250, but originally asked £500, standard for this size.

41. For Ruskin's account, Royal Academy 1974–5, pp. 161–3, and Wilton 1979, pp. 231–45 and Nos. 1523–1552.

42. Letter 264.

43. E. W. Cooke recorded the sale of five Turner drawings brought to Windus by his father, W. B. Cooke, on 11 August 1832 (*Diary*, Cooke Family Papers).

44. B. Webber, *James Orrock R.I.*, 1903, I, p. 60. For the watercolour collection in general, E. Shanes in *Turner Studies*, III, 11, 1983, pp. 55–8 and G. Waagen, *Treasures of Art in Great Britain*, II, 1854, p. 339.

45. An oil which may have been in Windus' collection, but whose history is unclear is BJ 352.

46. Sir J. Reynolds, *Seven Discourses delivered at the Royal Academy by the President*, 1778, Dedication.

47. Farington 16 July 1810.

48. For these two pictures, O. Millar, *Later Georgian Pictures in the Collection of Her Majesty the Queen*, 1969, p. 12; and for Bird, S. Richardson, *Edward Bird, 1772–1819*, Wolverhampton/London, 1982, and pp. 145–6 above.

49. TB CXI, p. 68a. For Turner's own thanks to Taylor, which may refer to this review, Letter 40.

50. W. T. Whitley, I, pp. 187ff and Farington 8 June 1811.

51. See the three works acquired as Watteau for the Prince in London, The Queen's Gallery, *George IV and the Arts of France*, 1966, Nos. 52–55. Two of them were lent to the British Institution in 1818. See Whittingham 'What You Will', *cit. Turner Studies*, VI, 1985, pp. 9ff.

52. Farington to Sir George Beaumont, 1819 (D. Sutton in *Notes & Queries*, 15th ser. 175, 1938, p. 166).

53. For the project and the occasion, G. Finley, *Turner and George IV in Edinburgh, 1822*, 1981.

54. Letter 101.

55. Thomas Phillips to Dawson Turner, 13 December 1822: '. . . the King has determined to have four large Military pictures in the new grand room at St James. He has brought Loutherbourg's very fine work of the 1st of June, commissioned Turner to paint a companion to it of the battle of Trafalgar, & [George] Jones a battle of Waterloo; & intends to give the Battle of Vittoria to some other painter or to him. This is the way to produce a school of art in the country, which no Gallery will ever do.' (Cambridge, Trinity College, Dawson Turner Letters; the final reference is to the proposal to establish a collection of Old Masters at the British Museum.).

56. For Stanfield and the King, Tyne & Wear County Council, *The Spectacular Career of Clarkson Stanfield, 1793–1867*, 1979, Nos. 169–171.

57. See Gage 1980 pp. 8f.

58. For Maclise's *Undine*, Arts Council of Great Britain, *Daniel Maclise, 1806–1870*, 1972, No. 80.

59. W. Vaughan, *German Romanticism and English Art*, 1979, pp. 12–15, has shown that Albert was not in fact much attracted to the severer forms of contemporary German art. Vaughan also (p. 103) notes the royal relevance of the large unexhibited oil *Heidelberg* (BJ 440), which shows the palace of Queen Victoria's ancestor Elizabeth, the sister of Charles I; and (p. 112) the oblique reference to a poem by Schiller in the caption to *The Hero of a Hundred Fights* (BJ 427) in 1847.

Notes to Chapter Seven

1. J. Burnet, *Art Journal*, 1852, p. 47.

2. The notes juxtapose two widely separated passages from Robert Blair, *The Grave* (1743), 11.465–6 and 77–8, with variations which suggest that Turner was quoting from memory.

3. W. M. Rossetti, 'Turner's Life and Genius', *Fine Art*, 1867, p. 309. Rossetti's transcriptions of Turner's *Southern Coast* poem were used very indiscriminately by Thornbury (1877, pp. 205–17). C. B. Tinker, *Painter and Poet*, 1938, pp. 148–9.

4. This is an approach which has largely been followed by the only other general treatment of Turner and poetry, A. Wilton, *Turner and the Sublime*, 1980. One of the very few early attempts to assess Turner's use of poetry in developing his painted imagery is C. Monkhouse, 'Ovid, Turner and Golding', *Art Journal*, (NS 32), 1880, pp. 329ff.

5. Westall's painting is loosely related to his poem 'On the Approach of Winter' in *A Day in Spring and other Poems*, 1808, which had been in preparation since the mid-1790s (Farington 23 February 1796). The connection between Turner and *Solitude*, was first made by David Hill, *Turner in Yorkshire*, York, 1980, No. 40. For Westall's career, R. J. Westall, 'The Westall Brothers', *Turner Studies*, IV, i, 1984, pp. 23ff. Eastlakes early poem, 'Effusions on a Summer's Evening', was published in *The Monthly Magazine*, July 1809, pp. 585–6. For Gisborne, see note 8.

6. Farington 8 July 1803.

7. See B. Venning, 'Turner's Annotated Books: Opie's 'Lectures on Painting' and Shee's 'Elements of Art', *Turner Studies*, II, ii, 1982, pp. 40ff; III, i, 1983, pp. 33ff.

8. For Gisborne's career, B. Nicolson, 'Thomas Gisborne and Wright of Derby', *Burlington Magazine*, CVII, 1965, pp. 58ff.

9. J. Lindsay, *J. M. W. Turner: A Critical Biography*, 1966, p. 36. They are *The Sailor's Journal*, from *Will of the Wisp* (1795), published in *The Professional Life of Mr Dibdin*, 1803, III, pp. 335–7, and *The Token*, from *Castles in the Air* (1792/3), *ib.* pp. 234–5.

10. Lindsay (*Turner*, *cit.* p. 223 no. 18) doubts Turner's authorship of this poem, although, ironically, he does attribute the passage from Addison's Ovid to the painter (*Sunset Ship*, p. 78). The trials of the first two lines, the awkward rhythm in the penultimate line of this stanza and the change of mind in the second line of the next, all seem entirely characteristic of the painter.

1. See A. L. Livermore, 'Turner and Music', *Music and Letters*, XXXVIII, 1957, reprinted in *Turner Studies*, III, i, 1983, p. 45.

2. The fullest account of the Danby connection is in Falk 1938, Chapter II. By 1801 Turner was sharing an apartment in Norton Street, Portland Road, with the publisher of John Danby's *Posthumous Glees* (1798), Roch Jaubert (Lindsay, *Turner*, cit. pp. 74–5). He may have been introduced to Sarah Danby through his early patrons Dr Monro, Tomkinson, or Lady Harewood, who appear among the subscribers to this collection, although, *pace* Falk, Turner does not.

3. *Danby's Third Book of Catches, Canons and Glees*, n.d. The *Ode to Hope*, among the *Posthumous Glees* (pp. 73–87) opens a theme dear to Turner, with its concluding image, 'O'er life's rough sea amid the Tempest's roar/Pilot my rolling bark and set me safe on shore'.

4. The date of acquisition may be deduced from the date of *c*. 1802 for the last of the series, which had begun in 1795. Volume 14, which was entirely composed of translations, and which was not in Turner's set, was not published until 1807.

5. Text to BJ 57.

6. Corrected and punctuated from the version in the text to BJ 86. The lack of euphony in lines 3 and 4 ('worth . . . verse', 'near . . . ensnare') are almost the only signs that we are not reading a very polished performer indeed, and Turner continued to work at this poem for several years after it was published.

7. Letter 38 (1811). The 'other things' may well be the genre paintings of Scott's compatriot, Wilkie.

8. B. Lamy, *Perspective made Easie*, 1710, p. 17. For the long tradition of this debate, E. H. Gombrich, 'Moment and Movement in Art' (1964), reprinted in *The Image and the Eye*, 1982, pp. 40–62.

9. Sir J. Reynolds, *Discourses*, ed. Wark, 1975, pp. 145–6.

10. For superior descriptiveness, M. A. Shee, *Rhymes on Art*, 2nd ed. 1805, pp. 104ff.; *The Artist*, IX, May 9 1807, pp. 3–4; *The Artist's Repository*, III, *Landscape*, 1808, pp. 81–2; J. Northcote, 'On the Indepencence of Painting on Poetry', *Memoirs of Sir Joshua Reynolds*, 1813, p. cxlvii, cl; 'On the Imitation of the Stage in painting', *ibid*. p. clx. For the 'pregnant moment', H. Fuseli, Lecture II: Invention, in *Lectures of the Royal Academicians*, ed. Wornum, 1848, pp. 407–8; J. Opie, Lecture I: Invention, *Lectures on Art*, 1809, p. 72.

11. B. Venning 'Turner's Annotated Books', cit. *Turner Studies*, II i, 1982, p. 39.

12. J. Ziff, 'J. M. W. Turner on Poetry and Painting', *Studies in Romanticism*, III, 1964, pp. 199ff.

13. J. Ziff, 'Turner's first poetic quotations: an examination of intentions', *Turner Studies*, II, 1982, pp. 2.

14. See Tel Aviv University, *The Seasons: Illustrations to James Thomson's Poem, 1730–1830*, 1982/3 (catalogue by M. Omer).

15. The 'fine effect of the smoke' in this scene was also noted by Farington and West at Greenwich the following year (Farington 30 June 1810).

16. Sir R. A. Blackmore, *A Paraphrase on the Book of Job*, 2nd. ed. 1716, pp. 65ff. This is a long-winded version of *Job* XIV, 18–19.

17. Cf. M. H. Vida, *Art of Poetry*, trans. Pitt, 1742, Bk II, p. 31: 'This is a rule the noblest bards esteem,/ To touch at first in gen'ral but the subject in a line;/ To hint at all the subject in a line;/ And draw in miniature the whole design./ Nor in themselves confide, but next implore/ The timely aid of some celestial pow'r;/ To guide your labours and point out your road . . .' 'Vida's Art of Poetry' is among the books on Turner's drawing.

28. Letter 43 (1811).

29. Lindsay, *Sunset Ship*, cit. p. 117.

30. J. C. Eustace, *A Tour of Italy*, 1813, I, pp. 519f. For the controversies over Virgil's tomb, J. B. Trapp, 'The Grave of Virgil', *Journal of the Warburg and Courtauld Institutes*, XLVII, 1984, pp. 1–32.

31. Line 9 of the passage from the *Southern Coast* poem on p. 196 relates to the opening line of the *Hannibal* caption on p. 192. Some drafts of verses in TB CCCXXIV, p. 26a, which Finberg (*Inventory*, II, p. 1040) associated with the caption to *War* (Fig. 228) seem very remotely connected.

32. *The Roman History Written in Latine by Titus Livius*, 1686, p. 360. This translation was in Turner's library.

33. See the text to BJ 126.

34. L. R. Matteson, 'The Poetics and Politics of Alpine Passage: Turner's *Snowstorm: Hannibal and his Army crossing the Alps*', *Art Bulletin*, LXII, 1980, pp. 389ff., has rightly suggested that one of the more important stimuli to Turner's conception was Gisborne's *Walks in a Forest: Winter: Frost*, where, at the summit of the pass, Hannibal, 'gazed again on Italy: while Hope/ Bade him with glance prophetic mark the stream/ Of Trebia choked with dead . . .'

35. Aphorism 239 in J. Knowles, *Life and Writings of H. Fuseli*, III, 1832, p. 149. As Ziff notes ('Turner on Poetry and Painting', cit. p. 196), Opie took the same view in a passage of his lectures (p. 62), which Turner made the occasion for the comment I have quoted on p. 187.

36. For the many contributory sources to the imagery of this picture, Royal Academy 1974–5, Nos. B 107–9.

37. J. Ziff, 'Turner on Poetry and Painting', cit. p. 203.

38. TB CXXIII, p. 156a. This section may refer to the view of Bridgewater, Somerset on p. 157, which was not executed, but it is close in spirit to *Minehead*, which had been sketched on p. 162a (Shanes 35 and Fig. 271).

39. Lindsay, *Sunset Ship*, cit. from TB CXXIII, p. 77a.

40. The sketch for this drawing is, however, in TB CXXV, not in the sketchbook with the poem (see Shanes 27).

41. Thornbury 1877, p. 446; T. J. Dibdin, *Melodrame Mad! or the Seige of Troy, a new Comic, Pathetic, Historic, Anachronasmatic, Ethic, Epic Melange* (1819), p. 38. Charles Dibdin's version had been published in *The Professional Life of Mr Dibdin*, 1803, III, p. 246.

42. Gage 1969, pp. 128–32. The topography of the area around the Bay of Baia south of Naples may have been suggested to Turner as appropriate to this subject by his reading of Henry Sass, *Journey to Rome and Naples 1818*, pp. 215–20. The characterisation of Polyphemus and his volcanic mountain seems to depend heavily on Dryden's translation of Virgil's *Aeneid*, Bk III, 745ff. See also p. 219.

43. C. Powell, '"Infuriate in the Wreck of Hope"': Turner's Vision of Medea', *Turner Studies*, II, i, 1982, pp. 12–18.

44. See the text to BJ 424 and especially J. Lindsay, *Turner, the Man and his Art*, 1985, pp. 153f.

45. *Punch*, VI, 1844, p. 200. The 'unpublished poem' is an allusion to 'The Fallacies of Hope'.

46. *Gentleman's Magazine*, November 1834, p. 478, cited by K. Solender, *Dreadful Fire! Burning of the Houses of Parliament*, Cleveland Museum of Art, 1984, p. 33. For the theatrical presentation of conflagrations reflected in water, S. Rosenfeld, *Georgian Scene Painters and Scene Painting*, 1981, pp. 118–9.

47. See, for example Thomas Grieve and George Gordon, 'A Wood near Athens, Moonlight', for Charles Kean's production of Shakespeare's *Midsummer Night's Dream* in 1856 (Victoria and Albert Museum; W. M. Merchant, *Shakespeare and the Artist*, 1959, pp. 108 and pl. 42a); also W. Telbin, 'Art in the Theatre, I: Scenery', *Magazine of Art*, 12, 1889, pp. 95–6.

48. J. Burnet, *Practical Essays on Various Branches of the Fine Arts*, 1848, pp. 130–2. Rosenfeld, *op. cit.* pls 71–2 reproduces two designs by Stanfield which are particularly close to Turner.

49. C. L. Eastlake, *Contributions to the Literature of the Fine Arts*, 2nd ser. 1870, p. 342.

50. W 1052–7. For an overview of Turner's illustrations, M. Omer, *Turner and the Poets*, GLC, 1975.

51. W 1211–1216, 1218.

52. Turner's early interest in steel engraving may be deduced from his ownership of T. C. Hansard &c, *Report on the Mode of Preventing the Forgery of Banknotes*, 1819. For the crucial role of banknote engraving in the development of the new technique, B. Hunnisett, *Steel Engraved Book Illustration in England*, 1980, pp. 21–3.

53. See C. Powell, 'Turner's vignettes and the making of Rogers' "Italy"', *Turner Studies* III, i, 1983, pp. 2–13. Turner's reference to Rogers and his sister as 'old friends' in 1827 (Gage 1980, p. 278), and their ownership of early paintings by the artist (BJ 539, 540) suggests that they may have been acquainted far earlier than has hitherto been suspected.

54. Hunnisett, *op. cit.* pls 8, 59.

55. G. Finley, *Landscapes of Memory: Turner as an Illustrator to Scott*, 1980, p. 72.

56. Farington 3 October 1802, cf. TB LXXIV, pp. 4, 61. Rogers' poem refers to Napoleon who 'wrapt in his cloak . . . reined in his horse'.

57. *The Historic Gallery of Portraits and Paintings . . .* I, 1807, n.p.

58. R. 356; see Omer, *op. cit.*, figs 1–3.

59. M. Reichard, *Itinerary of Italy*, 1819, p. 22.

60. See text to BJ 342.

61. Turner's friend George Jones had used each of these lines to caption a picture at the Academy in 1839 (597, 634).

62. See the bibliography for BJ 424–5 for this most studied of pairs; and, most recently, M. Omer, *Turner: Landscapes of the Bible and the Holy Land*, 1985, p. 174. The most lucid account is in Lindsay, 1985, p. 154.

63. W 1426: 'Wreck on the Goodwins/ And Dolphins [?] play around the wreck/ the man's [?] hope holding all that hoped/ Admits the work [? mark] of the almight's hand fallacy [? falling] Hope/ for sail'. Other sheets in the series are the *Lost to all Hope* at Yale (W 1425), and an *Iceberg* from the Taylor collection, but now untraced, which bore the inscription: 'Against all Hope – No one has lived to tell the tail. No vestige found, nor deck – no spar or mast –' (Not in Wilton; A. J. Finberg, *Early English Watercolour Drawings*, 1919, p. 21).

64. British Library, Add MS 46151, BB f.22v.

Notes to Chapter Eight

1. G. F. Palgrave, *Francis Turner Palgrave: His Journals and Memoirs of his Life*, 1899, p. 111. Palgrave had formed this view of Turner on meeting him in 1851 (Finberg 1961, p. 434).

2. Gage 1969, p. 209.

3. R. Jessup, *Man of Many Talents: An Informal Biography of James Douglas*, 1975, pp. 24–5, 80. For his picture-dealing and collecting, *ibid.* pp. 61ff., 190ff., 201 and Farington 24 February 1796.

4. TB XLV p. 1. See Burnley Borough Council, *Turner and Dr Whitaker*, 1982, No. 14/15. See also *The Seals of Whalley Abbey* (W 285).

5. For Turner's relationship with Colt Hoare, J. Gage, 'Turner and Stourhead: the making of a Classicist?', *Art Quarterly*, XXXVI, 1974, pp. 59ff. A possible link between Hoare and Turner in the Little Liber is R805: *Catania, Sicily in a Storm*, for Turner had not visited the island, but Hoare had (see his *Classical Tour in Italy and Sicily*, 1819, pp. 426ff). For notes by Turner from an unidentified book linking the earliest Christian church in Britain with Roman architecture, TB CV, pp. 80–81a.

6. *An Account of the Remains of the Worship of Priapus*, 1786, pp. 113f. Colt Hoare did not mention this treatment in his own discussion of Stonehenge in *The Ancient History of Wiltshire*, I, 1812, pp. 156ff., although he did quote the Greek account and note that it had been thus interpreted by T. Maurice, *Indian Antiquities*, VI, 1801, pp. 75ff. and E. Davies, *Celtic Researches*, 1804, pp. 188ff. For an early watercolour of Stonehenge by Turner, W. Rawlinson & A. J. Finberg, *The Watercolours of J. M. W. Turner*, 1909, pl. VII (not in Wilton) and for Turner's knowledge of Knight's *Worship of Priapus*, W. Chubb, cit. note 9, p. 35.

7. For an account of his approach, P. Funnell, 'The

Symbolic Language of Antiquity' in M. Clarke and N. Penny (eds.), *The Arrogant Connoisseur: Richard Payne Knight*, 1982, pp. 50ff.

8. See J. Gage, 'Turner and the Picturesque – II', *Burlington Magazine*, CVII 1965, pp. 76, 79.

9. W. Chubb, 'Minerva Medica and the Tall Tree', *Turner Studies* I, ii, 1981, p. 35 identifies a note by Turner in TB CXXII, p. 41 as from Jones' 'On the Gods of Greece, Italy and India', *Asiatick Researches*, II, 1790.

10. J. Ruskin, *Works*, ed. Cook & Wedderburn, XXXVI, p. 543 (1867).

11. R. P. Knight, *An Inquiry into the Symbolic Language of Ancient Art and Mythology*, 1818, pp. 99f., expanding on *Worship of Priapus, cit.* p. 131. Knight's *Symbolical Language* was originally intended to serve as a preface to volume II of *Specimens of Ancient Sculpture* (1835), a work Knight began about 1799.

12. R. P. Knight, *Symbolical Language, cit.* pp. 146ff. Knight had illustrated Greek coins with this motif in *Worship of Priapus*, PI.XVI, Figs. 5, 6.

13. H. G. Knight, *Phrosyne: A Grecian Tale* (1813), 1817, Canto I, 184–95. For the relationship between Turner and Gally Knight, J. Gage, 'Turner and the Greek Spirit', *Turner Studies*, I, ii, 1981, pp. 14ff.

14. F. S. N. Douglas, *An Essay on Certain Points of Resemblance between the Ancient and Modern Greeks*, 3rd ed. 1813, pp. 118ff.

15. J. J. Blunt, *Vestiges of Ancient Manners discoverable in Modern Italy and Sicily*, 1823. For Turner's use of this text, J. Gage, art.*cit.* in note 5, p. 77.

16. Farington 17 July 1813, 10 June 1814.

17. G. Penn, *A Christian's Survey of all the Primary Events and Periods of the World, from the commencement of History to the Conclusion of Prophecy*, 2nd ed. 1812, Introduction.

18. *ibid.* pp. 92–5; 134–43.

19. Lord Carysfort, *Dramatic and Narrative Poems*, 1810, I, p. 104. It seems possible that Turner's thoughts were turned to Carysfort again by the exhibition of the *Deluge* at the R.A. in 1813.

20. TB CXIII, p. 90a; Thornbury 1877, p. 213.

21. Carysfort, *op. cit.* p. 216 and cf. p. 237 on the Carthaginian hostages taken by Rome whom Turner mentions in the title to his painting, Fig. 290. See also O. Goldsmith, *Roman History*, I, pp. 305ff.

22. J. Lindsay, *Turner: A Critical Biography*, 1966, pp. 138ff.

23. *Turner in Yorkshire*, 1980, Nos. 74–76.

24. For Turner and the Lascelles, D. Hill, '"A Taste for the Arts": Turner and the Patronage of Edward Lascelles of Harewood House', *Turner Studies*, IV, ii, 1984, pp. 24–33; and cf. Farington 10 July 1796.

25. For the commissions, *Turner in Yorkshire*, p. 25, and for Fuller's politics, Shanes 1981, pp. 5ff.

26. For the significance of *Stonyhurst College*, Shanes 1979, No. 35. It was said of Egremont, 'In his political principles and opinions he was an anti-liberal, and latterly an alarmist as well as a Conservative. He had always opposed Catholic Emancipation . . .' (C. F. Greville, *A Journal of the Reigns of King George IV, King William IV and Queen Victoria*, ed. Reeve, 1898, IV, p. 24.).

27. See especially G. E. Finley, 'Turner's Illustrations to Scott's *Life of Napoleon*,' *Journal of the Warburg and Courtauld Institutes*, XXXVI, 1973, pp. 388–96.

28. For religious toleration see note 26 and on *Wycliffe* (w 568), Shanes 1979, p. 21 and *idem. Turner's Human Landscape*, 1987. For political reform, *Nottingham* and *Northampton*, Shanes 1979 Nos. 59, 53. Cf also the reference to early Quaker persecutions in *Launceston, Cornwall* (w 792): M. M. Edmunds, *Turner Studies*, IV, ii, 1984, pp. 50f.

29. J. C. Eustace, *Tour through Italy*, 1813, I, p. xxxii.

30. Turner referred to Leonardo's notes in the Ambrosian Library in Milan in a late addition to his Lecture V on Reflections, Light and Colour (British Library, Add. MS 46151, H, f.22). He may have visited the Library himself

in 1819 (cf. TB CLXXI, p. 6, CCCLXVII, p. 50) and other references are in notes on the back of a letter dated 1826 (British Library Add MS 46151, BB, f. 52). He could also have known about them from J. S. Hawkins' *Life in Rigaud's* translation of Leonardo da Vinci, *Treatise on Painting*, 1802, pp. li, lix. See also a discussion of Leonardo's treatment of clouds in the MS of Lecture V in the collection of Mrs R. Turner.

31. Farington 21 December 1803.

32. W. Blair, *Anthropology or, the Natural History of Man; with a Comparative View of the Structure and Functions of Animated Beings in General*, 1803, pp. 145–6. Cf. TB CXI, p. 93 and Lecture V (British Library Add MS 46151, H, f. 19).

33. Blair, *op. cit.* p. 161.

34. For Turner's rejection, B. Venning 'Turner's Annotated Books: Opie's "Lectures on Painting" and Shee's "Elements of Art", I', *Turner Studies*, II, i, 1982, p. 37. Venning does not note the connection with Carlisle in TB CII, pp. 29–28a, but Turner is in fact quoting from the first two lectures of the Professor of Anatomy, as he does from the third in TB CXIV, p. 6a. Here Carlisle also referred to Leonardo's studies of anatomy in the Royal Collection (cf. his 'On the Connexion between Anatomy and the Arts of Design', *The Artist*, XVII, 1807, pp. 8–9). Although he became sceptical, Turner did not lose his interest in phrenology, and it formed a topic of one of several conversations mentioned during his visit to Sir Walter Scott in 1831 (G. E. Finley, *Landscapes of Memory, cit.* p. 116).

35. Letter 214.

36. Shanes 1981, No. 115.

37. J. Lindsay, *The Sunset Ship, cit.* p. 111, from TB CXXIII, pp. 45a–49. Carlisle's interest in lobsters and other crustacea is suggested by the number of specimens he donated to the Royal College of Surgeons in the early 1820s (R. J. Cole, 'Sir Anthony Carlisle', *Annals of Science*, VIII, 1952, p. 262f.).

38. A. Carlisle, *The Hunterian Oration . . . February 14, 1826*, p. 18.

39. British Library Add MS 46151, R, f. 1.

40. A. Carlisle, *The Hunterian Oration . . . February 21, 1820*, pp. 9–10.

41. Gage 1969, p. 112. Cf. the unpublished lecture given by Carlisle to the Royal College of Surgeons in 1818, quoted by J. H. Kyan, *On the Elements of Light*, 1838, pp. 29–30.

42. [J. Rennie], *Conversations on Geology*, 1828, pp. 7–8. For this relatively new combination of Romantic touring and geological research, R. Porter, *The Making of Geology: Earth Science in Britain, 1660–1815*, 1977, especially pp. 141f, 180f., 219. I owe this reference to the kindness of Alex Potts.

43. G. Penn, *A Comparative Estimate of the Mineral and Mosaical Geologies*, 2nd, ed., 1825, II, p. 251ff.

44. ibid. pp. 53, 58f; Gage 1969, p. 129. Even closer to the date of *Ulysses* was a similar theory propounded by Sir Humphrey Davy before the Royal Society in 1828, and demonstrated at the Royal Institution about the same time (J. A. Paris, *The Life of Sir H. Davy*, 1831, I, p. 306; II, p. 347). Turner had been in contact with Davy in 1819 (Finberg 1961, p. 261) and they were in Rome again at the same time in the winter of 1828/9.

45. See *Murray's Handbook for Travellers in Switzerland*, 1838, pp. 41ff.

46. 23 January 1840: J. Ruskin, *Diary*, ed. Evans, 1956, I, pp. 82–3.

47. For Macculloch there, D. A. Cumming, 'John Macculloch F.R.S. at Addiscombe', *Notes and Records of the Royal Society*, XXXIV, 1980, pp. 155–83. He joined the staff a year after Wells, in 1814.

48. Thornbury 1877, p. 236.

49. J. Macculloch, 'On Staffa', *Transactions of the Geological Society*, II, 1814, p. 505.

50. J. Macculloch, *The Highlands and Western Isles of*

Scotland, 1824, IV, pp. 392–3. See also Note XL to Scott's *Lord of the Isles* (1815), which mentions the play of colours inside the cave. For the cave's history and reputation, G. Grigson, 'Fingal's Cave', *Architectural Review*, 104, 1948, pp. 51ff.

51. Macculloch, *Highlands and Western Isles, cit.* III, pp. 474–84. For Turner's visit, G. Finley, *Landscape of Memory, cit.* pp. 137–8.

52. J. B. Delair, 'A History of the early discoveries of Liassic Ichthyosaurs', *Proceedings of the Dorset Natural History and Archaeological Society*, XC, 1968, pp. 115–27. It need hardly be stressed that the overall form of Turner's Ladon is entirely imaginary.

53. G. Penn, *Comparative Estimate, cit.* II, pp. 134ff.

54. C. Lyell, *Principles of Geology*, 1830, I, pp. 123–53, *cit.* N. A. Rupke, *The Great Chain of History: William Buckland and the English School of Geology 1814–1849*, 1983, pp. 186–7; also p. 220 ff. for other writers.

55. Letter 262.

56. M. Somerville, *Personal Recollections of Mary Somerville*, 1873, p. 269.

57. Gage 1969, p. 120. It is likely that Turner saw the experiment in the late 1820s, between its publication in 1826, and its disproof by other research in 1829, after which, Mrs Somerville said, she burned all her copies of the paper (E. C. Patterson, *Mary Somerville and the Cultivation of Science, 1815–1840*, 1983, pp. 45–8). She made further experiments on the solar spectrum in 1835 and 1845. (*ibid.* pp. 173f., 193f.)

58. For the vignette, TB CCLXXX, 87. Galileo's discoveries are discussed by Mrs Somerville in *Mechanism of the Heavens*, 1831, pp. 145ff, but without reference to Milton.

59. For Turner's painting of the system into a picture of this subject by S. A. Hart in 1847, Gage 1969, p. 120.

60. For the status of the two versions, text to BJ 376.

61. M. Somerville, *Mechanism, cit.* pp. 148–9.

62. M. Somerville, *On the Connexion of the Physical Sciences*, 1834, p. 251. Mrs Somerville was already working on this book when she met Turner in Paris in 1832.

63. H. Davy, *Salmonia* (1828), 1870, p. 9.

64. T. J. Judkin, 'An Apology for Angling', *By-Gone Moods*, 1856, p. 11. Judkin's *Scene near Hastings*, shown at the Academy in 1831, was noticed by Turner (Thornbury 1877, pp. 304–5) and he was the first owner of the *Eve of the Deluge* (Fig. 302). He had been a pupil of Constable's and a friend to Bonington (M. Pointon, *The Bonington Circle: English watercolour and Anglo-French Landscape, 1790–1855*, 1985, p. 96)

65. M. Somerville, *Connexion, cit.* p. 250.

66. Patterson, *op. cit.* p. 130ff.

67. H. Bence Jones, *The Life and Letters of Faraday*, I, 1870, pp. 419f. For Barnard's view of Turner's watercolours, G. Barnard, *The Theory and Practice of Landscape Painting in Water-Colours* (1855), 1861, pp. 19, 41, 119–20. For Faraday and Hullmandel, *Art Journal*, 1851, p. 30, and M. Twyman, *Lithography 1800–1850*, 1970, pp. 133–4. Turner was still frequenting Hullmandel's *conversazioni* in 1831 (E. W. Cooke, *Diary*, 18 January 1831: Cooke Family Papers).

68. See Gage, 1980, p. 270 and S. P. Thompson, *Michael Faraday: His Life and Work*, 1898, pp. 183, 207; Bence Jones, *op. cit.* I, pp. 131f; II, p. 256.

69. Bence Jones, *op. cit.* I, pp. 308–9.

70. Gage 1969, p. 249 n. 179. Delaval's views a colour as material were also retailed by C. O'Brian, *The British Manufacturer's Companion and Calico Printer's Assistant . . .*, 1795 'General Reflections', n.p., which was in Turner's library.

71. Text to BJ 294.

72. British Library Add MS 46151, H, f. 4.

73. H. R. Tedder, 'The Athenaeum: A Centenary Record', *The Times*, 16 Feb. 1924, pp. 13–14.

74. Gage 1980, p. 270. For Sams' collection, most of which was later given to the Corporation of Liverpool, *Gentleman's Magazine*, 1832, i, p. 451, ii, pp. 65f; 1833, i, pp. 312–5.

M. B. Hall, *All Scientists Now: The Royal Society in the Nineteenth Century*, 1984, pp. 77–8.

Gage 1969, pp. 120–2. For Turner at the Royal Society, see also Finberg 1961, p. 432.

Gage 1980, p. 279. Turner related the Mayall experiments with the chemical effects of various colours on a prepared plate to the Daguerreotype in a note to Goethe of about 1840 (J. Gage, 'Turner's Annotated Books: Goethe's "Theory of Colours"', *Turner Studies*, IV, ii, 1984, p. 43).

TB XXXVIII, flyleaf: sketches are in TB XLI, pp. 1–4. TB XLII, pp. 60–1 also seems to show a factory interior rather than a belfry, and may be related to the early oil, reworked in 1849 as *The Hero of a Hundred Fights* (BJ 427), showing a bronze-foundry.

R.A. 1808 (132): *Captain G. Manbys' Invention of Effectually Rescuing Persons from Vessels Wrecked on a Lee Shore*. The painting was shown with an even more circumstantial title at the Norwich Polytechnic Exhibition in 1840 (No. 11) and is now in the Norwich Castle Museum. See also *Transactions of the Society of Arts*, XXVI, 1808, pp. 209–229; the picture, engraved by W. Woolnoth, is facing page 228. K. Walthew, *From Rock to Tempest: The Life of Captain G. W. Manby*, 1971, facing p. 33.

N. Pocock, *Captain Manby's Method of Saving Shipwrecked Seamen* . . . R.A. 1815 (119); Norwich 1840 (102). *Captain Manby's Method of Giving Relief to a Ship in Distress* . . . R.A. 1815 (270); Norwich 1840 (35). F. L. T. Francia, *Saving the Crew of the Brig 'Leipzig'*, R.A. 1816 (303); Norwich 1840 (208). *Saving the Crew and Passengers from the Brig 'Providence'* . . . R.A. 1816 (316); Norwich 1840 (189). All these works were included in the bequest made by Manby to the Norwich Museum in 1841. I am particularly grateful to Andrew W. Moore for supplying details of this material. Manby's propaganda at least had an effect on Francia who, when he moved to Calais, was active in setting up a lifeboat institution there (Pointon, *op. cit.* p. 125).

Seven marines by W. Joy were in the 1840 Norwich exhibition, of which five are still in the Manby Bequest. One of them was shown at the Academy in 1832 (1067): *Forcing a Boat from a Flat Beach in a Heavy Gale. By the Plan Brought into use by Captain Manby, for Affording Assistance to Ships in Distress at a Distance from Land with Facility and Certainty*. Manby was also commemorated at the Academy in 1811 by Samuel Lanes' portrait of him (64; Norwich 1840 (135)). Lanes told Farington (30 December 1811) both about the Captain's inventions and his vanity.

82. I have corrected the printed title on the basis of Turner's autograph list of exhibits in the Turner Gallery Archive.

83. Manby to Dawson Turner, 27 May 1830 (Cambridge, Trinity College, Dawson Turner Letters).

84. In July 1832 Manby was also invited to call on J. M. W. Turner's close friend Chantrey, another F.R.S. who was close to Dawson Turner (Manby to Dawson Turner, 6 July 1832, *ibid.*).

85. G. W. Manby, *Reminiscences*, Yarmouth, [1839], pp. 134–5.

86. Cf. *ibid.* pp. 107, 132. Blue marker-lights were also used in the Pacific whaling industry, which began to interest Turner from about 1840 (T. Beale, *The Natural History of the Sperm Whale*, 1839, pp. 281–3).

87. Manby, *Reminiscences, cit.* p. 107.

88. This is most striking in the cases of the early *Eddystone Lighthouse* (W 506; 1817) and in the *England and Wales* plates, *Tynemouth, Northumberland* (W 827), *Longships Lighthouse, Land's End* (W 864) and *Lowestoffe, Suffolk* (W 869): see Shanes 1979, captions to 73, 76, 91.

89. The most detailed account of this event and the pictures it provoked, is K. Solender, *Dreadful Fire! Burning of the Houses of Parliament*, Cleveland Museum of Art, 1984.

90. Walthew, *op. cit.* p. 83.

91. Manby to Dawson Turner, 17 October 1834 (Cambridge, Trinity College, Dawson Turner Letters) See also the letter of October 22 (*ibid.*)

92. A copy of this pamphlet is bound in with the Dawson Turner Letters. *The Times*, 17 October 1834 also wrote that 'it must be confessed that our ordinary engines are totally incapable of contending with such a conflagration as that of last night, and that our fire-engine system wants the great element of efficiency – a general superintendent. Each fire-office acts according to its own view; there is no obedience to one chief, and consequently where the completest co-operation is necessary, all is confusion or contradiction.' Manby was certainly used to prints as propaganda: among his bequest to Norwich were six lithographs, and Francia's pupil, R. P. Bonington had made a print after Manby's own sketch to illustrate his *Essai pratique et demonstratif sur les moyens de prévenir les naufrages et de sauver la vie aux marins naufragés* . . . 1827 (Curtis 53).

93. *The Times, loc cit.*

94. *ibid.* Chantrey's joke to Turner on Varnishing Day about a commission from the Sun Fire Office (Thornbury 1877, p. 347), probably refers to this picture.

95. Manby, *Plan, cit.* Also *Gentleman's Magazine*, 1834, ii, p. 478.

96. T. Balston, *John Martin*, 1947, pp. 124f. Turner was among six Academicians, including Eastlake, and six F.R.S., including Faraday. He had known Martin since the 1820s (Finberg 1961, p. 294), and was on good terms with him: at that moment when Martin, who was not an Academician, was denouncing the Academy before the Select Committee of 1835–6 he was also telling it of his and Turner's efforts to secure copyright arrangements for engraving (*Minutes of Evidence before the Select Committee on Arts and Principles of Design*, 24 June 1836, p. 74).

97. Balston, *op. cit.* pp. 205–6.

98. C. Babbage, *Passages from the Life of a Philosopher*, 1864, pp. 320ff. M. Moseley, *Irascible Genius: A Life of Charles Babbage, Inventor*, 1964, pp. 130–1. In a paper given to the Statistical Society of London in 1843 Babbage discussed the run, which clocked an average speed of 33 miles per hour, second only to the fastest line, the Northern and Eastern (E. T. MacDermot, *History of the Great Western Railway*, revised Clinker, 1964, I, p. 335). Babbage met Turner in the company of Sarah Rogers (Gage 1980, p. 280) and he was also a friend of the Eastlakes and the Carrick Moore's (Sir F. Pollock, *Personal Remembrances*, 1887, I, p. 14; II, p. 268).

99. J. Gage, 'Gautier, Turner and John Martin', *Burlington Magazine*, CXV, 1973, p. 393.

100. I have discussed the background to this painting in some detail in *Turner: Rain, Steam and Speed*, 1972.

101. *Ibid.* p. 33.

SELECT BIBLIOGRAPHY

Ackermann's New Drawing Book of Light and Shade, 1809
E. Adams, *Francis Danby: Varieties of Poetic Landscape*, 1973
H. Adhémar, *Watteau*, 1950.
M. Akenside, *The Pleasures of Imagination*, 1765
N. Alfrey, 'Turner en France': see Paris, Grand Palais
J. Anderson, *The Unknown Turner*, 1926
R. Anderson, *The Works of the British Poets*, 13 vols. 1795–c. 1802
Annals of the Fine Arts, I, 1817, III, 1818
Anon. 'Early days of an Artist', *The Month*, February 1866
——, 'British School of Living Painters: J. M. W. Turner R.A.' *Arnolds Magazine of the Fine Arts*, N.S. I, 1833
J. W. Archer, 'Reminiscences' (1862), *Turner Studies*, I, i, 1981
Architectural Association, *Joseph Michael Gandy*, 1982
W. Armstrong, *Turner*, 1902
Arts Council of Great Britain, *Daniel Maclise*, 1972
——, *Salvator Rosa*, 1973
F. Atin, *Handbuch der englischen Umgangssprache*, 1834
C. Babbage, *Passages from the life of a Philosopher*, 1864
A. G. H. Bachrach, *Turner and Rotterdam, 1817, 1825, 1841*, 1974
——, 'Turner's Holland', *Dutch Quarterly Review of Anglo-American Letters*, 1976
——, 'Turner, Ruisdael and the Dutch', *Turner Studies*, I, i, 1981
——, 'The Field of Waterloo and Beyond', *Turner Studies*, I, ii, 1981
T. Balston, *John Martin*, 1947
C. P. Barbier, *Samuel Rogers and William Gilpin*, 1959
G. Barnard, *The Theory and Practice of Painting in Water-Colours*, 1861
J. Barry, *The Works of James Barry*, ed. Fryer, 1809
J. Bayard, *Works of Splendor and Imagination: the Exhibition Watercolour, 1770–1870*, 1981
W. Bayliss, *Olives: the Reminiscences of a President*, 1906
T. Beale, *The Natural History of the Sperm Whale*, 1839
[Beavington Atkinson] 'Turner at Bristol', *The Portfolio*, 1880
H. Bence Jones, *The Life and Letters of Faraday*, 1870
C. Bell, *Landmarks of Nineteenth-Century Painting*, 1927
C. F. Bell, *The Exhibited Works of J. M. W. Turner*, 1901
——, 'Turner and his Engravers', see Holmes

Q. Bell, 'Haydon *versus* Shee', *Journal of the Warburg and Courtauld Institutes*, XXII, 1959
——, *The Schools of Design*, 1963
R. Blackmore, *A Paraphrase on the Book of Job*, 2nd ed. 1716
H. Blair, *Lectures on Rhetoric and Belles-Lettres*, 4th ed. 1790
R. Blair, *The Grave*, 1743
W. Blair, *Anthropology, or, the Natural History of Man*, 1803
P. Blanchard (ed. and trans.) *John Ruskin sur Turner*, 1983
V. Bloch, *Michael Sweerts*, 1968
J. J. Blunt, *Vestiges of Ancient Manners Discoverable in Modern Italy and Sicily*, 1823
T. S. R. Boase, 'English Artists in the Val d'Aosta', *Journal of The Warburg and Courtauld Institutes*, XIX, 1956
G. P. Boyce, *Diaries*, ed. Surtees, 1980
[E. Bray], 'Reminiscences of Stothard', *Blackwood's Edinburgh Magazine* 39, 1836
E. Bray, *Life of Thomas Stothard, R.A.*, 1851
H. Brigstocke, *William Buchanan and the nineteenth-century Art Trade*, 1982
M. Brion, *Turner*, Paris 1929
W. Brockedon, *Journals of Excursions in the Alps*, 1833
——, 'Extracts from the Journals of an Alpine Traveller', *Blackwood's Edinburgh Magazine*, 39, 1836
D. B. Brown, *Augustus Wall Callcott*, Tate Gallery, 1981
C. Bucke, *The Philosophy of Nature, or the Influence of Scenery on the Mind and Heart*, 1813
Van Akin Burd, 'Ruskin's defence of Turner: the Imitative Phase' *Philological Quarterly*, XXXVII, 1958
——, 'Background to *Modern Painters*: the tradition and the Turner Controversy', *Publications of the Modern Languages Association of America*, 74, i, 1959
W. Bürger (T. Thoré), *Trésors d'Art en Angleterre*, 1862
——, *L'École Anglaise*, in Blanc, Gautier, Jeanron (eds) *Histoire des peintres de tous les écoles*, 1863
J. Burnet, *Practical Essays on Various Branches of the Fine Arts*, 1848
——, *Turner and his Works*, 1852
——, *Art Journal*, N.S. IV, 1852
Burnley Borough Council, *Turner and Dr Whitaker*, 1982

M. Butlin & E. Joll, *The Paintings of J. M. W. Turner*, revised ed. 1984
Lord Byron, *Childe Harold's Pilgrimage*, 1812–18
W. Callow, *An Autobiography*, ed. Cundall, 1908
C. Campbell, *Travellers' Complete Guide Through Belgium and Holland*, 2nd. ed. 1817
A. Carlisle, 'On the Connection between Anatomy and the Arts of Design', *The Artist*, No. XVII, 1807
——, *The Hunterian Oration Delivered before the Royal College of Surgeons*, 1820, 1826
Lord Carysfort, *Dramatic and Narrative Poems*, 1810
W. Chubb, 'Turner's "Cicero at his Villa"', *Burlington Magazine*, CXXIII, 1981
——, 'Minerva Medica and the Tall Tree', *Turner Studies*, I, ii, 1981
M. Clarke & N. Penny (eds), *The Arrogant Connoisseur: Richard Payne Knight*, 1982
R. J. Cole, 'Sir Anthony Carlisle', *Annals of Science*, VIII, 1952
J. Constable, *Correspondence*, ed. Beckett, III, 1965
——, *Discourses*, ed. Beckett, 1970
W. G. Constable, *Richard Wilson*, 1953
T. S. Cooper, *My Life*, 1890
M. Cormack, '"The Dort": some further Observations', *Turner Studies* II, ii, 1983
H. Coxe, *A Picture of Italy, being a Guide to the Antiquities and Curiosities of that Interesting Country*, 2nd ed. 1818
A. C. Coxhead, *Thomas Stothard R.A.*, 1906
E. Croft-Murray, 'Pencil outlines of Shipping at Dover of the "Monro School"', *British Museum Quarterly*, X, 1935–6
——, *Decorative Painting in England*, II, 1970
D. A. Cumming, 'John Macculloch F.R.S. at Addiscombe', *Notes and Records of the Royal Society*, XXXIV, 1980
F. Cummings, 'B. R. Haydon and his School', *Journal of the Warburg and Courtauld Institutes*, XXVI, 1963
A. Cunningham, *The Life of Sir David Wilkie*, 1843
J. Danby, *Danby's Third Book of Catches, Canons and Glees*, n.d.
——, *Danby's Posthumous Glees*, 1798
H. Davy, *Salmonia*, 1870
E. Dayes, *The Works of the Late Edward Dayes*, 1805
J. B. Delair, 'A history of the early discoveries of Liassic Ichthyosaurs', *Proceedings of the Dorset Natural History and Archaeological Society*, XC, 1968

Dibdin, *The Professional Life of Mr Dibdin*, 1803

Dibdin, *Melodrame Mad! or the Seige of Troy*, 1819

S. N. Douglas, *An Essay on Certain Points of Resemblance Between the Ancient and Modern Greeks*, 3rd. ed. 1813

C. L. Dubosc de Pesquidoux, *L'École Anglaise 1672–1851*, 1858

Earlom, *Liber Veritatis*, 1777–1816

C. L. Eastlake, 'Effusions on a Summer's Evening', *Monthly Magazine*, July 1809

——, *Materials for a History of Oil Painting*, II, 1869

——, *Contributions to the Literature of the Fine Arts*, 2nd series, 1870

C. Eustace, *A Tour Through Italy*, 1813

. Falk, *Turner the Painter: his hidden Life*, 1938

Farington, *The Diary of J. Farington*, ed. Garlick, Macintyre, Cave 1978–84

D. Farr, *William Etty*, 1958

Feltham, *The Picture of London for 1805*, 1805

G. Field, *Chromatography*, 2nd. ed. 1841

A. J. Finberg, *A Complete Inventory of the Drawings of the Turner Bequest*, 1909

——, *Turner Watercolours at Farnley Hall*, 1912

——, *Early English Watercolour Drawings*, 1919

——, *Notes on Three of Turner's Architectural Drawings*, 1920

——, *The History of Turner's Liber Studiorum*, 1924

——, *Introduction to Turner's Southern Coast*, 1929

——, *The Life of J. M. W. Turner, R.A.*, 2nd ed. 1961

G. E. Finley, 'Turner's Illustrations to Scott's *Life of Napoleon*', *Journal of the Warburg and Courtauld Institutes*, XXXVI, 1973

——, *Landscapes of Memory: Turner as an illustrator to Scott*, 1980

——, '"Ars Longa, Vita Brevis": the *Watteau Study* and *Lord Percy* by J. M. W. Turner', *Journal of the Warburg and Courtauld Institutes*, XLIV, 1981

——, *Turner and George IV at Edinburgh, 1822*, 1981

. D. Fiorillo, *Geschichte der zeichnenden Künste, V: Geschichte der Mahlerey in Grossbrittanien*, 1808

B. Ford, *The Drawings of Richard Wilson*, 1951

E. Forssmann, *Venedig in der Kunst und im Kunsturteil des neunzehnten Jahrhunderts*, 1971

W. P. Frith, *My Autobiography*, 1887

W. E. Frost & H. Reeve, *A complete Catalogue of the Paintings, Water-Colours, Drawings and Prints in the Collection of the late H. A. J. Munro*, 1865

P. Funnell, 'The Symbolic Language of Antiquity', see M. Clarke

. Gage, 'Turner and the Picturesque', *Burlington Magazine*, CVII, 1965

——, 'Magilphs and Mysteries', *Apollo*, LXXX, 1964

——, *Colour in Turner: Poetry and Truth*, 1969

——, *Turner: Rain, Steam and Speed*, 1972

——, 'Gautier, Turner and John Martin', *Burlington Magazine*, 1973, CXV

——, 'Turner and Stourhead: the making of a Classicist?' *Art Quarterly*, XXXVIII, 1974

——, *Collected Correspondence of J. M. W. Turner*, 1980

——, 'Turner and the Greek Spirit', *Turner Studies*, I, ii, 1981

——, '"Le roi de la lumière": Turner et le public français de Napoleon à la seconde guerre mondiale', see Paris, Grand Palais

——, 'Turner's annotated books: Goethe's "Theory of Colours"', *Turner Studies*, IV, ii, 1984

——, 'Further Correspondence of J. M. W. Turner' *Turner Studies*, VI, i, 1986

Comtesse de Genlis, *Manuel du Voyageur or the Traveller's Pocket Companion*, 1829

H. George, 'Turner in Europe in 1833', *Turner Studies*, IV, i, 1984

W. Gerdts & T. Stebbins, *Washington Allston*, 1979

A. Gilchrist, *Life of William Etty, R.A.*, 1855

T. Girtin & D. Loshak, *The Art of Thomas Girtin*, 1954

T. Gisborne, *Walks in a Forest*, 1794

O. Goldsmith, *The Roman History*, 1769

E. & J. de Goncourt, *Journal*, several editions

L. Gowing, *Turner: Imagination and Reality*, 1966

C. F. Greville, *A Journal of the Reigns of King George IV, King William IV and Queen Victoria*, ed. Reeve, 1898, IV

G. Grigson, 'Fingal's Cave', *Architectural Review*, 104, 1948

P. Haesaerts, *James Ensor*, 1957

J. Hakewill, *A Tour of Italy*, 1820

M. B. Hall, *All Scientists Now: The Royal Society in the Nineteenth Century*, 1984

P. G. Hamerton, *Life of J. M. W. Turner*, new ed. 1895

T. C. Hansard &c, *Report on the mode of Preventing the Forgery of Banknotes*, 1819

N. W. Hanson, 'Some Painting Materials of J. M. W. Turner', *Studies in Conservation*, I, 1954

W. H. Harrison, 'Notes and Reminiscences', *University Magazine* (Dublin), I, 1878

M. Hardie, *Water-Colour Painting in Britain*, 1966–8

F. Haskell, *Rediscoveries in Art*, 1976

——, & N. Penny, *Taste and the Antique*, 1981

A. Haus, 'Turner im Urteil der deutschen Kunstliteratur', in Berlin, *J. M. W. Turner: Maler des Lichts*, 1972

B. R. Haydon, *Correspondence and Table-Talk*, 1876

——, *Diary*, ed. Pope, 1960–3

J. Hayes, *The Drawings of Thomas Gainsborough*, 1971

——, *The Landscape Paintings of Thomas Gainsborough*, 1982

Thomas Hearne 1744–1817, Southampton Art Gallery, 1985

K. Heleniak, *Wiliam Mulready*, 1980

L. Herrmann, 'Turner and the Sea', *Turner Studies*, I, i, 1981

D. Hill, 'A newly-discovered Turner Letter', *Turner Society News*, 23, 1981/2

——, *In Turner's Footsteps: Through the Hills and Dales of Northern England*, 1984

——, '"A Taste for the Arts": Turner and the patronage of Edward Lascelles of Harewood House', *Turner Studies* IV, ii, 1984; V, i, 1985

The Historical Gallery of Portraits and Paintings, I, 1807

R. C. Hoare, *The Ancient History of Wiltshire*, 1812

——, *A Classical Tour in Italy and Sicily*, 1819

Hobart, *Catalogue of the Art Treasures Exhibition held in the Legislation Council Chamber, Hobart Town, Tasmania . . . MDCCCLVIII*

W. Hogarth, *The Analysis of Beauty*, ed. Burke, 1955

C. Holmes, (ed.) *The Genius of Turner*, 1903

D. Howard, 'Some Eighteenth-century English Followers of Claude', *Burlington Magazine*, CXI, 1969

H. Hubbard, 'The Society for the study of Epic and Pastoral Design', *Old Water-Colour Society's Club*, XXIV, 1946

A. Hume, *Notices on the Life and Works of Titian*, 1829

B. Hunnisett, *Steel-Engraved Book Illustration in England*, 1980

T. F. Hunt, *Designs for Parsonage Houses, Alms Houses, &c.* 1827

W. Holman Hunt, *Pre-Raphaelitism and the Pre-Raphaelite Brotherhood*, 2nd. ed. 1911

R. J. Hutchings & R. V. Turley, *Young Algernon Swinburne*, 1978

S. Hutchison, 'The Royal Academy Schools, 1768–1830', *Walpole Society*, XXXVIII, 1960–2

J. K. Huysmans, *Certains*, 1889

D. & F. Irwin, *Scottish Painters at Home and Abroad*, 1975

W. Jerdan, *An Autobiography*, II, 1852; IV, 1853

R. Jessup, *Man of Many Talents: An Informal Biography of James Douglas*, 1975

G. Jones, *Recollections of J. M. W. Turner (c. 1857/63)* in Gage 1980

W. Jones, 'On the Gods of Greece, Italy and India', *Asiatick Researches*, II, 1790

[R. Joppien], *Philippe Jacques de Loutherbourg, R.A.*, Kenwood, Iveagh Bequest, 1973

T. J. Judkin, *By-Gone Moods*, 1856

J. Kirby, *Dr Brook Taylor's Method of Perspective made Easy*, 1754

M. Kitson, 'Turner and Claude', *Turner Studies*, II, ii, 1983

H. Gally Knight, *Phrosyne: A Grecian Tale*, 1817

R. Payne Knight, *An Account of the Remains of the Worship of Priapus*, 1786

——, *An Analytical Inquiry into the Principles of Taste*, 1805

——, 'The Works of James Barry', *Edinburgh Review*, XVI, 1810

——, *An Inquiry into the Symbolical Language of Ancient Art and Mythology*, 1818

J. Knowles, *The Life and Writings of Henry Fuseli*, 1831

J. H. Kyan, *On the Elements of Light*, 1838

B. Lamy, *Perspective made Easie*, 1710

[J. Landseer] *Review of Publications of Art*, I, 1808

[Lansdown], *Recollections of the late William Beckford*, 1893

Leonardo da Vinci, *Treatise on Painting*, trans. J. F. Rigaud, 1802

C. R. Leslie, *Autobiographical Recollections*, 1860

——, *A Handbook for Young Painters*, 1855

G. D. Leslie, *The Inner Life of the Royal Academy*, 1914

J. Lindsay, *The Sunset Ship: Poems of J. M. W. Turner*, 1966

——, *J. M. W. Turner: A Critical Biography*, 1966

——, *Turner: The Man and his Art*, 1985

A. Livermore, 'Turner and Music', *Music and Letters*, XXXVIII, 1957; revised in *Turner Studies*, III, i, 1983

Livy, *The Roman History Written in Latine by Titus Livius*, 1686

[M. Lloyd], *Sunny Memories*, 1880

London, Queen's Gallery, *George IV and the Arts of France*, 1966

——, Royal Academy of Arts, *Treasures of the Royal Academy*, 1963

——, ——, *Ensor to Permeke*, 1971

——, ——, *Turner, 1775–1851*, 1974/5

A. McCann, 'A Private Laboratory at Petworth House, Sussex, in the Late Eighteenth Century', *Annals of Science*, XL, 1983

D. S. McColl, 'Turner's Lectures at the Royal Academy', *Burlington Magazine*, XII, 1908

J. McCoubrey, 'War and Peace in 1842: Turner, Haydon and Wilkie', *Turner Studies*, IV, ii, 1984

J. Macculloch, 'On Staffa', *Transactions of the Geological Society* II, 1814

——, *The Highlands and Western Isles of Scotland*, 1824

E. T. MacDermot, *History of the Great Western Railway*, rev. Clinker, 1964

A. MacGeorge, *W. L. Leitch*, 1884

J. Mackintosh, *Memoirs*, ed. R. J. Mackintosh, 1835

Magazine of the Fine Arts, I, 1821

T. Malton, sen. *A Complete Treatise on Perspective*, 2nd. ed. 1799

T. Malton, jun. *Picturesque Tour of the Cities of London and Westminster*, 1792

G. W. Manby, *Reminiscences*, [1839]

A. Marks, 'Rivalry at the Royal Academy: Wilkie, Turner and Bird', *Studies in Romanticism*, XX, 1981

H. Matisse, *Écrits et propos sur l'art*, ed. Fourcade, 1972

W. G. Maton, *Observations Relative Chiefly to Natural History, Picturesque Scenery and Antiquities of the Western Counties of England*, 1797

L. R. Matteson, 'The Poetics and Politics of Alpine Passage: Turner's *Snowstorm: Hannibal and his Army Crossing the Alps*', *Art Bulletin*, LXII, 1980

H. Matthews, *The Diary of an Invalid*, 1820

R. Ménard, 'Institution de South Kensington, III', *Gazette des Beaux Arts*, 2ᵉ pér. VI, 1872

W. M. Merchant, *Shakespeare and the Artist*, 1959

P. Mérimée, 'Les Beaux-Arts en Angleterre', *Revue des Deux Mondes*, XXVIII, 2ᵉ pér., XII, 1857

J. G. Millais, *Life and Letters of Sir J. E. Millais*, 1902

O. Millar, *Later Georgian Pictures in the Collection of Her Majesty the Queen*, 1969

T. Miller, *Turner and Girtin's Picturesque Views sixty years since*, 1854

H. F. Mills, *Elegaic Stanzas on the death of Walter Fawkes*, 1825

C. Monkhouse, 'Ovid, Turner and Golding', *Art Journal*, N.S. 32, 1880

J. Moore, *A List of Principal Castles and Monasteries in Great Britain*, 1798

T. Moore, *Memoirs, Journal and Correspondence*, ed. Russell, 1853

J. M. Morgan, *The Revolt of the Bees*, 1826

S. Morris, 'Two Perspective Views: Turner and Lewis William Wyatt', *Turner Studies*, II, ii, 1983

M. Moseley, *Irascible Genius: A Life of Charles Babbage, Inventor*, 1964

Murray's Handbook for Travellers in Switzerland, 1838

P. Murray, *Dulwich College Picture Gallery: A Catalogue*, 1980

R. Muther, *The History of Modern Painting*, rev. ed. 1907

B. Nicolson, 'Thomas Gisborne and Wright of Derby', *Burlington Magazine*, CVII, 1965

C. Ninnis, 'The Mystery of the Ariel', *Turner Society News*, No. 20, 1981

L. Noble, *Life and Works of Thomas Cole*, 1964

J. Northcote, *Memoirs of Sir Joshua Reynolds*, 1813

C. O'Brian, *The British Manufacturer's Companion and Calico-Printer's Assistant*, 1795

M. Omer, *Turner and the Poets*, Greater London Council, 1975

——, *The Seasons: Illustrations to James Thomson's Poem, 1730–1830*, Tel Aviv University, 1982/3

——, *Turner: Landscapes of the Bible and the Holy Land*, 1985

J. Opie, *Lectures on Painting*, 1809

W. Y. Ottley & P. W. Tomkins, *The Most Noble the Marquis of Stafford's Collection of Pictures in London*, IV, 1818

R. Owen, *The Life of Richard Owen*, 1894

T. Paine, *The Age of Reason*, II (1795) in *Works*, 1818

G. F. Palgrave, *Francis Turner Palgrave: His Journal and Memoirs of his Life*, 1899

J. A. Paris, *The Life of Sir Humphrey Davy*, 1831

Paris, Centre Culturel du Marais, *Turner en France*, 1981

——, Grand Palais, *J. M. W. Turner*, 1983/4

L. Parris, *Landscape in Britain c. 1750–1850*, Tate Gallery, 1973

E. C. Parry III, 'Thomas Cole's "The Titan's Goblet": a reinterpretation', *Metropolitan Museum Journal*, IV, 1971

E. C. Patterson, *Mary Somerville and the Cultivation of Science, 1815–1840*, 1983

R. Paulson, *Hogarth, his Life, Art and Times*, 1971

G. Penn, *A Christian's Survey of all the Primary Events and Periods of the World, from the Commencement of History to the Conclusion of Prophecy*, 2nd. ed. 1812

——, *A Comparative Estimate of the Mineral and Mosaical Geologies*, 2nd. ed. 1825

A. Pichot, *Voyage Historique et Littéraire en Angleterre et en Écosse*, 1825

C. Pissarro, *Correspondence*, ed. Bailly-Herzeberg, I, 1980

M. Pointon, *The Bonington Circle*, 1985

C. Powell, 'Topography, Imagination and Travel: Turner's relationship with James Hakewill', *Art History*, V, 1982

——, '"Infuriate in the wreck of Hope": Turner's Vision of Medea', *Turner Studies*, II, i, 1982

——, 'Turner's Vignettes and the Making of Rogers' *Italy*', *Turner Studies*, III, i, 1983

N. Pressly, *The Fuseli Circle in Rome*, Yale Center for British Art, 1979

W. L. Pressly, *The Life and Art of James Barry*, 1981

J. Pye, *Patronage of British Art*, 1845

——, & J. L. Roget, *Notes and Memoranda Respecting the Liber Studiorum*, 1879

A. Raczynski, *Histoire de l'art moderne en Allemagne*, 1841

W. G. Rawlinson, *Turner's Liber Studiorum*, 2nd. ed. 1906

——, *The Engraved Works of J. M. W. Turner, R.A.*, 1908–13

——, & A. J. Finberg, *The Watercolours of J. M. W. Turner*, 1909

C. Redding, *Fraser's Magazine*, XLV, 1852

——, *Past Celebrities I have Known*, 1866

F. M. Redgrave, *Richard Redgrave: a Memoir compiled from his Diary*, 1891

R. & S. Redgrave, *A Century of British Painters* (1866) ed. Todd, 1947

L. Reeve, *Literary Gazette*, December 27, 1851

M. Reichard, *Itinerary of Italy*, 1819

S. Reiss, *Aelbert Cuyp*, 1975

[J. Rennie] *Conversations on Geology*, 1828

N. Revett, *Antiquities of Ionia*, II, 1797

G. Reynolds, *The Later Paintings and Drawings of J. Constable*, 1984

J. Reynolds, *Seven Discourses delivered at the Royal Academy by the President*, 1778

——, *Works*, ed. Malone, 1797

——, *Notes and Observations on Pictures*, ed. Cotton, 185

——, *Discourses*, ed. Wark, 1975

S. Richardson, *Edward Bird, 1772–1819*, Wolverhampton/London, 1982

D. Robertson, *Charles Lock Eastlake and the Victorian Art World*, 1978

S. Rogers, *Italy*, 1830

——, *Poems*, 1834

——, *Italian Journal*, ed. Hale, 1956

J. L. Roget, *A History of the 'Old' Water-Colour Society*, 1891

T. Roscoe, *The Tourist in Switzerland and Italy*, 1830

S. Rosenfeld, *Georgian Scene Painters and Scene Painting*, 1981

W. M. Rossetti, 'Turner's Life and Genius', in *Fine Art*, 1867

Royal Academy, *Report of the Commissioners Appointed to Inquire into the Present Position of the Royal Academy*, 1863

N. A. Rupke, *The Great Chain of History: William Buckland and the English School of Geology, 1814–1849*, 1983

J. Ruskin, *Notes on the Turner Gallery at Marlborough House*, 1856/7

——, *Modern Painters*, V, 1860

——, *Works*, ed. Cook & Wedderburn, VI, 1905

——, *Pre-Raphaelitism and other Essays and Lectures*, ed. Binyon, 1906

——, *Diary*, ed. Evans, 1956

E. Shanes, *Turner's Picturesque Views in England and Wales*, 1979

——, *Turner's Rivers, Harbours and Coasts*, 1981

——, 'New Light on the "England and Wales" Series', *Turner Studies* IV, i, 1984

——, *Turner's Human Landscape*, 1987

L. Stainton, *Turner's Venice*, 1985

H. R. Tedder, 'The Athenaeum: A Centenary Record', *The Times*, 16 February 1924

Tel Aviv, *see* Omer

W. Telbin, 'Art in the Theatre, I, Scenery', *Magazine of Art*, XII, 1889

J. Thistlethwaite, *The Etchings of E. T. Daniell*, 1974

S. P. Thompson, *Michael Faraday: His Life and Work*, 1898

T. Thoré, *see* W. Bürger

W. Thornbury, *Life and Correspondence of J. M. W. Turner*, 2nd ed. 1877

C. B. Tinker, *Painter and Poet*, 1938

C. Titterington, *William Turner of Oxford*, Woodstock/London/Bolton, 1984/5

R. V. Turley, 'Julia Gordon, Lithographer', *Wight Life*, Aug/Sept 1974

Tyne & Wear County Museums, *The Spectacular Career of Clarkson Stanfield, 1793–1867*, 1979

W. Vaughan, *German Romanticism and English Art*, 1979

——, *German Romantic Painting*, 1980

B. Venning, 'Turner's Annotated Books: Opie's "Lectures on Painting" and Shee's "Elements of Art"', *Turner Studies*, II, i, 1982; II, ii, 1983; III, i, 1983

R. Verdi, 'Poussin's *Deluge*: The Aftermath', *Burlington Magazine*, CXXIII, 1981

Victoria and Albert Museum, *Dr Thomas Monro and the Monro Academy*, 1976

M. H. Vida, *The Art of Poetry*, trans. Pitt, 1742

A. Vollard, *La Vie et l'oeuvre de P. A. Renoir*, 1919

G. Waagen, *Treasures of Art in Great Britain*, II, 1854

T. G. Wainewright, *Essays and Criticism*, ed. Hazlitt, 1880

W. Walker, 'The Portraits of J. M. W. Turner', *Turner Studies*, III, i, 1983

Walthew, *From Rock to Tempest: The Life of Captain G. W. Manby*, 1971

Watts, *Turner's Liber Fluviorum*, 1853

Webber, *James Orrock, R.I.*, 1903

Westall, *A Day in Spring, and other Poems*, 1808

R. J. Westall, 'The Westall Brothers', *Turner Studies*, IV, i, 1984

M. Wheeler, *The Family and Friends of W. F. Wells*, 1970

White, D. Alexander, E. D'Oench, *Rembrandt in Eighteenth-Century England*, Yale Center for British Art, 1983

V. T. Whitley, 'Turner as a Lecturer', *Burlington Magazine*, XXII, 1913

——, *Artists and their Friends in England, 1700–1799*, 1928

——, *Art in England, 1800–1820*, 1928

——, *Art in England, 1821–1837*, 1930

——, 'Relics of Turner', *The Connoisseur*, 88, 1931

——, *Thomas Heaphy*, 1933

Whittingham, 'Watteau's *L'Isle Enchantée*: from the French Régence to the English Regency', *Pantheon*, XLII, 1984

——, 'Turner's "Music Party"', *Burlington Magazine*, CXXVI, 1984

——, 'What you Will; or some notes regarding the influence of Watteau on Turner and other British artists' *Turner Studies* VI, i, ii 1985

G. Wilkinson, *The Sketches of Turner, R.A.*, 1974

——, *Turner's Colour Sketches*, 1975

H. W. Williams, *Travels in Italy, Greece and the Ionian Islands*, 1820

A. Wilton, *Turner in the British Museum*, 1975

——, *The Life and Work of J. M. W. Turner*, 1979

——, *The Art of Alexander and John Robert Cozens*, 1980

——, *Turner and the Sublime*, 1980

——, *Turner Abroad*, 1982

——, 'La technique de l'aquarelle chez Turner', see Paris, Grand Palais

——, *Turner in Wales*, 1984

——, 'The "Monro School" question: some answers', *Turner Studies*, IV, ii, 1984

R. Wornum (ed), *Lectures of the Royal Academicians*, 1848

——, *The Turner Gallery*, 1872

York City Art Gallery, *Turner in Yorkshire*, 1980

J. Young, *A Catalogue of the Celebrated Collection of Pictures of the late J. J. Angerstein*, 1823

P. Youngblood, 'The Painter as Architect: Turner and Sandycombe Lodge', *Turner Studies*, II, i, 1982

——, '"That House of Art": Turner at Petworth', *Turner Studies*, II, ii, 1983

J. Ziff, '"Backgrounds: Introduction of Architecture and Landscape": A Lecture by J. M. W. Turner', *Journal of the Warburg and Courtauld Institutes*, XXVI, 1963

——, 'Turner and Poussin', *Burlington Magazine*, CV, 1963

——, 'J. M. W. Turner on Poetry and Painting', *Studies in Romanticism*, III, 1964

——, 'Copies of Claude's Paintings in the Sketchbooks of J. M. W. Turner', *Gazette des Beaux-Arts*, LXV, 1965

——, 'Turner et les grands maîtres', see Paris, Grand Palais

——, 'Turner's first poetic quotations: an examination of intentions', *Turner Studies*, II, i, 1982

——, 'William Henry Pyne's "J. M. W. Turner R.A.": a neglected critic and essay remembered', *Turner Studies*, VI, i, 1986.

PHOTOGRAPHIC ACKNOWLEDGEMENTS

With the exception of those plates listed below, photographs have been supplied by the owners as indicated in the captions and are reproduced with their kind permission.

Thomas Agnew & Sons: 186, 282; Breslich and Foss: 113; British Library: 25; By permission of the Trustees of the British Museum: 22, 45, 46, 52, 54, 58, 60, 61, 70, 71, 73, 75, 84, 87, 88, 91, 94, 97, 98, 101, 102–6, 108, 110–11, 114–16, 118, 120, 123–4, 127, 130–1, 142, 145–6, 148–9, 152, 154, 158, 166, 172, 175–6, 178, 180, 182, 198–201, 205, 209–11, 215, 221, 229, 231, 233, 240–1, 243, 253, 255, 258, 269, 273–4, 276, 288, 298–9, 311, 315–18; By permission of the Syndics of Cambridge University Library: 32–5; Christie, Manson and Woods Ltd: 28; Christopher Gibbs Ltd: 125; The Courtauld Institute of Art: 126, 132, 204; Leger Galleries: 59, 219, 296; Leggatt Brothers: 256; National Galleries of Scotland: 36, 161; Paul Mellon Centre for British Art: 123, 281; Photographic Records Ltd: 191, 197; Royal Academy of Art: 246; Spink and Son: 292; The Tate Gallery: 6, 17, 19, 35, 47, 53, 77, 81, 89, 90, 92, 104, 107, 122, 136, 153, 165, 173, 177, 192, 196, 213–14, 216–17, 222, 226, 228, 244, 249–50, 257, 261, 265, 267, 270, 277, 280, 283, 290, 302, 305, 309

SPECIAL ACKNOWLEDGEMENTS

Boston Museum of Fine Art: 3, Bequest of David P. Kimball in memory of his wife Clara Bertram Kimball, 1923; 29 & 285, Bequest of Francis Bullard; 294, Henry Lillie Pierce Fund; The Art Institute of Chicago: 8, Gift of Mr & Mrs B. E. Bensinger and the Executive Committee, 1972; The Cleveland Museum of Art: 320, Bequest of John L. Severance; Indianapolis Museum of Art: 162, Gift in Memory of Evan F. Lilly, with the hope that it will bring beauty and inspiration to the lives of others; National Gallery of Victoria; 85, Felton Bequest; Reproduced by Gracious Permission of Her Majesty the Queen: 195, 218; The Santa Barbara Museum of Art: 9, Bequest of Katherine Dexter McCormick in memory of her husband Stanley McCormick; The Taft Museum: 99, Gift of Mr & Mrs Charles Phelps Taft; The Toledo Museum of Art: 79, 157, Gift of Edward Drummond Libbey; National Gallery of Art, Washington: 12, Andrew W. Mellon Collection: 304, Timken Collection

INDEX